PICTURES

WORDS

PHOTOGRAPHIC COMMUNICATION

PHOTOGRAPHIC

COMMUNICATION

PRINCIPLES, PROBLEMS

AND CHALLENGES

OF PHOTOJOURNALISM

Edited, with Commentaries and Notes,
by R. Smith Schuneman, M.F.A., Ph.D.

Based on contributions from the Wilson Hicks
International Conference on Photocommunication Arts,
University of Miami, Florida

VISUAL COMMUNICATION BOOKS

HASTINGS HOUSE, PUBLISHERS

New York 10016

Published simultaneously in Canada
by Saunders of Toronto, Ltd., Don Mills, Ontario

Library of Congress Catalog Card Number: 72-38937

Library of Congress Cataloging in Publication Data
Main entry under title:

Photographic communication.

 (Visual communication books)
 "Based on contributions from the Wilson Hicks
international conference[s] on photocommunication arts,
University of Miami, Florida [1957-1971]"
 1. Photography, Journalistic—Addresses, essays,
lectures. I. Schuneman, R. Smith, ed. II. Hicks,
Wilson. III. Miami, University of, Coral Gables, Fla.
TR820.P53 778.5'38'07 72-38937
ISBN 0-8038-5780-2
ISBN 0-8038-5788-8 (pbk.)

United Kingdom and Commonwealth Edition
ISBN 0 240 50823 8

Designed by Al Lichtenberg
Printed in the United States of America

CONTENTS

To the memory of Wilson Hicks, distinguished pioneer and one of the "greats" in the development of photojournalism and photojournalists.

Photo Center, University of Miami

Wilson Hicks, May 8, 1970

A TRIBUTE TO WILSON HICKS

Every photojournalist owes a gutsy chunk of his professional way of life to Wilson Hicks — even those one-camera, first-story, editor-baiting, art-director-hating, young, misunderstood geniuses who have never heard of Wilson Hicks. Executive editor at *Life* during the late 30's, in the war years, and each of the years until 1950, when standards of excellence within the single shot and the picture story were being established at *Life*, sometimes to be mimicked worldwide by others, Hicks laid down the artistic editorial ground rules by which photo essays were constructed and judged.

It was Wilson Hicks — revered by some, hated by others, respected by most — who sat behind his desk, impeccably dressed, feet often on the desk top itself . . . the old AP news-picture editor, icy-eyed and unbending . . . the man who carried each *Life* photographer's story and battle for identity into the inner sanctum of *Life's* brass. The man who spun slowly in his chair to stare out across the spires of Rockefeller Center into the heart of the stories *his* photographers were shooting around the world. Hicks, the photo-dreamer who, as far as I know, never shot a picture in his life. Hicks, who was never conned by a padded or rigged shot — whose imagination in pictures and picture stories spanned the spectrum of all that *Life* offered its weekly, waiting audience in those hectic, outrageous, king-of-the-mountain years; Hicks, who dealt kid-glove or brass-knucks with such diverse individuals as Bourke-White, Capa, Mili, Kessel, Elisofon, Goro, Eisenstaedt Silk, Parks or Duncan — each of us shooting flat-out against the others as though every photographer, on staff or off, was our deadliest foe. We were all gunning for those few available editorial pages; few, very few when one considered the number of photographers shooting each week for the same space.

Hicks during all of those years, Hicks and no one else, made us a team, and the product set the standard for ourselves which we always tried to surpass, a standard in pictures and photo-essays and sheer quality badly needed today. Now, Capa, Chim and Bischof have been killed; a few others have died; some have retired; Parks has broken into films; many have stayed with *Life;* advertising and television have challenged a handful; Elisofon and I have turned mostly to books, and one or two oldtimers have just disappeared. But, no matter where we have gone, regardless of the new horizons — or even those old ones — that beckon us, we all take Hicks along as our silent co-pilot. Welcome aboard — again — Wilson . . . I've got the damndest idea

DAVID DOUGLAS DUNCAN
University of Miami
May 8, 1970

FOREWORD

It all began in the spring of 1956 during a telephone conversation between New York and Miami. At the New York end was Morris Gordon, a former newspaper and freelance photographer, then director of photography for the Western Electric Company, and an activist in the American Society of Magazine Photographers. In Florida was Wilson Hicks, who had joined *Life's* staff as picture editor in March, 1937, just three months after its founding. Hicks had become executive editor of *Life* on the eve of World War II and built its staff of photographers from four to more than 40 during his 13-year tenure. It has been said by photographers and editors that Hicks assembled and administered the greatest staff of photographic talent in the history of photojournalism.

After leaving *Life,* Hicks wrote *Words and Pictures,*[1] a book which set forth the first "theory" of the photojournalistic form and defined a philosophy of editorial thinking for the use of the photograph in communications. He conducted two "roundtables" on photojournalism at Ohio University in Athens in 1953 and '54 before his acceptance of a faculty and administrative position at the University of Miami in Coral Gables, Florida, in 1955.

Wilson Hicks was, in his own words, a "sophomore teacher" when the call came from Gordon on that June day. Gordon asked Hicks whether the University would like to join the ASMP in sponsoring a short course in photojournalism, and the answer was not only prompt, but also affirmative. "The University would like that fine," replied Hicks, remembering a conversation with a University vice-president the year before about the desirability of such a short course. Ten months after the Gordon-Hicks conversation, the first annual Photojournalism Conference took place with Morris Gordon and Wilson Hicks as co-directors.

[1] New York: Harper & Brothers, 1952.

It was to be a question-raising, not an answer-giving affair. It was to help photographers, writers and editors with their *thinking*. "The greatest idea is the idea of the idea itself," a *Time* axiom, was to dominate programs and programming. Exchange of ideas and a creative approach would have front-stage-center as both the reason for and method of the Conference. "Wilson would sit on a high stool or table at the edge of the stage, interjecting questions that kept both conferees and speakers continuously alert, provoked and electrified," remarked one regular conferee.

In a 1959 discussion — when the Conference was but two years old — Wilson Hicks put his finger on Conference objectives in this answer to a question:

> We curious people, we picture people, including photographers — especially including photographers — we worry subjects and things. We expect to have conclusions. Well, you don't; you don't conclude anything. This is the purpose of this Conference: *to stimulate*. You go home with some ideas; maybe you go home with confusion. Then, in a month or longer, you're caught up; you remember things and begin to relate some of the things you've heard to your *thinking*.

On the first and each succeeding printed program of the Conference there appeared the oriental symbol of unity: the "two-in-one," the indivisible linking of elements to make the whole. In photojournalism those elements are *pictures* and *words*. A Miami freelance photographer, Flip Schulke, who was working at the University when Hicks joined the staff, explained it this way, "Words and pictures being uppermost in his mind, he felt that by bringing words and pictures together they (writers, photographers and editors) would begin to understand each others' problems, and learn to work together as a team."

The Conference was also unique from its start in that Gordon and Hicks did not permit the mechanics of photography to become a center of concern, the "technicals" as Hicks termed them. While the co-directors approached each year's program as a multimedia forum dealing with ink-on-paper, filmic and electronic journalism, major attention has been focused over the years on the still photograph, picture story and photographic essay for magazines and books.

The logical question, of course, is what sources could Gordon and Hicks attract to the Conference who could provide the necessary catalytic atmosphere to "spark" this exchange of ideas? The yearly search for fresh talent in photography, art direction and

editing was similarly as impressive as Hicks' staff-building while at *Life*. However, the search was broader, for it encompassed wider horizons in communications than picture-making alone. Hicks being "isolated" in Miami, it was Morris Gordon who was active in New York, center of the nation's communications industry, as well as internationally, for in later years he sought photographers, art directors and editors from Europe and Asia.

Permit me to share with you just a few names of the masters who have shared their knowledge with conferees: Wilson Hicks, the editor, of course, and Morris Gordon giving form and continuity to the remarks of such photographers as Arthur Rothstein, Ernst Haas, Bruce Davidson, Gjon Mili, Wayne Miller, Howard Sochurek, Pete Turner, Burk Uzzle, Yoichi Okamoto, Eliot Elisofon, Art Kane, Marvin Koner, Cornell Capa, David Duncan, Margaret Bourke-White, Edward Steichen and Philippe Halsman — virtually a Who's Who in Photojournalism. Editors, art directors and publishers, as well, have contributed an "editorial balance" to developing thought on photographic communication. The late Dan Mich, *Look's* editorial director, George Hunt and Ed Thompson, formerly of *Life's* staff of editors, and outstanding art directors including Willy Fleckhaus, Herb Lubalin, Frank Zachary, Bernie Quint, Allen Hurlburt and Will Hopkins have addressed themselves to problems and principles of group journalism. One publisher, the late Henry R. Luce, called for photojournalists to place greater emphasis on insight, and Gilbert Grosvenor said the failure of a magazine can generally be traced to problems in the editorial department.

Certainly just a listing of these names alone would form a most unusual and distinguished faculty for a series of conferences on photojournalism. But, the men and women above are small in number when one realizes that to this Conference have come about 235 individuals who have appeared on the programs — and that counts but once the Halsmans, Duncans, Rothsteins and others who have shared with conferees for second and third appearances! All of these "teachers" have given their personal insight in the true spirit of professionalism.

On the average there have been about 140 conferees each year with cumulative registration exceeding 2,000 by 1970. Some conferees have attended every Conference!

The Project is Born

A comment now on how this book project was born. Either you already know or are beginning to sense something of the "Wilson Hicks Challenge." One of his many challenges now results in *Photographic Communication,* but the idea was planted in 1967 during my first attendance at the Conference. Though I had known of Mr. Hicks and his work for some time — first having corresponded with him while a graduate student in fine arts photography at Ohio University in the late 1950's — it was not until the early 1960's that I met him personally in Miami on two or three occasions and experienced first-hand the stimulation of his persevering and razor-sharp questions.

So it was that during the 1967 Conference he wanted to discuss with me the historical value of an audiotape collection from all of the Conferences. Recordings from the keynote address in 1957 through some 325 hours of sessions to the present day had been saved and were in perfect preservation. What foresight Hicks and Gordon demonstrated when they determined to acquire broadcast-quality recordings of each year's proceedings.

"Would you have any interest in 'doing something' with the collection?" Hicks queried during our first discussion of the project. After studying the programs from all of the Conferences, it was evident that there was a great source of virgin material which should not only be available to students, but also to scholars and professionals, alike. Besides, what an opportunity to learn from the very best in the field. My reply, too, was prompt and affirmative!

More than 300 reels of tape arrived in Minneapolis — a year-and-a-half of "listening" during every spare evening. Some friends have asked how I could ever have listened to all of those days . . . and weeks . . . and, if you want to figure it out, months of talk! It was no problem, for I always approached "listening time" with great anticipation. It would be three or four hours with Halsman or Haas or Duncan. What would they say to me? What was their thinking?

About 100 hours of duplicate tapes were made from the total collection and transcribed into typewritten form. It was from those 100 hours that this book has been selected.

As transcripts began to accumulate, the significance and dominant values which the collection held for others came into sharper focus. Here were assembled the ideas, methods and philosophies of the top professionals in photojournalism. Nowhere in the literature did there exist so complete a body of knowledge by the "greats" in our field. Since each contributor delivered his thoughts as much for his peers in the audience as for the inexperienced pros or students, he had been at his best. Contributors often spent weeks — or months — gathering and considering their thoughts and photographs before the Miami appearance. Even if one were to visit each speaker at his home or studio, it would be doubtful if so concentrated and intensive a discussion could occur as unfolded at Miami.

There was another unique value in the collection. Many of the contributors had never set forth their thoughts in the written word; they were *visual* communicators. While one might examine their photographic efforts in magazines, books or museum archives, only in the Miami tapes were preserved their ideas and philosophies. There were, of course, magazine profiles and occasional biographies or autobiographies — Duncan's *Yankee Nomad* being a familiar example — but for the most part their ideas and philosophies were unavailable in our literature.

The tapes were, indeed, a very important body of work: a 15-year voyage of interaction among editors, writers, art directors and photographers, mutually exploring contemporary thought, performance and developments in photographic communication. There were spirited critiques of photographs, art direction and stories which provided additional viability.

If readers can sense and experience within the pages of this book the spirit and stimulation which conferees and speakers alike have found over the years at Miami, then its first objective has clearly been realized. A less impressionistic, more definitive, but equally important goal of this book is to focus the reader's attention on "five dimensions" of photographic communication. Each is important to the understanding of the photograph as a communication medium as well as toward an understanding of the process and professional practice of photojournalism from idea through publication.

The Five Dimensions

First of the five dimensions is a definition of the *medium,* itself. How is it unique? What can it accomplish and what are its basic ingredients? What has been its heritage? Two chapters develop this topic, including the book's "Introduction" which comes from the classic and timeless first unit of *Words and Pictures,* now out of print. By permission of the author and his publisher, here is Hicks' definition of photojournalism, his principle of the "third effect" and a basic theory of the photojournalistic process. Also within the "Introduction" is a re-cap of the development of the photojournalistic form during the late '20's and early '30's in Europe as well as the mid-'30's in America. Chapter 2 continues its examination of the medium of photographic communication as it carries our understanding from the 1950's into the '70's. Included is a comparison of still and moving images as well as color and black-and-white photography.

Second comes an examination of the *process* of creating photojournalism. It involves "group journalism" as practiced at *Life, Look, National Geographic Magazine* and others: the group process and group interaction of writer, photographer, art director and editor. Since a group, not an individual, creates and edits each story, compromises along the way are and always have been the point of controversy. By contrast, an emphasis on individualism is evident in the book publishing field, a topic found in a separate chapter devoted to the photographic book.

Hicks once spoke at Miami on the topic "The Camera is a Man." His title is corroborated and expanded in an in-depth chapter of photographers' *personal viewpoints and philosophies,* the third of this book's "five dimensions." Creativity, individualism, intuition, craftsmanship and love for subject and medium all are there to be discovered and examined. It ranges from the personal commitment and sensitivities of Ernst Haas for his life-long work on "Genesis" to the delightful anecdotes and serious advice of the "Yankee Nomad" himself, Dave Duncan.

Fourth are the *professional problems* of photographic communicators: the questions of shrinking or expanding markets; educational directions, needs and goals; and a problem now approaching a decade of serious concern, the economic crisis in magazine publishing. Publishers, editors, agents and photographers are drawn upon to approach these professional issues from a variety of perspectives and viewpoints.

Fifth is the *international view* of photographic communication, a consideration of developments, particularly in Europe, of both still and motion pictures. Photographers and editors from Sweden, Holland, Germany and France appraise change in the past decade and consider the future. Use of the photograph in international propaganda as provided for under terms of a cultural exchange agreement between the USSR and USA suggests the functional breadth as well as geographic sweep of photographic communication in the global communications grid.

Thus, it is hoped that the reader will find much more than a record or history of the Miami Conference herein; the book is not that. It should provide sound professional advice for study about or work within the field of photographic communication: what a photojournalist can do in the medium, how he works with the team in "group journalism," a

background of the philosophies and points of view operative today, insights into current problems and an understanding of international developments.

In the final editing of a manuscript for publication, the editor must assume full responsibility for his work. Each of the presentations has been carefully checked for accuracy of facts and spelling of names. While every precaution has been taken to guard against any distortion in fact or interpretation, there always exists such a possibility when working from recorded speeches (occasionally speakers left the microphone or two people talked at once, for example).

Some presentations in the book are rather short. They may either have been extemporaneous remarks from the floor or an opening or closing statement by a speaker whose time, in the main, was devoted to a showing of slides. This generally explains the variance in length among speeches. Occasionally only segments of a speech or a panel discussion have been included, and these have been noted as "excerpts."

Each selection has been carefully edited to make it readable to the eye, since all presentations were originally for the ear. Inverted sentences and grammatical slips have been corrected along with deletion of the "a's," "and's" and "but-a's" which are so much an accepted part of oral communication.

Photo Center, University of Miami

Morris Gordon (left) and Wilson Hicks at the Conference, 1970

Acknowledgments

The necessary location, organization and transcription of "raw data" before final editing could begin were accomplished with the able and friendly assistance of many individuals. Acknowledgment is in order for those institutions and very special persons who have helped so much in bringing this project to its conclusion.

At the University of Miami the staff of the Photo Center located hundreds of boxes of tape, stored in assorted places, and assisted Wilson Hicks in shipping them to Minneapolis. The Director of University Publications, Miss Betty Baderman, was particularly helpful in her support and problem-solving efforts following the death of Wilson Hicks on July 5, 1970. Miss Baderman provided uninterrupted continuity in the very professional relationship which has existed between the Universities of Miami and Minnesota during the four years of this project. The kind assistance of Mr. Charles Estill, Vice President for Development Affairs, is also acknowledged for his authorization on behalf of the University of Miami to use the original tape materials in this book. Preceding his death on November 13, 1971, Conference co-director Morris Gordon offered thoughtful suggestions, criticisms and support.[2]

At the University of Minnesota transcriptions of the Miami Conference tapes were completed under terms of two grants. The author is most appreciative of the support and assistance of a grant-in-aid of research from the Graduate School of the University of Minnesota and the McMillan Fund. The interest and enthusiasm for this cooperative project with the University of Miami by Dr. E. W. Ziebarth, Dean, College of Liberal Arts, and Dr. Robert L. Jones, Director, School of Journalism and Mass Communication, University of Minnesota, added greatly to the author's incentive and drive to complete the work. Of course the advice and counsel of my colleague and former teacher, Dr. Edwin Emery, was ever-present, always providing assurance and direction for whatever the question of the moment.

A comment now about the painstaking task of transcribing from the spoken word into typewritten form 100 hours of talk! Elizabeth J. Allen, who first joined my staff as a freshman in college, graduated in June, 1971, *Summa Cum Laude,* after having devoted all of her working time in my office during the past two years to this single project. In typing the finished manuscript, her constant questions on style, grammatical construction or even a speaker's logic kept this author constantly on guard.

Especially acknowledged and appreciated are the six-month association and editorial assistance of Joan M. Torok, who was responsible for the rough-editing of selections. Her work, too, was excellent. Miss Ann Noble of our School of Journalism Library demonstrated expertise as a library scientist in problem-solving searches for missing, incomplete or inaccurate information.

For their immediate interest in and appreciation for the values of materials from the Miami Conferences, and for their continued advice throughout the editing process, a thanks to Russell F. Neale and Alan Frese at Hastings House, Publishers, New York.

[2] Gordon chaired the 1971 Conference following Hicks' death, but had not planned to continue in 1972. As this Foreword was being written, plans were underway for Conferences in 1972 and beyond. Arthur Rothstein, director of photography at *Look* before its closing and an associate of both Hicks and Gordon, had accepted the chairmanship of the 16th annual session to be held in Miami in the spring of 1972.

And, for all of the time which I have devoted to the project — when my family would rather have enjoyed a Saturday hike, a Sunday swim or an evening bicycle ride — I acknowledge the interest and understanding of my sons, Thomas, 8, and William, 3, as well as my wife, Patricia, who became an untiring booster and associate in each step of the project.

Finally, this book could not have been published without the very significant contributions of each of the speakers whose remarks appear herein. Their enthusiastic support for the project, willingness to authorize permission for publication of their prepared remarks, and their cooperation in searching files for photographs or story layouts long ago "put to bed" reaffirm their status as professionals in the best sense of the term. I feel very certain that were Wilson Hicks and Morris Gordon living, they would wish to join with me in thanking each speaker for sharing his ideas and dreams — first with Conferees at Miami and now with readers of *Photographic Communication.*

R. Smith Schuneman
Minneapolis, Minnesota
February 10, 1972

The following section, "What Is Photojournalism," is reprinted from WORDS AND PICTURES (pp. 3-45) copyright 1952 by Wilson Hicks, by permission of Harper & Row, Publishers.

1

What Is Photojournalism?

WILSON HICKS

from *Words and Pictures*

1. THE GUIDING PRINCIPLES

The Secret Is the Fusion

The most graphic reporting is eyewitness reporting. "I was there; I saw it happen; it was like this"

In journalistic print the firsthand account which comes closest to reproducing the actuality of an event is the picture story: good headlines plus good photographs plus good captions.

In understanding what happens around him man depends primarily on his sight, secondarily on his hearing. In journalism which makes use of words only, the words bear the entire burden of re-creating for the reader an experience undergone by someone else. Printed words being visual representations of spoken words, the sense of hearing is basically related to the act of reading. The eye in conveying sound symbols to the brain appropriates the work of the ear, so to speak, and performs to a very limited degree its own peculiar function which, to put it quite simply, is to see. In journalism which makes use of words and pictures, to the stimuli of sound symbols there are added the stimuli of the forms of reality represented in the photograph. Together these stimuli call forth a collaboration of the two senses by which the quality of a re-created experience is enormously increased and brought much closer to actual experience.

This particular coming together of the verbal and visual mediums of communication is, in a word, *photojournalism*. Its elements used in combination do not produce a third and new medium. Instead, they form a complex in which each of the components retains its fundamental character, since words are distinctly one kind of medium, pictures another. Of various dissimilarities in the mediums the one most pertinent to an understanding of the photojournalistic technique is to be found in the ways in which they activate certain subjective responses in the reader.

The verbal medium is discursive. Words are facts, ideas and feelings in due arrange-
ment, in most languages, between two points left and right. About the sequence and
appearance of the words grammarian and typographer both have their say. For the
reader it is necessary, before the process of comprehension can be complete, to effect
an orderly series of visual moves through a variety of particulars set forth by sentences
such as these on this page. To the picture, however, the reader reacts in a strikingly
different manner, which Susanne K. Langer describes as follows:

> Visual forms — lines, colors, proportions, etc. — are just as capable of *articulation,* i.e., of
> complex combination, as words. But the laws that govern this sort of articulation are alto-
> gether different from the laws of syntax that govern language. The most radical difference
> is that *visual forms are not discursive.* They do not present their constituents successively,
> but simultaneously, so the relations determining a visual structure are grasped in one act
> of vision.[1]

Thus there is a fundamental difference in the acts of eye and mind by which words
and pictures are read. A "visual structure," for example a single black-and-white photo-
graph, is taken in all at once by the reader. He may not thoroughly comprehend it at the
first look, but at least he gets the general idea, and with a quick promise to himself to
return to the picture, he goes on to the words. His eyes may move rapidly through the
caption, or they may move slowly, depending on his perceptive capacity. Whatever the
individual reaction, the important point is that picture and words not only are read in
different ways, but also are read at different times, however close together those times
may be. The picture is almost invariably read first; the common habit is for the reader's
eyes to move back and forth from picture to words and back again to picture until the
meaning expressed in each medium is completely understood.

The intent of photojournalism is to create through combined use of the dissimilar
visual and verbal mediums a oneness of communicative result. If a fusion of the mediums
could come about on the printed page, the problem would be simplified to the extent that
only one perceptive act on the reader's part would be required. As noted above such a
coalescence is impossible. A fusion does occur, but not on the printed page. It occurs in the
reader's mind.

The basic unit of photojournalism is one picture with words. When a newspaper
or magazine prints such a unit, the subject of which is news or within the vast bounds
of matter related to news, it is practicing photojournalism in its simplest form. But, it is
practicing it in the true sense only if the photograph and the words which accompany
it constitute "a single expressive statement"[2] or produce a unity of effect within the
reader's consciousness. In a single expressive statement it is essential that the comple-
mentary relation between picture and words, in terms of subject matter, be fully realized.
Unity of effect can be obtained by a use of words in counterpoint to picture. The
subject matter of the mediums might differ completely and yet, through an ironic or
other interplay, produce a singleness of effect in the fusion process.

[1] Susanne K. Langer, *Philosophy in a New Key* (Cambridge, Mass.: Harvard University Press, 1942), p. 75.
[2] Elizabeth McCausland, "Photographic Books," *The Encyclopedia of Photography* (Chicago: National Educa-
tional Alliance, Inc., 1942), p. 2783.

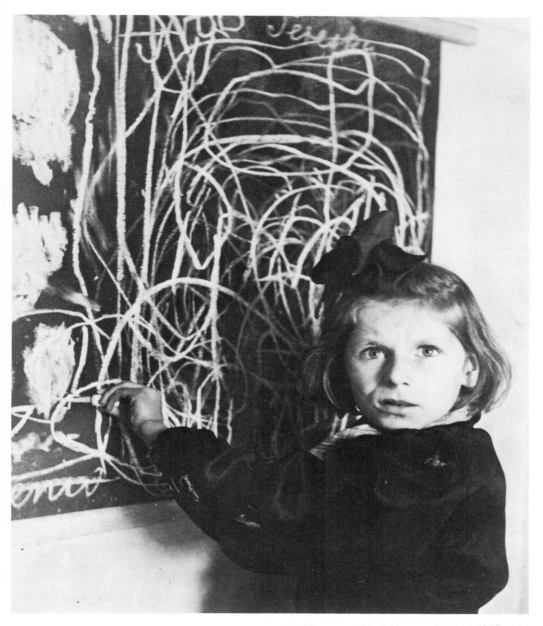

David Seymour "Chim," Magnum, 1948, UNESCO series

Tereska, a Polish child in a home for disturbed children of post-war Europe, produced these scrawls when asked to draw a picture of her home.

This is an example of the basic unit of the photojournalistic form, in which the word and picture mediums, radically unlike though they are, collaborate to create a unity of effect.

Dallas Kinney, Palm Beach **Post,** 1969
From his Pulitzer prize-winning photographic documentary on migrant workers

"No matter what kind of housing you have for your help, the laborers won't take care of it; they just won't." — Floyd Ericson, president, Everglades, Florida, Farm Bureau (as it appeared in the Palm Beach *Post*, Oct. 5, 1969, with the above photograph).

By juxtaposing the photographer's visual document beside words of opinion about the subject, the editor can create a summation effect, in which the whole meaning is greater than the sum of its parts. The reader's own background and memory are called into action, thus providing additional information. His contribution is called the X-factor, a communicative overvalue.

In the re-creation of an experience in photojournalism, pictures and words together perform a more effective function than either can perform alone. There can, however, be an inequality in their communicative values, the value of each medium being the clarity, coherence and force with which, in its own way, it says something about a given subject. In some instances the picture can have a value in excess of the accompanying words; in other instances the opposite can be true. The ideal is reached when the values are equal and in balance, for then the single expressive statement has maximum impact.

Time, Space and the X Factor

For the fusion process to be set in motion with the utmost effectiveness there is required another balance in the photojournalistic form which may be explained by a comparison with television. The observer at the television receiving set sees and hears what is happening at precisely the time it is happening. With sight and sound synchronized so that both the chief senses are stimulated at the same time, there is produced a secondary realism of only slightly less force than that of the event on which

the camera is turned. When a television reporter complements the images of an event with his own spoken account of it, his problem of combining pictures with words is similar to that encountered in photojournalism with an important exception. In television the phenomena of sight and sound occur *"simultaneously in time."*[3] This is the simultaneity of actual experience: that ideal coming together of sense stimulations which does most to bring about an immediate comprehensive reaction and can produce the greatest impact, emotional or intellectual.

As explained earlier, in photojournalism the picture and the words are read at different times. Photojournalism is thereby denied the coincidence in time of sight and sound. In its case, "The parallel . . . must be . . . a coinciding of the picture and the printed word in *space*."[4] Hence one of the main techniques of photojournalism is aimed at obtaining such efficient relationship of picture and words as will produce an equilibrium between the visual image and the auditory symbols or words. The nearer this equilibrium is achieved, the nearer the effects of the mediums in combination approach the simultaneity of actual experience. Photojournalism makes space do the work of time.

When pictures and words are organically related and their values balanced to create a single effect or series of effects of maximum impact, they still have not accomplished all of the communicative result which the photojournalistic form is designed to accomplish. In fact, the very foundation of the form rests on its extraordinary ability to induce a phenomenon wherein the total of the complex — that is, picture and words together — becomes greater than the sum of its parts.

This phenomenon is caused by the addition of an X factor to the joint impression made on the reader's mind by the mediums acting in concert, the X factor being the reader's own contribution to the communicative chemistry. Appealed to through eye and ear, his emotional or intellectual reaction doubly stimulated, the reader supplies material from memory and imagination to round out and enrich what is being conveyed to him. Thus he elaborates and evaluates by drawing on his experience and knowledge, gained firsthand or from reading other words and seeing other pictures. Fresh pictures and words evoke in him mental images of remembered objects and actions or abstract concepts which have previously become a part of his emotional or intellectual background. There is derived out of the reader's interpretative process an overvalue which aids and increases his understanding of the facts, ideas or feelings conveyed to him and enhances their sense of reality. Produced by a basic unit of one picture with words, this imaginative "plus" is multiplied in a picture story far beyond the arithmetical limits of the number of photographs and words actually involved.

The overvalue phenomenon can be demonstrated by looking at, say, 25 pictures taken for a story having unity of time and place, or a group of related photographs setting forth various aspects of a specific subject. As a viewer turns through them, whether or not they are in a particular order and even before they are captioned, he realizes at some point along the way that he is experiencing a cumulative effect by which the story is suggested as a whole, that whole having proportions over and above the simple addition of all the pictures. Their narrative and descriptive content is so

[3] *Ibid.*, p. 2785.
[4] *Ibid.*

expanded by the viewer, imaginatively, that they take on something of a motion picture's fullness and fluidity. When photographs are selected, organized and joined with words, the overvalue is increased, the extent of the increase depending on how well those modifications are made. When a picture story, or a page or two-page layout within a story, has that extra quality, it is said to jell.

Such, then, is the theory of the co-operative action of eye, ear and mind which enables photojournalism to effectively communicate through its complex of unlike, but mutually dependent, mediums.

Photojournalism does not, strictly speaking, involve one individual, but three: photographer, writer and editor. They, too, are dissimilar, but interdependent. (Seldom are three, or even two, of the skills of photojournalism combined in one person. As the techniques have developed there have come forth photographer-writers, but a photographer-writer-editor is indeed a rarity.) The skill with which photographer and writer each creates his part of the communicative form and the editor integrates those parts determines the degree of the reader's response. In exercising their skills all three of the participants enter into still other complexes, one of them being the delicately balanced complex of the photographer and his camera; others are the writer and his researcher, the editor and his art director, the art director and the layout man who shapes the words and pictures physically together. There is the over-all complex of which the editor is the chief component; then there is the editor and his editor-in-chief, the policy maker.

This compounding of skills in photojournalism is termed *group journalism* at Time, Inc. A variety of talents and techniques is required to communicate the simplest fact or idea. The free-wheeling individual of traditional journalism is replaced by a group which gathers the material for and "writes" a report or interpretation of the news or related subject matter. The success of the group's operation depends on a disciplining of those who compose it to operate smoothly as a unit and to understand one another's function; otherwise there can be no translation of words into pictures, and back again.

On Seeing Things

The power of keen observation is not a conspicuous virtue of the average man. As he moves among the people and objects of his everyday environment he makes careless use of his eyes; what comes within his viewing range he seldom sees clearly and accurately. Office, factory and home, and the streets which connect them, exist in a veil of near invisibility because of the readiness with which human beings become dulled to repetitious experience. The distinguished art critic, Roger Fry, wrote:

> The needs of our actual life are so imperative that the sense of vision becomes highly specialized in their service. With an admirable economy we learn to see only so much as is needful for our purposes; but this is in fact very little, just enough to recognize and identify each object or person; that done, they go into an entry in our mental catalogue and are no more really seen It is only when an object exists in our lives for no other purpose than to be seen that we really look at it[5]

[5] Roger Fry, *Vision and Design* (New York: Peter Smith, 1947, by special arrangement with Chatto & Windus, London), p. 16.

Of things seen, reports made to the mind by the eyes are, for the most part in ordinary existence, fleeting and incoherent. And when a man, even with 20-20 vision, is a participant in, or spectator at, an event which is a departure from routine, especially one that causes an acute emotional reaction, the mechanism which relays visual images from eye to mind operates with still lower efficiency.

Why?

To that question both psychology and physiology contribute answers. Those answers have a special bearing on photojournalism and its techniques, for they help to explain the significant fact that people see objects and actions as portrayed in a photograph better than they would have seen the original objects and actions had the observers been in a state of high emotional tension while looking at them. To illustrate this point Roger Fry in a pioneer study (1909) of this difference between perceptive response to reality and to reality as reflected in a picture cited the example of a man suddenly meeting up with a wild bull in a field.

> The nervous mechanism which results in flight causes a certain state of consciousness which we call the emotion of fear [A] great part of human life is made up of these instinctive reactions to sensible objects and their accompanying emotions [In] actual life the processes of natural selection have brought it about that the instinctive reaction, such . . . as the flight from danger, shall be the important part of the whole process, and it is towards this that . . . man bends his whole conscious endeavor.[6]

The unlucky fellow of the bull incident did not, therefore, get a clear and complete view of the beast the moment he had the best opportunity to see it, which was at the beginning of the encounter. Naturally he acted on his instinct to survive. Today science would analyze his "instinctive reaction" in greater detail. Assuming his body functions were normal the physiologist would say his adrenal gland had much to do with the reduced sharpness and extent of his vision. When adrenaline is introduced into the bloodstream of a person suffused with fear, anger and some other emotions, drastic interference with his ordinary responses, including those of the eyes and brain, results. To this the psychologist would add that the psyche of the man who met the bull was not equal to the task of sorting out and co-ordinating the ensuing confusion of ideas. Probably both explanations apply.

Other emotional reactions, not induced by so powerful a stimulus, can have similar effect. If the wild bull instance seems extreme, take the example of a bride at her wedding. "I didn't really see any of it," she says later, "I was so nervous." Again, to an amateur public speaker an audience is a shimmering mural of faceless listeners. And inconsistencies in reports of accidents by various witnesses are in part caused by the inability of people to see with thoroughness when excited.

Paradoxically, man sees more clearly and completely when there is established for him an indirect relationship to the manifestations of reality, a relationship which permits him to be a spectator at events in the external world. This indirect relationship is made possible by the photograph, which derives its power to accomplish that feat from the unique capacity of man to live two lives, one the actual, the other the imaginative.

[6] *Ibid.,* p. 12.

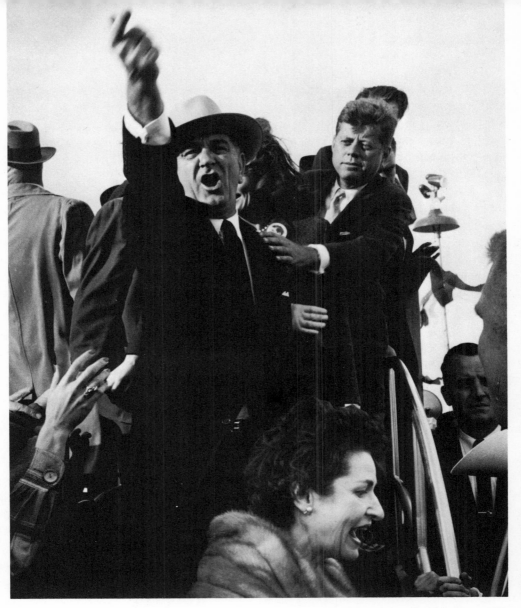

Richard Pipes, Amarillo **Globe-News,** 1960

John F. Kennedy was giving a campaign speech at the Amarillo, Texas, airport in 1960. Suddenly a turbo-prop jet started its whining engines. Vice Presidential candidate Johnson and Lady Bird screamed for action — Stop the noise! (The photographer reports, however, that his editor *did not* use the picture, and that it was not published until November, 1966, when it appeared on the cover of *Infinity.*)

In times and places of excitement, or when in states of mental unrest, human beings do not see clearly and well. The people who had come to hear John F. Kennedy at the small airport in Amarillo, Texas, during the 1960 campaign probably did not see clearly all of the human expressions of this emotional instant. Only later by looking at the photograph with dispassion could the essence of that moment be fully appreciated. This photograph is a classic example of the fact that the camera sees differently than the eye.

The Calm Eye and the Trained Eye

> . . . [Man] has the peculiar faculty [wrote Roger Fry] of calling up again in his mind the echo of past experiences . . . of going over it again "in imagination" as we say But, in the imaginative life no [responsive] action is necessary, and, therefore, the whole consciousness may be focussed upon the perceptive and the emotional aspects of the experience. In this way we get in the imaginative life a different set of values and a different kind of perception.[7]

The imaginative life is the life of the images of memory as contrasted with the "pictures" of reality seen by the eyes and perceived by the mind in actual life. There is, of course, a close affinity between a memory image and a photograph. The latter is, in a sense, a captive memory image of a photographer which others can share. Like the remembered scene or event the photograph demands no responsive action, stimulates no secretion by the adrenal gland, replaces chaos with order for the psyche.

In a photograph, as in a memory image, emotion can be felt and, at the same time, seen dispassionately. An emotion presented in a photograph may not affect the observer with so much force as that which occurs in real life, but it projects itself more distinctly and with greater clarity into the consciousness. The viewer of a photograph, whether it involves him or others with whom he can identify himself, can have a detached point of view, a "disinterested intensity of contemplation"[8] not available to him in actuality. Moreover, he can enter into its emotional content without physical involvement, a mental act similar to the theatergoer's projection of himself in imagination, when deeply moved, into the action on the stage, although in fact he remains quietly in his seat.

People are sometimes heard to remark that looking at the photograph of an event is "like being there." The fact is that when expertly made a photograph is better than being there — in a sense it is more real than reality — because of those peculiarities of human beings which prevent their seeing plainly and precisely when in a state of mental unrest.

Man is not always in such a condition. Even so, when he is calm of mind and relaxed of body, he still does not see as well as the camera sees. Whether surveying a landscape or glimpsing a friend in the street, his eyes do not take in all that the camera trained on the same scene takes in. Within the limits of a given scene the eyes see selectively, the camera indiscriminately. "In seeing, you use a kind of visual shorthand, whereas your patient camera takes everything within its ken in laborious, literal longhand the camera is always a stranger; it takes nothing for granted."[9] The camera is thus more inclusive in its "perception" than the eye.

This quantitative value of the camera's "sight" is at once an advantage and a disadvantage in photojournalism, for sometimes it is as bad for a picture to have too much in it as too little. Photojournalism demands of the camera that what it sees it see better than the eye; that unlike the eye it miss nothing important. To these demands the camera, inanimate object though it is, is completely capable of acceding. But, photo-

[7] *Ibid.*, p. 12.
[8] *Ibid.*, p. 19.
[9] Thomas H. Miller and Wayne Brummitt, *This is Photography* (Garden City, N.Y.: Garden City Publishing Co., Inc., 1945), p. 11.

journalism goes further. It demands that the camera be selective, that it discern as well as see, that it lay hold of what it sees with understanding. Obviously, with these latter demands the camera cannot cope; a human being — the photographer — is required to exercise his discretionary powers in making use of the machine. To see well the photographer should have as much emotional control as he can muster — and a trained eye.[10]

In a reference to the trained eye in one of his courses at Columbia University Jacques Barzun, professor of history, tells his students that the artist has a capacity for superior perception and a more sensitive reaction to his environment than the non-artist. The painter, Mr. Barzun says, has an idea, formulates it, then transmits it through technique to canvas. After that it is communication. The artist can say he sees things better, more interestingly than, or merely differently from, the other person. The other person — the non-artist — therefore has his own view of things, plus an opportunity to see the artist's. The artist enlarges the experience of the other man.

Mr. Barzun's assertion has a fundamental meaning not only for the painter, but also for the writer and for the journalistic photographer, whether that photographer is or is not an artist in the strictest sense.

Vision, Inward and Outward

> I look up and see a bird on a branch [writes Herbert Read.[11]] I close my eyes, but if I so desire I can still see the bird in my mind's eye. What I still "see" (i.e., retain) is an "image" of the bird I then dismiss the bird from my mind and the image disappears; but if some days later I am reminded of the bird, the image returns.

> Memory is the capacity to recall such images in various degrees of vividness; and imagination . . . is the capacity to relate such images one to another — to make combinations of such images either in the process of thinking or in the process of feeling.

With those definitions in mind now consider imagination in the light of the role it plays in the work of the painter on the one hand, and, on the other, that of the photographer, in producing communicative images.

Art derives out of the imaginative life of the artist.

Even though the painter uses an actual person, place or thing as a model, as soon as he departs from rigid realism he enters upon that process wherein his memory images are combined and synthesized to formulate new ideas in the handling of a subject. The artist's mind is an accumulation of memory images. What he puts into a picture is, in a sense, himself in terms of what his experience has made of him. He does not state a fact or idea, describe an emotion or make an observation or comment in a painting without a certain distortion that grows out of his thinking or feeling. For him man and nature do not exist apart from his interpretations of, and reflections on, life and his beliefs, attitudes and prejudices. There is no limit to his opportunity within

[10] Emotional tension as it affects vision sometimes causes even the ablest professional photographer to smile at himself. In David Douglas Duncan's *This Is War!* (New York: Harper & Brothers, 1951) is a picture of Marines stealthily advancing under fire against the building fronts of a Seoul street. Not until six months after taking the picture did Duncan discover on closer examination four more Marines, their heads protruding from a hole in the pavement.

[11] Herbert Read, *Education Through Art* (New York: Pantheon Books, 1945; first published by Faber and Faber, London, 1943), p. 39.

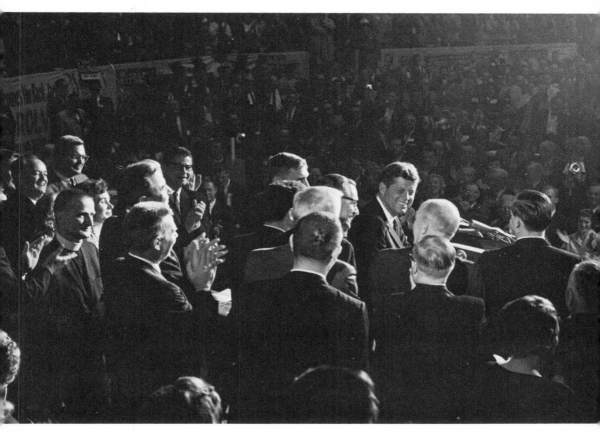

President John F. Kennedy addresses a Democratic Farmer-Labor Party bean feed at the Hippodrome in St. Paul, Minnesota, during the 1962 Congressional Campaign. Senator Hubert Humphrey was to become Vice President and, in 1968, a Presidential candidate. Senator Eugene McCarthy, also in the group, would oppose Humphrey for the nomination.

Here the camera is definitive as it reveals the political hierarchy of the nation — then and later. The photographer's purpose is to give order to the chaos of forms which is reality. In this example the photographer contends effectively with the essential disorder of the crowd on the speaker's platform in the moments of the President's arrival.

the scope of his talent to alter reality, to intermix the real images of the present with the stored-up images of his mind. In the creating of his picture he has complete and utter control. He is the master of reality, which for him can range all the way from naturalism to fantasy.

(A distinction is made here between art in which the painter deals with recognizable subject matter of the tangible world and abstract art in which the painter makes use of a private symbolism consisting of mental images unique with him. The present concern is with representational art, although that is not to say that the abstractionist, too, does not at times operate under Herbert Read's definitions. "Rigid realism," described above, is defined here as art in which an object is copied with direct and

"photographic" exactitude. Even so, it is most difficult, if not impossible, to say that a "fully realized" objective painting does not contain imaginativeness in some degree.)

In photojournalism the photograph is derivable only out of reality itself.

The photographer in relation to the subject matter of his picture does not have a choice between staying with or departing from realism. Reality is the master of the photographer. Only what appears before his camera — nothing else — finds its way into his picture. That which is in front of his camera is a picture in and of itself, or the photographer makes of it a picture by modifying the scene or situation, by imposing his personality with its various attributes on external reality and photographing whatever transformation results. Whether his "model" is a person, place or thing, he cannot change it by an intermixture in the emulsion of his negative of images past and present, imagined and real. It is just such a transmutative process that takes place between the painter and his pigments.

But, as a human, the photographer is very much like the painter. He, too, has imagination — the capacity to relate and combine memory images and actual images, a capacity which he longs to put to use; and he has an unremitting urge to communicate not just what he sees, but also what and how he feels about what he sees. How then, and to what extent, does photography permit him to act on these compulsions?

In the esthetic sense the moment the photographer establishes a vantage point from which to take a picture, he abandons the objective point of view. In choosing a stance he performs a mental act of discrimination with reference to external reality as anyone might see it, and thereby he makes his first move toward interpretation. When he decides on his composition, lighting and determines the most meaningful moment at which to trip his shutter, he further exercises his faculty of selection. It might be said that the more he sees in his own way the more he departs from objectivity. As affecting the photographer, the three terms, *objectivity, interpretation* and *point of view* have important distinctions in their uses in art as contrasted to journalism. In the esthetic sense, the photograph is never *objective,* since it represents conscious choice, exclusive with the photographer, of composition and other characteristics. Journalistically, a photograph is *objective* when it does not imply the photographer's individual belief or opinion with regard to the subject. *Interpretation* has a threefold connotation. More particularly, in the esthetic sense a photograph may be *interpretative* in that it presents physical reality in the special manner, involving personality and taste, in which the photographer looks upon it. Journalistically, a photograph may be *interpretative* merely in explaining what it shows, or it may be *interpretative* in explaining what it shows in terms of the photographer's own personal ideas and interests. *Point of view* may simply indicate the physical point from which the photographer views what he wishes to picture. In an esthetic sense it may refer to the original way in which a photographer endeavors to reflect the physical world, a way different from that of other photographers; in this meaning it is virtually synonymous with *interpretation.* Journalistically, *point of view* may mean the photographer's distinctive intellectual position, involving belief, opinion or special attitude with respect to what he photographs. In the case of each of the three terms the journalistic and esthetic senses frequently intermingle. Whether a journalistic photographer should imply or express opinion or belief is another matter.

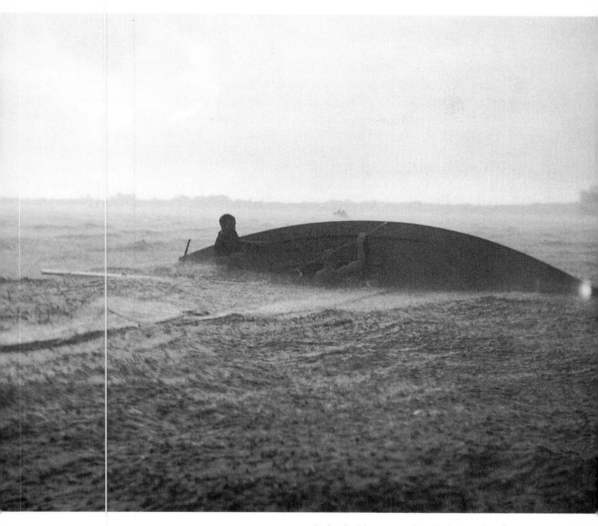

R. Smith Schuneman, **The Okobojian** (Iowa), 1959

A skipper and his one-man crew weather a thunderstorm and severe winds in their just-overturned sailboat during a national regatta on Lake Okoboji, Iowa.

This is an impressionistic photograph in which the photographer used a slow shutter speed to achieve a slight blur in motion suggesting boat movements in the waves. The low contrast print was made to communicate the dullness of light and detail during a wind and rain storm.

The Magic Amulet

The photographer's purpose is to give order to the chaos of forms within reality. In seeing clearly and in understanding what is before his camera, he is able to organize, condense and define a small unit of reality so that it will be plain and intelligible in his photograph. To heighten the explanatory value of his picture he calls upon emphasis to assist him. By judicious use of accent and stress with respect to certain forms in his picture, he intensifies the picture's significance and meaning.

In this process the all-important act of selection is the overt manifestation of the

photographer's judgment. It is in the exercising of this intellectual faculty, rather than in the expressing of his emotions, that his imagination becomes his ready and willing servant. In the selection of photographable images the photographer's memory images serve as precedents and examples against which he can effect comparisons to aid him in his choice of a combination of forms from actual life which are suitable for a photograph. If he wishes, he can also combine memory images to formulate new ideas in the handling of a subject. Conceiving an "ideal" picture in his imagination, he can bring a synthesized, prior image to materialization by discovering the particular combination of forms in reality which most nearly coincides with what he has conjured up in his mind. He thus can produce an imaginative photograph.

But what of emotion? Can the photographer express his own feelings in his picture?

When a person is photographed, two sets of emotions are involved, those of the subject and those of the photographer. The photographer's emotions may be in sympathy with, in some manner different from, or at odds with the subject's. If sympathetic, the photographer in all probability will make the most of his subject's feelings. But if the photographer has a special, private emotion, stimulated, but not shared, by the subject, can he convey it to the viewer of his picture? The answer, obviously, is no. The camera can fix the image of the eye; it cannot fix the image of the mind. The photographer can express directly only the emotions of others. He cannot express an emotion of his own except by taking a picture of himself or through indirection. Just as he can find a counterpart in reality for a prior mental image, so he can materialize a combination of real forms which most nearly expresses his own feelings. For example, if he is nostalgic, he can seek out a landscape that suggests such a mood and, by implication, pass along his state of mind.

Photojournalism requires of the photographer a sensitivity to the emotions of others as well as to the moods and atmospheres of their environments. In meeting these requirements the photojournalist first avoids a confusion of his own emotions with those of his subject; judgment must have full play. Selection again becomes the act of greatest consequence to him. With writer and editor he shares possession of the magic amulet — judgment — by which understanding of the rational world is made possible. In the journalistic sense judgment guarantees the photographer a detached point of view in behalf of true report and interpretation. In the esthetic sense judgment and taste guarantee him a good picture. In the end, if his own emotion with respect to a subject remains important, it can find expression at the hands of one of his companions in the joint enterprise of photojournalism, the writer, with whom the next section deals.

Words — the Equal Partner

Inherent in the photojournalistic complex are two kinds of images, the visual and the verbal. The writer is a picturemaker, too. In writing captions or introductory or connective text matter in a picture story, he can create word-pictures to increase the number of images in the combined form, thus heightening its total effect. Because English, more than most other languages, is a language of similes and metaphors — which is to say, images — it finds itself quite at home in its co-function with the visual medium.

As Susanne K. Langer observes, "the correspondence between a word-picture and a visible object can never be as close as that between the object and its photograph."[12] Though the photograph is more exact in its imagery than the word-picture can ever be, it is significantly true that it still falls short, in varying degrees, of saying all there is to be said about what it represents. Although the photograph frequently conveys something of the spirit as well as the reality of a subject, in both respects it has shortcomings for which only words can compensate.

Some photographs or paintings have emotional meaning of such depth and power, or present an idea with such coherence and completeness, as to require no further explanation, not even a brief title. If the idea it contains is simple enough, a sequence or a series of photographs may also convey its meaning without the help of words, as some comic strips which use no balloons. Words become essential in a more complicated picture story in which several different elements are developed within a general framework. Without them there arises the question of how far human perception and patience can be taxed. The more relevant question is whether in a picture story the nondiscursive photographic medium can be put to discursive use. So used, it would be necessary for each picture to present clearly and completely a fact, idea or feeling which the reader could comprehend in a single visual act. This perfection in itself is not attainable. But if it were, could the reader's mind retain the idea conveyed by each picture through a varied progression of pictures and co-ordinate all into a meaningful whole? The answer is no.

There are those who believe there is a bright future for extended statement in still photography without the aid of words. From the photojournalistic standpoint this view is not sound. The wordless picture story, narrational or expository, is and will be the exception. The point is not whether photographs can get along without words, but whether with words they can perform their own function better.

Of the simpler ingredients of subject matter in the photojournalistic complex, the who, the where and the when are questions answered by the photograph only in part, if at all. Often the photograph is not fully clear with respect to the what and raises doubt or conjecture as to the why or how. In supplying or completing these answers the writer proves the need of his medium. He identifies people, locales, objects and establishes the relationships among them. He fixes the time of what is shown in the photograph. He confirms or corrects the reader's analysis of emotion and explains other obscurities. He supplies evidences of the other senses: sound, smell, taste, feel.

The photograph does not always tell how an emotion was caused or what its

[12] Susane K. Langer, *op. cit.,* pp. 76, 77. Mrs. Langer explains: "Like language, [a picture] is composed of elements that represent various respective constituents in the object; but these elements are not units with independent meanings. The areas of light and shade that constitute a portrait, a photograph for instance, have no significance by themselves Yet they are faithful representatives of visual elements composing the visual object. However, they do not represent, item for item, those elements which have *names;* . . . their shapes, in quite indescribable combinations, convey a total picture in which nameable features may be pointed out. The gradations of light and shade cannot be enumerated. They cannot be correlated, one by one, with parts or characteristics by means of which we might *describe* the person who posed for the portrait. The 'elements' that the camera represents are not the 'elements' that language represents. They are a thousand times more numerous [An] incredible wealth and detail of information is conveyed by the portrait That is why we use a photograph rather than a description on a passport or in the Rogues' Gallery Photography . . . *has no vocabulary* There are no items that might be called, metaphorically, the 'words' of portraiture."

effect will be later. Unless a man of 40 has been the subject of a detailed photobiography through the years, the camera cannot say what he was like when ten years old or what he had for breakfast this morning or what train he will take tomorrow. So it becomes the duty of words to provide the facts of before and after. Again, the camera is present at a spontaneous event less often than at its aftermath. The news has happened. There arises the practical problem of how on the basis of the evidence it has left to recall it, to reconstruct scene, cast and action, to re-create the atmosphere, to make flesh and blood of a skeleton. The camera can go just so far. Words go the rest of the way.

Within the realm of abstract concept, of unpicturable facts, ideas and feelings, the writer perhaps makes his greatest contribution to the photojournalistic complex. For example, man has an exasperating habit of exhibiting one character without and harboring another within. The impression he creates for the camera may be only half true or entirely false. When a photograph fails to disclose the make-up of the man behind the face, not through the fault of the camera, but of the subject, words fill in the details. If the camera can reveal external reality with a similitude unmatched by any other medium, words can claim a comparable virtue with respect to "internal reality." So it is with the subjective or inner, rather than the objective or outer, content of a photograph that the writer can often mainly concern himself.

To whatever points within a picture the writer wishes to address himself, he should have before him, invariably, the picture about which he is to write. This is Guiding Principle No. 1 for the writer. As to the externals shown, he writes *to* a photograph. With reference to the internals, he writes *into* it.

Another obligation of the writer grows out of the fact that different readers are inclined to interpret the same picture differently. Unless adequately explained, a photograph may frequently mean to a reader what he brings to it; that is, his reaction may be colored by past experience, a preconceived notion, a bias. By turning the implicit into the explicit, words make it possible for the intended central point or idea to find its way intact into the reader's mind. And, just as man when in a state of mental unrest sees badly in actual life, so at times he is inefficient in observing the secondary realism of a photograph, despite the dispassion with which he can inspect it. The writer does not let the reader skip anything important; hence, words are insurance against oversight.

Beyond what a photograph clearly and completely shows, a single word provides interpretation. This is a generous opportunity for words. Also, among the intangibles are the import and significance of the news or related subject matter which the pictures portray. Evaluation in this sense is the words' exclusive province.

Such then are the duties words promise to perform when they team up with pictures to produce the photojournalistic form.

In traditional journalism words are produced first and the picture is used to illustrate them; this is, of course, still the more common practice among newspapers and magazines. In photojournalism there is an exact reversal of that order. This transposition of the sequence in which the mediums are created calls for a reorientation of writer and photographer accustomed to working the other way round.

It is understandable that a writer outside the field of photojournalism might look upon his medium as more important than any other, and expect that the photographer

regard words in a similar light. In traditional journalism, where most of the emphasis is on the word, the writer has real or implied support for such an attitude. In photojournalism where the apparent emphasis is on the picture, it might seem that the photographer's view of his medium's superiority would be similarly upheld. In practice such is not the case. The photographer cannot maintain that one picture is worth ten thousand words, nor the writer that one word is worth ten thousand pictures,[13] if the photojournalistic form is to be created effectively. An equality in their appraisals of and feelings toward each other's mediums is mandatory. It is not correct to say that either medium *supplements* the other. The right verb is *complements*. Even prides of authorship are mingled.

2. BIRTH OF THE FORM

The Bonds of Tradition

Fundamental changes in the thinking of editors together with mechanical advancements of the camera had revolutionary effects on production and use of the journalistic photograph in the years 1925 to 1935. New techniques originating in the United States and Europe underwent intensified growth during that decade and reached a highly developed state as the period ended, thus giving birth to the genuine photojournalistic form as it is known and practiced today.

To understand the new attitude toward the photograph and the altered approach to the problems it presented as a communicative medium, it is necessary to examine the manner in which the photograph was regarded and used as such prior to that significant span of years.

In the early years of photography, as now, its inherent paradox lay in the simple fact that a machine could make a picture. Since that highly specialized act had been the sole prerogative of the human being, it was only natural for painters to seize upon the first cameras, either in enthusiasm over what they considered the machine's esthetic possibilities, or in fear of the competition of its product with that of their hands. So, no sooner was the camera in quantity production in Paris in late 1839 than "artist-photographers" began to take pictures with it in the tradition of painting. Their interest in subject matter was essentially the same as that of classic and romantic painters. During the photograph's formative decades of the nineteenth century many artist-photographers were of the unrelenting opinion that their medium was not alone the equal, but indeed the esthetic superior of any medium in the graphic arts. With their work the long and rushing stream of pictorial photography found its source.

Within a year after the original cameras were marketed, other photographers, many of them likewise painters but impelled by motives not altogether artistic, started using the machines for pictures primarily of an informational rather than an esthetic character. These photographers were the chroniclers, and with them a rudimentary form of the news photograph may be said to have come into being in the early 1840's.

[13] Jocular remark by Noel F. Busch, former *Life* staff writer.

Probably acting chiefly in the role of chronicler, although he was also a painter, Samuel F. B. Morse, inventor of the telegraph, took in 1840 one of the first group photographs, a reunion of his class of 1810 at Yale. In 1841 the Austrian brothers Joseph and Johann Natterer took one picture of a crowd and another of a detail of mounted police in Emperor Joseph Place, Vienna. In about that same year a certain Reiser, also an Austrian, took 14 "news pictures" of a military ceremony in Linz, Austria, using two cameras to obtain more exposures in the short time allotted to him. In 1842 Hermann Biow and Carl Stelzner took 40 or more pictures of a great fire in Hamburg, Germany. In 1849 Gustave Flaubert, French novelist, and Maxime du Camp, writer and photographer, went to Egypt and what is now the Anglo-Egyptian Sudan to produce a folio of photographs on architecture and sculpture. They were perhaps the first photographer-writer team.

Whether a desire to take an informational picture or a purely artistic one motivated the photographer, it was not surprising that in its beginning photography would emulate the painting art, which it resembled in important aspects. Lacking such endowments of its own, photography chose to adapt to its requirements the philosophy, critical method and certain technical principles and practices of painting. Without them the photographer could not have operated at all, nor, for that matter, could he today.

The camera had been born of a liaison between science and art, but he whose tool it became could not very well be titled scientist. The product of his use of that tool was not scientific, except quite secondarily; it was, in a very real sense, esthetic. So the photographer could not divest himself of the artistic aura which enveloped him. Even if the photographer was not outwardly "artistic" in dress and demeanor, he was different from the writing man in mental make-up, skill and conversational bent. He was, in a word, an artist.

The chronicle photographer in the nineteenth century, while having the earmarks of the artist, was a journalist, too — but without a journal. His great frustration was rooted in the fact that technology had not yet provided him with a satisfactory outlet for his work. Original photographic prints came to have technical quality and news value of a high order by today's standards, but they could only be published in newspapers, magazines or books as hand drawn engravings. Artists became highly proficient in making "replicas" in pen or pencil from which wood engravings were cut. Reproduction by hand transcription was first based on the daguerreotype image:

> Copies of the *Illustrated London News* and its counterparts, such as *L'Illustration* (Paris), the *Illustrierte Zeitung* (Leipzig) and *Gleason's Pictorial Drawing-Room Companion* (Boston), of the 1850's not infrequently contained pictures of railroad wrecks, balloon ascensions, and collapsed or burnt-out buildings which bear the credit "From a Daguerreotype." The use increased with wet plates. [Roger] Fenton's Crimean War pictures were reproduced in the *Illustrated London News* and *Il Fotografo* (Milan). Many of the Civil War photographs appeared in *Harper's Weekly*, the *New York Illustrated News*, and *Frank Leslie's Illustrated Newspaper*.[14]

[14] Beaumont Newhall, *The History of Photography* (New York: The Museum of Modern Art, 1964), pp. 175, 176. (In *Words and Pictures* Mr. Hicks cited the 1949 edition of Newhall. Because Newhall's revised 1964 edition contained additional information, that substitution has here been made).

A Technological Trinity

Not until the 1880's did crude photoengravings begin to reward the chronicle photographer with an approximation of facsimile reproduction. *The New York Daily Graphic* printed in 1880 what in all probability was the first halftone. It was a view of Shantytown in New York City, showing a group of wooden shacks rising behind a bare outcropping of rock. Insignificant as a photographic image, it was a news picture of a kind, and it gleams now with historical significance. In 1886, *Le Journal Illustré* published a two-page interview consisting of eight photographs of Michel Eugène Chevreul, French scientist, on his hundredth birthday — words by Charles Chincholle, pictures by Paul Nadar. Two or three years later the same team interviewed General Georges Boulanger in *Le Figaro,* 24 pictures of the general in various poses taking up three pages. The photographs were reproduced in halftone. While in retrospect the publications used more pictures of the subjects than would now seem necessary, the layouts with their captions and text blocks would not appear too ill at ease in a picture magazine today. In the 1890's the *Illustrated American* set out to be a picture magazine, printing groups of photographs on single subjects, but eventually it changed over mostly to text because of irregular picture supply.

Sparse though the examples of direct reproduction of photographs were, they were enough, together with the drawn versions of photographs, to point the way. Because more time was required for its perfection and also because of scepticism as to its desirability or practicality, it was almost 20 years after the *Graphic's* Shantytown that the halftone photoengraving process, which permitted photographs to be reproduced in the same operation with type, began to achieve widespread use. General acceptance was accorded this process at about the same time as the camera reached a sufficiently improved state to form an effective alliance with the halftone plate and the high-speed press. At the beginning of the twentieth century, journalism could print a photograph mechanically engraved from the original on a mass-production scale.

The technological genius of the previous era having put that potential tool into the editor's hands, why, in the first quarter of this century, did he not recognize and act on the full possibilities of employing the photograph with words to give him a mighty new instrument of communication? Even if he had seen the opportunity he could have done only half the job. Evolving and converging, but not yet far enough progressed, were influences which would create the subtle situation essential to the birth of the photojournalistic form. It was to be some years before these influences were translated into action.

Meanwhile, how did the photograph fare?

The editor had not inherited from his professional forebears any clear-cut set of rules to guide him in his dealings with the photograph. Exactly what was it, art or information? Bred to the literary tradition, which held that words were the foundation of his craft, the editor solved his problem temporarily by looking and acting upon the photograph in the main as art, a term still applied to it in many newspaper offices. Oddly, in so regarding it, the editor shared the attitude of the pictorial rather than the chronicle photographer.

Whatever else it was, the photograph was a novelty. The editor used it because he

believed it brightened or dressed up the newspaper or magazine page, but if one or two were left out of a publication for lack of space or to accommodate more words, no harm was done. In illustrating text the editor thought of the photograph in the esthetic tradition as a self-contained entity, as an end in itself. If it did not quite jibe with the words in sense, why, that was all right, too. The editor selected the picture and his art department "tricked it up," the better to catch the reader's eye. It was in wholly sympathetic hands at last when it reached the newspaper or magazine layout artist for the silhouette, cooky shape or decorative border treatment. A layout so handled was a spectacular thing. The artist "added" to the photograph; there were no bounds to the audacity of his efforts to "improve" it. Unlike the editor, who felt about the photograph the way many people feel about a painting, the artist was not afraid of it.

Some newspapers were slow to adopt the halftone process because they believed the directly reproduced photograph failed to harmonize with their typographic appearance. That was the extreme on the negative side of the question. On the positive side the news photograph was expanding in production and use by the end of the century's first decade. In 1914 The *New York Times,* which had pioneered 18 years before with halftone illustrations in a Sunday supplement, started its rotogravure section (later dropped in favor of a gravure magazine, mostly text, of less than tabloid size). In 1919 the *Daily News, New York's Picture Newspaper,* as it came to be called, was founded. In that year also Wide World Photos (The *New York Times*), a news picture service designed to provide rounded coverage for large groups of newspapers, was established, though International News Photos (Hearst) preceded it by a decade. Acme Newspictures (which became United Press) was founded in 1923 and The Associated Press News Photo Service in 1927. Thus chronicle photography had become journalistic photography in a large and active way, and the dimensions of the cameraman's adventure and enterprise were the length and breadth of the world.

The Doctrine of the Scoop

In the daily press one overriding idea came quickly to rule the news photograph: Get a picture fast and print it first. Nothing else really mattered. The newspaper or wire service photographer worked under a set of pressures imposed by a dash to the scene of the news and then the dash back to — and through — the darkroom to meet his deadline. His practice of holding coverage of a given subject to a single picture or a small group of single pictures was forced upon him. To meet his editor's requirements his operation had to be streamlined throughout. He came to favor a negative size of 4 x 5 inches, which called for a correspondingly large camera. Its film could be processed quickly, and the bigger image provided for effective reproduction on news stock even from a contact print. As the photographer was essentially a "one-picture man," the time loss between pictures caused by changing plateholders and pulling dark slides was not crucial.

In this scheme of things the esthetics of the photograph were incidental or absent, which is not to say that many pictures by ordinary standards of composition, physical point-of-view and lighting were not reasonably well taken. But, artistic quality was by no means a controlling factor. More important than a fine photograph of artistic or esthetic merit as such was the event itself, with stress on the fact of the photographer's presence

at that event. Sometimes the action which occurred spontaneously before the camera was of such an unusual or dramatic nature as to give the picture an originality or significance of its own. But, the photographer and his camera served only as a mechanical recorder. Otherwise, for the most part news and feature pictures were either static or stereotyped. A different idea in the treatment of a subject produced a model for other photographers to follow. Inventiveness was scarce; seasonal pictures especially were clichés. New Year's Day was a baby breaking through a calendar; opening of the football season was the rest of the team seen through the center's legs. A picture of an individual most often was a "straight portrait," which meant that the subject stood against a wall for a glorified snapshot. The group portrait was eight men against a wall in a regimented row looking bored, scared or vacuous. Indoors flash powder either burned the photographer or choked those he wished to have cooperate with him. Instead of picture consciousness, it was a time of camera consciousness. Practically everybody looked at the camera, a holdover from the studio portrait photographer's admonition to watch the "birdie." When the photographer entered a situation involving people and movement, life stopped dead in its tracks and oriented itself to the camera. Galvanic pose and posture were the subject's technique for getting his picture in the paper.

The editor took what photographs he was given, critical chiefly of delays in their production, and used them to supplement or illustrate his textual news report or feature story. A picture to match a dispatch, that was the idea, but it was just an idea until wire transmission made possible simultaneous publication. Meanwhile, air mail had cut down the lag between receipt of the news in words and the subsequent arrival of corresponding "art." The newspaper did not produce spontaneous or interpretative news coverage in photographs or allow the photographic image to compete on an equal footing with word news. Nor did the newspaper in general make special effort to develop staff skills in selecting pictures and in relating words to them in such a way as to get more out of the mediums in combination. Now and again a big story broke which could have provided the editor a half page or full page of pictures. But, with regularity the picture was first and the word second only in the rotogravure section, wherein the principal subject matter was babies, brides, social leaders, club groups, landscapes, views around town 50 years ago and famous paintings reproduced in an all-consuming brown. Despite their faults pictures on the printed page were becoming more and more popular.

Germany Sparks a Renascence

After World War I more people were taking pictures throughout the world than ever before in history. Not since Europe was overrun by the "daguerreotypo-maniacs," as the first camera fans were called, or the United States by the "Kodak snappers" of the 1880's and 1890's had enthusiasms been so fervent. The revival in the 1920's involved thousands as compared with the scores of previous periods, and the thousands were only the beginning.

There was a fundamental reason for this expansion in camera use. It was a further and much longer step in the popularization of photography as a communicative medium. From the time of the camera's first apearance, this process of making the medium intelligible and acceptable to people generally was sure to be faster than popularization of the

art of writing. For the latter process, as Whitehead said, "the time period is of the order of a thousand years."[15] But photography came into a world far different from that into which writing had come. The same science which produced the camera had "opened avenues of thought" and created highways of communication which required another vehicle to help transport the all-important cargo of fact and idea. In the quieter pre-war world words by themselves had been sufficient for the task. While they were by no means worn out by 1920, the postwar world was to be the new world of mass culture; the things it stood for were Convenience and Efficiency. The photograph was the ideal mate for the word, and photojournalism was to be a child born in perfect coincidence with a time and its need. Meanwhile, renewal of interest in the camera's use on a broader base was perhaps attributable to the release of creative energies suppressed during the war and to the war's widening and lifting of human horizons. Five years of conflict certainly did more to empha-size the photograph's communicative value than any event which had gone before.

Of the postwar resurgence the busiest center was Germany. "There were amateurs all over the place," *Life* photographer Alfred Eisenstaedt has said of the middle 1920's when he was living in Berlin. Predominant among amateurs throughout the land were the pictorialists of whom Eisenstaedt was one. They organized clubs and went on picnics, and their great urge was to take pictures which "looked like" paintings. The painting art had started to flourish again, but it could not lure these pictorialists from their cameras. Why should it? Mostly young, these Germans had been through World War I; now they were striving to forget defeat and rebuild their world. For them life should include an oppor-tunity for self-expression. Cubists, Futurists and other abstract artists had dehumanized art and cast away the last vestiges of natural form. Chaos of art or of war seemed the same to these amateur photographers. For the peace and for living again, said the photog-raphers, give us the realistic medium of the photograph. So they set about filling what was a graphic vacuum for them. With cameras of various sizes and makes they took pictures of trees, clouds, bridges, sailboats, babies, pets: the usual subject matter of beginners. Some never got beyond that stage. Others did.

Naturally the camera makers were busy during this time. By 1925 the Ermanox and the Leica were available on general sale. They were the small cameras which were to help initiate a new era in news photography. The Ermanox had some of the attributes of the Leica, which will be described, but it also had an insurmountable defect. It used only glass plates, each in an individual metal holder which the photographer had to insert for every picture. Because of that, from the outset it was doomed to obsolescence in a few years in favor of the Leica, but while in use it served a most important purpose. The Ermanox was a transitional link between the large news camera and the finally consum-mated small one with all its special capabilities.

The Leica was the invention of Oskar Barnack, an expert technician who in 1911 was constructing microscopes in the E. Leitz factory, Wetzlar, Germany, and as a hobby was taking motion pictures with a homemade camera. To keep from wasting film footage, there being no light meters then, Barnack fashioned by hand a small still camera with which to make exposure tests. His ingenuity led him to employ a short roll of standard

[15] Alfred North Whitehead, *Science and the Modern World* (New York: The Macmillan Company, 1939), p. 140.

35mm motion-picture film as negative material, which in turn dictated the camera's shape and size. Fitting it with the largest and fastest lens available to him — the lens was neither very large nor very fast by today's standards — he took pictures of a quality which surprised him and his associates. The work of perfecting the camera was interrupted by World War I, but at its end Barnack resumed his efforts. In 1924 half a dozen experimental models of the Leica, of which his "exposure meter" was the prototype, left the Leitz factory. A year later it was manufactured in large numbers and its distribution began to spread in Europe and elsewhere. Not until 1932 was the camera in refined form, with built-in range finder and interchangeable lenses of sufficient light-passing power to give it the flexibility required of such a machine.

A New Look at Reality

There had been small cameras before, but never so well organized an instrument as the Leica. It was a masterpiece in basic design. Its size, compactness and trifling weight by comparison with traditional news cameras made for an ease of handling which gave the photographer an unprecedented freedom of action, mental and physical, while taking pictures. There were no plateholders to change, no slides to pull. Thirty-six pictures could be exposed on one loading of film, each negative about twice the size of a single motion-picture frame; exposures were made lengthwise, instead of across, the film. The camera could be held firmly against the eye, thus producing a still closer coincidence of human vision and camera "sight." Its film could be advanced almost instantaneously, allowing exposures to be made in rapid succession, and there was a device to prevent double exposures. Once having become thoroughly familiar with the camera's mechanism, the photographer could attain that "perfect state" in which finding, framing and focusing a picture all could be accomplished in a single viewfinder. The machine's presence could affect the photographer's consciousness to so slight a degree that the making of an exposure could almost become instinct, virtually an automatic reflex.

The small camera having become practically an added organ of his body, the photographer was left freer than ever to concentrate on the exercise of judgment and selection in relation to subject matter. Not bound by the single-picture technique of the orthodox news photographer with his larger, less portable and less manageable camera, the Leica user could sustain his shooting efforts in a situation of movement, thereby increasing the likelihood of his getting exactly the right picture out of many pictures taken. The greater mobility of his camera permitted him to photograph successive change within an event, insuring a more even flow of action pictured in one-two-three order. Bigger cameras were and would remain important for their particular purposes, but the Leica, with its ability to capture a sequence in a manner approximating the motion picture's serial image, achieved for the photographic medium a fluidity which was to prove of indispensable value to the photojournalistic form.

These were advances of high consequence. Of equally high consequence was the small camera's contribution of a new sense of realism to photography. Unobtrusive little object that it was, it did not attract so much attention to its user, and the quickness with which the photographer could bring it into action allowed him to take pictures of human beings without their knowing it. Events involving people could be recorded just as they

happened. To take a picture it was no longer necessary to halt people in the course of life, depicting their personalities as camera conscious or arranging themselves as they would like to appear, not as they really appeared. More often, with the coming of the small camera people failed to look at the camera simply because they did not note its presence. The ease with which the photographer handled his apparatus, together with his new-found capacity for observing and photographing without intruding, helped his subjects to be more relaxed even when aware of him. Hence, with the introduction of the Leica a vitally different relationship was set up between the photographer and the world about him. Nor was that the only way in which a new sense of realism was infused into the photograph. Another was mechanical. Combining large lens and small negative size to picture a scene or situation in existing light, the Leica could preserve the quality of naturalism so often destroyed by the artificial illumination of flash or flood. This held true even after general marketing in 1929 of the flash bulb, welcome advance though it was over the magnesium flare.

Small cameras soon came into many hands, amateurs' and professionals' alike. In the advance guard of their users in Germany were two men whose pictures were to establish notable precedents in the annals of the new approach. One was Paul Wolff, the other Erich Salomon.

Wolff, a commercial photographer, acquired a Leica in 1925 and by 1934, when he published *My First Ten Years with the Leica,* he had accumulated 50,000 negatives. A well-rounded photographer, he did not belittle accomplishments of the big camera, but concentrated on developing potentialities of the small one, thus becoming the great demonstrator of its versatility. His enlargements, up to 30 x 40 inches in size, attracted wide attention from fellow users of the Leica; of its mechanical techniques he was the oracle. Operating in the feature rather than the news field and outdoors oftener than in, he was leader among those who believed that an interesting picture could be made of "anything," and his work helped extend the limits of subject matter with which the contemporary camera could concern itself.

Salomon, on the other hand, was an out-and-out news man. A lawyer by training, he began photographing in 1928 when 42 years old, after his family's fortune, gained from piano manufacture, had been lost in the postwar inflation. His first camera was an Ermanox. Despite its one-picture handicap, that camera had a faster lens than the Leica and enabled him to take the pictures by which he became known as the father of "candid" photography. With it and the Leica, which he later adopted, Salomon specialized in political personalities. A wizard at the difficult business of entree, he attended plenary sessions and social gatherings of the highest governmental functionaries in Berlin, Paris, Geneva and other capitals. When his distinguished subjects, allergic to the distractions of flash powder, learned how painless his available-light technique was, they let him move with comparative freedom about their sumptuous halls. Photographically, the *mise en scène* of statesmanship had been stilted and without poise. But, as Salomon saw and photographed presidents and premiers, they were themselves in a most convincing way, perfectly at ease and oblivious to the camera. The sense of intimacy in his pictures, the feeling they transferred to their beholders of being on the inside of things, was electrifyingly new and different. The suave and cultured Salomon, who spoke seven languages and wore white tie and tails when indicated, and who had a great relish for life and affairs as well

In formal "working" attire and with his Ermanox camera Dr. Erich Salomon photographed the important social and political gatherings in Europe in the late '20's and early '30's for *Die Dame* and *Berliner Illustrirte*. His trademark was his social grace *while* photographing.

Lore Feininger, Berlin, circa 1929

as a gift for getting along with people, designated himself a *photojournalist*. If he was not the first, he was one of the first to apply that term to a photographer. To his profession he added immense stature and prestige besides contributing a creative technique.

When Salomon decided on a photographic career, he was already working in another capacity for the House of Ullstein in Berlin, then the unrivaled leader of the German publishing industry. Five daily newspapers and several magazines, including the weekly *Berliner Illustrirte Zeitung* and the monthly *Die Dame* (*The Woman*), made up only part of its vast output. In 1928, a decade after World War I, the *Berliner Illustrirte Zeitung* had a circulation of two million. It and *Die Dame* printed many photographs, *Illustrirte* so many, in fact, that it sometimes is described as having been a picture magazine. By later definition and formula it did not meet that description, if for no other reason than that it had at least as much text as picture content. The particular pictures *Illustrirte* and *Die Dame* printed and the way they handled them, rather than quantity, were what set the publications apart. When photographers who had been experimenting with their cameras thought of selling their work, they thought first of Ullstein. Naturally *Illustrirte* printed Salomon's history-making pictures.

At a reception in Berlin in 1931 a young Albert Einstein explains his theory of relativity to British Prime Minister Ramsay MacDonald.

Prof. Fritdjof Nansen, famous North Pole explorer and philanthropist, is interviewed by the English journalist, Miss Round, in Geneva at the League of Nations Palace lobby. As a very early example of photography by existing light, this image has soft gradation and open shadow detail, accomplishments not always evident in existing light photography of the '70's.

An early example of the candid, existing light picture story appeared in the 1929 *Berliner Illustrirte*. It was a view of the "House of Silence," a French monastery, photographed by André Kertész, an Hungarian.

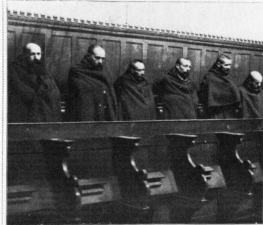

Berliner Illustrirte Zeitung

Das Haus des Schweigens

Das Mutterhaus des Trappistenordens „Notre Dame de la grande Trappe" in Soligny

Berliner Illustrirte, January 6, 1929
Photographer: André Kertész
Editor: Kurt Korff

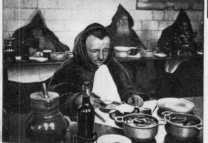

A Fresh Editorial Approach

Manager of all the Ullstein magazines was the late Kurt Safranski, appointed to his post in 1924; editor-in-chief of the two magazines named, and a principal teammate of Safranski's, was the late Kurt Korff. They shared the conviction that more could be done with the photograph as a communicative medium than had been done. They considered their contemporaries, *The Illustrated London News* and the French *L'Illustration,* excellent weeklies; however, both were strictly traditional. Meanwhile, the European newspaper or wire service photographer was operating in much the same way as his American colleague: he was intent on getting one picture of an event, seldom more, and that picture usually had to fit hard-and-fast specifications of conventional news. Before Salomon's debut, *Illustrirte* had depended on artists for on-the-spot sketches or "conceptions" of events inaccessible to a photographer who used flash powder. The artist's drawing, though, was not completely satisfactory as a substitute for a good photograph, no matter how skillfully or correctly made. Readers had begun to look upon hand-drawn forms as insufficient.

The new picture thinking may not have been at a rolling boil in the House of Ullstein, but it was at a lively simmer. The venturesome Safranski and Korff probed for novel photographic ideas. They were acutely aware that pictures could show readers things which the readers ordinarily would not observe for themselves, that with pictures an idea could be expanded and its essence interpreted. They understood that the photograph could be a symbol of the "something larger" behind a subject. They knew that the photograph had a power stronger than words to "draw people into" a journal's page and "make" them think. Safranski and Korff learned to accumulate related single pictures of a developing subject which became available at different times for building an eventual story. They assigned the shooting of many pictures of an event instead of one or two, and showed acumen in selecting pictures for publication, using them in strip and layout.

In formulating their attitude and approach Safranski and Korff were stimulated by Alfred Flechtheim, a Berlin art dealer, who had founded the little house organ *Querschnitt* (*Cross Section*) to advertise his wares. If in that publication he did not discover, still he was one of the first to apply the *principle of the third effect.* Under this principle when two selected pictures are brought together, their individual effects are combined and enhanced by the reader's interpretative and evaluative reaction. Safranski and Korff tried it out mainly with the simple juxtaposition of two pictures which had different subjects but similar designs or patterns, wherein the overvalue went no further than amusing the reader, frequently with his not knowing exactly why. Ullstein soon bought *Querschnitt.* In England *Lilliput* made extensive use of the juxtapositional device.

In the House of Ullstein the photojournalistic form was not, however, fully realized. What *Illustrirte* and *Die Dame* did was experimental, and appraised as a whole in the light of what was later to happen to the form in the United States, that whole was amorphous. One of the principal failures in continuing the evolution was Ullstein's neglect toward the participating medium, words. In their enthusiasm over pictures the two magazines which represented Ullstein photographic philosophy, allowed picture-for-picture's sake to carry them away. More often than not files of these publications show the "picture story" as a grouped miscellany rather than an ordered and progressive narration. Word treatment

Der Schauspieler Michail Sharoff als russischer Arbeiter

Junge Bolschewistinnen vom kommunistischen Jugendverband „Komsomol"

Der Querschnitt, June, 1925

An early juxtaposition in the Ullstein publication *Der Querschnitt,* then edited by H. v. Wedderkop.

rarely matched photographic treatment, and often it was inadequate even by traditional standards. Ullstein did not find the touchstone of integration by which picture, words and idea become as nearly one as concept and execution can make them. Nevertheless, the Ullstein contribution toward the beginnings of the photojournalistic form was of great and basic value.[16]

[16] *Editor's note:* Mr. Hicks did not include in his discussion of Ullstein and its contributions to American photojournalism the work of Stefan Lorant, an Hungarian-born innovator who served as Berlin editor of *Münchner Illustrierte Presse* (Munich) from August, 1928, until he was named its editor-in-chief in 1932. Lorant argued that a photographer should use his camera as the reporter uses his notebook: that events should be recorded as they occur without posing or arrangement. He experimented with the capturing of "live" action through use of the fast lens and shutter of the 35mm camera. Lorant also utilized many creative variables in layout: size, shape, contrast, key and mood. He championed the use of natural or existing light for photography whenever possible rather than the artificiality of powder or flash. Lorant moved to England in 1934 after being imprisoned in Germany. He first edited the *Weekly Illustrated* there, then founded and edited *Lilliput* in 1937, and in 1938 when *Picture Post* was founded he became its editor. Upon emigrating to the United States in 1940, he continued his work in the format of the historical picture book.

More of this value can be expressed in terms of how Ullstein encouraged innovation in the taking of pictures. Ullstein and the photographer understood each other; the publisher believed that the editor could tell the photographer what to do, but that in the last analysis it was the photographer who had to execute it. Fortunately for Ullstein and other publishing houses, in the middle 1920's development of a rich new source of pictures by the postwar revivalists was reaching a peak. Their range of subject matter had broadened; it no longer began and ended with "pretty" pictures of pat and easy subjects within the photographers' immediate environment, pictures fraught with the artifice and sterility of pictorialism. They were discovering the commonplace in its relation to contemporary life and its environment. Not only was new subject matter being found, but much that was old

CHAMBERLAIN THE BEAUTIFUL LLAMA

Juxtapositions or doubles from the English magazine *Lilliput.*

 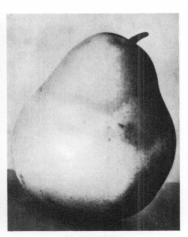

THE RIPE PEAR **THE JOLLY PUBLICAN**

(But don't tell me the caption is wrong on this page)

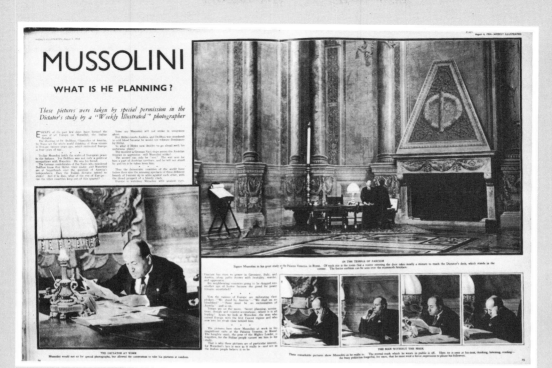

Weekly Illustrated (London), August 4, 1934

In Munich editor Stefan Lorant assigned Felix Man to photograph Mussolini in 1931. The use of available light is remarkable. Lorant's layout could have been done in the '70's considering the effective use of contrast in size of photographs and the basic simplicity of the spread.

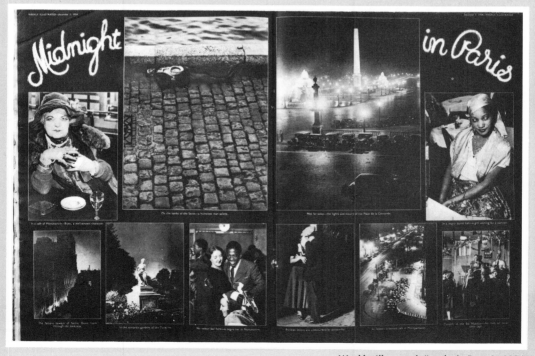

Weekly Illustrated (London), Dec. 1, 1934

French photographer Brassai handled this assignment from Lorant showing night life in Paris. Photographs are candid, honest. Reverse type and black background treatment were very advanced display techniques.

and familiar was being revealed with surprisingly new vision. With their cameras photographers were examining objects close up, seeing with them what the eye could not or would not take the trouble to see: the underside of a leaf, the fabulous design of living stone, the hair growth of an insect. Angles other than eye level were being investigated still further so that the new realism of the photograph could be observed from unusual points of view, as well. Experimentation was not restricted to Germany. It was going forward in Scandinavia, Hungary, France and other European countries as well as in Japan and elsewhere in the Orient. In the United States photographs — not photograms — were being made of objects in the manner of abstract painting.

A Maturing of Camera Talents

From his native Hungary one of the European experimenters, Martin Munkacsi, traveled to Berlin in 1926. With him were 200 pictures which he had taken before he left home. Mutations in natural form and natural light fascinated him, and more than anything else he liked to photograph people in realistic action in their normal surroundings. Within his portfolio were sequential photographs showing variations in facial expressions as well as other ideas which had grown out of his thinking about the serial possibilities of stills. The next year he showed his samples to Safranski and within the hour had negotiated a three-year contract. He had really intended to proceed to the United States, but his good fortune in Berlin prolonged his stay there. He did not come to this country until 1934. Meanwhile, in working for *Illustrirte* and *Die Dame* he pushed his experiments further with notable achievements in fashions. Models had been as stiff and impassive as plaster manikins, but he photographed them in action, thereby introducing an idea for the handling of style subjects which photographers follow today. He also was a pioneer in the use of deliberate blur to denote action in photography, and his experiments with selective focus set precedents which are still followed: pictures having foreground faces or figures in focus, backgrounds out.

From the revivalist throng in 1929 also emerged Alfred Eisenstaedt. Late that year he left the button and belt business in Berlin for full-time professional work in photography on a 50-50 arrangement with the Associated Press. A few years before, as already noted, he had been an amateur pictorialist; a photograph he had taken in 1927 of a girl tennis player he had later sold to *Der Weltspiegel,* rotogravure section of the *Berliner Tageblatt.* Other sales followed; then it was only a matter of summoning up enough courage to make the break. Six days after joining the agency, Eisenstaedt was on his way to Stockholm to cover a Nobel prize ceremony, his first assignment. He was now a professional.

In February, 1930, Korff called Eisenstaedt to his office at *Die Dame.* The winter sports season at Saint Moritz was in full swing, Korff explained, and he wanted Eisenstaedt to go there. What he was most interested in, Korff added, was a picture in which snow would look like sugar.

All the way to Switzerland Eisenstaedt pondered the odd assignment. The question, "Why snow like sugar?" kept rising up in his mind. Well, he'd try, but it didn't make sense.

At Saint Moritz he waded out into the deep Alpine drifts. One day and part of the next he photographed snow at various angles and levels as well as in different light. At night in his bathroom at the Grand Hotel he developed his films. He was using a Mentor Mirroflex; not until a year later was he to buy a Leica. The best negatives he took to a

local commercial photographer for contact prints. He could hardly wait to see them. At last, there they were. The snow did look like sugar. Or did it? Perhaps having been conditioned by the word *sugar* and its memory image, he just imagined that it did. Anyway, he had done everything he could with the snow.

Eisenstaedt poked around the hotel. It was filled with members of the international set, with skaters and skiers. Outside was a cocktail rink where waiters wore skates and performed jumping and juggling feats. There were attractive women and handsome men about, and in the evening the ballroom was crowded and gay. Before he knew it, Eisenstaedt was taking pictures of everything in sight.

Years later Eisenstaedt analyzed the motive for Korff's brief instruction. Korff had given him a point of view, a simple one, but a point of view nonetheless. The sugar idea kept Eisenstaedt from setting up a direct relationship between himself and snow as snow, thus producing pictures such as anyone else might produce. The suggestion generated in his mind a sense of conflict and challenge which caused him to work harder, creatively. He could *see* all kinds of things to photograph.

"I didn't realize it at the time," Eisenstaedt has said, "but it also relaxed me. Naturally I was nervous on getting my first story from *Die Dame,* and the snow idea made me more so. After doing that part of the assignment, the reaction set in. I had fun and got a set of pictures that Korff liked."

Eisenstaedt had experienced the new picture thinking.

An Experiment and a Design

After perusing the first issue of *Time, The Weekly Newsmagazine,* the late Robert Benchley, humorous writer and actor, remarked that its pictures looked as if they had been engraved on slices of bread.[17] That first issue was March 3, 1923. Five years later there was no very noticeable improvement in the pictures' mechanical appearance, though here and there one looked as if it had been engraved on pound cake, with its somewhat finer texture. At the turn of *Time's* first decade the editors could insert the parenthetical "(see cut)" with reasonable expectation that the reader could comply, and they had all but lost their fondness for silhouettes in which the environment had been painstakingly removed from around full-length human figures, some of them in action.

The anatomy of *Time* was words, but the photograph was by no means mere adornment. *Time* had a "feel" for pictures and a belief in their value as amplifiers of text. The way it employed them was in some respects new and unique. For example, a head and shoulders portrait, of which it printed many, would not have as significant a meaning in isolation, even with its caption, as it could if related in spatial proximity to the larger text piece. The caption, consisting of the subject's name and a few short provocative words, could serve as a teaser to draw the reader into the story near by. If the reader chose the opposite course and moved from text to picture, the caption, pithy and incisive, would highlight a story point to edify or amuse him. This remained *Time's* practice with scene and situation pictures similarly treated. In recent years the magazine has made use with some frequency of the single news picture with definitive

[17] Eric Hodgins, *The Span of Time, A Primer History of Time Incorporated* (New York: Time, Inc., 1946), p. 3.

caption as a self-contained entity. Occasionally it has printed in black and white or color groups of pictures on one subject in one to three or more pages. In 1934 and 1935, preceding *Life's* actual experimental period, *Time* published several one-page and two-page pictures stories. For some of them the photographs were specially taken; for others pictures which had been printed haphazardly elsewhere were given coherent grouping. On the whole, however, *Time's* use of the photograph has not been photo-journalistic. And yet, *Time's* philosophy and techniques prior to *Life's* inception with regard to words as well as pictures provided the intellectual *milieu* essential to *Life's* materialization and birth of the true photojournalistic form.

What circulated in the umbilical cord leading from *Time* to *Life* was not simply the money necessary to establish a picture magazine. In a sense that was the least important nourishment received by *Life*. From its beginning *Time* had brought to bear on the photograph the same stern appraisal and judgment as it applied to words. Never had the news picture been subjected to such harshly critical — editorially critical — examination. Did the picture say something? Did it contain a fact or an idea? Did it make a point? Judicious selection was almost a fetish with *Time*. The photograph had sorely needed this discipline which gave recognition to the photograph's worth and demanded that it meet prescribed standards if it were to justify its association with the already tractable words.

This attitude was only one of a body of intangible assets at *Time* on which *Life* would draw. Another is to be found in *Time's* basic approach to its own job. "Its aim," says Eric Hodgins [18] of its first issue, "was to present the news . . . in orderly arrangements and with a continuous flow so that, category by category, and all things in their places, the news of last week would appear in such a way as to make sense." That statement of *Time's* purpose, which has never been altered, could with slight amendment become the definition of a picture story. The concepts of "orderly arrange-ments" and "continuous flow" were ready-made for *Life,* some of whose editors and writers had been trained by *Time* and had incorporated into their editorial thinking the sometimes elusive, but always incontrovertible logic that everything, including a picture story, has a beginning, a middle and an end.

To *Life's* conceptual background *Time* made another contribution by formulating and then proceeding to act upon its own journalistic theorem that the greatest idea is the idea of the idea itself. Journalism had always lived on ideas; *Time* laid new stress on their value. A method for their discovery and development could not be formal nor reducible to a set of easy instructions which anyone might follow. But, the produc-tion of ideas was put on a taken-for-granted basis: they were to be expected, just as facts, stories or pictures were to be expected. Satisfying the need involved idea men, but it gave the opportunity to all *Time* journalists to be self-generating idea men, whatever else they were. As a group they set out consciously and with systematic intent to make ideas the major part of their operation. Into the resulting lively and vital atmosphere *Life* came. It did not come, however, until seven years after the entrance into the same atmosphere of *Fortune,* which was *Life's* most significant fore-runner with respect to pictures.

[18] *Ibid.,* p. 2.

The growth of *Time Incorporated* as a distributor of information [says Hodgins][19] has never been so much out of growth itself as out of the pressure of things that were otherwise being left unsaid. As the days of Coolidge Prosperity thundered on toward the crash of October, 1929, the editors who wrote in *Time* of business and finance were forced every week to throw away ten stories for every one they printed Thus it was that out of the overset columns of *Time's* Business and Finance Department there came *Fortune*

Fortune was to be a magazine of business, not in terms of the statistics of carloadings, but carloadings plus drama, plus personalities, plus balance sheets, plus technology, plus art. It had never been tried before If business *was* the unique expression of the American genius, then *Fortune* would undertake to give this genius a literature which it hoped might be worthy of it.

Fortune started publication in 1930. Its editors and writers were predominantly word men, and if they were not also picture men, they were soon to become acquainted with the photograph's potency. The camera had not been called upon to perform such a special job as *Fortune* required of it, but the magazine's picture-editing efforts were characterized by ingenuity and a "nothing is impossible" attitude which yielded results not possible in an atmosphere muscle-bound by routinism and taboo.

Fortune's debut and Margaret Bourke-White's "arrival" as an industrial photographer were coincidental. Wisely, *Fortune* made effective use of her newly-blossomed talent. Assignments took her on wide swings through the United States, to Russia and to Germany where she visited Safranski, Korff and others in the Ullstein picture group. Miss Bourke-White and other photographers, notably William M. Rittase and Russell Aikins, discovered anew for *Fortune* the world of business and industry, "bursting," as Hodgins [20] says, "the conventions of established magazines and, in effect, crying out for a new medium in which to present their unique angles upon the world of action — of blast furnaces erupting, of soup being cooked in kettles a thousand gallons at a time, of locomotives being hammered together red hot" And, in 1931 *Fortune* brought Erich Salomon to the United States as guest photographer, thus effecting a tie between creative picture experimentation in this country and Europe.

During *Fortune's* first years locomotives were indeed being forged, but there were soup lines, too. While very real, *Fortune's* pictures had about them an air of fantasy, imparted by the voids and nightmarish frustrations of the Great Depression. Businessmen and industrialists were impressed by the pictures' beauty and revelatory power and enjoyed the image of their enterprise while waiting for the original to reconstitute itself. As Hodgins [21] says, the depression "made the subjects with which *Fortune* dealt matters of debate and conversation as otherwise they might never have been." First *Time,* then *Fortune* proved that photographs, in a collective sense, can have characteristics which distinguish them from other photographs in much the same manner as the text matter of one publication can be distinguished from that of others. "*Time* pictures" and "*Fortune* pictures" were embodied into the new tradition of the photograph which *Life* was to inherit.

[19] *Ibid.,* p. 6.
[20] *Ibid.,* p. 7.
[21] *Ibid.,* p. 6.

Life's experimental period, which began in its preliminary "think" stage in 1934 and culminated in a first issue November 23, 1936, brought forth only a rough mock-up of the photojournalistic form. The background against which experiments were carried on was a mixture of the old and new in photographic tradition. All around the experimenters was a journalism predicated on established attitude, approach and technique. It was impossible in the exceptional situation at *Life* to maintain an aseptic field. In retrospect what emerged in the first issue was a product of transition, a combination of the new and the old, with the new side favored; to most people at the time only the new showed. But the mixture was there: the process of creating the magazine was following the usual course in a pioneer development. It is surprising, not that the experiment produced so little, but that it produced so much.

More Gropings and More Findings

The first few years of *Life* were a continuation under actual publishing conditions of its experimental period, and the magazine then in some aspects bore slight resemblance to the *Life* of the 1950's. "Bring us lots of pictures," the editors had ordered, and thousands upon thousands were laid before them. The photographic medium had never been used on so large a scale, and some of the magazine's "mixed up" appearance reflected the almost frantic efforts of editors to keep afloat in a photographic sea.

Life had been projected headlong into its own evolutionary state. Its overall formula and the photojournalistic form on which it was based had yet to undergo the major portions of their refinement. Some basic editorial elements remained after drastic revision, but through the years *Life* was almost entirely reshaped. Clearer signs of the application of the principles of "orderly arrangements" and "continuous flow" appeared toward the end of 1938, and from then on what was to be the ultimate structure of the magazine became steadily more distinct.

Life's editors learned during the experimental period and prior to publication that when a picture story is being composed, pictures, though not a discursive medium, lend themselves to something of the same manipulation as words. The editors applied to groups of pictures the notion which *Time* had applied to the individual picture — the notion of point. A photograph contains a fact, idea or feeling, and these points as well as the photographs themselves come together to comprise a picture story; with points and logic, and not with picture *per se,* is coherence achieved. Perhaps the simplest example of point coherence is that contained in a picture story arranged in chronological sequence, time being a point in a most elementary sense. To retain coherence while violating chronolgy is one test of an editor's skill. The fact that an editor can think in pictures as he can think in words is a key to the technique of photojournalism.

During its experimental period *Life* adopted as part of its working philosophy the principle that the photograph should not be retouched except in the rarest circumstances. The day of the intervention of hand illustration between camera reporter and reader was over. Yet, primarily for mechanical, but also for "artistic" reasons, most newspapers and some other magazines had carried retouching to a point where the printed picture was a combination of photograph and hand "art" work. *Life* acted on

its strong conviction that if the photograph as information was to be worthwhile, it should transmit the world of appearance to the reader in the purest form possible. Exception was permitted only on grounds of taste in a photograph otherwise desirable for use, or to remove obvious and distracting defects usually in background areas where retouching could be done without destroying accuracy of representation. There was no attempt to convert a bad photograph into a good one with a brush. If a picture was important or interesting enough, it was used, unretouched, even though of inferior technical quality. When *Life* took this stand it rendered a great service to the photograph as a communicative medium.

As one holdover from the past the early issues of *Life* contained many pages of physically abused photographs which now have a unique value as horrible examples. Some were rounded, ovalized or scalloped into cooky shapes; others were silhouetted: hours, even days, were spent by artists "whiting" out backgrounds of the most intricate objects. Other pictures were left in their original square or rectangular frames but were cocked in layout at precarious angles off vertical or horizontal; still others were given a rhomboidal trim or cut into the weirdest shapes of esoteric geometry. All bore the marks of the creative artist who had an understandable urge, but was working in the wrong *métier*. Just as the magazine had to develop editors and writers who could make pictures tell a story coherent in content, so it had to develop art editors and layout men who could make pictures tell a story coherent in form. Essentially the editor approached the photograph as information; the art editor approached it as a design element. It was necessary for each to adapt himself to the attitude of the other so that a workable compromise could be effected. This is what happened at *Life*. It came to respect the photograph as complete in its original composition. If the picture did not say enough within those limits, alteration of the shape in which the photographer had conceived and taken it could not force it to say more. A practical medium should have a constant form; this was fundamental. *Life's* affirmation of the absolute character of the photograph's shape — subject, of course, to intelligent cropping — was of the utmost significance to photojournalism.

As *Life's* editors established a working relationship toward and better understanding of photographs, the contours of the picture story in a number of variants began to emerge. A picture story was referred to as an "act," and the description, borrowed from the theater, had a peculiar fitness: it implied the visual and the concrete, and somehow made pictures seem more manageable. An act could be two photographs, 10 pages of them or even more. Between those extremes were various combinations of pages and half-pages. Any given act could be laid out several different ways, but only one way was right with respect to what the editors intended it to say. There was much merit in keeping some of the magazine's spaces open to more flexible layouts; to others *Life* gave basic plans, which were more or less fixed, and established for them a specific character which they would have in the abstract, before a single picture was selected for them. Noteworthy among such layout concepts was the photographic essay, which *Life* created in analogy to the literary form. This idea did much to emphasize the susceptibility of the photographic medium to stylistic use.

In its issue of April 26, 1937, *Life* printed in its own behalf an advertisement headed, "The Camera as Essayist." It stated:

> When people think of the camera in journalism they think of it as a reporter — the best of reporters; the most accurate of reporters; the most convincing of reporters.
>
> Actually, as *Life* has learned in its first few months, the camera is not merely a reporter. It can also be a commentator. It can comment as it reports. It can interpret as it presents. It can picture the world as a seventeenth-century essayist or a twentieth-century columnist would picture it.
>
> A photographer has his style as an essayist has his. He will select his subjects with equal individuality. He will present them with equal manner. The sum total of what he has to say will be equally his own.
>
> Above in sharp reduction is Alfred Eisenstaedt's essay on Vassar as it appeared in *Life* for February 1, 1937. Together these twenty-four pictures give an impression of that college as personal and as homogeneous as any thousand words by Joseph Addison.

The advertisement reproduced the Vassar essay in miniature and listed other "essays" which *Life* had printed. Not all of the stories mentioned met the specifications which further development was to give to the essay form. Largely because of the certain parallelism between it and the word essay, of which many people had some understanding, this particular structure for a picture story, quite apart from the ideas presented in it, had popular appeal and gave the layman a better comprehension of the photojournalistic form as well as insight into its technique. While perfecting the essay, the magazine placed no limitation on the kind of subject matter with which such stories could deal. The leisurely studies of a Charles Lamb or an Agnes Repplier may have inspired the form, but after World War II essays became more topical in substance and point of view as the times demanded additional current news interpretation. In developing the photographic essay *Life* had contributed something more to the formalizing of the picture medium. Change in editorial direction within the essay demonstrated the flexibility of the photojournalistic form and at the same time *Life's* impatience with set patterns.

With *Life* the still photograph came into its own in terms of its prime and most effective function, that of mass communication. "The urge to knowledge and information and understanding," says Hodgins[22] "seems to have become, in twentieth-century man, almost a biological urge like hunger." The picture magazine was the twentieth century's scientific version of the ancient Chinese scroll with its hand-drawn sequential pictures which had been founded on the ancient Chinese contention that "one seeing is worth a hundred listenings." To be measured and matched against this new communicative medium was *Life's* sense of sight for pictures and sense of hearing for words, together with its sense of curiosity, its sense of drama, its sense of history — and its sense of humor. So much of the world, so judiciously selected, had never been seen before in one place, in one week, as in *Life*.

[22] *Ibid.*, p. 12.

2

The Medium of Photographic Communication

With announcement of the "mirror with a memory" in Paris in 1839, news of Daguerre's remarkable invention diffused rapidly throughout Europe and the rest of the world. Published descriptions contained numerous references to the capability of this new visual medium to capture and preserve "with incredible accuracy" fine detail — "the minutest indentations and divisions of the ground, or the building, the goods lying on the wharf, even the small stones under the water at the edge of the stream, and the different degrees of transparency given to the water"[1]

The photograph as a communicative medium either possessed or was to later acquire individual qualities which would distinguish it from other two-dimensional visual media. Photographically a subject can be represented in various perspectives, determined by the photographer's viewpoint and his selection of a lens-to-subject relationship. Photographic control of the tonal scale permits a photographer to represent his subject in shades of gray or in the extremes, black and white. Wide control of hue is possible in color photography.

Because the photograph relies upon a lens to form a clear and sharp image as well as a shutter to control the length of time in which light strikes its sensitive film, two additional visual qualities are unique to photographic communication. As the lens aperture is opened or closed to allow varying amounts of light to strike the film, a change in "depth-of-field" occurs which is of creative value. The photographer may use a selective focus and render only the subject sharp with details in foreground and background blurred to reduce their importance, or he may show an entire scene from the nearest to the farthest object in sharp focus.

The photograph also represents a photographer's conscious control of time through selection of a wide variety of exposure lengths. He may use a long exposure, in which

[1] Beaumont Newhall, *The History of Photography from 1839 to the Present Day* (fourth edition; New York: The Museum of Modern Art, 1964), p. 17, quoting *Mechanic's Magazine*, 1839, p. 320.

57

case a moving subject might blur in the finished photograph, or a very short exposure to freeze a moving subject at a precise instant. After the photographer has determined the length of exposure for the effect he desires, he must exercise another important selective act in determining *which moment* to capture of the millions available. An outstanding French photojournalist, Cartier-Bresson, refers to this act as the determination of the *decisive moment*.

A photograph reproduced in a newspaper, magazine or book is an abstraction of reality. It is a two-dimensional representation of a subject which originally had four dimensions: length, width, depth and existence in or perhaps movement through time. It may also be a black, gray and white representation of a subject originally in many colorful hues. The photograph is an abstraction of its subject in terms of size, for in most every case the photographic image has different dimensions than its original model. In photographic communication it is neccessary for the photographer to condense these dimensions and conditions into a space having only length and width with black ink on white paper — unless he has the additional value of process color, of course.

Selections in this chapter develop a further understanding of the nature and definition of photographic communication as a unique visual medium. New findings are identified, explored and discussed. Examination of design elements as part of the "family" of a photographic statement suggests the breadth of concern, as does an evaluation of the importance of context in viewing a photograph. Events or conditions which precede, succeed or accompany the viewing of an image can have a significant influence on its interpretation. The creative process and creative thinking, too, have great impact on the nature of the final visual message. One photographer makes the surprising, but provocative suggestion that the color photograph may, after all, be the "creative" or "abstract" medium, leaving to the black and white photographic image the task of communicating "realism."

The viewer of the still photograph may select the specific time of day when he wishes to read, as well as set his own pace in examining the contents of a printed medium. His eye can move about, hesitate, return and look again. A still photograph encourages exploration and expansion of vision. It is unique in that it can expand *an instant into infinity!*

Unlike the motion picture whose frames pass swiftly by without allowing the viewer his desired time to encompass or study carefully all of the visual information in a given image, the still photograph is definitive. It can record more than the brain can retrieve from its storehouse of constantly moving images. There the image is — for one to contemplate and study — in all of its original detail. The still photograph does, indeed, possess the "dignity of permanence."[2]

[2] Remark by George P. Hunt, managing editor, *Life*, Keynote Address, International Conference on Communication Arts, University of Miami, Coral Gables, Florida, April 24, 1968.

THE PHOTOGRAPHER'S CHANGING VISION

MARVIN KONER, 1964

Mr. Koner is a photographer in New York City. He has contributed outstanding documentary picture stories as well as experimental photographs. During World War II he served in Photo Intelligence, U.S. Air Force. His work has appeared in *Fortune, Life, Look, McCall's, Redbook, This Week, Esquire, Playboy, Time* and *Pageant.* He served as a correspondent for *Collier's* during the Korean War.

I would like to make a statement on photography. It is personal and brief for a sophisticated audience. I want to talk about the photographer's changing vision.

In order to survive in the world as an artist, whether a photographer, a writer, or, for that matter, in any of the arts, you must be able to search and continually find something new. This is not because the creative communicator is searching for novelties, but because he is trying to provide people with a fresh look at the world around them and, at the same time, express the sensitivities and sensibilities of his inner self. The subject of my address is the photographer's changing vision, his manner of seeing things and the need for this creative approach if he is to remain an interesting communicator of ideas and thoughts.

Everyone in the audience is aware of a good photograph when he sees one. There is a general level of acceptance in photography which we share as a group. As critics we are neither laymen nor professional; we are presently involved or aspiring to become involved in photography. We have learned to discriminate in our taste toward photographs and generally respond to ones which are good. We don't analyze in terms of composition, print quality, color fidelity or subject matter. We have seen enough photographs to understand a good or great one, and our reaction is to enjoy and be stimulated by it.

When I speak of "we," I refer to a viewing audience which is photographically oriented. There is also another audience, the mass audience, which photography has been reaching regularly during the last 30 years. The advent of superb picture magazines and books, use of more photographs in newspapers and facilities to transmit photographs by wire and wireless has oriented almost every living person to photographic communication. Our ideas about the Antarctic or the Russian steppes or Chicago or a Spanish village are basically conceived from visual impressions we have received through photographs.

The language of the photographer is truly a universal language in the world. It is unencumbered. One need not be born in a particular country to speak it, nor must one attend a school to read it at a basic level. It is the language most readily under-

standable to all and our most important form of communication among nations and cultures. A medium of such significant potential thus places an enormous responsibility on the shoulders of the men and women who make photographs — the photographers. What kind of human is a photographer? What are his likes and dislikes? What is his education? Does he limit himself? Is he aware that as the world changes, so, too, must the language of his art? Does he continue making his visual statements to a public which already understands him, but is eager to advance its own photographic stimulation to a higher, more responsive level?

On Sight And Seeing

The photographer is a man endowed with a great feeling for humanity, combined with his acute power of observation. Man's sense of *sight,* most important of all senses, becomes for him a sense of *seeing.* He can sit in a room and see the play of soft red light reflected by a brick wall and compare its delicacy with the cool blue light of evening. He observes the hands pouring tea. He sees a highlight flicker on a frozen window pane and studies the facial lines of a patient in a mental ward. He sees beauty in white sand outlining a prone figure, cheek pressed against rifle stock in the fiery sun of a South Pacific island.

His impressions cumulate and sum up, and when correlated, assume a pattern and create an idea which defines or becomes his world. Goethe was able to explain his whole world in a single sentence: "I see only what I know." This appropriately applies to the photographer, who daily is impelled to call upon his world as he continues in his work.

Because of the variety in a photographer's experiences, his world is a constantly changing cosmos. He must intellectually and analytically keep apace to maintain a current perspective and definition. His honesty and integrity will also need to be consistent with his world perception. As he grows, so must his intellect and, consequently, his approach toward his medium.

There are always young photographers who have exciting ideas and will share their contemporary experiences. It is the photographer's duty to remain abreast of recent developments and to capitalize on the greatness of his personal experiences in producing new and exciting images, endowed with the richness of all he has learned and come to know.

Toward a Definition

To better understand how the photographer must equate his constantly changing society with his way of seeing, let us briefly review highlights in the development of photography and then consider what governs the photographer's vision. I reiterate, the objective is to discover how a photographer continues changing his way of seeing to survive in a changing, dynamic society.

Photography, in a sense, is a mechanical process. The photograph is created with a piece of apparatus by chemical and optical methods and limited only by the photographer's artistic and technical capabilities.

The earliest forms of photography were based on arresting a segment of time. To

achieve a satisfactory image on a light-sensitive plate may have taken 50 seconds or 1/15th to 1/500th of a second. Nevertheless, the idea was to capture a moment of time. Every tourist is doing this when he slings his camera over a shoulder and then uses it to produce a picture which will later help him to recall the family trip. This was an early concept in photography. As serious photography came into being, the photographer and camera were gradually liberated from serving as a tool to reproduce or copy objects and persons. Photographic equipment and light-sensitive films were improved as many technical limitations were overcome. Photography found new freedom. Other considerations entered into taking pictures: composition, awareness of the characteristics of light and above all, the desire to express human relationships.

Photography began to flourish, because a few of its pioneers discovered how to communicate more than had been achieved with pastoral scenes and flattering portraits. These notable men included Brady, Lewis Hine and Jacob Riis, who produced miracles in the face of tedious technical obstacles there to cope with. They were harbingers, forerunners, followed by photographers like Eisenstaedt, Cartier-Bresson and Dorothea Lange.

These photographers concentrated on communicating what they saw; preoccupation with equipment became a minor consideration, which helped the photographer in changing his vision.

The viewing audience became more involved in the reading of pictures and less with casual perusal. An instant in time which had been stopped by the camera became meaningful, and the reader felt compelled to associate himself emotionally. In fact, so meaningful was this moment of time that it was utilized in the title of a brilliant book by Cartier-Bresson, *The Decisive Moment*. It is the instant in time when all the governing forces of a great photograph come together to be arrested by the perceptive photographer. Photography suddenly found itself endowed with a tremendous validity, the novelty long having worn off.

The next significant impact on the photographer's vision — his way of seeing things — was invention of the repeating electronic flash tube. This led to photographs taken in a super-instant, thousandths of a second. A whole new world, invisible to the naked eye, was opened to the photographer. There was newly found esthetic beauty in a drop of milk as it broke on the surface of a saucer; shattering glass took on new visual meaning. Multiple exposures produced by rapid sequence of electronic flashes revealed patterns of motion never before visible to a photographer and his audience. With development of instant photography the photographer responded in creating a new way of seeing. Time was stopped in units of thousandths of a second, then millionths.

How is the creative photographer thinking and working today? Is he at the same impasse as his fellow artists in music, literature and painting? The serious artist is at a constant impasse. He always seeks to strike out in new directions for himself and his medium. The creative photographer is forever rebuking the present. His free time from professional photographic obligations is spent in constant search to discover a new perception, a new vision of the world around him. Subjects do not change, but the way in which they are seen must, can and does.

Subject, Optics and Space-Time Abstraction

However, it seems to me that a photographer's creativity is limited to several key elements which I should like to enumerate and comment on briefly. Number one: first in importance is what the photographer elects to photograph, his choice of subject. This can be a thoughtful, analytical process in which he studies his ideas on the subject, or it may be a fleeting second when all parts of the picture come together momentarily and offer themselves to the camera. Choosing the subject naturally depends on values and sensitivities of the individual photographer. Every photographer sees his subject differently. He reacts on two levels: one is emotional, the innermost part of his personality; the second is intellectual, which is derived from a conscious and inquiring interest in the world about him. Combining these levels, a talented, creative photographer is able to produce memorable photographs.

Number two on my list of photographic elements: creativity is governed by photographic or optical perspective as contrasted to the visual perspective of the human eye. One talks of the photographer's eye, its ability to see and perceive subjects in a different manner. What must be stressed here is the importance of a photographer developing the sensitivity to see *optically* — as if through the lens of his camera — rather than *animately* — as through the human eye which sees a broad field of vision and simultaneously absorbs many visual experiences from different directions. We sit in a baseball park and are simultaneously conscious of action on the field in one corner of our eye, a hot-dog vendor in another area of vision and, finally, in yet another segment, a father and son eagerly enjoying the day together. We are greeted with series of these simultaneous impressions, each of which causes a response in us. On the other hand the optical view through the lens of a camera is greatly different. Perspective is changed by each different focal length lens. In his creative effort, the photographer must first see the subject with his own eye as if through a camera lens. Then he must select the proper camera lens to achieve the desired effect. His eye becomes the camera eye, and he must learn to differentiate between the two forms of vision.

Number three: the photographer must abstract from a subject only that spatial area which is necessary to achieve a good photograph. A photographer has in his hands an instrument which faithfully records everything within the field of its frame. He cannot, as a painter can, eliminate a cloud or move a tree. He must utilize only that portion which he feels is important. He can document all that is included within the frame as faithfully as possible, thus using the camera to its fullest advantage, or he can eliminate marginal elements by composing his picture in a certain manner. He can utilize selective focusing, to accent or diminish areas in his view. He can also exercise control in the darkroom of tonal values and exposure. The mark of greatness very often is the ability of the photographer to abstract or select from his subject that area which will yield a lasting and memorable picture.

Number four: this is the relationship of time and subject. A photograph is made by light which falls on the film after passing through a lens for a given period of time. The photographer isolates a subject from its natural course in time. When he presses the shutter release, a finite fraction of the infinite time of the universe is preserved forever. No

other creative medium makes this possible or can duplicate it. Painters and writers have reflected their historical periods, too, but never with the sense of intimate detail created only through the medium of photography. How does this interaction of subject and time affect the creativity of the photographer? He may select any one of a wide choice of shutter speeds, so is compelled to call upon his artistic sense and feelings in making that decision. He may desire absolute crispness accompanied by maximum detail in a photograph, or he may look for moderate to extensive blur. Does he desire partial sharpness or partial blur? He thinks in terms of his finished photograph, and the length of time the image passes through his lens is of prime importance.

The creative photographer has been required to maintain an ever-changing vision. With the development of new technology he has been able to alter his way of seeing the world, and his need to discover new subjects and see the established world in different ways has, in turn, demanded the development of equipment to aid him.

Into the Future

Now for questions and considerations about the future: where now and what next? There is no fast and true formula or prediction for what is next in photography; besides, it would be pretentious for me to predict. I can only suggest in very personal terms and reflect my own opinions. There is much which is new and exciting among many photographers, but there is an approach to photography which interests, gratifies and excites me. I cannot defend its validity; that is not my purpose. I can only express how I feel and continue photographing in this way until the approach loses its personal meaning. Precisely, at present I'm excited about unlearning some of the concepts of contemporary photography. I believe it has become encumbering and is capable of limiting creative endeavor. This is an important consideration, because techniques in photography have advanced so much that the sheer wonder of simplicity is often lost or confused.

Earlier I discussed the photographer's concern with instants in time. Yet for the past four years, I have found myself more and more occupied with what happens between those instants. To perform an action involves a length of time, not an instant. Rather than arrest a point of action, I discovered it was possible to create beauty of the action itself during its elapsing time. Thus, time itself becomes subject of the photograph. Every action is accompanied by a movement, but often because of the speed with which it is accomplished, the beauty of this movement is visually lost. When the magician produces a cigarette from the air, he performs an action which unfolds, but is not seen by the human eye. When a horse runs across a field, the eye is incapable of extending and cumulating its perception of time to reveal the rhythm of the animal as it moves through space. What we see is a series of movements, and the eye and brain give the movements a flow which is visually understandable to us. This approach is much the same as seeing the world in slow motion, restricting the speed of time and adopting it for expression in still photography. The simplest movement has a newfound beauty and here is an exciting way for communicating it.

I am not the first to see the world about me in this way. It is not a technical trick for the sake of being eccentric. Rather, it is a serious effort to show the world in new,

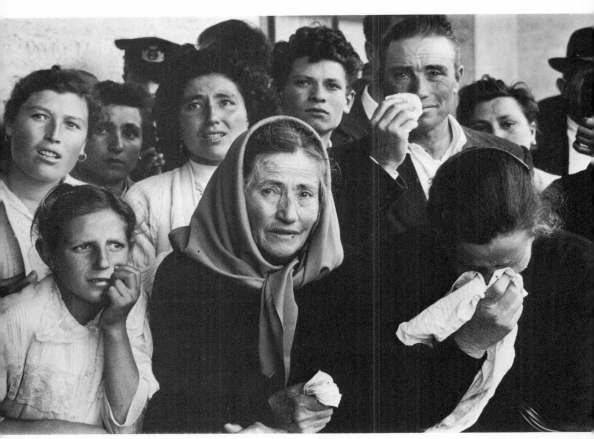

Marvin Koner, 1959

From "Carmela"

but meaningful terms to myself and others. It accepts that the viewer of today is much more sophisticated in his photographic taste than he was 30 years ago. If the content of the photograph is not readily recognizable, he does not dismiss it, but with respect for the photographer, attempts to understand what he has tried to say.

However, what I see as now meaningful in photography or what other photographers are attempting becomes a matter of irrelevancy. What is important is for the medium to progress, and for that to occur, it must exist in an ever-changing, fluid state. Photographers must always be in search of greater abilities to communicate and must stimulate new forms of vision.

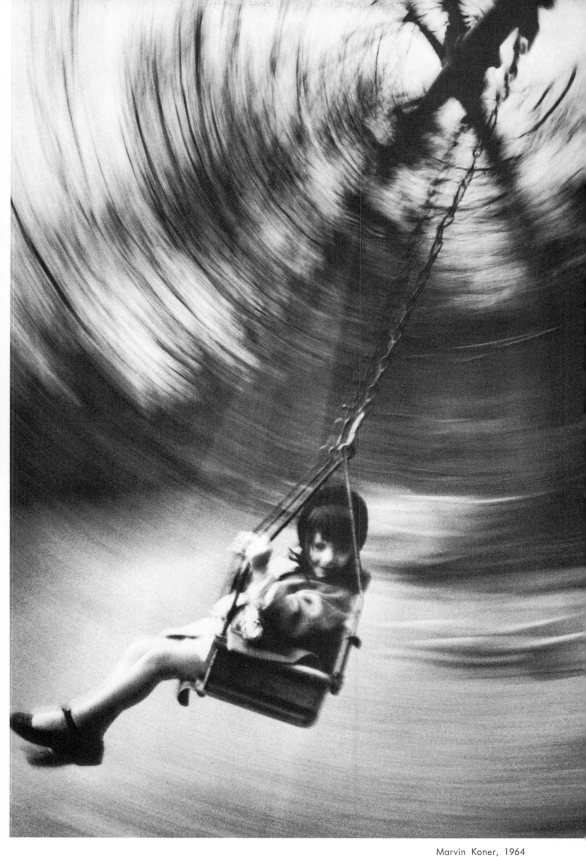

Marvin Koner, 1964

COMMUNICATION:
SIGNALS, CHANNELS AND ICONS

MICHAEL J. O'LEARY, 1959

Mr. O'Leary is associated with the Public Relations Department of Western Electric Company in New York City. One of his principal responsibilities when he delivered this speech was the editing of WE magazine, a publication of Western Electric.

Communication is the exchange of information by one system or another. That certainly is over-simplification and generalization, but we could work pretty hard to bring the definition into more precise focus. In the context of this Conference and my particular assignment, I think we're more interested in the consideration of a specific system of communication. Somebody asked a question the other day about television as a medium. Well, it is just one of a dozen systems of communication.

Let's first postulate that the industrial magazine or newspaper is a channel of communication. For the most part it's a one-way channel, not much different from consumer or trade publications. And the purpose of a communication channel, of course, is to carry information in the form of signals. In the case of a printed publication the signal is in the form of type and pictures, as contrasted with many other types of signals. If we continue our analysis of this channel concept of publications, we eventually identify the publisher as the transmitting agent and his reader as a receiving agent. In an industrial publication, management is publisher and employee is reader. An editor is the specialist who is responsible for the orchestration of his publisher's communication effort. These concepts are, I'm sure, quite clear to you; no doubt I'm going over old ground, but it seems important to review the process as we start.

In communications when a signal is received without distortion, we credit the channel with being noise-free. If the signal has been affected and distorted, we term the channel noisy. The word *noise* is a perfectly simple term for a simple concept. Radio static is noise. A publication, itself, can be a noisy channel if the reader has difficulty in receiving clearly the signal which the publisher intended to send. The word *noise* defines any influence which distorts the signal.

A publication is one form of communication channel for which it is very difficult to obtain any meaningful measure of noise. Magazines and newspapers run surveys continually to measure readability and acceptability. But, in the final analysis, it is almost impossible to know with certainty what percentage of readers understands what you're trying to say to them at the time you're trying to communicate.

Emphasis Without Distractions

Generally speaking, the man who attempts to control noise in an industrial publication channel is the editor, who is in charge of the magazine. He is or should be responsible for its contents — not only the words and pictures it carries, but also its physical appearance, right down to the quality of the paper, the intensity of the ink and size of display or body type. All of these elements in one way or another, and in varying degrees, can introduce noise and adversely affect transmission of the signal to the reader. It is the editor who performs the functions which will either filter out or admit noise into the channel to such a degree that the whole signal may be lost.

Not only is he responsible for noise which affects the message, but also he is responsible for the communicative signal strength. A strong signal has significant noise blocking capability. If an editor defers control of the communication process — if he lets someone tell him what to do — then he is in effect no longer an editor, but an expediter of printing!

What does this mean in everyday language? In communicating through printed words and pictures — in industry and elsewhere for that matter — actions of the editor determine effectiveness of the communication operation. It is the editor who controls the force and emphasis given to a message. It is the editor who must carefully screen out those influences which would distract the reader from a clear understanding of his message. Thus, my reasons for using this signal strength and noise analogy should now be apparent.

Now let's zero in on the concept of signal strength. In the ideal situation what the reader should receive is a clear, emphatic and forceful message. He should be aware of what has been communicated to him. Often that is not so easily accomplished. What is it that prevents a message from being clear, emphatic and forceful? If the editor himself is vague and uncertain about what the message should be — if he's foggy about what it is he wants to communicate — he can't very well transmit a clear message to his readers. On the other hand, if his concepts are clear, if he knows what it is he wants to tell his reader and if he understands the importance of the subject to the reader, he can hardly avoid being clear and emphatic. This matter of an editor's understanding which content will be important to the reader is very significant. It is on that point that an editor can make his reputation.

The editor uses words and pictures to give his message form. If his is a magazine-type publication, he will shape content into feature articles, usually publishing several such articles in a single issue. The editor will strive for a balance and relationship between one article and the next and impart to the whole issue a subtle unity which may not be immediately or ultimately apparent to the reader. But, this balance and "editorial mix" will be very important to the impression which the reader forms as he puts the magazine down. The editor is responsible, in short, for orchestrating all of the elements which combine to form his magazine. Thus far I've used the word *picture* rather than *photograph,* for if the editor is to perform his function in the fullest sense, he can't be limited solely to photographs. A graph, map or painting may give his message better support. He may also be limited in available budget. The editor should

be most interested in *iconography,* rather than a specific process, photography, in the sense of image. He should be interested in the image, regardless of what process was used in achieving it. And, I believe photographers might extend their own development and value to editors if they thought in terms of iconography — icon, the image, the picture.

The Photographer's Expanded Role

Now, we have talked about communications and the job of editor and publisher. Of what importance to the photographer are these travails, the problems of editor or publisher, or whether or not the reader is disappointed? Photography, to a great many people, performs a service function. It is subject to the direction of an editor or art director. So you ask, why should the photographer worry about this total message concept? Looking at photography as a service, if the editor wants a certain photograph, the photographer has completed his job when he has supplied the image. Why concern a photographer about such concepts as signal strength and interference? Actually, if a photographer is perfectly content with his service function — and there are plenty of competent men who are — I wouldn't propose to burden him with any consideration of the theory or philosophy of graphic communication.

On the other hand, you encounter competent photographers who aspire to become the best photographers in the world. For the sake of these dedicated men and women, I would like to offer these thoughts.

I think a photographer, if he is directing his work to a magazine, should think in terms of the printed reproduction on the publication's page, rather than in terms of a photographic print or transparency. He may produce a print which in its subtlety and gradations simply delights him, and he may be convinced that it is the most "publishable" in the world. But, the reader can't see that print. He will see a photo-mechanical reproduction, good or bad, which appears in the publication. For that reason I would expect the photographer to acquaint himself most intimately with the process of photoengraving. He should know precisely what will happen to the image he has made between engraving and reproduction. I am not speaking of the kind of casual and airy familiarity one gets in a 45-minute waltz through an engraver's shop. I am recommending that the photographer acquire a solid and thorough knowledge of the many effects which a first-rate engraver can achieve with the same original print, using modern techniques. Photoengravers themselves are artists, and I have respect for them. A photographer who does not make the effort to learn as much as these craftsmen will share with him is missing an important aspect of his education. Photoengravers are quite anxious to disseminate information which relates to their work, for they desire that photoengraving be used to its best, that its customers be satisfied.

When a photographer thinks in terms of a spread, in terms of all of the elements which will appear on the spread, he is in effect thinking in terms of the total message concept. He may get his first impression of the final spread from the editor or the art director. About the same time the editor should convey to him a comprehensive impression of the projected message. If the photographer has demonstrated his judgment and ability, any suggestions he may offer at this point may have considerable

influence on the final product. If the photographer has a full understanding of the collaborative nature of his role, and if he regards himself more as a communicator than as a photographer he will be perfectly justified in suggesting ways the message can be transmitted more effectively. Sometimes I believe that many talented and gifted men may be unconsciously restricted by the label *photographer,* which designates a person who specializes in the production of a very particular kind of picture. Maybe you just can't go around calling people iconographers, but for me this is a broader term and, I think, a better word for the job I have described.

Editors have word-sense in shaping a message, and iconographers have graphic-sense. The information content of a final printed message is affected by both values. It is theoretically possible for a good word man — a semanticist — to reduce even the most complex messages to a series of yes-or-no word-signal propositions. A man at Bell Labs, Claude Shannon, evolved that theory of information.

In certain respects, however, I think that graphic-sense is a much more subtle thing than word-sense. Let us now consider information transmitted by image. In spite of the fact that there is a large volume of information contained within a photograph, the photographic image does not transmit a clear message on a single frequency. One person may receive a certain meaning from a picture while another viewer will form an entirely different impression from the same picture. The evidence on which each impression was formed was contained within the picture, but the process of selection was different, the selection of evidence varied from one observer to the next. In that respect pictures — photographs, paintings and all other types of images — are very much like music. One listener will form a certain emotional response to a specific piece of music, while another listener forms quite a different response to the same work.

But to return to graphic-sense, in industrial publications pictures are used too frequently to convey identifying information. The photographer uses his camera to answer the simple question, who was where? Usually there are enough elements in a situation to challenge the photographer to offer some additional insights for the reader: the type of person, the degree of skill involved in the person's work, or even some characteristics of the subject's surroundings. This is photographic comment; it can be very subtle and abstract. It makes the greatest demands on a photographer's ingenuity, but by and large it is the area in which the photographer will make his personal reputation.

A good picture man shouldn't limit himself exclusively to being a photographer. If as a photographer he has a well-developed graphic-sense, his discriminatory faculty in other graphic areas is no doubt valuable. The visual expert as well as the editor does well to keep in mind the extent and amount of information to be communicated and the purpose of the information which is to be conveyed to the reader. There are a great many interesting and diverting pictures in this world, but unless they support and amplify the basic message, they are not of use to the reader. In fact, they may introduce an element of noise in message transmission. Pictures in the proper context can be used with powerful effect, even though a precise measure cannot be made of that effect.

To have any control over the effect which he wishes for his pictures to evoke, the photographer should have an understanding or instinctive feeling for the readers of his publication. He should be aware of their preferences and biases and have a sense of *simpatico* for what they need and desire, for their favorite clichés and tribal

customs, because knowledge of these attributes can be useful in communicating to them.

The title of this talk has been "Communication: Signals, Channels and Icons." I'm not sure my words have had anything to do with the title, but I wanted to unburden myself of some ideas. One doesn't have such opportunities that often. I suggested that a good photographer should know everything, be the Renaissance man! There's no question about it. In fact, I would submit in conclusion that a photographer or iconographer should even know more than the editor, but he must be tactful about it!

CONFEREE: Would you give us a general definition for iconography?

O'LEARY: It's as Greek as photography. *Photography* means light picture, and *iconography* is image picture. It's a more general term than photography. The point that I was trying to make is that photography is only one way of forming an image. What a photographer creates that is of lasting value is not the print which he holds in his hand, but the image. This is what he owns; this is his thought. It's the image regardless of how it was made. I thought iconography might be a freer, less limiting term for a photographer to use, at least in concept.

CONFEREE: You recommended that a photographer should have a complete understanding of the purpose of the magazine he is shooting for. Do you think that on an employee magazine a staff man can do a better job than a freelance from outside?

O'LEARY: A freelance from outside generally must take his direction in very specific terms. He comes with no knowledge of what is wanted or the special problems of the magazine and the specific article which he is to work on. Of course a good freelance has intuitive qualities and practical experience in working for a great many publications, so he may intuit a lot of this information. The editor may be able to say confidently, "We want to reflect the warm human qualities of this employee in his home environment," and be certain that the job will be accomplished in any one of many acceptable ways.

A staff photographer has more knowledge about the specific purposes of the magazine and special problems about which the outsider could not know. I don't know whether freelancers or staff men are more creative. In general a photojournalist who works for a company takes on an added measure of value over the years. He attains importance as an employee for his special knowledge of the company he works for.

CONFEREE: As a staff photographer for a company I would like to verify what Mr. O'Leary just said. A part of our job is cooperating with a visiting photographer; that's where we have a chance to show ourselves off as real photographers. Of course, we like to see our own pictures in print. Recently I worked with Peter Stackpole on a story which appeared in *Life*. I'd love to have seen the seven-page spread of my own pictures in *Life*. But Pete approached things differently than I would have. He saw things there that I couldn't see. My own technical knowledge helped Pete, I believe, in a great many ways. If a staff photographer can work with a visiting photographer, he may learn a great deal, himself.

CONFEREE: I was a little shocked at the way you skipped over art as a background for the photographer. I wonder if you have a special reason. From my experience I've found that there are more artists successful in photography than persons from any other field.

O'LEARY: If I left that inference, it was not intentional. I made reference to the value of the photographer's graphic-sense. Whether he has the technical training to synthesize an image in making a painting or sketch or anything like that does not affect his discriminatory graphic faculty. The main point is that the photographer almost needs to know everything.

IMAGES AND IMPACT:
A STUDY OF PRINTED AND
PROJECTED IDEAS

ALLEN F. HURLBURT, 1969

Mr. Hurlburt was named art director and member of the editorial board of *Look* magazine in 1953. He was then promoted to vice president of Cowles Communications in 1962 and in 1967 was named director of design for Cowles Communications. His work has been honored by more than 60 citations and awards including the Art Directors Club Gold Medal for editorial design in 1955, and 1961-1970 inclusive! He was named Art Director of the Year by the National Society of Art Directors in 1965. In 1971 he authored *Publication Design: A Guide to Page Layout, Typography, Format and Style.*

In recent years the printed image has been seriously challenged by the electronic media. Pushed by critics like McLuhan into obscure orbit in the Gutenberg galaxy and abandoned for dead by too many advertisers, print has a real need for creative people to re-examine its somewhat premature burial and bring it back into a more realistic perspective. This is not a defense of magazines; it is in no way a plea for return to old values, nor is it a put-down of the television medium.

A magazine is a highly individual kind of communication. A magazine is held in the hands and read by one reader at a time.

Television and the accompanying boom in film-making have encouraged new attitudes and new ways of seeing things, adding both excitement and force to the creative arts. But, the very nature of motion has a direct and immediate connection with the clock. Film can move slowly or swiftly. It can hold, recall and play back images. But time is irretrievable and the clock cannot be reversed.

Where television is dramatic and theatrical, the printed page is direct and personal. Where television controls time, the printed media reader picks his own time and sets his own pace. He can move forward, hesitate, return, and look again. He can even ignore the careful order of format or the logic of design and reverse action by reading from back to front.

The eye is certainly the most ingenious of lenses. It responds to the mind in a controlled zoom action that we call concentration and assists the mind in remembering meaning as well as visual experience.

The impact of the printed page is not all things to all people. But it conveys many meanings and brings understanding to people. It may be a sweep across an austere or inviting land, seen through the eye of the artist-photographer and studied with care by the reader. It is the expressionist's view of action and of man's violent involvement. It is a hundred views revealed by the camera's curious ability to create images of the real and the unreal. While film demonstrates through continuous scanning, the printed image can encourage the exploration and the expansion of vision. One carefully planned and composed photograph can reveal not one, but many different and rewarding images that build to a final cumulative effect.

The creative opportunities of the printed page are boundless. We can only hint at their potential through the evidence of images that have already appeared in print. Photographs in print can focus on the issues and dilemmas surrounding us, projecting thought-provoking images of present challenges and continued wrong. They can be combined with words to make a serious editorial statement which has special relevance to our time. When pages are carefully structured through design, the results are often greater than the sum of their parts.

Where film gives us the rhythm and beat of the soundtrack, print gives us the enduring power of the printed word. In a time of accelerating change and new visual experiences, in a time when each succeeding generation is better educated, it is increasingly clear that the new generation cannot satisfy its need for knowledge in the fleeting images of film alone. But, it is equally clear that today's methods of communication in print cannot begin to satisfy tomorrow's needs.

I would like to turn now specifically to the role of the designer in printed visual communication. Let me say at the outset that those of us who are in the design profession tend to back away from speaking of our work as "design accomplishment" because we understand the true meaning of the word design. In many circles, there is a negative attitude towards this word. We hear expressions like "over-designed," and "design for design's sake," which are really rather meaningless when you compare them against definitions of the word. My Webster's dictionary uses these positive words to describe the verb design: "create, produce, delineate, form an idea, project;" nowhere do I find "embellish, obscure, or distort," words so often found in the lexicon of design's detractors. If we are to meet the challenge of change and intensify the impact of our images on the printed page, we must use design intelligently and effectively, whether we are planning an editorial concept, taking a photograph, or structuring a layout.

What are some of the ways in which design influences visual communication? There are at least four — and I've been a little arbitrary about this; anyone who tries to lay down rules and set arbitrary boundaries for anything in our business is in some trouble. You can quarrel with many of my categorizations, but I wanted to give you a range of the broad application of design. You should not think of it only in terms of the photograph or the layout or some simple part of the design.

the **O**utrageous

*Photographer: Irving Penn Designer: Allen Hurlburt Courtesy **Look** Magazine, January 9, 1968*

Though the typographic treatment of this spread is important, the design within the photograph is the dominant factor.

Some Basics in Design

Design appears inside the photograph itself. It's the old thing we've called composition all these years, but we've always done it a little bit by the wrong rules. We've formalized composition, settled for too little of the relationship of composition to content, and hence not produced the pictures that really come through successfully in a total design way.

Second, the design needs inside a photograph may sometimes dictate or control the photograph. The creative concept which precedes shooting may dictate what the photograph will be. This is no put-down of the skill of the photographer who brings the thing into final being. There is a small part of our business where design does dictate the photograph. It's an area that I'm not especially strong for or proud of, but it's an area that involves the serving of editorial needs with the photograph. The photograph might have to yield to scale because the editor requires that scale or proportion. The idea for a photograph can be implanted in the assignment, but execution is dependent upon the photographer's option and skill. Call it design within the photograph or call it the dictation of the photograph.

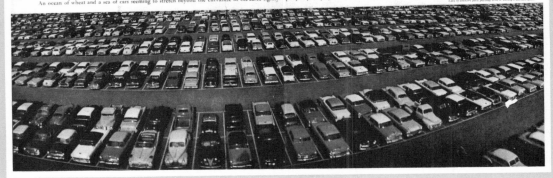

An ocean of wheat and a sea of cars seeming to stretch beyond the curvature of the earth signify prosperity, employment and industrial evolution in the Midwest

Photographer: Frank Bauman Designer: Allen Hurlburt Courtesy **Look** Magazine, September 30, 1958

The art director's concept for this *Look* spread for a story on the Midwest dictated the planned distortion of the photograph.

Photographer: Douglas Kirkland Designer: Allen Hurlburt Courtesy **Look** Magazine, January 9, 1968

Here design serves the photographs through enhancing their interrelationship and expanding their individual meanings.

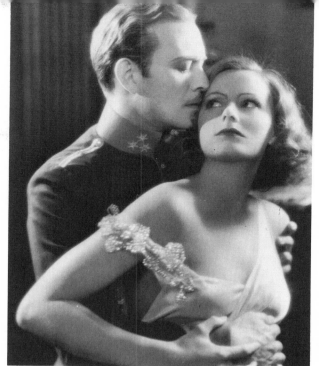

This familiar shot of Garbo was reshaped by tight cropping to become a key visual element in the spread.

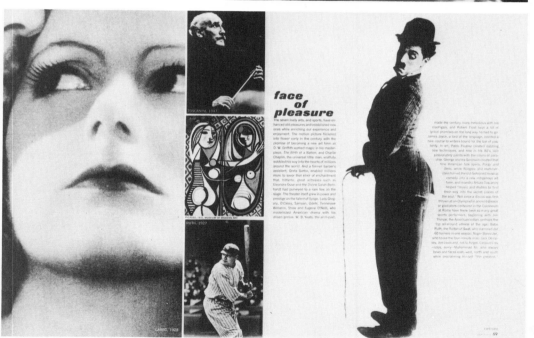

Photographers: various Designer: Allen Hurlburt Courtesy **Look** Magazine, January 12, 1965

Third, sometimes design reshapes the photograph, uses it differently for a different purpose.

Fourth, design mostly serves the photograph. It is the combination of word elements and pictures that are in themselves well-designed, selected to be used together so they have a cumulative force. Design may make the decision not to use the obvious big picture big and obvious small picture small, but to reverse that, staying very true to the concept, cropping and ideas of the photographer, but still adding that kind of

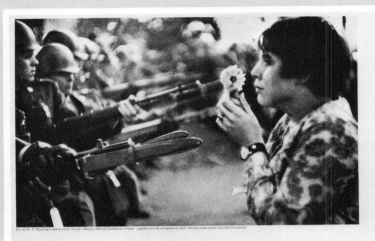

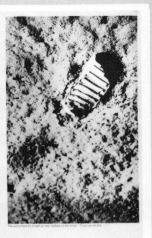

THE ULTIMATE
CONFRONTATION:
THE FLOWER AND THE
BAYONET

THE FINAL
IMPOSSIBILITY:
MAN'S TRACKS ON
THE MOON

Photographers: Marc Riboud and NASA (moon) Designer: Allen Hurlburt
Courtesy **Look** Magazine, October 30, 1969

The contrast of a dramatic photograph of the moon's surface and the reality on earth at left makes a thought provoking statement. Use of this principle of layout results in a juxtaposition effect and summation in meaning not evident in either individual photograph.

dimension. By the arrangement of two pictures, by their use together, the effect of each is heightened. Design is the simple servant of the picture. Placement is important. The eye of the great photographer creates the designed picture, carefully worked out. Hours are spent on a single picture to yield a form of design which I think is becoming increasingly significant as people turn to print for the image to be studied, the image to be retained.

I've been talking about ideas and imagination. Said another way, it's better photographs, and, we hope, the better use of photographs. I would like to close with just a few words of advice. If you came to this Conference to learn how to take a better photograph, how to sell more pictures to magazines, or how to make as much money as David Douglas Duncan, you may well be wasting your time. On the other hand, I think you are on the right track if you came here to increase your awareness of the problems and the dilemmas we face.

THE THIRD EFFECT

WILSON HICKS, 1968

The late Mr. Hicks, formerly executive editor at *Life* and co-director of the Conference, was a lecturer in journalism and Director of University Publications at the University of Miami, Coral Gables, Florida. His remarks were extemporaneous during a question-answer session.

We know so little about the photograph, really, though it has been 129 years since the image was fixed. We have just begun to learn about it. I teach just one course now in photo communication, but each year I bring it up to date by reading, by talking to people from other parts of the world and by attending this Conference.

So, I was in the process of updating my course a few years ago when Reuven Frank, an executive at NBC News and a former producer of the Huntley-Brinkley Report, showed a film. It was a newsreel of the 1960 Republican convention. The camera was trained on Richard M. Nixon, Henry Cabot Lodge, the Vice Presidential candidate, Pat Nixon, Mrs. Lodge and Dwight and Mamie Eisenhower. All were in a line, waving and smiling. I don't know much about the emotions of Mrs. Lodge, but she was so overcome by the character of the event that she broke down and wept, right there before everyone. How many people saw her? Maybe 75 million.

When Reuven Frank showed that film at this Conference, it was the year after the event. When that instant came and Mrs. Lodge burst into tears, everyone in the Conference audience broke into raucous laughter. Whereas, a year before many of these same people had suffered through that moment with her or felt sorry for her. So you see, a picture might mean one thing today and a year later mean something quite different. That's one point I wanted to make about the photograph.

You look at a photograph. You read a photograph. Since we have no better verb than read, you *read* a picture in terms of yourself: what you are, who you are, your experience, your knowledge, your imagination, your intuition, your instinct. And, different viewers or readers of photographs have different responses to the same image. You, yourself, read a certain photograph. It causes a multi-response. It sets up certain mental echoes within yourself. You think about other images which you've seen and are suggested by this picture. This is a second point with respect to the photograph.

Import of Context

I learned something just the other day in my class. Each semester I have those who are photographers in the class — and only some of them are — take a photograph of an idea. Non-photographers may clip an example from a magazine. Anyway, photographers in the class always ask me, "What do you mean? How do you photograph

an idea?" Many of the students succeed, but none of their classmates sees or comments on any photograph until it has been converted into a slide and projected. Then the whole class views all of the pictures and seeks answers to three questions: (1) Is this the photograph of an idea? (2) What is the idea? (3) How well did the photographer succeed in his attempt to translate an idea into an image? We were showing this semester's pictures recently when we came to one which had been clipped from a magazine by a non-photographer in the class. It was a campus scene, a horizontal picture with dim suggestions of buildings in the far background and in the middle foreground a sidewalk with students walking to or from class. Also in the photograph by themselves on the lawn in the foreground were a young man and woman who were wrestling. At least they looked as if they were wrestling.

One of the students said, "Yes, that's the picture of an idea."

Another said, "I get from that picture the impersonality of today's people. Look at those students walking along and not looking over this way at all."

I said, "They're just considerate."

A picture or two later we projected an idyllic image of a young man and woman, obviously college students, hand-in-hand, entering a woodland. The young man who took that picture came to me after class and said, "Mr. Hicks, I'm sorry you showed that picture of the wrestling match before you showed mine, because after reading that first picture, the tendency was to invest in the second picture the same idea as the first."

I'm making the point of the effect that one photograph can have on another, *the principle of the third effect*. I first introduced that phrase to describe this response to pictures or words and pictures in my book, *Words and Pictures*.

This idea of the third effect first came to my attention in a little pocket-sized English magazine — I wish it were still in existence — called *Lilliput*. It was about people and had many pictures. One day I opened it to find a picture of some bald-headed Germans, all close together. The photograph was taken from above, and the heads looked like — if you used your imagination — billiard balls on a table. And, indeed, the picture juxtaposed on the next page was of billiard balls on a pool table. So, the reader glances back and forth between those two somewhat similar pictures to form a new idea, a new meaning, a third effect.

THE PHOTOGRAPHER
AND THE LOGIC OF DISCOVERY

MICHAEL J. O'LEARY, 1959

For a biographical note on Mr. O'Leary see page 66.

When I was in college, I remember very clearly a teaching device which one of my English professors used to give his students a starting point in their study of literature. He said that for practical purposes all literature could be divided into two classes: the literature of knowledge and the literature of power.

Under the literature of knowledge he grouped the writing which we read purely for its information: weather reports, railroad timetables, bank statements, film speed ratings and medicine bottle labels. This is the literature which is concerned with statistical and quantitative values. In the course of a lifetime one encounters this type of literature most frequently. Its preparation requires careful writing, editing, proof-reading and printing, just as any other kind of literature.

In the literature of power category — remember these are very, very broad categories — he grouped what we generally call "creative" writing, writing which to a greater or lesser extent has the power to stir in us some sort of emotional response: amusement, sadness or apprehension. In this category would be placed the *Canterbury Tales, Midsummer Night's Dream* and *Death of a Salesman*. Also in this category would be classified Mickey Mouse and Superman, because if you limit yourself to two categories, they are necessarily broad. Of course there is always the problem that the beast you're trying to study appears to possess equally the characteristics of two classes, but these two categories are just submitted as a starting point for discussion.

It is apparent that the division between the literature of knowledge and the literature of power probably follows the same line as a division between "non-creative" and "creative" writing. The job of the non-creative writer is one of accumulating, sorting, selecting and recording data. He is a disinterested agent. In "creative" writing, the novel or poem, for instance, the writer literally takes the information from himself. When he writes with power, he is reflecting his own thoughts, his knowledge, likes, dislikes, pleasures, aversions and everything else which makes him the individual he is. And to his revelations of self, his reader responds.

I believe exactly the same division can be applied to photography. There are photographs of knowledge and photographs of power. We encounter countless visual representations of people and things which have as their primary purpose that of showing what something looks like. In ads, consider the photograph of a medicine or perfume bottle. These are photographs of knowledge.

In the category of photographs of power we have images which were made for a purpose well beyond representing the likeness of a person or thing. They do something more; in some way they draw our attention to that which we had not before noticed. They may have the power to move us profoundly. These are images to which the photographer has added his quality of creativity. They are photographs of power.

An artist who sketches a picture synthesizes an image. He assembles it, stroke by stroke. He handcrafts it. Meanwhile, the photographer records a total image instantaneously with any of a wide variation in effects, depending on his control and an adjustment of the intensity of light, duration of exposure, and sensitivity of emulsion.

Every Photograph a Discovery

We say the hand artist has synthesized his image. But, how does the photographer make his image? From where does his image come? The photographer discovers his image. In the case of the hand artist the image is created as a result of synthesis, of putting together. In the case of the photographer the image is created as a derivation of the art of the heuristic. The word *heuristic* comes from *eureka* and has to do with discovery; of course, it's Greek. The Greeks have words for everything.

When I say that the photographer discovers his image, I don't mean to imply that photographic images continually form and reform themselves, waiting for a photographer to record them. Quite often the photographer can be in absolute control of all the elements in an image. In the studio, for example he can control both subject and lighting. More precisely, the photographer discovers relationships between man and things which are expressed or implied in the photographs he makes. His photograph is a record of this discovery of relationships. These may be new, unusual or old relationships, presented in a new and forceful way. It is this art of discovery that I think is the special talent of a good photographer. In the process of his observation of life, he detects a relationship between man and things which interests him. This relationship may reveal itself to him for only a moment, but he can remember it and arrange things in the studio to demonstrate it. Sometimes he can record the image at the very instant the relationship forms itself. We have many effective and dramatic news photographs which have become more than photographs of information.

Nurturing Creativity

This talent for discovery ties in with creativity. The creative person discovers more than the so-called non-creative or less creative person. This quality of creativity in the human is a very essential national resource. In competitive industry there is a fundamental need for its employees and management to be as creative as and preferably more creative than people in other companies. Creativity is a human quality which can be improved by certain kinds of education and mental disciplines.

In the scientific world, the creative person is absorbed in a study of relationships, usually those which exist between physical bodies and forces. The artist is concerned with relationships which involve man in some way: with himself, with his God, with his fellow man or with the world around him. The existence of many of these

relationships can be powerfully communicated through a meaningful photographic image. And, photography is just one of almost unlimited ways of creating these images.

Now to return to the editor. When he needs an image for a communication task, he should not concern himself with how the image is made. He should be concerned with message content.

What makes a creative photographer creative? First, there is a difference in people. Some are mentally agile, more perceptive, more imaginative. There are slow thinkers among us who require a long time to accept a new idea, let alone form a new idea. Creativity begins with aptitude. While it's possible to improve the creative quality in a normally creative person, I think it would be extremely difficult to even implant a spark of creativity in the non-creative person. But that is open to argument.

Assuming that a creative aptitude exists — this aptitude probably exists in many individuals without their being aware of it — I think that the quality and degree of a person's creativity may be improved by the pattern of knowledge he acquires and the habits of thought he develops.

The education of a scientist or an engineer lays particular stress on the substantive derivations of natural law, of measurable relationships between things. When he's thoroughly familiar with established and demonstrated relationships, a scientist is trained to detect essential relationships in very complex situations and identify new ones. And when he has identified a new relationship, we say he has made a discovery.

The proper education for an artist is, in my opinion, drawn from a much broader field. It should be an education which is preoccupied with man. In detail, I doubt very much if it makes any difference whether an artist studies the history of art, Aristotelian philosophy or the economic structure of 19th century England. He learns to know himself and his neighbor; that is the object of his study and should remain his continuing preoccupation. He knows what other people know; he knows what they are thinking about. It must be assumed that an artist's education includes adequate training in the techniques of the medium in which he expresses himself.

It is only if an artist continues to grow in his thinking that he will develop a degree of discernment and a speed of recognition which will identify him as a creative person. Alexander Pope said that the proper study of mankind is man. And certainly it is entirely appropriate to say that the proper study of photographers is man. Man is essentially the basis of humanistic studies. This is the area in which the photographer can discover new relationships and confirm old ones in a new light. In those discoveries he can make photographs of power. If he is competent and informed, he should be able to make good photographs. If he is unusually gifted, he may make great photographs.

The creative process works in a great many ways and with widely varying effects. I have tried to approach some of the principles of creativity for the sake of discussion. If your theories disagree with mine, that's fine. The important thing is that photographers have a point of view from which they operate and that they spend time thinking about that viewpoint. They must also be willing to change their point of view as the world continues around them. Too often a man whose opinions and point of view have crystalized is a man who has stopped thinking.

Let me conclude with what the photographer needs for his job. First, his technical training must be so complete that his use of the machine is purely reflex; no conscious thought of the technicals should be required. He should react constantly and instantly to the technical requirements of the situation. Second, and most important, it is virtually impossible for a photographer to create meaningful images without a deep understanding of people. Not only do they form his most important subject matter, but also it is their understanding of and response to his photographs which will be the important measure of his success as a photographer. These are the major things. Finally there is a third quality I think ought to be mentioned in passing. Almost everyone of us develops a special subject matter knowledge of one kind or another as we go along. Something catches our interest, and we develop that interest. The topics are myriad. One man will know about tugboats, another about skiing and still another will know a great deal about birds. The graphic man is well advised to also become an expert in a special interest area. It may bear no relation to photography. But, as an expert on something, his photographs of that subject will be clearly more authoritative and significant. Today we encounter many more problems than we encountered 50 or even 25 years ago. It's no longer possible for even a photographer to remain a general practitioner. I believe a photographer's best work can be done most consistently with subjects familiar to him.

If a photographer has these abilities and he is reasonably well and broadly educated, I don't see how he can miss discovering the relationships in the world around him that will make good and occasionally great photographs.

And that we could call the end of the gospel according to St. Mike!

COLOR IS A LIAR

ART KANE, 1961

Mr. Kane is a photographer in New York City and is noted for images of strong graphic design as well as for his creative use of color.

The title of this talk, "Color is a Liar," is weird! I thought of it quickly, and I wasn't sure what I really meant when I wrote it down. But, I do believe — in a sense — that color is a liar; now let me explain.

This thought about color is essentially the motivation behind my whole approach to photography, and it is based on a serious personal theory. I am not suggesting that color is a liar in the same sense as a person might be a liar, but more in the sense that poetry might lie. For me color photography is valid only when it reveals a psychological truth rather than a documentary lie, only when it interprets rather than accepts.

For example, suppose you were assigned to photograph a funeral and register in your statement the tragedy of death: a sad, sombre, morose statement. However, further

suppose that the funeral occurs on a bright, sunny, spring day: the grass is bright green; the sky royal blue; and the flowers are in full bloom, creating patches of glorious reds, blues, violets, pinks. These are not the colors of death or tragedy, nor are they conducive to creating the sad, sombre, morose impression of a funeral. Yet, if you were to photographically record this scene exactly as it occurred and under those very circumstances, no one could argue that your pictures were dishonest or consisted of anything but the truth.

However, this photograph would be truth based on fact, but a lie in terms of its serving as a reflection of the prevailing tragedy. Thus, it becomes the duty of the color photographer to interpret rather than to record, to distort rather than to accept. Therein lies the distinction, I believe, between the artist and the reporter.

It is easier to accept or record similar conditions in black and white photography and still express the truth, because the absence of color in a photograph permits the viewer to add his own chroma to the image or, perhaps, never feel the need for color. Most of us never experience the intensity of color in reality which we sense in observing a color photograph.

For that matter I believe that all photographs — black and white or color — are lies, even when the color photograph exactly duplicates the existing colors of a situation. When we look naturally at anything, we are aware of our immediate vision plus a

peripheral vision which exists on either side. We are also somewhat aware of space beyond our immediate and peripheral vision, for a human is sensitive to his existence in universal space. Your other senses are also working during any normal seeing experience. We can touch; we can smell; we can hear; we can taste.

A Photograph — Super-realistic

All of this tends to dilute each visual experience before us. However, a photograph dares to pull a tiny segment of life from its context of enormous space and in so doing makes it super-dramatic. The hard edges of a photo, black and white or color, are extremely final as is the blackness which surrounds an image on a motion picture screen. Thus, the portion of life which a photographer dares to remove from its vast surroundings necessarily appears as super-realistic even though the subject itself is merely realistic.

It is because of this phenomenon that after having seen a Technicolor motion picture production and after having walked out of the theater into an atmosphere not unlike that depicted on the screen, I have suddenly wondered where all the color has gone! It hasn't really changed. It was super-realistic and super-dramatic in the darkness of the theater because of spatial selectivity and framing, but not at all because of a physical distortion of color.

Now, if black and white photography is also super-realistic, why, then, do I prefer it rather than color film as a medium for depicting the truth? It is due to a combination of elements.

The very nature of pulling something from the context of its natural surroundings automatically creates a super-dramatic image. However, this super-dramatic image minus its natural color equates itself into a psychological truth. In other words it is a combination of overstatement and understatement. Any photograph is overstatement; absence of color is understatement. This combination results in an acceptable or believable statement.

This theory is not meant in such absolutes as to deny that a photographer can also achieve interpretation in black and white, for I do believe that one can both record and interpret in black and white. But color photography is best suited to be used in an interpretive way. Subconsciously these and many other thoughts have guided me in my approach to photography, but on the surface the predominant factor has been personal enjoyment and self-satisfaction. If you don't enjoy every moment of photography as a child does his toys and if you don't approach it with the same naiveté, recklessness and abandon, no guidebooks, set-of-rules or photojournalism conferences, for that matter, are going to help!

WILSON HICKS: How much of the painting art did you study before you actively began taking pictures?

KANE: I had originally intended to be either a painter or a designer, and I studied painting and advertising design at Cooper Union in New York. Prior to my working with a camera, I had been painting and studying painting in Mexico until I reached a point where I knew it really wasn't the medium for me. I had nothing to

say as a painter, but am passionate about graphic design. So I resumed a career as an art director and designer. There is no question in my mind that my training as a painter as well as advertising and editorial designer have had an enormous influence on everything I have done.

I also honestly believe that my so-called theory has motivated my approach to color and black and white photography. To record a subject in color simply because it is there is completely wrong. The only tool the photographer has to paint with is light. We do not have pigment. We have only this damnable machine which, frankly, I hate; I do not like cameras or machinery. I don't even like the way the world is going. I'm an extreme romantic. I prefer green grass and human flesh and human anything. I don't particularly like science, so I really resent this camera which I am forced to use in expressing myself.

HICKS: You don't like the camera but the camera surely likes you.

KANE: Well, I try to work as if there is no camera. That's another reason why personally I love a small camera — there's less machinery between me and what God has created. I wish there were a thing that I could put in my eye, just blink, twist my ear and pull it out of my mouth!

In the almost two years in which I've been a full-time professional photographer I have had one hell of a ball, enjoying every minute. I've approached photography the same way whether my pay was to be $300 or $2,000 for a photograph. I'm just like a kid going out there to see what is going to happen. If I make a mistake, great! It's this kind of naiveté in the medium and a contempt for equipment which summarizes my approach.

COLOR VS. BLACK AND WHITE

PANEL, 1968

Contributing to this discussion are Philippe Halsman, photographer, New York City; Arthur Rothstein, then director of photography, *Look*; Gjon Mili, photographer, *Life*; David Douglas Duncan, freelance; Ernst Haas, photographer, Magnum; and the late Wilson Hicks, University of Miami.

Is Conversion Desirable?

ARTHUR ROTHSTEIN: I asked a question of Mr. Hunt of *Life* earlier this morning and felt that while his answer was good, it was somewhat inconclusive. Since we have four photographers here, all of whom have worked for *Life*, it would be interesting to get their viewpoints about the choice of color or black and white in editorial features. Hunt said it was up to the photographer to make the decision, and if this is true, how do you make those decisions? He also said he almost never used conversion.

GJON MILI: Let me ask you a question. Do you believe in conversion from black and white to color?

ROTHSTEIN: I do, yes.

MILI: Very good. Now, would you make that a standard rule, that you could shoot scenes in color, and then convert to black and white if you needed to?

ROTHSTEIN: Why not?

PHILIPPE HALSMAN: I don't believe in this.

MILI: Here is my point. Do you believe that one can mentally look at the subject and shoot and forget whether he has shot with color or black and white?

ROTHSTEIN: I cannot do that.

MILI: In other words, you cannot shoot color or black and white at the same time.

ROTHSTEIN: What I'm saying is if conversion occurs, it must be done after the story has been shot.

MILI: When you shoot with color you handicap yourself. You shoot with less speed than you otherwise can have in black and white. I don't know how that kind of decision affects you, but, for me it brings instantaneous changes. If I put color in my camera, I react instinctively. How can you say that if you shoot with color and it is converted you will get that which would have transpired in your head if you were working in black and white? You said you don't object; you said it's perfectly okay.

ROTHSTEIN: I'm asking you to make the decision. How do you decide?

MILI: Whether I use color or black and white?

ROTHSTEIN: That's my question.

MILI: All right, the answer is very simple. *Life* does allow you that privilege and forces you to think about the subject. If you think there are elements in the subject which make necessary higher film speeds, use black and white. If the subject is one that black and white will enhance, then by all means shoot black and white. If you shoot with color, you know the color does certain things which black and white cannot do.

HALSMAN: There are many other points which, in my opinion, are more important. I shoot color when the color will contribute to the story. The fact that some parts will be red, blue or green will imply a new visual, emotional or content element. When shooting color you must think completely differently. If you have something red and you photograph it against blue, that is terrific contrast. If you photograph the same subject in black and white, you get a medium gray against medium gray and lose all separation. When I am shooting in black and white, I try to emphasize a point or a feature. I try also to incorporate the greatest contrast in tonal values. The grain of my picture will always be there where the white meets the black. This is not the way I am thinking in color. Mili, who is the champion of high speed photography, thinks he needs black and white for speed.

MILI: I didn't say that. I said that if speed were important, then it would be a singular inducement for me to go to the fastest film. If color adds something, then obviously I must use color.

HALSMAN: As a matter of fact the premise that *Life* gives the photographer the decision is not true. Very often *Life* magazine has asked me to photograph something. I have asked if it should be in black and white or color. And they would suggest without any evident reason to try it this time in black and white or another time in color.

MILI: Philippe, you are right about this. An editor is a man whose job it is to balance elements. He will say, "We have space and we can use it in black and white." This is an *a priori* statement. He doesn't say use color or use black and white. He says, "If you don't feel like shooting this thing in black and white, you don't have to shoot it at all. My point is he doesn't tell you what to shoot or how. He may say there is a subject available which is, in his mind, in black and white. If you see this subject in color, you will not be the man they send. No principle, my friend, will apply consistently in practice.

You can say you're doing very well if you're allowed freedom. And that I ought to know. But the important thing is that they will not force you to accept an assignment if you are against conditions of the assignment. This has been my experience at *Life*. You will not be asked to shoot in black and white something which you want to do in color.

WILSON HICKS: What are some of the different considerations from an editor's viewpoint with respect to the choice that has to be made at some point between photographing a picture or a story in black and white or in color? I remember several years ago Alfred Eisenstaedt was in some island in the group north of Australia, and there was a very warlike tribe there. All the men did was fight. Oh, they ate a bit and loved a bit, but essentially they were fighters, the fighting tribes of New Guinea. Alfred went there and shot in color. When I saw his work, it didn't look real to me; it looked like a movie. About that time there was an earthquake in Alaska. The photographer who covered it shot mostly in color. And when I saw that take, somehow color didn't seem to be right for a great catastrophe and tragedy. I just wonder if there isn't more to this matter of choice between the two.

ERNST HAAS: If you have a girl in a yellow pullover, the decision must be made by you to shoot in color or in black and white. If you want to shoot for the face, you shoot in black and white, because the color of the pullover is so dominating that it becomes too important. But very often you are not asked to make a choice; you are sent out to shoot in color. If I shoot for myself, I know exactly what I want.

MILI: No, but there is one element which has to be taken into consideration. If you're asked to shoot the girl in a yellow sweater, it's not for the look of the girl, but for the sweater.

HALSMAN: I think we have not answered our friend, Wilson Hicks.

HAAS: Wilson has posed a very valid problem. I can give you a more interesting example — poverty. It is very difficult to photograph poverty in color, because suddenly poverty becomes attractive, glamorous. The reason is very simple. It lies in the color material we shoot. Color photography dramatizes and overemphasizes the color. Most landscapes look much more beautiful when photographed in Kodachrome than when seen by the human eye. So this is something that we should understand; colors are exaggerated when we photograph, and thus introduce an element of artificiality. This is all right in fashion, drama, theatre, or even in landscape. But it is absolutely wrong if this element of artificiality is introduced where the sincerity is of basic importance, such as poverty or tragedy. And, it is only when the photographer can control either his emulsion or reality that he can photograph heartbreaking things in color.

Somebody spoke about the movie *Crime and Punishment*. It just happens that I photographed *Crime and Punishment* for *Life* magazine in black and white. But if I could

control colors, and suddenly in darkness show a bright red, or a violent green and so on, I could also photograph *Crime and Punishment* in color.

MILI: It is not a question of color; it's a question of control.

HALSMAN: That's what I am saying.

HAAS: That's it.

The Ethics of Color

CONFEREE: But what about color vs. black and white in the photography of war?

DAVID DUNCAN: I'd like to pick up on that point, and I think I can speak with authority on this subject. To this day I've never made a combat picture in color — ever. And I never will. It violates too many of the human decencies and the great privacy of the battlefield. There's a second point that goes slightly beyond the matter of control. In the photography of war I can in a way dominate you through control of black and white. I can take the mood down to something so terrible that you don't realize the work isn't in color. It is in color in your heart, but not in your eye. I'll leave it at that.

HAAS: And also because black is so strong.

DUNCAN: What else have I been saying? You know there are pictures you have seen of the fellows out there that are in black and white because they couldn't have been printed in color. If they were in color, it would have been impossible.

MILI: Looking back now for a moment, because this is very crucial, we started with *Look's* policies on conversions, and we have arrived at something basic. There is no single principle which can be followed in determining whether or not to shoot in color. It is in the human heart, in the nature of the man — the man who holds the camera, who looks at the subject. He must photograph so what he has to say reaches you directly. And you can't get away from this. Do you think Wilson Hicks as my editor ever said to me, do it in black and white or do it in color? He'd say, if you do it in black and white, we have space for it. If we think far enough ahead, there is room for color. Then you try to adjust your sights.

DUNCAN: And then shoot it for yourself the way you want to do it.

MILI: That's all and nothing further, but there's no policy of *Look* or *Life* that differs.

HICKS: Can you comment on this one war picture? . . .

DUNCAN: It's a great photograph, of course, and it's not offensive.

HALSMAN: What does that mean, not to be offensive? Do you mean that a war picture can upset us only to a certain point, and no further? I don't understand.

DUNCAN: Well I do.

HALSMAN: I want you to explain it.

DUNCAN: I think I'm qualified to express my own reservations, at least. I'm also dealing with the sons of families unknown to me. I will not shoot a closeup.

HALSMAN: May I say a few words. I have never been a war photographer, so I'm not qualified to talk about photographing on the battlefield. But, as a human being I am against all wars. It seems to me that if you try to protect us from the terrible horror that war brings, that if you show war as a kind of chivalrous killing, and that if you don't show all the horror, then you have perpetuated war. Finally we should have the courage to show

war in all its disgusting ugliness so we feel we must stop the killing and slaughtering and maiming and producing all this ugliness.

DUNCAN: I do not agree. There's still one more consideration — the guy you're photographing and his family. It's a decision I have to make. It's a matter of ethics.

HALSMAN: Don't you realize that what you are fighting for is trying to save all his buddies, all the armies of young people that will be killed in the future. Are you protecting one family in order to make many hundreds and thousands of families go through the same ordeal?

DUNCAN: War won't be stopped by my photographs.

MILI: Morally you are correct, Philippe, in every way. War is pestilence; war is everything that's wrong. Let me be honest. To propose that if a photograph is shot in color, showing all the gore, it will change war is unrealistic. It won't. These are matters of taste and outlook in the mind and heart.

HICKS: With war pictures in particular, doesn't color answer too many questions? Color leaves nothing to the imagination compared to a black and white photograph into which you read color, into which you interpret color from your conscious or subconscious mind. It seems to me that the color picture answers practically all the questions.

DUNCAN: In the first place, color is much easier than black and white to shoot and to read.

HALSMAN: To read but not to shoot.

MILI: To read.

DUNCAN: I think color's easier to shoot.

On Reading the Photograph

MILI: Let's go back. If you'd only learn to read the photograph. You don't look at the page and say, "This is the meaning of it; I like it." Absolutely not. The photograph reads exactly like a page. It has a lot to tell. And you have to learn to read it. Time and time again color can facilitate reading because you can react to it much more spontaneously. If you are a man who has been trained properly, you can allow the black and white to speak to you beyond color. Black and white is color.

CONFEREE: You're talking to professional photographers and telling us that we need to learn to read the photograph. What in the world is the general public supposed to do? How are they going to learn to read photographs?

MILI: We'll have to teach them. Photography is only a hundred years old. They'll have to learn it. They'll learn it in their bones in time, just the way people learn the alphabet. You didn't start with the alphabet; you started with a drawing on a cave. The photographer has got to learn how to read his subject, or he won't be a photographer, let alone a good one.

CONFEREE: Well then we'll have to give the public something they can read now, because we have to communicate.

MILI. You're going to give the public what you can. And you hope to God that they will read it. That's the truth. I don't know how the public will read. Everybody has a different notion about any given photograph.

HALSMAN: It seems to me that we are talking now about a very profound problem. Whenever you produce something — say a work of art, a photograph, painting, drawing or a sculpture — first it is the feeling of the artist that goes into it. How well he has accomplished inducing this feeling is the result. You now have the photograph. The communication is not finished. Then comes the onlooker, who must contribute attention, imagination, and understanding. I have made a photograph — let us say a portrait — in which I have fought and suffered until I finally got the expression which I wanted to show, which meant something to me, only to witness a viewer say, "My, you can see every pore in this face!" That is all the person saw, because he didn't finally receive the feeling that this is the face of a mother who is describing to me that her only child was crippled forever by polio. Your eyes can never learn when you have no response to the things that you see.

HAAS: You mean you can read a photograph without understanding.

HALSMAN: Yes. You can read without understanding. In talking about reading, I am reminded of my belief that more and more of today's youth are losing the art of reading. It is not enough to read that David stopped to pick up two stones before going to fight Goliath. You must ask why two stones? Is it because he will have at most only two chances? And then you think of this little boy facing a giant with two stones. The giant is coming toward him with a sword. When you imagine that your heart starts pounding. Now that is what I call reading. Your imagination accompanies and fills out every sentence. That kind of reading is being lost, for youngsters see movies, television and pictures and somehow lose the ability to imagine words, to transform words into visions. The images are right there in front of their eyes.

HAAS: In photography there's something that happens simultaneously. The photographer must read and write as he reads. This simultaneous process of reading and writing you have in absolutely no other medium.

HALSMAN: That is something I never thought about. It is absolutely right.

HAAS: You read and write simultaneously.

HALSMAN: Yes, because you transform the image that you see into an image. Is that the same thing?

DUNCAN: He did it better.

HALSMAN: He did it better?

HAAS: I didn't understand!

HALSMAN: I agree, I concede.

3

Editorial Process in Group Journalism:

PHOTOGRAPHER, ART DIRECTOR, WRITER AND EDITOR

Whenever photojournalists come together their discussion quickly focuses on a long-debated issue: the quality and validity of methods employed in the editing of their work. Essentially they question how editors who have not experienced a story "first-hand" in the field can edit that work without distorting truth — unless the photographer, himself, plays a major collaborative role in the editing. Editors and art directors, too, have their viewpoints on the issue.

Of course to make functional the group process in the production of stories for major magazines, specialists are assigned to each "step" along the way. Someone does the research. Then there are reporters, writers, photographers, and the assistant, associate and full-ranking art directors. Finally, a managing editor or editor may become involved in final decisions.

Most vocal and firm in individual beliefs about the function of this group process are three segments of the operation: photographer, art director and editor. Each sees problems of responsibility and authority from a different viewpoint, and those viewpoints frequently fail to align. Some of the issues which trouble this editorial triangle are directly related to each member's individual authority; others are broader, involving questions of "group" vs. "individual" journalism.

For example, many editors question if the photographer can function with any degree of effectiveness as editor of his own work. While at *Life* and even afterwards, Wilson Hicks did not disagree with the basic philosophy of group journalism, and was particularly negative and vocal in his belief that a photographer was too emotionally involved in the making of images to be of value in their editing. He favored a rather strict separation of functions and powers. Will Hopkins, formerly *Look's* art director, practiced the other side of the coin as a kind of "visual managing editor." He argued for a closely-knit group effort of photographer, editor, writer and art director, each contributing to the "whole" —

the story — without specific territorial limits. Frank Zachary, while art director of *Holiday,* argued in favor of the "dominant editor," one who creates the personality of an entire magazine in his own image, giving it a distinctive and individual character.

Another area of debate concerns the photographer-writer relationship. Should the photographer be "boss" when with the writer? Or, should the writer be in command? Is it better that no one runs the show? When there are conflicting viewpoints on the interpretation of fact, how should differences be resolved? How involved with the photographer should the writer become in the making of photographs?

The photographer-art director relationship at some publications involves an art director's origination of the assignment as well as his editing and layout of the photographer's work. How much direction can or should the art director give the photographer? Should the photographer accept a "tissue-paper" assignment from an art director? Does the photographer have a responsibility to "shoot-around" the art director's assignment and present that, too? Should the photographer and art director work together as a team in picture selection and layout?

While there is seemingly an endless fountain of unresolved issues in the complex network of relationships among members of the editorial team, the selections which follow will bring into sharper focus and definition the principal themes on which positions and opinions have been formed. The process of creating a story — from idea and research through photography, writing, layout and publication — is related to individual viewpoints and the creative thinking involved in each of the editorial functions.

THE EDITOR-PHOTOGRAPHER TEAM

ARTHUR ROTHSTEIN
and
DOUGLAS KIRKLAND, 1962

At the time of this presentation Mr. Rothstein was director of photography, *Look* magazine. He is author of *Photojournalism* and *Look at Us* with William Saroyan, as well as a text on creative color photography. His early photographic experience included work with the famed FSA under Roy Stryker. Mr. Kirkland was associated with *Look* magazine both as a freelance photographer and as a member of its staff for many years.

Arthur Rothstein:

My relationship with the Miami Conference is an old one; it goes back to the very first session in 1957. The Conference has always been very stimulating and rewarding, and the atmosphere here is sympathetic to the problems of a photographer: receptive, inquiring and constructive. We're concerned here with photography as an effective medium

of communication. But, I deplore the fact that the basic principles and unique assets of photography have been forgotten and misunderstood.

As a medium of expression the photograph produced in a camera by an intelligent, trained photographer is unequalled by other graphic media. Photography has its limitations, but with full knowledge of these limits we should concentrate on exploiting the inherent characteristics of the photographic process and use them with skill and imagination. These characteristics include reproduction of fine detail and texture, accurate rendition or willful distortion of perspective through choice of lens and viewpoint, infinite range of tonal values from light to dark which may be compressed or extended at will, and finally the ability to stop motion — capture the decisive moment or exact instant. There are numerous challenges and opportunities for exploration in these four areas.

Wilson Hicks noted in his keynote address that many photographers, perhaps motivated by feelings of inferiority, attempt to work as painters. However, the invention of photography displaced the painter from the world of reality. Painters must now deal with nature in non-objective and abstract terms, because they cannot equal what the photographer can achieve in accurate representation. By the same logic, the photographer who attempts to compete with the painter in non-objective or surrealistic work is at a great disadvantage. It is understandable that some photographers may try to say something new and different, but no amount of rationalization will raise much of our blurred, out-of-focus and inferior photography to a high esthetic level. I plead for a restoration of the value of discipline in photography, for much of the thinking about photography seems to be in a state of chaos.

In news and magazine photography we must not lose another essential characteristic, believability. There is a great strength in the traditional concept of the photojournalist who operates with honesty and integrity. It is important that we should not give credit to the phony and the faker. Some photography which lacks believability has resulted from the growing ease and simplicity of amateur picture making. Every year photography for the masses has become more foolproof. With modern films and automatic cameras anyone can make correctly exposed pictures. As a result, many people who admire the glamorous, exciting life of the photojournalist — and this includes some writers and art directors — project themselves into the ranks of "photographer" with a minimum of effort. But, the art of communicating with the photograph is much more complex than the technicals involved in taking a picture. A monkey can be taught to operate a camera, but he is not a communicator of facts and ideas.

Photographer as Generalist . . . or Specialist?

Another trend which bothers me is the growth of specialists. Photographers are being typed and classified according to their supposed speciality with increased frequency. Some photographers, especially in the advertising and commercial fields, have found specialization to be more profitable than versatility. One photographer may specialize in high fashion; others concentrate on architecture, entertainment, science or sports. It is approaching the medical profession in which few doctors know how to treat the whole man. I do not like to see this happen to the photojournalist whose interests should be universal. I like to think of him as a kind of Renaissance man with many talents, interests

and capabilities. He should be technically competent and intellectually qualified to cover anything, anytime, anywhere in the world. To function best as a photojournalist it is important to be versatile. The photographer who is versatile must be able to change his approach to suit the subject, remain flexible, be adaptable and have a large quantity of picture-making skills readily at command.

But, all of his skills, efforts, art and intelligence are in vain if he fails to communicate. He must convey a message or transmit information, and some people — preferably as many as possible — must pay attention and understand. Communication implies and requires understanding.

An Editorial Trio

The photographer has two partners to help in producing a message which can be understood: the editor-writer who may accompany him on location and the art director who displays words and pictures. Each of this trio contributes to the creative effort; a true spirit of cooperation must exist among all three. They must respect and appreciate each other's contributions. Failures in communication often result when the photographer demands excessive space for his pictures at the expense of necessary, explanatory text. The same problems arise when the editor does not effectively blend or fuse words with pictures and when the art director imposes a design or layout for its own sake rather than to enhance the story.

Some photojournalists think they can take the pictures, write the words and design the layout themselves. While this is theoretically possible, it is rarely accomplished with effectiveness. It may be compared to those rare films in which the producer is also director, writer, cameraman, sound engineer and film editor.

Another important dimension of the photographic medium which helps visual statements to be more effective and better understood is color. Today the decision to shoot black and white or color is rapidly becoming less significant. With the arrival of the color negative a photographer may produce a black and white print, a color transparency and a color print all from the same film. In recent years more color film is being exposed than black and white.

Compared to color photography, shooting in black and white is simpler in some ways, but more complex in others. The photographer who works in black and white must learn to disregard color and evaluate his subject in shades of gray. He emphasizes contrast, shapes, lines and texture. Through the use of filters he can darken skies or create dramatic impressionistic effects. The black and white photographer thinks of color in terms of its transformation into gradations of light and dark. A good black and white photograph may be more exciting for the viewer than a color photograph of the same scene, because the viewer's imagination must provide missing color information. The essence of a picture may be more easily understood in black and white without the added and sometimes confusing qualities of color. For example, a slum in color may become more esthetically pleasing than pitiable.

The approach of the color photographer is decidedly different. Far from disregarding color, he is very conscious of its attributes. He develops an eye for color which is sensitive to shifts in color intensity, brightness and saturation. He develops an appreciation for color

harmony and the psychological effects of color. The photographer often will use great restraint and selectivity in creating a color image. He discovers that in a color photograph contrast results from the colors themselves rather than from tonal value differences or minor changes in lighting. With continuing improvements in high speed color presses and expanding use of color in publications, every photographer should develop an eye for color. It is another valuable dimension and opportunity in photographic communication.

Printed Media in the Electronic Era

For generations visual communication in the mass media has been made possible by the printing press. Now there is another technology for transmission of the image to a mass audience. I refer to the electronic image, television. We must be aware of its assets and limitations. In the future, just as photographers replaced the portrait painters, so, too, cameramen with television equipment may replace our traditional photojournalists who use film and paper.

Electronic visual communication is immediate and instantaneous in its transmission of the image to a mass audience. However, fortunately for us who work with the printed page, television has one great limitation: it is a transitory medium without permanence. It is moving and temporary. By contrast, the picture on the printed page may be examined as long and often as desired. With a blend of meaningful words and skillful layout it becomes more than a mere witness to an event. It can provide insight, interpretation and information which far transcends the transitory electronic image of television.

Thus, photographers, editors, writers and art directors who combine to communicate via the printed page have a greater responsibility to their audience. They must leave superficial and immediate coverage of events to television. The people who work for printed publications now have the great opportunity to probe the past and present in an effort to throw some light onto the future. In such domestic crises as segregation, labor racketeering, crime, juvenile delinquency, dope addiction and the nature and cost of medical care, communicators in the printed media should provide a solid background of information, guidance and enlightenment for the reader. In international relations the printed media should analyze the nature and the extent of the Communist threat, dissect and explain motivations of the world's political leaders and describe and interpret the social and political revolutions sweeping other countries. The great challenge for the photojournalist lies in the way in which this can be done. Original crusading and investigative reporting must be stressed.

At *Look* magazine it is said that the modern photojournalist doesn't merely cover the news; he makes the news. The process of mass communication is so complex and expensive that to justify costs and efforts a photojournalist must have something important to say and know how to say it. Our need to communicate effectively with the rest of the world has never been greater, and pictures offer one of the most effective means of communication which we have. Because communicators have not tapped the surface in learning to use media to their full potential, I am convinced the challenges ahead are greater and more interesting than those we have already met. Our profession is becoming more and more important.

Finally, as a working photographer I offer these suggestions to fellow photographers, art directors and editors. Photographers must recognize the strengths and limits of their

medium. They should develop an inquiring point of view and a versatile, individual style in which techniques are at hand to fit a specific communication problem. The art director must utilize design to enhance the total message. He should not complicate the page with pretty, but unreadable, type or shape the photograph into something which will win an award from a mutual admiration society. Editors must give their communications team the opportunity, time and money to probe for truth. If an editor goes on assignment with a photographer, he should assist with constructive guidance and criticism. Words, pictures and layout must be fused into a single, harmonious, readable message. We have both a greater opportunity and a greater social responsibility than ever before. Our success depends upon how well we penetrate and probe the problems of our times to communicate ideas, facts, opinions and emotions with inspiration.

Douglas Kirkland:

I am going to add to some of the things that Arthur said about the versatility required of *Look* photographers and the photographer's relationship with the editors with whom he works — what actually the editor's job is, how he aids the photographer and how the photographer aids him. When I was freelancing before joining *Look's* staff, everyone was trying to force me into a slot. They said I must specialize. So I would specialize in their field when on their assignment. If I were at a fashion magazine — "Oh, I just do fashion, believe me, just fashion" — and then if I were at an oil company — "I spend all my time doing this type of reportage for oil companies." So a photographer is forced to specialize in everyone's field until he is caught. The only place for me was *Look,* because I wanted a variety of assignments.

At *Look* you have to work with many people, not only on the outside, but on the inside, too. You must be as diplomatic as possible and yet accomplish the assignment on which you're sent. When I was working with Judy Garland about a month or so ago, some unusual things happened because she becomes very nervous when a camera is around her. She feels as though she is working. That big eye is out there and she feels ill at ease. She would say, "Oh, don't! Stop! Stop! Just sit with me, but don't take pictures." Should you sit with her, just being friends? What's the photographer's responsibility here? At what time can I start taking pictures? That's why I'm here. It's the only reason I'm here. You have to be very diplomatic and subtle in your movements. You might have to waste a whole day and then get nothing.

That story required a month's shooting and involved trips to Toronto, New York, Washington, the West Coast and Berlin. Though the subject is a great performer, she is also rather nervous when it comes to photographs, picture stories and cameras of any type. The story ran only three or four pages. We had expected to work much more extensively with her, for example in Berlin where we got only one picture, but she'd get sick or things would happen. You just have to do the best you can, be diplomatic, but finally bring home the bacon! You stay with the story and keep asking whether you are accomplishing anything. If it's worth accomplishing, you keep on working. If it becomes hopeless, photographer and editor confer as to whether work should proceed any longer. Maybe the story should become a text piece.

Teamwork on Assignment

Now, on to the subject of working with various editors. Editors say photographers are a strange breed. Photographers say editors are the same. Achieving a proper balance between editor and photographer can at times be delicate. At *Look* we have some great people. However, with probably more than 30 editors with whom you might work, you're bound to have some friction. But, you still must do your best job with them and remember your responsibility: to bring home good pictures. In a similar vein, the editor must get along with his photographers as well as he can. He, too, must bring home a good story, both in words and pictures.

Editors worry about pictures. They say that once the pictures have been taken they are not concerned, for they can always get words together. Photography is probably a major concern of most editors on stories. The photographer must be able to work with his editor and get along with him. If he can't get along, he must talk to the editor about the problem.

I was working in the Pacific Northwest with an editor last summer, and after about two or three days, he asked one night how I thought the story was going. I answered honestly that I didn't feel it was my story because I hadn't had anything to say about it. He had been looking over my shoulder and into the camera — that sort of thing — and continually asking, "Have you got it? Have you got it?" I just told him that I couldn't finish the story that way. We would have to start the story all over again. Being an intelligent editor, he understood, and we discussed the problems, starting again on a new level. This is the type of open relationship you must have with editors.

It is a fortunate relationship that both editor and photographer have at *Look*. It is very carefully balanced. Some photographers find it easier to work with certain editors, and, of course, some editors find it easier to work with certain photographers. Some people become tied together.

A big question which arises in my mind is whether one man can make the pictures, design his layout, write the text and accomplish all of the other tasks which go into the production of a picture story. I do not believe it is feasible. For one thing, it is very difficult to get any copy if you are shooting. I find I am thinking in one direction. I do not see things which require written expression. I see pictures. So, it is generally necessary to assign two people on each story.

And one very good thing at *Look* is that the editor who creates the story goes on location with the photographer. He, too, wants to create the best possible story, because he has developed the story idea right from its initial stages.

At the Editorial Office

After the story is shot, both photographer and editor go through the contacts back at the editorial office. There may be from 1,000 to 7,000 shots, though a take of 1,000 is typical for the average 5- or 6-page story. The editor and photographer next select about 50 or 60 pictures to be printed 8 x 10. These blow-ups are rough prints, produced in volume because of the number of stories which are shot. Next, work begins on creating the layout. Pictures are selected from the enlargements as the editor and art director work together.

After the art director has completed the layout, the photographer generally has another look. He may, however, already be away on another assignment and not have such an opportunity. Fortunately at *Look* there is great respect for the picture and the photographer. If you don't feel you have gotten a "fair shake" on a story, you can present reasonable variations which are certainly considered and frequently followed. You feel that you are participating to a great extent, although you are not doing everything yourself.

One good question is where the photographer's responsibility begins and ends. You can become involved in many aspects of a story, but should you always be aggravating people and agitating for more space or bigger pictures? You have to be reasonable. Your first responsibility is the overall vision of the magazine. You must say, "Well, maybe it started out to be an 8-pager, but it really isn't there. Let's face it." So you let it go for what it is. There's no use trying to kid yourself or downgrade the magazine. The magazine must be flexible in both directions. Page space might go up if you have a great story.

That is the course of what occurs after shooting a story. Has anyone any questions at this point?

CONFEREE: Doug, what percentage of the stories which you shoot get into print?

KIRKLAND: I've been very lucky in this past year. Of all the stories I shot this year, I think only two bounced. Sometimes a story will be in the file for a long time until it fits a spot in the magazine. There is no guarantee that any story will appear in print, and we can't suggest to anyone whom we are photographing that a story will run for certain. There's always a chance that it won't appear. But, the largest percentage of completed stories do appear. As far as actual percentages I can say in my own case that I probably shot 25 stories last year of which two did not appear.

CONFEREE: Doug, what have you found in your experience to be the greatest source of conflict or disagreement between the editor and yourself?

KIRKLAND: Well, there isn't always conflict, but if there is it generally involves, strangely enough, a play for power. Sometimes you'll get an editor who feels he wants to be the master of all he surveys. He'll try to drag a photographer along, saying, "Oh, meet my photographer," and that sort of thing. Arthur told me one time to say, "Oh, meet my editor!"

CONFEREE: Before beginning production on a story, is there fundamental agreement on the approach? How should a photographer and editor work together?

KIRKLAND: There must be a comfortable balance when you're working. The photographer cannot run away with people, cornering them with, "You stay with me and forget him." Nor can the editor do that. And if this is unbalanced there is something seriously wrong. It rarely occurs. I've had a great relationship with almost every editor. They are helpful companions, and that's another benefit. I'm glad I don't have to travel alone. As Pete Turner said this morning about the freelance, "You're a man all alone in your own world." At *Look* we have somebody to talk to while covering an assignment. Stories are often evaluated at night as you work along. "What have we got? How is it working? Let's evaluate what we have here." The photographer and editor go over this each night to determine what they need. If everything is going smoothly, they can relax.

CONFEREE: How much studying goes into a major picture story before the photographer and writer go "into the field?"

ROTHSTEIN: I would say a considerable amount of work goes into preparation for a story. The editor or writer on the story begins with correspondence. He sets up conditions for doing the story. This may run months. To give you an example, recently editor Moskin and photographer Hansen did a story on the Polaris missile. This story began with an idea from our editorial board in January of 1961. Hansen was not able to start shooting until the necessary clearances, planning and other work were completed. Shooting began about May of 1961, and the story finally appeared in August, 1961. It's almost like giving birth to a child — a period of gestation of about nine months!

CONFEREE: When the reporter and photographer team come back to the office, do they work together in fitting the pictures to the page?

ROTHSTEIN: They work together. The photographer sees the pictures first. He then consults with the editor who has been out on the story, and they make a preliminary selection of photographs to be enlarged from the contact prints, or, they may make a preliminary selection of the 35mm color transparencies which will be projected for editors and art directors. This is the first picture editing job, and the selection is usually made by the photographer and the editor on the story working together.

CONFEREE: You mean the two men do a preliminary edit of their own material?

ROTHSTEIN: Yes, definitely.

DESIGN IN PHOTOGRAPHIC COMMUNICATION

ALLEN F. HURLBURT, 1967

For a biographical note on Mr. Hurlburt see page 71.

The relationship between the art director and the photographer has not always been the easiest and most comfortable relationship on this earth. And young art directors are surprised when I tell them that working with photographers isn't always as easy as they like to think it's going to be. Photographers resent the insidious cropping of their photographs by art directors and designers, while art directors charge that photographers too frequently bring in a set of pictures from an assignment all of which are shot on the horizontal axis. To do justice we would have to have a spread for each photograph.

Forgetting if we may for the moment the aspect of photographer and art director as collaborators, I like to think of myself as a part of the photojournalism tradition that embraces all of photographic communication. This tradition, in my estimation, includes people like Alexey Brodovich as well as Steichen and Avedon; it includes Wilson Hicks,

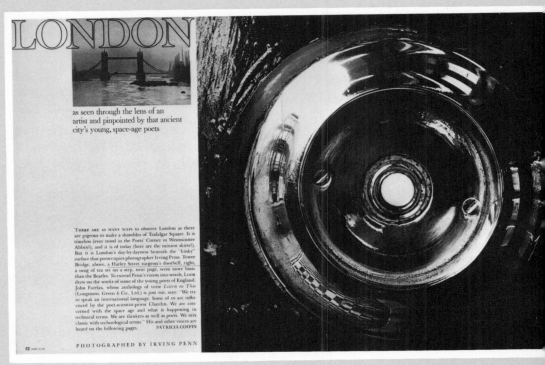

Photographer: Irving Penn Designer: Allen Hurlburt Courtesy **Look** Magazine, May 2, 1967

This layout demonstrates the power of contrast in size. Here the effect is enhanced by the surprise of seeing the small object (a doorbell) large and the large object (a bridge) small.

Daniel Mich, Charles Tudor, as well as Margaret Bourke-White, Bob Capa and John Vachon. It is as part of this tradition that I want to talk to you, to explain as much as I can of my deep involvement with photography and my working as a magazine art director, pointing out some of the problems we have to face.

This tradition I speak of has a proud and early beginning. Long before man had learned to exchange ideas through speech, let alone the printed word, he used devices such as painting on a cave to tell about something that had happened to him. This was a beginning of visual communication. Something we tend to forget is that visual communication was for thousands of years a more significant line of communication than speech, and certainly more than the printed word, because it was not until Gutenberg's revolution and the invention of movable type that literacy could become widespread and reading could become an important line of communication. It's interesting that in the 400-year period following Gutenberg the word tended to dominate civilized man's communication, and only in the 20th century did pictures come into balance with words — a troubled balance, I must assure you, that is still being sought.

Some Fundamentals

In our time, because of the competition of visual and word images and ideas, we have to overcome a factor we call reader apathy. It need not be an enemy, for it can be our friend. It's the problem which the designer with his material can meet head on. Some of the techniques used to capture and hold interest include typography, the headline and how it is

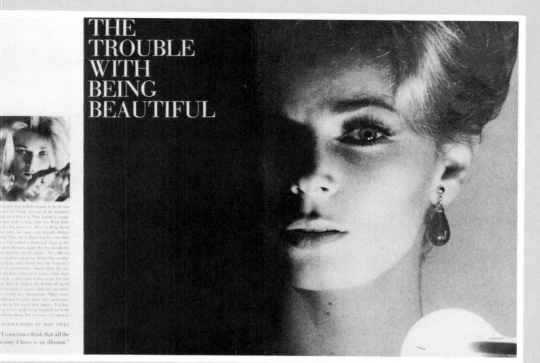

THE TROUBLE WITH BEING BEAUTIFUL

Photographer: Bert Stern Designer: Allen Hurlburt Courtesy **Look** Magazine, November 20, 1962

The dark area at the left of the large photograph creates a contrast with the lighter value of the small picture as well as the lighter area on its right.

positioned, the type size, and varying the margins. One picture can be made deliberately small so that the picture which follows it comes on even stronger. That's a hint of the inter-relation of pictures. Layout is not just the simple page; it's often the combination of elements in a story. We use the tools at our disposal to enhance and sometimes even over-ride the limitations of content.

One of the devices of layout that a photographer should keep in mind because it improves his work on the page is contrast. There are ways in which you can use contrast: contrast in size, the big picture against the small picture; contrast in color or value, the dark picture against the light, the cool against the warm. Sequence is another layout device. The design of a spread may be contained within the design of the photograph, and this is always a good solution. Design may have to reshape the photograph. This used to be done frequently; it is the old school of layout where you tilted things at angles and cropped excessively. But it's still a way in which art directors are sometimes required to cope with pictures that don't quite work, or with old pictures that can no longer be retaken or replaced. Finally, the oversized image can be used to take a tired point and give it a touch of freshness again. These are all factors in layout that do not intrude upon the pictures, but make pictures work to help each other.

One of the great weaknessess of photographers laying out their own work, or of new-comers to the layout field, is a tendency to design pages from the outside edges in. The layout in your design thinking should begin somewhere near the center. I don't believe in any theory of a precise optical center.

A magazine gets its style, its purpose, and creates its environment by not being single pages, but by having a unity from cover to cover and a continuity from issue to issue. Every two weeks we place on the walls of our conference room a complete issue of *Look,* with comprehensive color layouts of all editorial content, a very close approximation of the ads placed in position, and both covers. In this environment, we change, alter, redesign, and move material in and out of the magazine. A great many of our layouts are created right in the conference room so they will have a sense of unity. This doesn't mean the blankness of a flat, over-organized continuity; it means lively continuity, with variety, in which impact can come naturally out of the material without being destroyed by confusion and clutter.

This is a difficult problem for a magazine built on the philosophy that it has cover-to-cover editorial content. Its most important article may appear on its last seven pages; key articles can appear anywhere in the content, and ads and editorial material are freely intermixed. This is a philosophy we rather like to work with. Out of it comes a lively and exciting magazine.

A magazine is a great deal more than handsome pages and spreads held together by a binding. Its production represents victory over many important problems of publication. Every two weeks we get out an issue of *Look,* but before that issue is bound, five freight cars back into the Donnelley plant in Chicago loaded with nothing but the wire from which the three staples for those magazines are made. That gives you some idea of how big this whole operation has become.

Three Stages of Development

I'd like to go into some personal feelings about not just my years with photography but the last 30 years, the years of picture magazines. At the beginning of the picture magazine we had the newest thing going for us. Everything was fresh and new; pictures could be great; they could be exciting; simple ideas could be done for the first time and be given big, intelligently laid-out space. This was the most exciting, but also the simplest era of photojournalism. With the saturation of visual images — not just the printed image of the picture magazine, but the imitators of the picture magazine, the extension of the picture story into other magazines, and the coming era of the TV image — the photographer had to reach further and further to bring in fresh and important ideas.

It was only an accident of history that this need came about the same time that technical advancements in photography reached a point where color could be used in special ways, where effects could be achieved that were before impossible. This was good. I have no criticism of any of the periods. But the things that looked so different three years ago are now beginning to look a little bit the same — the color filter, the sandwiched image — though they are all still valid if they project a significant editorial idea.

We are entering into a third phase which is very much concerned with the big photographic statement, with the photographer returning to the role of subjective reporter. He can take a scene that would almost be turned down because it sounded so commonplace, and with his skill, his artistry, his own viewpoint bring to it a newness and freshness. To achieve this, the photographer can no longer be just a technician. He must be concerned with the total area of communication. He must be concerned with and acknowledge words.

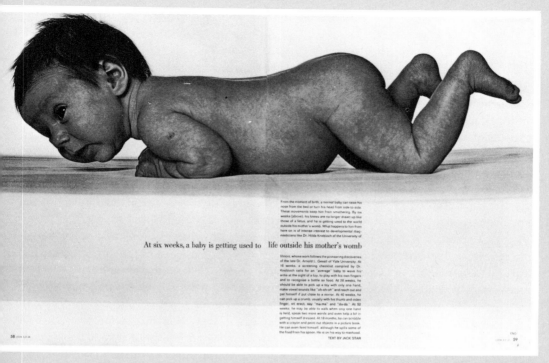

At six weeks, a baby is getting used to life outside his mother's womb

From the moment of birth, a normal baby can raise his nose from the bed or turn his head from side to side. These movements keep him from smothering. By six weeks (above), his knees are no longer drawn up like those of a fetus, and he is getting used to the world outside his mother's womb. What happens to him from here on is of intense interest to developmental diagnosticians like Dr. Hilda Knobloch of the University of Illinois, whose work follows the pioneering discoveries of the late Dr. Arnold L. Gesell of Yale University. At 16 weeks, a screening checklist compiled by Dr. Knobloch calls for an "average" baby to wave his arms at the sight of a toy, to play with his own fingers and to recognize a bottle as food. At 28 weeks, he should be able to pick up a toy with only one hand, make vowel sounds like "oh-oh-oh" and reach out and pat himself if put close to a mirror. At 40 weeks, he can pick up a crumb, usually with his thumb and index finger, sit erect, say "ma-ma" and "da-da." At 52 weeks, he may be able to walk when only one hand is held, speak two more words and even help a bit in getting himself dressed. At 18 months, he can scribble with a crayon and point out objects in a picture book. He can even feed himself, although he spills some of the food from his spoon. He is on his way to manhood.

TEXT BY JACK STAR

Photographer: Robert Freson Designer: Allen Hurlburt Courtesy **Look** Magazine, May 31, 1966

The composition of this photograph itself determines the design of the spread.

To link words and photography goes right back to the work of Jacob Riis. His word-and-picture reporting was one of the models of photojournalism, and his work was used to persuade others to his point of view. The photographer must recognize the word orientation certain magazines are undertaking — it must be understood and studied, if we are going to do meaningful things in this third visual era.

You must know more about magazines. It isn't enough to look at the magazine you want to work for. You must try to sense the nature of the editors, the kind of articles they run, not just pictures. The kind of pictures they run is only one area of judgment. Try to sense the line of communication they're trying to follow. Keep in mind the fact that you, like the editors, are finally a communicator, and when you are at your best, you are showing a picture to someone almost in the terms in which you would converse with him.

Magazine journalism is at its best when it's as personal as a conversation; the significant exchange takes place when the individual reader picks up his copy. These things can all be done, but they are going to take a kind of depth of thought and concentration and a complete involvement that doesn't always exist today in photography.

Some years ago an interviewer approached a famous German architect and asked him how, in designing buildings, he could create each one differently, and how he could keep them all interesting. The German turned to the interviewer and said, "But I don't want to be interesting, I only want to be good." And that's what we're talking about.

CONFEREE: To what degree does your own subjective interaction with the photographer work?

HURLBURT: Let's say that in most cases the problem between photographer and art director is not a serious one because it's a part of a positive exchange. We expect the photographer to come back all involved in the thing he's done and with a complete involvement in his subject, in what occurred, the sounds, the smells, the environment in which he operated, and the way he felt toward the people; we expect some of this to show in his pictures. It's for us, the art directors, to determine when that does or does not show. A photographer is often so close to the scene in some of these things that he will feel that a picture works when it really doesn't.

In the exchange with a photographer in the layout session the art director becomes a reader. The art director was not there when the event occurred, but he sees the pictures the way a reader's going to see them, for the first time, and he will help to judge what works and what doesn't work.

We work quite well with nearly all of our photographers, but this doesn't mean that there aren't points of disagreement. We leave our layouts wide open for anybody to criticize who wants to. The layouts are in our conference room on the wall, and I've told photographers at the sessions we have together that if they have a comment or a suggestion on layout, to make it. Finished layouts are often a hell of a lot better than they started out to be because a photographer had a good idea that was better than mine. So, it's a good interchange.

ART DIRECTION IN THE
MAGAZINE OF THE '70's

WILLIAM HOPKINS, 1970

Mr. Hopkins studied design at Cranbrook Academy in Michigan, then worked in Chicago for *Playboy* magazine and later *Chicago Scene*. He joined the staff of *Twen* in Munich, Germany, in 1964, working as assistant art director under Willy Fleckhaus. In 1966 he accepted a position as assistant art director at *Look*. He was promoted to associate art director in 1967 and in January, 1968, became its art director. He has also designed a number of books, among them *Sense Relaxation*.

It is difficult to stand before you as some sort of authority on magazines, since so many of them are presumed to be in so much trouble and since I'm one of the youngest art directors of a major magazine — what's left of them, anyway. Here I am, just starting a career in a very specialized area of a relatively new kind of business, and according to most of the rumors you hear, magazines are already faced with extinction. Magazines have not really been around all that long. Besides, I have a theory that media are ever-expanding.

Newspapers spawned magazines and books, but didn't themselves fade from existence; nor did movies or radio vanish with the advent of television. Older media have generally found their own direction, though not always with ease, in *relation* to newer media, not in

competition with them. The television tape cassette or the capsule magazine is probably next on the scene. But I, for one, don't believe that will mean an end to print. It will mean change: a new medium of transmission and a new avenue of expression for us as designers, photographers and writers.

Some magazines have died; others undoubtedly may also be buried because they couldn't accommodate or initiate change in relation to newer media. We all know how magazines have competed with television — and lost. Let us hope by now this is over.

I am not an expert on the subject of magazines in general. I only know a little about the one I work for. But, I do know *Look* is changing. It has been changing ever since I have been there, and it was changing before. As an example, at *Look* we don't work with the photographer as if he were some guy for a couple of snaps; we don't think of him as an illustrator. He often knows as much, if not more, about the story than the writer, and we try to utilize his knowledge. Because of that recognition of the broader editorial or communications values of the photographer, *Look's* editors changed writers' credit lines on stories last year from "produced by" to "text by" in an effort to equalize the credit with "photographed by." At *Look* the art director shares more in editorial responsibility than any magazine I know, another example of change in magazine journalism.

I was recently called a visual managing editor, which, of course, was a derogatory remark. It was made by a writer after I, the art director, had changed a headline on a story which we were working on. In many ways he was probably correct; in fact, I'm quite proud of it! I have always sought a relationship as partner with my editors, and, of course, it never quite works. It has come close, but in group journalism as it is now practiced there has to be a boss, and I, for one, don't think the art director should be that boss. But, there is no reason why the art director should not function on the same level as a managing editor, both men then reporting to the editor. The main point is — and it's a very important one — that the art director and photographers have to be as well informed about editorial content and its possibilities as managing editor and writers.

Cooperative, Creative Group Journalism

One of the most revolutionary things to happen in advertising agencies in years was the breaking up of so-called artist "bull pens," officing art director and copywriter together to work on an account. After all, what is important in advertising and communication is the best picture suggestion, the best headline and the best story idea — not *who* conceived it. At *Look* we've been functioning as a conceptual team for years. After a writer and photographer return from the field with a story, they meet with the art director in his office for a layout session. It is that art director's job, his responsibility, to learn the combined knowledge of writer and photographer about the story. The discussion is not just about which picture goes here or what picture goes there; it is about the story. What is the story? What do you want to say? How should we go about doing it? Our concern is not just one of creating beautiful pages. That's great if we can also accomplish it. We want to move you. We want you "turned on" to read the text, the pictures and to get into what we are talking about.

I was quite surprised to learn this morning that the picture story was dead, because one of my great experiences at *Look* has been the opportunity to work with Paul Fusco. I believe he is a great photographer, but probably more important, he thinks in terms

LOOK ■ MARCH 4, 1969 Volume 33, No. 5

Appalachia is a promise we have not kept

GEORGE'S BRANCH, KY.

Eight full years after America became aware of Appalachia, hunger hangs on in the hollows as strip miners dismember the mountain land and a stubborn poverty threatens to create an American peasantry

Mary Combs and her ruined husband Rado: "Hit's awful how people'll do ye."

BY WILLIAM HEDGEPETH
LOOK SENIOR EDITOR

PHOTOGRAPHS BY PAUL FUSCO

LOOK 3-4-69 **25**

Photographer: Paul Fusco
Designer: William Hopkins
Courtesy **Look** Magazine, March 4, 1969

of the picture story. He constantly searches for and generates story ideas, and he also has a great interest and part in putting each of his stories together. Paul and I have been experimenting with some new multi-level ways of putting stories together. In a piece about "The Runaway" a few years ago, we tried to tell that story on four levels: the photographs, self-copy of subheads, captions and text line. We tried to give each item within a spread its own position. In a story on Appalachia photographed by Fusco we were working with the writer, William Hedgepeth. His text would be great, we knew, but he needed a lot of it. In seeking a way to combine the picture story with continuous text, we gave a spread to each character in the story. Hedgepeth first defined each character in the large text and then developed his profile in continuous text.

Another picture story photographer is Stanley Tretick. Last fall he went out with Fletcher Knebel to find the mood of America. After an initial trip, we talked, and he began to define the mood he was searching to document. Later, while I was working on the final layout, I came upon a memo he had sent me after his first trip. I thought it might be of benefit to some of you the next time an editor or art director asked you for a memo on a subject or story. It's very telegraphic, very direct. Here are some parts of it:

Everybody is against the war, inflation, concerned about youth. Older people are trying to understand them, but emotionally they can't. The new music bothers them. And the sex thing, they feel envious because when they were young they weren't getting all this. Blacks are moving too fast. Too much welfare, crime, high taxes. Cities are ugly, physically. People are living worse than they ever did: ugly urban sprawl, ugly fat families, food, everything geared to burgers and pizzas everywhere you look, pollution.

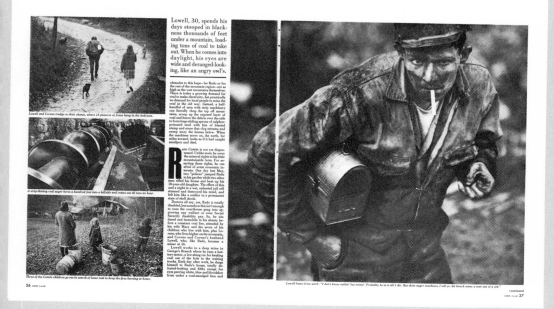

Lowell, 30, spends his days stooped in blackness thousands of feet under a mountain, loading tons of coal to take out. When he comes into daylight, his eyes are wide and deranged-looking, like an angry owl's.

Lowell and Corene trudge to their shanty, where 15 pictures of Jesus hang in the bedroom.

A strip-mining coal auger bores a hundred feet into a hillside and reams out 45 tons an hour.

Three of the Combs children go out in search of loose coal to keep the fires burning at home.

Lowell home from work: "I don't know nothin' but minin'. Probably be in it till I die. But them auger machines, I tell ye, hit knock many a man out of a job."

continued

A little less than two years ago someone came to us with a story idea about a group of young blacks in Harlem who were going to Africa for summer study. Many other groups were also going at that time. The purpose was to study the heritage of black America: to live for short periods in various cultures, to follow the old slave routes, to visit universities. Jack Shepherd and Joel Baldwin went with them to gather material for the special issue of 1969, "The Blacks and the Whites." Along with reportage on the young people, we initiated an essay for Joel to shoot along the way, "Black America's African Heritage." The essay allowed a much broader approach than straight reportage would have for Joel and Jack to reveal what they learned. Also, I hope this essay in some small way helped to break down the American myth that great cultures came from all continents except Africa.

Turning to another consideration in creating the magazine, I should like to mention the problem and concept of editorial balance, usually an ugly word in circles of magazine critics. It is often thought of as a compromise, a weakening of the message, but for me at *Look* it is a lot of fun. Since *Look* is a general magazine, editorial balance helps to make it more like a conversation or an evening with friends. We might be discussing this or that problem for a while, but then someone would say or do something to relieve that pressure in the conversation. In "The Blacks and the Whites" issue we achieved balance with Pete Turner's story on "Black Beauty."

I believe quite strongly that in the last few years we have begun to establish a new tradition in personal journalism. In our first issue of 1970 — on the '70's — I think we carried that tradition a bit further. George Leonard, the editor in charge of that issue, had developed a theory that sounds pretty revolting on the surface. It was

BLACK AMERICA'S
AFRICAN HERITAGE

Sunrise at Olduvai Gorge, Tanzania, East Africa, where Dr. Louis Leakey found the bones and teeth of the earliest humans, an African boy and girl who lived almost two million years ago. Right, a more modern wrist guard, perhaps for a Hausa archer.

We lied. We tried to hide the shame of slavery by calling Africans lazy and uncivilized. We taught the lie; we murmured it over tea. We created Tarzan and Amos 'n' Andy. And now we reap the darkness of it. In truth, man's sunrise glowed first in Africa. He began there. In West Africa, historical homeland for most American Negroes, he built the powerful states of Mali, Songhai, Kanem, Benin that thrived long before Europeans came. The old Ghana empire lasted 1,000 years, to 1240. Timbuktu, Jenne, Kano traded gold, ivory, slaves. Nok and Ife art had no equal.

TEXT BY JACK SHEPHERD PHOTOGRAPHS BY JOEL BALDWIN

18 LOOK 1.7.69

continued

Photographer: Joel Baldwin Designer: William Hopkins
Courtesy **Look** Magazine, January 7, 1969
From "The Blacks and the Whites" issue

LOOK 50 CENTS · JANUARY 7, 1969

A special issue
THE BLACKS AND THE WHITES
Can we bridge the gap?

Norman Mailer on Black Power

Black and white pro football

Black Power shakes the white church

Black America's African Heritage

Godfrey Cambridge declares peace

Jimi Hendrix socks it to the white cats

Black and white sex hang-up

Photographer: Pete Turner
Designer: William Hopkins
Courtesy **Look** Magazine, January 7, 1969
From "The Blacks and the Whites" issue

set forth in the '70's issue. The theory proposes that we all work together equally in groups, without personal competition within any group, and that the individual can be enhanced and enlarged by his participation in the group.

We applied Leonard's theory in producing the issue on the '70's. About six of us put this issue together. Strangely enough, we still don't quite understand all of what we did. We were given clearance by our editors on the general theme last May, and we went off and did it. We didn't show them anything — not one picture, not one layout, not one word — until the issue was completed about two weeks before it was to go to press. We hammered out story ideas as a group; we did layouts as a group; we constructed the total issue as a group. Art Kane talked about Paul Fusco's layout; Fusco talked about Kane's. In the end just about everybody got to say what he wanted.

Everything is changing all around us. We all come here to learn new methods; some come to learn formulas. There are new methods; there are new media. But, believe me, there are no formulas. Individual successes will come to those who expand and develop the new media as well as to those who change the old.

"Synthesis of joy, sadness; composite child of life."

Charlene Dash, a beauty who attends Hunter College at night, models by day, embraces one of her own with the exultation sounded by South African Bloke Modisane in *blue black*:

"God!
glad I'm black;
pitch-forking devil black-
black, black, black;
black absolute of life complete,
greedfully grabbing life's
living,
stupor drunkenness,
happiness,
depth of hurt,
anger of sorrow:
synthesis of joy, sadness;
composite child of life....."

74 LOOK 1-7-69

OVERDESIGNED

WILLY FLECKHAUS, 1969

The original design concepts of Willy Fleckhaus, especially revealed in the pages of *Twen* magazine, have earned him international recognition. Allen Hurlburt has said that "the advent of *Twen* in the magazine world was a movement of considerable excitement for those of us who watch the development of new graphic and visual ideas in publishing. Willy Fleckhaus, its more-than-able art director, approaches the printed page with a remarkable freshness, and his pages reflect the spirit of our changing world in a way that is unique in contemporary communication."

In my office in Munich I have only one photo on my wall. In ten years of *Twen* I have seen many thousands of pictures, many thousands of good pictures, marvelous pictures. But on my wall there is only one picture. It's a picture of the stars and stripes by Art Kane. This picture is very important to me because I don't believe that I will hang the flag of the German Federal Republic on my wall.

For me, America has been very important. After the War, I studied American magazines, for in Germany there was nothing. There were two American magazines I liked very much. The first magazine was *Look* — the *Look* of Allen Hurlburt. And the second magazine was the *Esquire* of Henry Wolf. In *Look* I liked the excellent photography; in *Esquire,* the excellent design.

But, you know better than I that Germany lost the best people. You know the Salomons were killed. And that is the reason why there are so few good magazines in Germany. I think you have so many good magazines here because so many immigrants came over. You have many Henry Wolfs; you have many European people, but we miss them. And *Twen* is now a success because we have done things the best American art directors and photographers had already done.

When I began 10 years ago with the magazine *Twen,* the title "art director" didn't exist in Germany. Maybe I was the first man who put "art director" in the issue. We began with European photographers, especially Jeanloup Sieff in Paris. At first I tried to impose a design on photographs in a layout, but it was artificial, and I think it was wrong to do it that way. I am here speaking about over-designing. I heard this phrase in America and was very impressed with it, because it is not possible to translate it into German.

Courtship, Marriage and Conception

In the meantime I think I have learned the true function of the art director. It involves more than the design of layouts. What is the function of the art director? Of the photographer? It's the old fight. I think the art director is the father; the

photographer is the mother, and the picture is the child. And the picture comes of the union. The photographer can't make pictures, of course, without the art director. A woman can't make a child without a man. For photography it's good that the picture grows up in a family. And the art director and the photographer should be a family.

Now about the courtship of the photographer. Before the photographer goes out to take pictures, he must know that he takes pictures for a magazine and that he does not take pictures for a book or for an exhibition. I think photographers often forget when they go to work that they may have only three pages. They come back with hundreds of pictures, and then fight with the art director, asking him, "Why don't you print more of these pictures?"

Most often the art director has failed to communicate with the photographer, before the assignment, about how few available pages there are. This is a simple, but very important point. The photographer always should know how many pages he will probably have. Frequently the photographer does not know what other "must" things are planned for the magazine — that there are stories and other photographers' work which need a place, too. And it may be that what will sell the magazine is the work of another photographer and not the pictures of this particular photographer.

The art director or the editor has a similar fight for pages and space with his publisher, though the photographer never has to fight that battle. What other functions and roles does the art director have? His most important role is the stimulation he gives the photographer. He must be more than a friend to his photographers. The photographer must know exactly what the art director wants. It must be a true love also at times: a true love between the art director and the photographer, especially when the photographer has difficulties in getting his pictures. The photographer may not always be a good photographer, and the art director may not always be a good art director. But they belong together. I think it is impossible for a photographer to take pictures without the art director.

About 10 years ago I met Will McBride. He was in the army. We began to work together. At first we fought, but we spoke day after day about pictures. For us it was the best way; we had the best results. Now it's no longer necessary to discuss things at length. This is a point of a new beginning. But, you must have patience. William Hopkins, now art director of *Look,* came to Germany for about five years, and we worked together. I am really proud of him.

Things discussed by the art director and the photographer may be very simple. Most often the problem is that no one speaks about them at all. The art director must remind the photographer to take pictures for the format of the magazine. If the photographer wants his pictures to be published, he should be taking them for one particular magazine. When one is taking pictures he must be careful, because if he wishes to see his work as a double page, he must remember there is a fold in the middle.

A Conversation with the Photograph

When the picture is developed what does one do with it? The question, then, is how big must the picture be? Ask the picture how big it wants to be, how big it must be. The picture will say how big it must be. I think this is not a question of

Representative layouts from *Twen*
Designer: Willy Fleckhaus

Page and gatefold from a feature on goldfish (October, 1964)

Note designer's use of contrast in size and reverse type on a black page

DER FOTOGRAF ZIEHT IN DEN KRIEG

Page and gatefold from a feature on the film *The Charge of the Light Brigade* (May, 1968).

Double spread from a fashion section on men's bathing wear (May, 1968).

HAPPENING IN MUSIC

Page and gatefold announcing Philips-Twen record.

design. The best way to bring a picture out is to use one or two whole pages. Most people think there must be as many pictures as possible on one page. Sometimes, of course, you can't put only one picture on a page, or one picture on two pages, but if you publish more pictures on a page, it should not be a question of economics. If you put two pictures on a page, or on a double page, there should be a contrast, or a combination. It is possible to intelligently design a layout which makes a new picture of two different pictures. The photographer is too emotionally involved with each image to look for this.

I think photographers know too much about their pictures to do their own art direction. If one needs 10 hours to take one picture and it's very difficult and dangerous to take, and then in doing his own layout the photographer must decide to eliminate the use of that picture, he can't understand. The art director is less close to the original shooting and situation. He sees the work differently. Maybe this concept is very simple, and what I have told you is not new.

I think art direction and layout are not mysterious. You must have good taste to be an art director; you must know what a good picture is. The important point is to find the right picture from many thousands or tens of thousands of pictures and to enlarge each on one page. The bad picture will not enhance the page.

Young people will ask if it is desirable in this Vietnamese situation to make aesthetic pictures? They say aesthetic photography disguises the real situation. Maybe, but after the May revolution in Paris I looked for the new-revolution photography. I didn't find it. Why doesn't a magazine with this anti-authoritarian photography exist? The anti-establishment people have some new, good newspapers, but photography requires so much publication quality; you need so much technique; you need so much discipline. You can't produce a magazine of quality approaching photography as they wish to work.

I think the real revolution is work, is intelligence; it's not burning and fighting. Maybe sometimes burning is necessary, I don't know. But I think the people forget that we must work for progress.

Photography is sometimes a dream, or the realization of dreams, and we need these dreams. The underground in Germany dislikes formalistic, nice pictures, because they are dreams. The underground needs dreams; they smoke pot and other things. But why shouldn't other people have their dreams? Is it forbidden to make dreams with a camera?

Paul Valery said if you want to realize your dream, you must see it clearly. I think that is very true. Andy Warhol and the work of his friends has nothing to do with photography. Their photography is not functional. I'm sure it is art, but it has nothing to do with photography. Young photographers think if they take a picture and it's not very sharp, it must be like a picture by Warhol.

I beg your pardon, I was to speak about over-designing. Magazine design is not design in the classical sense. Sometimes in magazines you do not need big, fantastic pictures. I have never printed pictures by Cartier-Bresson, although I think he's really one of the greatest photographers in the world. Why haven't I published Cartier? Because Cartier-Bresson needs walls for his pictures, like museum walls. A magazine

is not a museum, and a good magazine has no walls for pictures. The picture must be a part of the magazine. This results from interaction between art director and photographer.

Art directors and photographers speak an international language. Good photographers and good art directors know each other and together they have much power. They realize the optic for millions of people. We are more powerful than the writers of the newspaper. One of the most powerful messages I have seen in the last few years was Pete Turner's story "Black is Beautiful" in *Look*. Thank you my friends, cosmopolitans, and powerful photographers in this international visual language.

DO YOU DIRECT THE ART, OR DOES THE ART DIRECT YOU?

Frank Zachary, 1964

Mr. Zachary, art director of *Holiday* magazine in 1964, joined its staff in 1951. He had also published and edited *Portfolio*, a magazine of the graphic arts, and had been associated with such magazines as *Modern Photography*, *Time* and the *New Yorker*. He co-authored *Jazzways*, a picture book on jazz. Mr. Zachary continues to live and work in New York City.

In opening this I should like to request that my remarks quickly evolve into a dialogue with you and somehow, through a mutual exchange of attitudes, ideas and prejudices, perhaps we can come to some better understanding of the roles of the photographer *vis-à-vis* the art director and of the art director *vis-à-vis* the photographer.

I work with many fine photographers, but every one of them believes that he's a better editor than the editor, a better picture editor than the picture editor, and a better art director than I. That's all right with me because I think that anybody with the creative temperament of a photographer has an ego, and the ego needs to be expressed.

But, what bugs me about this particular attitude is that it is arrived at with a complete misunderstanding of the role of the art director who functions editorially on a magazine. Photographers somehow have the mistaken idea that an art director makes layouts with the photographer's pictures. That is something in which many art directors are not directly involved.

When a photographer dumps his pictures on the art director's desk, it is the art director's particular function to sift through the pictures, not necessarily to select the best ones, but to isolate and identify relationships and unities which are discernible to no eye but his own. And, then he begins to make use of proportion, scale and position to fit these particular unities and relationships into a larger entity, the story itself. He seeks a combination of visual units which allow the very essence of the story to be expressed.

Orchestrating the Magazine

The art director has an additional and larger responsibility to the magazine itself. Each story must be evaluated in its relationship to the whole of the magazine, just as single pictures must be examined for their individual contributions to the story. You cannot design a magazine in bits and pieces; it must be designed as a whole. The art director orchestrates a visual score with harmony, melody, dissonance and counterpoint. At least I hope that is what I'm doing.

In this process inevitably some stories get hurt, and God knows over the years I've been guilty of butchering many a one. But, unfortunately, Mickey Mantle was sometimes sent up to bunt to advance a man from first to second. That's the way ball games are played, and that's the way art direction on a magazine is done, too.

Last night Morris Gordon asked me ·a leading question. He wanted to know if I thought today's magazines are being over-art directed, over-photographed and over-designed. As a generalization I would say all are probably true. There is less journalistic photography being practiced today than ever before, and the farther you move from the journalistic base, the more personal the expression becomes. As the picture becomes more personal and emotional, it also becomes a little more esthetic and a little more abstract. This isn't necessarily bad.

As an art director, I'm all for graphic kicks, but as a journalist, I deplore the sacrifice of content. I think that pictures for the magazines must begin as thoughts in the photographer's heart and mind which he wants to communicate.

Robert Frost was once asked to define the creative process by which a poem is made. He said, "When I am writing a poem, it is only the subject matter which counts. And, when I am finished with the poem, it is only the form that counts." This is a fine credo for photographers and art directors, as well.

I did not plan to deliver a long speech, but I wanted you to have these thoughts about photography and art direction in mind so we would have some mutual basis for discussion. Are there any questions?

CONFEREE: You spoke about journalistic photography. I assume you had reference to the "old" layouts in *Look* and *Life* which had so many pictures as contrasted with the fewer but larger pictures now in a story, an approach which makes the media seem more graphic. Do you think that pictures and the whole course of journalism are changing? Are we expressing ourselves differently? Are we showing our pictures differently? Or, are all of these changes taking place while, essentially, the message remains the same?

ZACHARY: In my opinion the direction has changed quite radically over the years. I think the picture story *per se* has been dead for a long time. Pictures have tended to get bigger and more illustrative. The photographer is being used today as the illustrator was once used. The demand for attention is tremendous, and you need to have a compelling image on the page. It's when you carry the thing too far, when you begin to sacrifice content for the sake of the graphic image, that you begin to hurt the basis of photography as an editorial tool.

WILSON HICKS: I've heard it said that the magazine editor and art director today worry about advertising pages as competition, that the graphic force of the advertising page calls on the editor to do something on his pages to compete. Do you feel that is a valid commentary?

ZACHARY: I've never felt that pressure, myself, but I do feel this to be true: in order for the magazine to *get* advertising the editorial side must be one step ahead of Madison Avenue in terms of its graphic treatment. I think the editor and art director must show advertising photographers trends and styles toward new graphic images. If you analyze many of the successful magazines today you'll discover they have inspired confidence in advertisers simply because they have had a fresh outlook. As to whether there is conscious concern on the art director's part about similarity of graphic treatment between editorial and advertising pages, I don't think it is a factor.

CONFEREE: You no doubt see thousands of pictures coming across your desk every month. Do you think that most photographers now are shooting only in terms of what they hope will be full- or double-page bleeds? Is there a lack of thinking in terms of the story on the part of the photographer? Do many young photographers today fail to think about and shoot complete coverage because they are only shooting for that one, big bleed shot?

ZACHARY: I would say this is more true of the younger photographers whom we see rather than the older pros, who not only shoot for the big pictures, but also provide continuity images as well. Many of these stories are problems, particularly when you get a story such as the one Burt Glinn shot on Russia. He came back with about 7,500 pictures, and they had to be edited down to about 30 which would tell the story.

I do find myself thinking in terms of big pictures; I must say that. Photographers are not altogether to blame for this big picture concept. It is much easier to lay out a book with large pictures than it is to make layouts in which small pictures are counterpointed against the large. We sometimes get a little lazy, I'm afraid.

CONFEREE: What kind of feedback do you get from readers on your art direction, particularly with regard to picture selection and layout? What kind of research is done on reader reaction to your layout?

ZACHARY: We don't do any. The art director and his staff do what they like. If circulation slips we're out of a job. That's about the only way you can edit and art direct. You can't really involve the reader in it at all. Readers don't know what they want. You've got to show them what they want and help them to like it.

MORRIS GORDON: Henry Wolf said something *apropos* to that. He said the trouble with research is that perhaps only 12 people respond on a panel and then their reactions are multiplied to represent the universe. You then have a mishmash of opinion which a highly trained editor is told to follow. The editor should lead, not follow.

PHOTOGRAPHERS AND
ART DIRECTORS' DIRECTIONS

Panel, 1969 (Excerpts)

Contributing to this discussion are Allen F. Hurlburt, director of design, Cowles Communications; Willy Fleckhaus, then art director, *Twen*; Herb Lubalin, art director, New York; Jeanloup Sieff, photographer, Paris; and William Hopkins, then art director, *Look* magazine.

WILSON HICKS: I've never been an art director, but as an editor I never told any photographer how to take a picture during my many years on *Life*. I have had photographers say to me, "I took a picture for an advertising agency and the art director drew the picture in advance." I should like to ask Mr. Lubalin if he finds that any photographers — or some photographers — resent the practice of an art director specifying how a particular photograph shall be made? Do they feel that they're being limited by having to hew to the line laid down by the art director?

HERB LUBALIN: Yes, there are many photographers who would not stand for this kind of relationship. But an individual, working relationship is only established over a long period with each photographer. For instance, there are some photographers with whom I would never attempt to be that explicit about the kind of photograph that I wanted taken. I will only go to those photographers who I know want that kind of direction from me if the assignment calls for my strict control. Photographers who can make me look good I will never direct that way. There are photographers whom I wouldn't think of imposing my ideas or standards of creativity upon, because I would be hampering their creativity. There would be no point in my going to them if I were to impose an added restriction which would make the photographs which they produce not really theirs. You have to select your photographers very carefully. You also have to know which ones demand direction, and there are lots of photographers who demand that kind of direction.

WILLY FLECKHAUS: I think it's easy to speak with photographers about that which you want. Always be definite about what you want — how many pages and the mood in the pictures. I always tell the photographers what they must do, and then I say that when they are shooting and they think that my directions are all wrong, they must do exactly the opposite.

WILL HOPKINS: I think our situation at *Look* is quite different. We work in writer-photographer teams and deal in actual picture story situations. Very rarely do we work with set-up photographs. We may seek a certain kind of mood before the photographer goes out, but it can quite well wind up being the opposite situation. When the team returns we almost play "method" actors, spending a great deal of time finding out what went on and how it went on to be able to intelligently handle the material.

ALLEN HURLBURT: There is a wide polarization between the journalistic photograph which depends on the event and its occurrence, and the advertising photograph which must illustrate a pre-determined copy concept. But there is also something happening in magazine photography. There is today a movement away from the purely journalistic. Television has usurped at least a part of this role. We are more frequently going into a kind of photographic illustration for the editorial pages in the magazines than we did. For example, in the political campaign of 1968 Art Kane did a series for *Look* on the issues that were facing that convention. He did this photography by himself, but there were at least four advance meetings to discuss the nature of the subject and possible pictures which would work to illustrate this subject. This is a little more planned than stories at *Look* or *Life* might have been. I suspect that it can also be true of *Life's* large portfolios. This approach is working its way into the whole magazine picture as the emphasis has shifted to words and a little further away from pure journalistic reporting which television does so well in many instances.

JEANLOUP SIEFF: About my relation to the art director, when I do advertising just for money, I have two approaches to a campaign: if everything is decided in advance by the art director, and I have to do an illustration with no freedom at all, I can either accept or refuse the assignment. If I don't like the idea or think it is wrong, I don't do it. If I think it's right and the best way to sell a product, I do it, sometimes with just a little changing. That's the advertising business. Editorially, I am more free. It's not always published, but I'm free to do as I want.

CONFEREE: Don't you think that the photographer who can work on his own, the one who works with loose guidelines and the one who will follow the art director's tissue could be one and the same?

LUBALIN: Yes. Photographers are people. They all vary. There are some photographers — for instance Art Kane — who understand the problems of the advertising business and also understand problems of the art director. Art Kane is a great photographer in my opinion because he was once a great art director. I can impose very rigid restrictions on Art's photographs, and if, as Mr. Sieff says, he agrees that the concept and interpretation of the ad are right, he will do the photograph for me. If he thinks that the concept is ridiculous or might make him look bad, he will not accept the assignment. There are many photographers whom you can put rigid restrictions on and at another time give them complete freedom. Some photographers will not be restricted by art direction. Some must be directed all the time. We have a wide choice.

CONFEREE: This question also is for Mr. Lubalin. On an assignment for a photograph you have a definite idea. I think most photographers would shoot an idea as close as they possibly could to the way you directed, but they might also wish to shoot around it with their ideas. As an art director, how open and receptive are you to other ideas of the photographer after he's shot as close to your direction as possible?

LUBALIN: Every situation is a little bit different. There are some cases when I'm very restrictive, when I don't want the photographer to shoot around or even make an additional suggestion. As the creator of the piece of advertising, I feel so strongly about the visual solution in some cases that I cannot afford to take the

responsibility for the success of that total piece of advertising unless the photographer shoots exactly what I want. There are other situations, however, even though I have created the idea, when I am very eager for the photographer to contribute much more to the idea simply because he's a photographer and sees things a certain way through the camera which I can't see.

There's another point I would like to make. There's very little artistry left in photography in advertising; most of it is in editorial. The reason for this is that most advertising photographers are probably more interested in making money than they are in creating great photographs. You go into some studios and they've got six sets. They want the art director to come in and tell them what to do, because it takes extra time for them to make any original suggestions. So if the art director comes in and says, "I want this picture exactly like this," they will shoot it that way, tear down the set and go on to the next set. Many advertising photographers just do not want to spend the time to create additional suggestions that might make a design better than the way I had visualized it.

CONFEREE: I would like to direct a question to Mr. Hurlburt. Being a young person and an aspiring photographer who is very interested in photography, I should like to ask what are the opportunities of marketing photography with the larger magazines? I love photography; I think it is the most tremendous thing and the most expressive art form I have ever known. It is modern; it is within the last 125 years; it's what's happening. And, although my interests right now are in the fine arts, just what chance does a younger photographer have with a large publication? To someone like me the only publications which would seem to be interested are those related to photography: *Popular Photography* or *Modern Photography,* for example. They don't have the room to consider everyone. In what direction should someone like myself move?

The Secret is the Idea

HURLBURT: We'll start on the big magazine side. We love photography, too. All of us here are involved in that part of it. We are interested in photographers and in new photographers. At *Look* we have recently set up our machinery to be better equipped to handle new photographers with new ideas. The word *ideas* is the key. We have a staff of experienced photographers whom we will call on to execute the ideas that are originated within the magazine. But, magazines are desperate for ideas, new ideas for a story that someone thinks is right for *Look,* even though it isn't like anything we've ever run. But you must have the idea. And this is a great weakness of photographers, both in this room and elsewhere: they have not thought enough editorially. When they start to think about a magazine picture story they look at what a magazine does and say, "I can do that; why don't I do it for the magazine rather than someone else?" Photographers who have broken ground with us — and I think this is going to be true wherever you turn — are the ones who came either with an executed or unexecuted idea, but with an idea that was very good.

We are very rigid and strict in our guarding rights to an idea when a submission comes to us from anyone. At that moment of time when an idea arrives at *Look,* it belongs to whoever brought it to us. Now, we've had photographers fail because

their technical execution of an idea wasn't up to the idea itself, and it has sometimes been reassigned to someone else for production. But, the photographer is rewarded for a big step in closing the gap on that idea.

When David Douglas Duncan was explaining this morning about his coverage of the '68 conventions for NBC television, he said, "I think editorially on my feet, and I have to think fast." Duncan does think as an editor, and nearly all of the photographers whose names have come up during this Conference think like editors. When an idea is in their hands, they execute it with editorial thought, conviction and it becomes comprehensible communication.

The worst thing on this earth is to take what you think somebody else wants, to take a picture because you think that's the kind of picture a magazine runs, to do what you think is right for somebody else as an end in itself. To start with you must do a thing that is right for yourself! But, it must have within it the threads of editorial idea and continuity if it really is to work.

CONFEREE: I have a question for Mr. Hopkins, please. When *Look* plans a picture story, is the stress consciously placed on the written text with the pictures expected to illustrate that text, or are the photographs primary with words expected to support the photographs?

HOPKINS: Neither comes first. For the picture story, the writer and the photographer go into the field and find out what's going on. When the team returns, we make a layout, but we make that layout only after long discussions about the story. Together — writer, photographer and art director — we edit the pictures, and then the layout is further developed with dummy text in position and real headlines. Next, that layout is considered by the editor for insertion in the magazine.

HURLBURT: In some kinds of stories the pictures illustrate words. In a picture story the words explain pictures or work with the pictures.

CONFEREE: In your layout sessions at *Look* following shooting, how does the photographer participate and how much affect do his opinions have upon the layout?

HOPKINS: He participates a great deal, though it's always questionable in a team effort to determine whose opinion actually prevails. I think in every team situation some people are dominant and others aren't. Recently a writer came in from the West Coast with a story that he had already laid out. It was great, and I took it, making only about two adjustments. There are other times in dealing with photographers when they might edit down to six pictures and that's it. We might just run it that way! Of course at other times we all have to plow through contact sheets for weeks.

HURLBURT: I want to take us back to a session this morning when the question was raised regarding David Douglas Duncan's coverage of the young people during the '68 Democratic Convention in Chicago. I had the privilege of seeing his photographs the night they first ran on NBC. And the question that was raised was that he hadn't been fair, that he hadn't shown the razor blades and the insults to the police and the rest of it. Dave's defense of himself was a valid one. He said that he went to do this story and photographed what he saw. He reported what he saw where he was. He didn't pretend that it was the whole story.

But, I think his defense could have gone beyond that. On the subject of fairness, I think we've got to face it a little squarer than that. Fairness in itself is good enough. But, if we also say balance — if we say that it's the duty of every journalist, of every reporter, to come back with an absolutely equalized view between the negatives and the positives, between one side and the other, between one political party and another or one statesman and another — I think we're talking about the dullest kind of journalism that one can imagine. It really is the responsibility of the reporter for the magazine, the network or whatever it is to find the degree of fairness which will make his publication relied on and depended upon. But, this fairness should never be so complete that one's publication lacks conviction, lacks belief. It should never be so overpowering that journalists lack a concern about the issues surrounding them. I think if anything bad is happening in magazines today, it is that they are afraid at a time when they should be bold to stand up and be counted on a lot of things.

Daumier wasn't fair. Nast wasn't fair. The great journalists and their great publications weren't completely fair, always giving all sides of everything. If we in publications don't succeed in making a measure of our audience mad at us from time to time, we're just all going to go to sleep some day, and that will be the end of publishing.

WRITING FOR THE
PICTURE MAGAZINE

JOSEPH KASTNER, 1964

Mr. Kastner began his journalistic career on *Time* in 1924 as a copy boy and reporter. Then followed a period of experience on the New York *World*, the *New Yorker* and *Fortune*. He joined *Life*'s staff during its experimental pre-publication period and has served as a writer, departmental editor, division editor, and, since 1950, copy editor. Mr. Kastner retired from his position as copy editor in 1971, but remained with *Time, Inc.*, in that organization's Record Division.

I don't usually lecture to large audiences about writing for a picture magazine; my lectures are a lot more private. I'm at my desk, copy before me, writer sitting beside me, hearing how he should have written what he just turned in!

He's a select and often surly audience, and since he usually disagrees, the lecture becomes a rather heated dialogue. Since I've been writing, rewriting, and editing captions for *Life* since the magazine began, new generations of writers think I go back into the prehistory of picture journalism. Sometimes I do.

I once started to look into the history of picture writing, and before I gave up, I found that writing for pictures has presented problems as long as there has been writing for pictures. Artists on *Harper's Weekly* turned over inaccurate information to writers,

and caption writers in the old rotogravure days battled layout men who used fiendish visual devices: elaborate curlicues or oval pictures with captions underneath, precisely copy-fit. Since oval pictures in the roto sections were frequently of high society, the caption writer had to pack long names into a three-pica measure.

I once came upon a Renaissance painting of some important, but long forgotten battle, for which somebody had written an identifying caption. The historian who was commenting on the event said rather acidly, "The identification in the caption is, of course, quite wrong." The caption writer has always been the patsy for somebody who seems to know better.

To make things convenient for me, I'm just considering that modern picture-writing — writing for picture journalism — started in the 1930's with the birth of *Life* and *Look,* as well as the resurgence of the use of photo stories in newspapers and Sunday supplements, and the expanded use of photographs in basically non-picture magazines.

With the recent increase in the number of words in the picture magazines and the expanded number of pictures in magazines like the *Saturday Evening Post,* an innocent photographer — contradiction in terms — might wonder what happened to the pictures in picture magazines, or to the words in word magazines. It is a good question!

Reading Before Writing

In writing for a picture magazine there is one obvious and inescapable fact: the picture. You can't get away from the photograph when you're writing for a picture magazine, and if you do, you'd better get away from the picture magazine. Almost everything you write is oriented to the photograph, and this means a lot more than simply saying, "From left to right in rear are"

We learned about the art of writing for pictures at *Life* by learning to look for good pictures. But, we didn't know how to read pictures. They were a foreign medium to us. We only considered composition, expression and mood. That pictures gave facts, told stories and contained elements of important information eluded the word men.

Gradually we learned that pictures said something, and we had to take this into account as we wrote about them. Even with this realization we wrote captions which today would seem pretty square. We pointed out things in photographs anybody could see — over there was a white-bearded man smoking a cigar; the girl over here was showing her knees — all of which was then necessary, because our public was even more illiterate in terms of photography than we. Although they were delighted by pictures, they had to be told very specifically what was in them.

We developed techniques in the early days of reading into the picture and not letting the reader get away from what was in it. It took nearly a generation before readers learned to read pictures.

My son was born when *Life* was just a few months old, and for him *Life* was part of the household furniture. He would spread it out on the floor and look, long before he could read words. He grew accustomed to reading pictures; he didn't have to be told what was in them. At seven he was more sophisticated in looking at pictures than I as an adult.

Today a reader can look at a picture and see what's in it; he no longer needs a caption to point everything out. The caption can be more relaxed and, in a sense, more sophisticated. The obvious is not repeated in words. A glancing reference, a nod of recognition for something in the picture, draws enough attention so the reader won't miss. The caption can provide relevant non-visual facts and interpretation.

The old technique of cramming facts into captions to provide context and background has gone because more text accompanies the picture stories. I was browsing through some fairly recent copies of *Life* and was struck with the number of subtle ways that our stories talk right into the pictures.

We once talked into pictures much too directly and redundantly. We would write in a caption, "The remarkable picture above shows three men parachuting at once from a plane," or something as brusk and fluffy as that, intended to make sure the reader knew that the picture was great stuff. There are three men, count them, three men doing this foolish thing all at once.

Now, our copy refers to the picture in much more delicate and, I think, interesting ways. The word pays homage to the picture. What's going on in the picture serves as a starting place for the copy. The writer trys to merge points of the picture with points of the story.

The picture caption now serves a much more direct purpose of identification. But, as a form of writing it's still imperfectly understood at many newspapers and magazines. I frequently get the impression that newspaper picture captions are written by the first man to walk into the city room. "Here's a picture; write the caption, and try to find out something about it from the photographer if you can."

One of the important parts of the caption, and the part most frequently misunderstood and misused, is the lead-in, either bold-faced or all-cap, something set off from the rest of the caption. It's a very useful device in picture journalism, although we find ourselves relaxing in its use in picture magazines. It serves as a kind of minor headline to quickly point up what the picture is about, or what we want you to think the picture is about. It serves to join a series of pictures in a chronology. It provides a sense of reference. It can give coherence to a series when properly used. It wasn't properly used at *Life* in the early years.

In a very early copy of *Life* there was a story on the Duke of Windsor. Toward the end we printed a striking photograph showing the ex-king's appearance as a poker-faced boy, bored, forlorn and lonely when not exhibiting his remarkable charm. This picture told a fact that the reader could probably not derive for himself, but our writer knew it and with the appropriate caption was able to give the photograph a dimension of meaning it previously did not convey.

Life caption writers, especially in the early days, felt very dutiful about telling everything we thought our readers ought to know. We identified everything. The clincher in one story was, "Corpse in foreground is real." And that hit home. At *Life* we were all saying things like, "Smile on face is forced," "Hat on head is awry," and it taught us a lesson.

Sometimes captions utterly fail to talk into pictures. There was once a caption which read, "Police seized a quantity of opium." But, in the picture there were no police

and nothing was being seized. It was a cluttered picture with a perfectly worthless caption. I remember talking to the guy who wrote the caption. He said that he wasn't there, and the photographer didn't know the details, so what was he to do? I didn't help him.

In magazines such as *Look,* captions are becoming much more casual. Writers are not trying to emphasize who is what. One recent *Look* caption said, "When it comes to explaining and persuading, Ricky is as effective as a hypnotist." And it's much more important to make that point than to say he's trying to argue some player or other into something, thus reading directly out of the picture.

Brevity is the Key

I haven't talked about brevity, a prime requirement in writing for a picture magazine. There isn't an art director in the land worth his paycheck who won't try to chivvy the word man out of any number of words to make space for a little more sky, water, or white space. The writer is usually left with a few sentences, short ones, and he has to exercise considerable skill to make things fit and read smoothly.

Transitions frequently have to be sleight-of-hand — a play of words, a play of sounds, or an alliteration. The word *but* is absolutely indispensable in helping to join two contradictory facts, a frequent task.

The simple declarative sentence is a mainstay of the picture magazine and a good thing too. When writing a block of text for a picture magazine, say what you have to say and get it over with. It's good to have a beginning and end. The text should also have grace, and it benefits from a little wit which can brighten up an anecdote. A point of view, an angle or a frame from which to hang the whole story is essential.

Words are moving into the picture magazine very gracefully, though I haven't considered here the trend in picture magazine journalism toward greater use of the pure text article, a signed piece which is not a picture story. They're being used more and more. In an issue of *Life* we may have as many as a dozen by-line pieces scattered throughout, sometimes independent, frequently as trailers to stories and ranging from 300 to 6,000 words. This reflects the subscribers' greater interest in reading and their demand for more information, comment and different points of view. Increased text can expand the picture story, giving it greater depth; picture magazines which were timid about using articles consistently years ago now use them without inhibitions.

Frequently *Life* runs the first person picture story. The photographer reports what he has seen through his camera while the reporter tells what has happened; the first person quality is enhanced by the word-picture combination.

The institutional or group journalism aspect of the picture magazine is fading somewhat as writers are encouraged more and more to be personal and give their own critical points of view. This is all to the good in the general rise and sophistication of the picture magazine and its audience, though I won't suggest whether it is the audience or magazine which leads.

I've spoken so far of writing in terms of technique, not in terms of art. Good writing is an art, no matter where it's applied. The demands and the devices of picture journalism impose certain techniques. But, the instrument of the technique is also the

instrument of the art. It is the English language, itself a surpassing medium for evoking pictorial images.

We are told that Shakespeare didn't need stage sets, only words to conjure up his Forest of Arden. The fact that we in picture journalism love pictures more than other journalists do doesn't mean that we love the English language less. But this instrument, the English language, is too often blunted by carelessness, by clichés, or by ignorant usage in ways that horrify those of us who love it.

To write in any form requires care, patience, a good ear and the sternest discipline. In picture journalism there are rigorous confines of space and of reference imposed by layouts and pictures. The form demands much care and patience. The writer produces a kind of sound track to be played as an accompaniment to the visual track, pictures. He writes half of a duet. The discipline is of an order that no other kind of journalism requires. And when this discipline is exerted, it produces writing that is as taut, as spare, as evocative and as cogent as any writing in journalism today.

A PICTURE MAGAZINE
AND ITS EDITOR

Arthur Rothstein, 1966

This presentation was the Daniel D. Mich Memorial Lecture given at the Conference which followed the death of Mr. Mich, a long-time editor of *Look*. For a biographical note on Mr. Rothstein see page 92.

To Wilson Hicks and Morris Gordon I would like to say that I am grateful for the opportunity to give the Daniel D. Mich Memorial Lecture. This lecture will stand as a tribute to this great editor of *Look* magazine, who died after a lingering illness in November, 1965. I have known many fine editors, but Dan Mich was the best of all. I worked with him for more than 20 years. His efforts toward molding the character and personality of *Look* were enormous. It is quite appropriate that Dan Mich should be honored in this way, because he also made many fundamental and enduring contributions to the art of communicating with words and pictures.

Dan had two beliefs. First, he was continuously dissatisfied. He always believed that his magazine could be made much better with improved ideas, deeper thinking and more hard work. Second, he believed that the *Look* editorial approach should deal effectively and dramatically with the tough and controversial issues of our time. His editing angered some readers, but it won the respect of many more. One of Dan's sayings was, "Nothing we have done in the past will ever be good again." Another was, "The hottest places in hell are reserved for those who maintain their neutrality in time of moral crisis."

I don't have to remind you that *Look* was doing stories on civil rights long before the historic Supreme Court decision. Over the years *Look* has played a major role in exposing our nation's errors in treatment of the Negro. A current issue with the story on the Ku Klux Klan and many previous issues have exposed the extreme right. Dan Mich also opened the pages of *Look* to men like John Henry Falk, who had been wronged by the witch hunts of the McCarthy period. Falk was allowed a hearing and an audience when he was down and out. This approach was backed by a strong sense of editorial integrity.

In the field of mass circulation magazines and newspapers, I fear a collapse of these high standards of editorial integrity. We all know of some publications which have been edited for advertising promotion purposes. Many of these are no longer being published.

An editor functions for the reader, and he attempts to build an audience which will continue coming back for more. Advertising men have the job of selling that audience interest and readership to advertisers. When there is any attempt to mix those two functions, the publisher will wind up with chaos and, most probably, nothing short of disaster. It is bad business to edit with an eye on "box office."

I am willing to admit that editors and advertising executives have one thing in common: the necessity to arouse and keep an audience interested. They each have that selling job to do. It may be a shocking realization to some editorial minds, but they must be salesmen, in a sense. If they are not successful at achieving readership of their publication, they will be looking for work. The editor's job is not only to sell the entire publication to his audience, but also to deliver each individual story and layout so that it gets maximum attention from his audience.

Personal, Direct Editing

This brings me to another concept which Dan Mich understood so well. No matter how large a mass audience may be, it is composed of individuals. People do not receive any form of communication *en masse*. If you are reading a magazine or a newspaper, watching television, listening to a radio broadcast or seeing a film, you may be part of a mass audience, but the message you receive is personal and direct, an individual matter. That is why one does not edit for, broadcast to or advertise to a mass. Every message, commercial or otherwise, must be directed to individuals.

Today there seems to be a great reliance on quantitative measurement to create a composite picture of the "average" reader or listener. *Look* learns as much about its audience as possible. We know our audience is relatively young, well-heeled, active and acquisitive. Our editors know the breakdown of their readers by economic status, sex, and educational level, but they don't edit the magazine for an imaginary Mrs. Schultz in Omaha, or a composite Mr. Nelson in Minneapolis. They know that variations among individuals are too great. Dan Mich always placed great emphasis on the individual nature of a mass audience. He believed that mass communication is really communication between one person and another.

When you are comunicating with another person, how can you best hold his attention? Obviously it is wise to talk about something which interests him in a manner

he finds fascinating, though that is easier said than done. It is impossible for an editor to avoid offending some of his millions of readers. But, he cannot shrink from realizing that controversy and vitality are two sides of the same editorial coin. Too many editors today are too careful, too cautious and too fearful about upsetting their readers. As a result, much of mass communication is dull.

Advance planning, ideas and imaginative editorial leadership can overcome this dullness. *Look's* operation is based on long-range planning, for we do not cover spot news. Many of our writers and photographers are working on projects which may not appear for as long as a year. An editor must have faith in the ability and talent of his writers and photographers, and Dan Mich exhibited that quality to an exceptional degree. He backed them all the way, and they respected his judgment and decisions.

Dan was one of the pioneers in elevating the status of photographer to the same level as writer. He believed in the power of the photograph. He understood the concept of related pictures and the role of photographic talent. His book, *The Technique of the Picture Story,* which was published in 1946, was a classic in its time. He believed in supporting the photographer in every possible way, particularly with first class equipment and materials. He expected and demanded first class work.

Guidelines of Effective Writing

But, good photography must be accompanied by fine writing. A few years ago Dan gave his writers this advice at an editorial meeting:

> If I were a *Look* writer, I would stress the simple declarative sentence. I would avoid long, complicated sentences. I would never, if I could avoid it, start a sentence with a participle, or a dependent clause or a phrase. I would study the power of strong nouns and active verbs. I would minimize the use of adjectives and adverbs. I would try not to fog up my meaning by overusing words with prefixes and suffixes. I would work very hard on my leads, and I would try to make every lead as simple and strong as the one on this sports story. Here it is: "Rocky Marciano's biggest victory was not scored in the ring. It was won over his manager, Al Wilde." Two short sentences and 18 simple words, yet that lead gives the reader information, piques his curiosity, and leads him into the story with a minimum of effort.

> If I were a *Look* writer I would not write down to anybody, but I would try always to make myself so clear that nobody could misunderstand. I would realize that mass communication means communication to a great variety of people. It isn't hard to make yourself clear to a Harvard professor. No matter how you stumble, or how badly you express yourself, he is fairly certain to understand what you are trying to say. It is the person without education or an elastic mind who must have everything said to him clearly and succinctly. Yet, never can a story be so childish that your more sophisticated readers will be offended.

> And, if I were a *Look* writer, I would do three other things. First, I would surround every assignment. I would learn every fact about the subject that could be uncovered by reading and talking to people. I would try to learn 10 times as much about it as would seem necessary for the space allotted. I would be prepared for a 5,000 word piece, even though the space called for only 300. That way, I could be fairly sure of doing the best 300 possible. Before starting out on field work or interviews, I would read every available word on the personality or situation involved. I would make notes on what I read. When I

reached the point of asking questions, I would know what questions to ask. Instead of boring my source of information with dull routine, I would be able to make the interview challenging and interesting for him. I would play the fascinating game of seeing how much I could get, and if there were one key, important question that had to be answered to make the story hot, I would wear out everybody I talked to until I got it. That to me would be the fun in my job.

Second, I would read. I would read *Huckleberry Finn* every year. I would read Hemingway, Scott Fitzgerald, Tolstoy, John Gunther and a hundred others. I would read every article in *Look*. I would be aware that the best writing has a rhythm, a cadence that pleases the eye as well as the ear.

Third, I would rewrite my copy until I was positive that I couldn't make it any better. I would not want to be classified with writers who dash it off and figure the copy department can do the rest of the work. I would have too much pride to turn in anything except the best piece of copy of which I were capable. I would rewrite and rewrite, and if I still were not saisfied, I would rewrite some more.

To my knowledge this has never appeared in print, but I consider it a superb summation of the writer's job on any publication.

Graphics of Communication

For those of us who are involved in the art of communication, written and visual messages must be presented to our audience in the most effective manner, which brings me to another concept. I'm conscious of an over-emphasis on the design of some publications and total disregard for it in others. In recent years we have seen disaster strike some magazines as art directors' efforts were allowed to get in the way of the editorial message. On the other hand, we see too many newspapers of very poor design. They are made-up by old-time journeyman-printers or make-up editors who know little about design or typography and the many graphic techniques for creating readable and exciting pages.

At *Look* our art director, Allen Hurlburt, who is one of the best in the business, ranks right below the editor in decision-making authority. He helps to decide how a story idea shall be developed and suggests ways to give it maximum visual impact. He knows how to blend type and photographs so each helps the other, so that each page comes alive to intrigue the reader. Some art directors abuse this responsibility and permit design to overpower the story, rather than assist in the telling of it. They become fascinated by shapes, forms and patterns, forgetting their basic goal: to blend words and pictures so that the message communicates quickly and effectively.

I see less photographic journalism being published and more photographic illustrations. This trend can partly be explained because some art directors have become photographers, and some photographers have become more concerned with design for design's sake than for the story to be communicated. Photographs are selected by art directors on the basis of their form or design rather than on the message revealed. Overemphasis on design must be avoided. Let us return to the old axiom that form follows function.

A Publisher's Philosophy

While handing out advice so freely, I would like to quote Gardner ("Mike") Cowles, who founded the *Look* operation, which Dan Mich, myself and many other editors and photographers have found such a satisfying environment. To a group of journalism students in Kansas, Mike said:

> Dare to be unpopular. If you win a popularity contest, you probably aren't doing your job. You can and should be respected, but not necessarily popular. Always edit just a notch over the heads of your reader. They want to read a publication which they can look up to, and one which stimulates them to think, even if they are occasionally annoyed. If you are in doubt on a particular issue, lean over backwards to present adequately the less popular side. To help make this country truly civilized, we need to make it safe for diversity in thought, in morals, in customs and not try to force everyone into the same mold.

> When you become an editor, never "get in bed" with a politician. You will become a captive; you will lose your objectivity and chances are, eventually you will find that your idol has clay feet. Learn to be very skeptical of government statistics and press releases. They are frequently designed to lead a reporter away from the real news.

> Part of the job of an editor is to keep the temper of the country on an even keel. When the public gets too optimistic, warn it of possible troubles ahead. When it becomes too pessimistic, remind readers that the country isn't really going to hell, that it has come through hundreds of past crises.

With all their faults, the magazines, newspapers and broadcast facilities of this country are the best in the world. And, they are better, on the average, than they were a generation ago. What we need are more editors like Dan Mich, who really care about the editorial qualities of their product and who are courageous enough to demand the best of their associates. We need men who stress editorial integrity, who understand the individual aspect of mass communication and who demand meaningful, revealing photography, clear and concise writing and effective layout. Those of you who are fortunate to find such an editor will discover how truly rewarding your work can be. Your life can be dedicated to performing a vital service with enthusiasm. You can't ask for more.

4

The
Photographic Book

It was the mid-1950's when Edward Steichen invited a select group of New York's book publishers to preview in photostatic form what was to become the world's greatest photographic exhibition, *The Family of Man*. Publishers would certainly be interested, Steichen reasoned, in creating a book from this monumental effort.

Such was not the case. They came to the loft on 52nd Street where the exhibition was being designed, viewed the work, remarking that it would make a great show, but each privately resolving that *The Family of Man* would never make a book. Only one publisher came forward, Jerry Mason, a "friend of photography," who resolved to see the work into print. Five years and 2,000,000 copies later there was no question but that it was Jerry Mason's judgment which had been sound! *The Family of Man* was a great success in photographic book publishing history, becoming a very significant and influential historical landmark.

Thus, for the photographer who wishes to work in a more individual vein, to see his efforts in print and to reach a wider audience than the exhibition wall, the book is a preferred medium. It involves a long-term effort with the extended statement, seemingly the dream of every photographer. A book can be documentary in approach, taking a position on an issue of social concern, or it may be archival. And, there are explorer's books as well as other books of information which utilize the photograph as the principal form of communication.

Richard Grossman, who was associated at Simon and Schuster with the late Richard Simon for many years, and who later formed his own house which publishes many photographic books, sets forth the scope of photographic book publishing in this chapter. Also included is a first-person case study from idea to publication of *The World is Young*, a popular photographic book by Wayne Miller in the early 1960's. Miller served as assistant to Edward Steichen in creating *The Family of Man*.

Time-Life launched a major involvement in the publication of picture books in the early 1960's, and by the 1970's publishers, notably Doubleday, were experimenting

with sale in bookstores of boxed prints of photographs. Some individual authors are finding financial support from non-profit organizations or public corporations to produce a book themselves, delivering the finished "package" to an established book publisher who then acts as distributor of the work for a percentage of the profit. Thus, the market is an expanding and experimental one, with cooperative arrangements among publishers becoming more common on both the national and international level.

THE PHOTOGRAPHIC BOOK

RICHARD GROSSMAN, 1971

Mr. Grossman began his work in book publishing in the early 1950's as an associate of the late Richard Simon of Simon and Schuster, Publishers, New York City. Since then he has become president and editor of Grossman Publishers and vice president of the Viking Press, both in New York City. In addition to authoring *Bold Voices* (Doubleday), he has edited or published such books as *Observations* by Richard Avedon, *Images of War* by Robert Capa, *Black in White America* by Leonard Freed and the *Concerned Photographer*. He also lectures in humanities at New York University.

Welcome to the linear hour! During the next few minutes you will see no slides, see and hear no films or tapes, touch no cassettes or lenses or even be exposed to electricity. You are going to hear an ancient and honored form of communication called the voice of a man.

I am a book publisher and a teacher, and in either capacity it does not matter to me whether or not books remain a dominant form of communication throughout the rest of my natural life.

I have chosen to spend most of my time publishing books, writing them, using and owning them and returning to them. It is I who choose the book, not the book which chooses me. It is not the book which validates my existence, but I who validate and guarantee the continuing existence of books.

I choose books as my medium. But, allow me to suggest that you make a substitution in that sentence and play the semantic game yourselves by saying, "I choose photography; I choose film; or I choose cinema as my medium." I believe that the utmost in human achievement comes when the human chooses his medium of expression. I urge that you do not permit the medium to choose you.

On the subject of media, Marshall McLuhan's book, in which he prophesied that people would not read, was cited several times last night. Incidentally, it sold about 780,000 copies and, by my observation, fills the hip pockets of more blue jeans than any book except *Che Guevara*. It has occurred to me that what probably went wrong with the concept of the medium being the message was that for many people who saw some possible truth in it, the medium became the Messiah. McLuhan has a real understanding that our children are not like us. However, the possible truths

subtleties and nuances of McLuhan's revelation are being lost by infatuation with the idea of Messianic reading.

Now, we have all had our media mix-ups, and I am reminded of a mix-up in which I was involved within six months after coming into New York publishing. I was brought into publishing from a small town in Ohio by Richard Simon, founder of Simon and Schuster. In the 1930's he had written *Miniature Photography From One Amateur to Another,* which had sold 36,000 copies at the height of its popularity when he withdrew it from the market. Since he was writing mainly about the Leica camera, he believed further success of that book was a direct commercial benefit to the German manufacturer, E. Leitz.

Early Picture Books

His keystone contribution in the field of photographic book publishing was made in 1952 when he recognized the importance of publishing a book entitled *The Decisive Moment* by Henri Cartier-Bresson. I joined him just after its publication.

One very warm day he received a call from a friend of his whose name was Steichen. And Steichen said, "I'm in a second floor loft on 52nd Street above a place called Green's Luggage Store. I wonder if you would come over to look at what I'm doing?"

Dick said to me, "We're going over to see Steichen."

It was extremely hot. Steichen was stripped to the waist, pipe in his mouth. His assistant was a striking young man named Wayne Miller, who looked like a ship stoker dripping with perspiration. The entire second floor of the building was set up as an exhibition in miniature with scaled photostats of the photographs mounted on orange crates. There were even small galleries and alcoves made of these orange boxes.

This was going to be a monumental photographic exhibition, and we were there to look at it as book publishers. The late Dick Simon was a man six-feet-five-inches tall, who, I often thought, in many respects had the attention span of an alcoholic May fly! After he had bent his frame over those small photostats for as long as his lanky back could bear, he looked at his watch, slapped his forehead, and said, "Oh, my God, Oscar Hammerstein is waiting for me. I must run! You stay."

He bid Steichen good-bye and said, "Dick Grossman, my assistant, will stay and look over the entire thing." I stayed till 7:30 p.m., ultimately stripping to the waist to accommodate myself to the environment. The next day Dick asked, "What did you think of the exhibition?"

I replied, "Dick, it's going to be one of the great photographic exhibitions of all time, but it will never make a book!"

Dick put his hand on my shoulder and said, "I always knew you were a born publisher."

Nine months and one million copies later *The Family of Man* had proved that Dick Grossman didn't know his medium very well. I should say in passing, however, that I was probably right. If I suffered from anything, it was from a lack of imagination, for it was Jerry Mason's concept of putting that book into a paperback format and marketing it broadly throughout the United States at $1 a copy which was a revolutionary idea at that time. His idea gave some codified indication to the impact of this fantastic exhibition which made it the justifiable success that it was.

However, I stayed in the book business. And, I shall now enjoy sharing with you something about photographic book publishing.

Books have never been what you as photojournalists have referred to in other discussions as a "market" for photographers. From Richard Avedon to Leonard Freed, every one of the photographers who has been associated with me over the last 18 years has lost money as a result of creating photographs for the books I have published. The money was not lost in out-of-pocket expenses, although in the cases of Avedon and Penn, I daresay those expenses ran into staggering figures. The loss was more in terms of gross dollar yield from the book venture in comparison to a photographer's earning potential for a comparable work effort on regular commercial jobs. Books have always been, in the photographic sense, a relative luxury for photographers.

Books and Culture

Next you should know something about the strange relationship with exists between the book business generally and our culture. Visualize, image-makers that you are, a triangle and think of it as representing the American economy. Almost at the apex of that triangle is a tiny horizontal line, the area within indicating the small portion of the total economic triangle which is occupied by books. Visualize another pair of triangles with the same size relationship. Label the large one culture. Visualize it as a physical, triangular test tube into which the impact of ideas, values, ethics, imagination, excitement and human potential filters down, much of it from the small triangle, which again is books. Books have their impact in the large cultural segment. So, if you lay the cultural triangle over the economic triangle, you can see why photographers are willing to make economic sacrifices to do books and why some publishers are also willing to be in the break-even book business.

As to any general threat to books I'll have to say parenthetically that it's not new. It is recorded that in 1905 there was a bicycle craze in the U.S., and people took the trouble to write editorials in the *Christian Science Monitor* prophesying that the increasing popularity of bicycles would transform us into a mobile culture with nobody staying home or reading any more. In the early 1920's when KDKA broadcast its first static from Westinghouse in Pittsburgh, the assumption was that due to American fascination in radio listening we would never read again. In 1924 when contract bridge became popular, the assumption was that the culture would become a two-couple, four-legged table nation bereft of books. In 1940 when someone projected future use of the electron television tube, a similar prophecy was made. In the 1950's and early 1960's our kids said to us, "Man, like you're not with it, because it's the rock culture, and it's here; like man, you don't read." Once again it was prophesied that books would die. But, the books which make such prophecies are in the hip pockets of the kids who are predicting their demise.

The fact is there are more books published now than ever before. And even in that tiny, tiny portion of that tiny triangle which photographic books occupy, there are even more of them. Issues of survival are too large for me, so let's just say that Dick Grossman thinks books are still here. And I think they are here to stay not because of any arguments I just gave, but ironically, because if there is one man who knows

how to make books and wishes to do so, they will always be here. There is no smaller minority than one author or one photographer and one publisher. But, that duet can publish a book!

Current Photographic Books

What kinds of books are there? In the photographic field these are dictated partly by the sense which publishers have of themselves. You should understand that most publishers are only partly motivated by economics. When a manuscript comes into my office, the first question asked is not, "Will it sell?" as you might expect, but, "Is it publishable?" We don't know as much about what will and will not sell as many of you would like to credit us with knowing. We sit as advocates for a large, sleeping audience with whom we have some spiritual identity. And the best publishing comes by advocating from the bellybutton and reacting to the book first and then second to the practical matters of how to make it possible to publish.

Permit me now to describe a few of the categories of photographic books that are published and try to explain the relationship of publishers to these categories. There is, of course, what always existed before Dick Simon saw the photographs of Cartier-Bresson: the technical photographic book. By that I mean not only the manuals which are part of the industrial spill-over from producing cameras and equipment, but also the technical books which address themselves to the problems of the use of such equipment. They have been and probably always will be with us.

Second, there is a category which you might call the informational book, a very broad category. I label it informational, because it is a category in which pictures are an accompaniment to text which is intended to inform or instruct its reader and viewer. An example of this would be Jerry Greenberg's books on the underwater: how to shark-fish or how to skin-dive. A more elaborate example of that would be an encyclopedia, a dictionary, or any other kind of book whose basic thrust is to provide its potential reader and viewer with information.

Third is the category which I've come to call explorers' books. What first reaches my mind, of course, is my association with people like Emil Schulthess, who is an explorer because of his physical intrepidity. The great challenge in his life is to go wherever people don't dare go, won't go or can't go. I'd like to broaden explorers' books to include the work of people like Inge Morath in Russia, Doug Faulkner with his sea books and others who don't photograph out of a desire for the challenge of danger to their body, their person or their spirit, but simply photograph a topic long enough and deep enough to share with us their very personal experience. I call that approach an explorer's book because the photographer becomes an advocate for a viewer who wants an in-depth image of Russia or of coral which is amplified beyond a surface line of text.

For example, Inge took a photograph of Romanian peasants and their horses in snow. As an explorer she discovered and captured for us an image which we can relate to our association with peasantry, with snow, with horses and with the land. Does anyone have to know more about a Romanian pastoral setting than that portrayed by Inge? So, those photographers, too, are explorers, because they bring the story back.

A fourth category is relatively new. It could be called a position or issue book. It is a reflection of the new age of muckraking, the new age of individual advocacy and the new age of believing, perhaps, that one man can fight city hall. They have editorial points of view that are calculated to include a polemic quality which asks the reader for a direct response in a civic, personal or private action. The Sierra Club is the incarnate example. The essential ingredient in a Sierra Club foldout or projection is to engage you in the saving of your land and water despite great beauty and the fact that photographs in them are chosen for esthetic as well as polemic reasons. This I foresee as an expanding phenomenon.

Fifth, and the one with which I have been most associated, is the documentary book. The book which brings you from David Douglas Duncan to Leonard Freed, from something as relatively narrow as a study of Germany to the breadth of a study of the phenomenon of war. The documentary demands to be told in words and many pictures, because its story cannot be contained in any singular form. In this instance we have the manifestation of the classical principle that form follows function. And, the function of a full-scale documentary story in the hands of any of the people we know as documentary photographers can only reach its fruition in book form.

Permit me to digress here for a moment. I hope that no one in this audience has an old copy of *Infinity,* because I once wrote an article for that magazine in which I said, "I will not take any photograph I respect and put it on an American printing press." That was another of Grossman's great lulus alongside, "It'll make a great exhibition, Dick, but it will never make a book."

When I made the statement which was published by *Infinity,* I had recently experienced two possibilities in book publishing. First was the possibility of sheet-fed gravure printing on a high-quality, German-made paper with press work in the hands of the craftsmen from Switzerland or Holland or Italy, all of whom developed their skills with the background of generations of apprenticeship, journeymanship, and diligence. I had that experience with the Avedon book.

I referred to two possibilities in book publishing. The second possibility began when I took a book which I cared about, with photographs by people whom I cared about and with photographs which I respected greatly to an American offset printer. Through making that compromise I got back less than blotting paper. Finally I reached the point where I could not tolerate that kind of product.

Quality Reproduction Important

My position with the photographer has to be that I can *enhance* his work in book form, not that I will *dilute* his work. I made that statement to *Infinity* at a time when the American printing industry was unwilling to invest any money in the development of a gravure technology on the grounds that as long as it could get full-color offset jobs from corporations like General Motors, there was no motivation.

But, somewhere out in the atmosphere somebody heard me and sent the message along, because in the last nine years I have seen an improvement in the quality of American printing processes and paper that I would say runs near 1,000 percent. But, I really cannot yet say that I can put photographs which I respect on American

printing presses without fear. However, the development and sophistication of double-dot printing has been an immense encouragement to the possibility of the continuance of documentary photographic book publishing.

There is a sixth category of book which exists, will persist and, in my opinion, probably will enlarge for an ironic reason. It is what I call the archival book. In 1967 I was at a photojournalism conference in Santa Barbara when Byron Dobell, who had been a picture editor before becoming a literary figure, said that despite my admiring comments about the works of Cartier-Bresson and other contemporary photographers whom I respect, the fact remains, "There is no such thing as a bad picture that's over 40 years old." I suggest to you that in 1971 another group of pictures has become 40 years old. More and more we are discovering photographic and cultural insights not just in or from the work of the obvious Lewis Hines, Jacob Riises and Atgets, but from the treasures of glass plate negatives which document forgotten periods of history such as life on St. Helena Island off the coast of South Carolina. Photographic treasures have also been discovered in the archives of the Hampton Institute in Virginia which tell us more about black culture in the 19th Century than all the prose we've read until now.

At this point permit me to issue an injunction in case any of you has an archival tendency — and I honor that tendency. Just because you subscribe to the notion that there are no bad pictures over 40 years of age, don't think that you can drop them on a page or hang them as a nostalgic gallery. What those photographs really do for us is open our minds to further questions about the setting, the environment, the culture and the atmosphere in which they were taken.

I prophesy that the archival book will expand in titles and will be accompanied by a new kind of writing in American history. In this country, especially, there will be restoration of archival photographs and pictorial materials as well as old architectural drawings, renderings and sketches. From and through those images we shall learn more of how America evolved. Images of how man related to his machinery will help us come to know more about what has "technologized" the American psyche. So the archival is an exciting area.

The Changing Scene

Now, what has disappeared or is in the process of disappearing? The coffee table book and the Christmas book will disappear, I think, for a very valid reason. And that reason is economic. Forcing the consumer into a large size, expensive format and high cost is antithetical to the welfare of the American society. These books will necessarily have to be restrained. Forgetting age differences or generation gaps for a moment — people are people when they first get up in the morning or go to bed at night — it is impossible to believe that the American culture will absorb books which perforce, even on a break-even formula, are going to cost an amount of money which is symbolic of the waste that devastates our country. I subscribe to the notion that every effort should be made to teach our government that it should spend money which is needed for our people in this country and not in the waging of war. However, I suggest that publishers and authors ought to think how their activities contribute to the

country. Do we waste money, energy and attention? Do we pervert the priorities of American life by fostering the concept of the highly expensive book? There can be no other way; I prophesy its gradual disappearance within five to 10 years.

Another kind of book which is disappearing in photographic publishing is the retrospective. I seem to have a great record of prophesying the disappearance of things and then promptly publishing them. I once prophesied the disappearance of the anthology. Then I became a pacifist and decided that what we really needed was a great anthology on non-violence. But, I do prophesy the disappearance of the retrospective. There is a handful of chronologically older photographers — I have a very special one in mind — who are owed a retrospective book and a lifetime show hung on the printed page. I'm thinking of André Kertesz. I think it is shocking that none of us, including Richard L. Grossman, has had the imagination or the courage to do that book.

Beyond that, the retrospective, one-man show, hung as a gallery on book pages, is a thing of the past. The linkage of photographs by their maker is not a general value in American life. American life is emphasizing subject, content and theme, and the direct one-to-one relationship of person-to-person. To link a collection of pictures in a photographic book because they were taken by a great photographer over a period of time can only be justified by virtue of fantastic achievement over half a century, which is the case in André Kertesz's life. I am publishing a new Kertesz book, but it is not the great retrospective.

Here is how it came to be. André came into the office one day, and although he makes many friendly visits, he rarely comes in with the classical yellow box. This time he had one. He said, "Perhaps you'd like to see some of these pictures I've been taking now for some time; I visualized them in Budapest in 1915 with the same style."

I answered, "Of course, a Kertesz picture is a Kertesz picture; I'll look at any."

It was an entire box of photographs of people reading, taken from 1912 to 1971 in every conceivable country, situation, environment and context which you could imagine. It is the most enchanting vision of this phenomenon I have ever seen.

Now, there is a little bit of merchant in every publisher, no matter how noble his protestations, and the merchant in Dick Grossman said, "Aha, I shall call on W. H. Auden to write a little essay entitled, 'On Reading.'" Then I thought to myself, "No, I haven't the hutzpah to do that." That would be putting a maraschino cherry on something which was not, by any means, an ice cream soda!

Later I had an interesting confirmation of that decision. I have a West Coast photographer friend who is strictly in the Edward Weston tradition. Now, this man is always eager and willing to voice his prejudices against photojournalism — reportage — the kind of thing that really hits me. So, I thought here would be a test. If he got anything out of these pictures, then they needed nothing more. I left them alone in a room. Now within the Kertesz series there is one photograph of someone reading in the French countryside, and Kertesz took it at that decisive moment when the largest cow in the herd had just chosen to look over the shoulder of the reader. All of a sudden I heard a California belly laugh coming from the office in which I enclosed them. I said, "No text; the book will be called *On Reading*!" And those two words plus André Kertesz will be the only four words in the entire book. We'll see if that pays off.

The Future

Now, what is new? Doubleday is experimenting with boxed prints; the figure is not in yet on whether it is succeeding or not, but they have made an attempt with the work of two photographers to sell boxed prints through bookstores at a price related somehow to what people used to pay for books. Interesting phenomenon. I can remember that since 1955 there has been a preoccupation in New York with translating the possible merchandising tactic of printselling into the bookstore. It hasn't yet been conquered. Doubleday may have the beginning of an answer, or perhaps *Look's* sale of high quality original color prints selected from work published in that magazine may be a partial answer. In any case that is a direction in which book-related photography may survive and expand.

What else is new? Cornell Capa is persisting, as only Cornell can persist, to create the Library of Concerned Photography, an ongoing library of books in the tradition of Lewis Hine's approach to the use of the camera. *Concerned Photographer II* will be published in 1972.

In addition, at Grossman Publishers we are continuing the expansion of an experiment which I began some years ago: our publication of a series of Paragraphic books. These are very small, six-inch-square books, not expensively printed, but presenting the work of an individual photographer, thoughtfully edited, and including at the end more bibliographic material on the work of that photographer than available elsewhere. We are going to revive those in a larger size, that of the *Aperture* magazine monographs. We are doing a series of monographs on individual photographers' works, though not in the depth of a retrospective, because these are very inexpensive.

Key to this idea is the acknowledgment that the paperback photographic book is here to stay. These monographs, which will sell at $2.95 to $3.50 at the most, will be an estimable addition to the young person's library of photography. And I shall not deny for a moment that publication of that series is aimed directly at the 700 college courses given in the United States in photography or related fields. This is a minimal kind of reference which those young people need and have a right to expect. We should make available in one location reference to every article ever written about or by Inge Morath and her photography before much more time elapses. This must be published for the student so he can say, "I want to do my study on Inge Morath and I have a reference guide." He can then follow her from Persia to Russia as her career unfolds. A $2.95 book will make that possible in a full way.

Again, remember there is no money in it for the photographer, no money in it for the publisher. And when I say no money, I am not implying that we are intentionally running a non-profit organization, but that historically "break even" is usually the greatest expectation the publisher and photographer can have.

Other new ideas include the $3.95 and $4.95 paperback. In a country in which a dollar is worth as little as it has come to be here, that price is proven not to be excessive for books people want. Sales figures on *Black in White America* and *Concerned Photographer* indicate that $3.95 to $4.95 is a perfectly valid level for a well-printed, 176-208 page book which has somewhere between 150 and 185 photographs in it.

Finally, there is the possibility of a mass-market paperback book, a book which is

4-7/16 x 7-1/16 inches, the classical drugstore mystery. Right now there are two very interested New York publishers who are trying to do something with photographic books in that format. These publishers would like to work out contracts either with us as basic book publishers or directly with photographers to do books which will retail at 95¢ to $1.25 in the mass market.

Perhaps what is really new, as always, is only what is really understood. And maybe what is really understood is suggested by a paragraph or two I'm going to quote on the possibility of a photograph. This paragraph appeared in an essay some years ago and has just been reprinted in a little-known publication called *Manas*. It was written by Jay Wolff, who is a painter and who has just written a book called *On Art and Learning* which I am publishing this month (April, 1971).

> The best contemporary photography strengthens our visual powers, not by changing and altering familiar things, but by giving us a chance to see the thing observed in terms of itself. Although there are factors which prevent the easy identification that is made in everyday life, things do not seem as familiar as they should. At this point we can ask ourselves whether the camera has distorted life or whether we see it in a focus our eyes have never known. Photographs may record the everyday world exactly as it exists, yet the camera, with this detachment of uncompromising truthfulness, can render this world unfamiliar. Obviously something is wrong here. In our search for the error, we can eliminate the camera. It is within ourselves we must look for the answer. How are we to determine the factor which makes the photographic record so different from the familiar impressions of our smugly trusted eyes? Perhaps the answer is this: the camera sees as well as looks. We look, but do not always see. Familiarity does not necessarily imply seeing. More often, it is the point in the course of contact that the eye is relieved of further search. We look at an object not to see it, but to identify it.

I must say that so long as photographers of any kind, with any kind of outlook, believe that their camera can see as well as look, my door will be open to them.

AN AGENT CONSIDERS
THE PICTURE BOOK

CHARLES RADO, 1968

The late Mr. Rado, founder and owner of Rapho-Guillumette Agency in New York City, was distinguished as one of the pioneers in magazine photojournalism. Born in Hungary in 1899, he emigrated to America in 1941. His early experience included a post as picture editor in a large German publishing house. In 1933 he founded the picture agency Rapho in Paris, and in 1942, in association with Paul G. Guillumette, established Rapho-Guillumette in New York. His family of photographers included Marc and Evelyne Bernheim, Brian Brake, Bill Brandt, Brassai, Robert Doisneau, Donald Getsug, J. H. Lartigue, Jay Leviton and the late Ylla. Mr. Rado died in September, 1970.

Many years ago a successful magazine photographer confided in me how pleased he was to see his work printed between hard covers, his name on the spine, leaning against other books on the shelf. It was his first book of photographs. As I have worked closely with photographers from the early 1930's in the marketing of photography, it was inevitable that I should become involved in the adventure and excitement of the creation of books.

Observing first from the sidelines, I became a participant in book making in 1955 upon the death of Ylla in a tragic accident in India. In her last will she had appointed me to carry on publication of her photographs in books, a project which had great personal meaning for Ylla and was meeting with success. For example, in 1967 the number of Ylla's books marketed by Signet and shown on a Harper's statement totaled 55,000 copies, earning $17,000 in royalties. Two sets of these books were posthumous productions. By 1967 more than a half million books by Ylla had been sold in the United States and abroad.

From my first involvement with books by Ylla as well as by several other photographers whom I have served over the years, I have drawn a few lessons. Let us first consider children's books. I believe, and this may come as a surprise to some of you, that words are fully as important as the photographs. Photographer, writer and designer should work as a team from the start.

Books of photographs for the general reader are more numerous than ever, but too quickly some of the expensive books wind up in remainder shops. Handsomely printed, *Life*-size books with many photographs, some perhaps in color, and text by a good writer must sell at prices ranging from $15.00 to $25.00 or more, even when several publishers here and abroad share production costs. Books in that upper price range must clear publishers' shelves, as a rule, within a few years. Past that time, the advertising budget allotted for a book has been exhausted and the invested capital is needed for new titles. Because of these conditions, many worthwhile projects of distinguished photographers await publishers.

Occasionally a fine book comes out in a very small initial printing, and thus is priced, by necessity, too high. And, since advertising and promotion money for such a small printing is practically nil, the book fails to find its public at the publisher's price.

For the vast majority of publishers bookstores are a necessity, conveniently located to display new publications and with floor space for the public to browse. But, most of these stores buy from publishers at a 40 per cent discount from retail price.

There are various ways to bypass the bookstores, among them selling by mail order or through book clubs. Mail order publishers have sold very large printings of attractive and well-illustrated books at reasonable prices. These same publishers, though, have been less successful with expensive art and photography books.

Of special interest to photographers is the Sierra Club, which offers its members beautifully reproduced books of photographs on nature subjects. The Club also markets a soft-cover reprint edition of each book in smaller size at $3.95 for the general public. Perhaps commercial publishers will also find a way to bring out parallel editions of great books of photographs, the full-size, high-priced, limited edition for collectors or the gift book trade, and then the soft-cover, smaller size popular edition at a very reasonable price.

CONFEREE: With the expanding market for foreign editions of an American-published book, do you sell world-wide rights or do you negotiate individually for each foreign edition printing?

RADO: The arrangement which we have with some publishers such as Time-Life Books for the use of our clients' photography is that they pay a fee for the U.S. edition and then pay again as much for all foreign editions. For instance, the minimum rate for a color photograph used as a full page is $125.00 for the U.S. edition. For all other editions the publisher must again pay $125.00. The minimum rate for small pictures is $100.00.

THE WORLD OF THE
PICTURE BOOK IS YOUNG!

WAYNE MILLER, 1960

Mr. Miller served under and developed a warm friendship with the great Edward Steichen in the Navy photographic unit during World War II. After the war he received a Guggenheim fellowship in 1947 and 1948 preceding his acceptance of a staff photographer's position at *Life* from 1949 to 1953. It was about that time his association resumed with Edward Steichen, on this occasion to assist in the creation of *The Family of Man*. Subsequently, Mr. Miller published his own work, *The World is Young*. He was elected to membership in Magnum. Presently he is based in Orinda, California, and does editorial photojournalism and advertising assignments.

I would like to begin with the story of the publication of the book *The Family of Man*. I was working with Edward Steichen in a loft on 52nd Street above a strip-tease joint. We couldn't have had a better beat as far as background for our efforts! It was three months before the show was to open, and we were still working with paste-up prints, tear sheets and everything "to scale." We hadn't started making the exhibition prints.

We were interested in some sort of permanent record of this show, something that would be comparable to a museum catalog, that would encompass the exhibition so that it could live longer than the term of the show itself.

We talked with several prospective publishers. Dick Simon of Simon and Schuster came up, shook his head and left. It wouldn't go! We had people from Harpers, Random House and Doubleday. They liked it, but it wouldn't go. We felt that this was a package, something worth keeping. Steichen was discouraged by the publishers' lack of interest in a book from the show. It so happened that at the time Jerry Mason, who is a good friend of photography, was publishing soft-cover books, using news-stand distribution techniques. Jerry had hoped that he might publish the book and had talked to Steichen in the very beginning of *The Family of Man* effort. At that time he was interested in founding a larger publishing house. Steichen said, "Jerry, you're not set up for it. You'd lose your shirt. This

is not a project for you to get started on." However, when Jerry had heard that Steichen was having trouble interesting a publisher, he mentioned it to him again. Jerry came in and looked; he was still excited and wanted to do it. Steichen was so pessimistic that preliminary efforts were made to backstop the expected loss on the book.

The Family of Man was published six weeks after the show opened. Before it was received by any dealer for sale, 26,000 copies had been purchased in advance. As of today — these are rough figures, because publishers are more confused than photographers — sales total approximately 1,500,000 of the $1.00, soft-cover edition, 400,000 of the Pocket Books edition, 60,000 of the $2.95 edition, 10,000 copies of the original hard cover, which was a sell out, and 150,000 to the Book of the Month Club! The success of the book woke up publishers, who became more interested in picture books. Within a year of the show we had some embarrassed friends in the other publishing houses which I mentioned. On the basis of the success with *The Family of Man,* Jerry next published Duncan's book, *The Private World of Pablo Picasso.* The Picasso book was a special kind of book, soft-cover and printed by a new method, the first such book published by Jerry.

I have singled out Jerry Mason for a reason. He represents a special kind of publisher in what heretofore was a vacuum, a man who could think beyond past practices in book publishing. He is a young, exciting man who believes in photographs and hasn't been in this business long enough to believe things cannot be done. In effect he became a manu- facturer as well as a producer. He also distributes and sells books. Those facts alone would not guarantee the success of a book or make it possible, but he uses the same plates to tie in with a hard-cover publisher where royalties and profits are greater to all concerned. Jerry has worked such arrangements with Random House and in the case of my book, with Simon and Schuster. I'd like to tell you something about this book of mine as well as how it came about.

The Family of Man show was over. It was March, 1955, two months after the show had opened. In searching for photographs to be considered for *The Family of Man,* I had been struck that there did not seem to exist, at least to any degree that we could detect, a conscious or an extended effort on the part of a photographer to understand and com- municate about a typed group of people — any in-depth photographic documentary which added to the understanding of a people.

From the Exhibition, An Idea

I had the very strong desire to explore a specific area of human concern, to do my best to penetrate a topic. I also wanted to spend some time at home. I told Jerry Mason that I wanted to do an intensification of one facet of *The Family of Man.* I wanted to do a story on childhood. I defined this idea briefly one day as I walked along beside him down Fifth Avenue. He was going to another luncheon appointment, but replied after about a "two-block" explanation, "I think it's a great idea; let's talk about it further." The idea had clicked with him, and I was going to explore the world of childhood to the best of my abilities. To put some meat on the skeleton I had hoped that an original thinker in the area of child development would join with me and add his understanding of the world of the young in practical, usable terms. The specialist whom we approached wanted to collabo- rate with a well-known baby doctor.

On this basis I received a fine advance — $10,000 — from Jerry. An advance from a publisher is given to help create the work and ready it for publishing. If you walk in with a completed job in your hands, there is no basis for an advance. If you wish a cash payment for your work, that's something else. An advance also shows that the publisher believes enough in your work to stake money on a forthcoming package before he has specific assurance about its final form.

I initially became involved with this subject with the intent of completing it in six months. After seven or eight months, I'd hardly gotten started. As my work approached a year, I realized that I was immersed in a rare subject and an opportunity, which, if I didn't take now, I would have to pass up forever. This was a moment in life when I could say, "I'm wrapping this thing up; here's the package." I also had the chance at that point, to continue involving myself until I could finish and say, "This is the best I can do." I made the latter decision and continued working on *The World is Young* for two-and-a-half years. Of course I did have to some other work during that time.

The original plan called for submitting the completed and edited photographs to the specialists in child development who were to write the text. When Jerry Mason saw the work after it had been laid out, he talked with colleagues at Simon and Schuster as well as Pocket Books. They were wondering whether we should go any further with the other writers. The layout was shown to the child development experts reluctantly, half hoping they wouldn't wish to get involved in it.

One of the specialists felt that I had said what I had to say photographically, which was an upset to me. In a way I had a sense of ambivalence about their participation because I had wanted to find out what kind of a book would result with the combination of photographs which were purely subjective and text which would have been written by people who were knowledgeable in this field and who would have approached it from a scientific point of view. So, when it was concluded that the book was complete as it stood, I was happy, but yet I felt I had suffered somewhat of a loss. Jerry was very pleased; we put the final version of the book together, and it was published.

Putting the story of the young into a book was a period of discovery for me, for I had no idea what the world of childhood was. I had gone through childhood, but I didn't remember much about it. I still don't! I was interested in seeing it, in effect, to find out what did happen. It was an important effort on my part to say something which was very, very important to me. Perhaps I gained a kind of an understanding. I didn't pretend to say that this is what children are concerned with; I said this is what I see them as concerned with.

Living with the subject matter and sensing the feeling of what the subjects had to offer — the importance of their lives, worlds and moments — proved a frustrating experience — especially when I looked at my photographs of the situations. Practically speaking, a photographer is involved in daily self-analysis. I felt that I could know more about myself and the important things in my life and world by searching for understanding through the active practice of photography. When one looks at a photograph, he reveals himself to himself, which may be baffling, degrading or sometimes exciting. It's a good way to know oneself.

Thus, I didn't really do the book to show to you. I did it for myself. I don't mean to

be precious about that, but I wanted to know what this world was, and I wanted to know how well I could document the world of the young.

I would like to turn now to a more general evaluation of picture books. One publisher said, "The motive in a picture book should not be to make money." This publisher is suggesting that if you are interested in your subject, if you believe in it and if you feel that it's so important that you've got to do it, then don't cloud the issue by trying to do a best-seller and make money.

Photo Books Must Be Pictures Plus

We have too many books today — fine books, exciting books. Norm Ross at *Life* expressed it this way, "Photographic books don't *appear* to the potential buyer to represent the values which buyers must identify in order to purchase. So, you have to overcome the appearance of limited values." In a bookstore I have watched as someone leafs through my book; it's a maturing experience. Ross continued, "To the possible buyer, the subject of the book should meet a need, as a reference book. A book must also have values beyond those which the person gets as he riffles through it. The average purchaser feels that words represent substantial values. We've been conditioned to this. The photographic book can be so easily consumed that you have to have more than an attractive photographic presentation."

In another sense, we are on a threshold of opportunities as makers of visual images which will beggar in description anything we have enjoyed to now in existing publications — and I'm including magazine advertising photography. We have a chance to become involved in a revolution in the use of the visual image for children in textbooks. I'm talking about the use of the photograph not as the cliché of educational materials of the past, but as part of a whole new movement which may change our concept of picture stories and picture use.

Publisher as Distributor

If you want to publish a general interest picture book for sale in the trade — the bookstores — and you feel that potential publishers lack enthusiasm for it, you should consider the feasibility of persuading an interested organization to pay for it. The finished package is then maneuvered into an established publisher's distribution machinery. The person who has carried this idea to its maximum is Dave Duncan.

His book, *The Kremlin,* was a very expensive book. Dave told me that to publish that book in this country it would have had to be priced at $35 to $50. At a price like that U.S. publishers will not become interested or involved. Duncan went to European publishers who also were interested, but, because of cost, they, too, were unwilling to publish it. Dave felt so strongly about the book that he finally published it himself after the New York Graphics Society agreed to be listed as publishers and purchased 20,000 copies.

In my mind the publisher was the one who made sense out of the stuff you brought in and saw to it that it was organized, manufactured, promoted and sold. Today a publisher may have nothing more than a small office with desk and telephone.

On the basis of the New York Graphics Society guarantee, Dave was able to plan the book, purchase the paper, worry over the engravings and get it out. He was responsible

for embossing the cover, the printing, lamination of the jacket and design of editions in English, French and Italian. While an American book publisher normally works on a 300 to 600 per cent markup above his cost for printing and binding, Dave published at a 300 per cent markup. He had a great many expenses, too: five trips to the Kremlin and trans-Atlantic flights back and forth between France and New York.

Of course there aren't many people who can handle the whole package as he did, but he has the top qualifications in every department: he is a fine photographer; he understands his subject matter; he is a good writer; and he knows how to research or direct others in the research.

Life's managing editor, Ed Thompson, said the other day that he had seen Duncan walking along Fifth Avenue with "a copy of his book under one arm and press releases in his other hand." Then Ed said, "By God, there's the original Armenian rug salesman." Dave has arranged television appearances and radio interviews, and *Life* will publish 10 pages in color in the next week or two.

Duncan is an expert salesman. I saw him one day, and he just happened to have a fist full of telegrams. One was from a well-known publisher with an order for 20,000 hard covers — name your price! Another was a typed telephone message to Dave from the Hotel Vanderbilt with a similar order from another publisher. In the first five days·following publication it sold 2,000 copies at $25 in New York stores, alone. This is certainly one way to wrap up an idea which a man really wants to do, though, of course, few of us can execute an idea on such a large scale.

I also talked to Philippe Halsman about his adventures in book publishing. I asked him what the "best" book was which he had done, and he named *The Frenchman*. When I asked why, he answered, "Well, it sold 100,000 copies at $10 and at a 10 per cent royalty — $1 a copy — I made $10,000. It only cost me 55 minutes of shooting and two weeks for captions.

You probably know that Time-Life has started a book publishing department. Think what that means. There is an organization loaded from top to bottom with professional talent in publishing. They have all of the financial backing necessary as well as the courage to go ahead with this.

Their book on World War II sold 200,000 copies at $15 — that is a $3 million gross, which is just about the total income last year for Alfred A. Knopf publishing company! *The World We Live In* grossed $7 million; *The World's Great Religions* totaled $4 million and *Life's Picture Cook Book* about $3 million.

Time-Life is going into the book publishing business hook, line and sinker. They are interested in all kinds of picture books, encyclopedias, dictionaries, atlases and text books. Some people predict that their book publishing venture will yield income far exceeding what the other Time publications now produce.

We must begin to understand what a photographic book is, because this area can move us into larger markets and operations. The excitement of being totally involved in something which you believe in and a work situation which involves maximum cooperation, effort and understanding are thrills which I hope many of you can enjoy. The photographic book goes beyond the magazine. It permits a treatment which is limited only by our abilities.

One final word about photographic books which all publishers will agree on: nobody

knows how they'll ultimately fare. I inquired about my book over at the campus bookstore. And, I was quite pleased to find that it was sold out. Inquiring further as to when there might be more copies in, they shared with me the truth: that they had never heard of the book! So, distribution and the success of your book is something which does not solely depend upon the author's or photographer's expertise!

WILSON HICKS: I was just curious to know what the sale of your book has been up to now?

MILLER: This book was printed by rotogravure, and in that particular process it pays only if you make a big press run. The original run of the soft cover edition was 75,000. Of that, it is estimated around 45,000 have been sold. The same plates were used in the making of the $10 hard-cover book, which was printed on a heavier paper to give the book a greater bulk.

HICKS: Quick, tell how many it has sold, Wayne.

MILLER: I don't think it has sold a damn one . . . actually about 2,000.

HICKS: Isn't that extraordinary — 47,000 copies on a children's book. I'd like to pursue one point that you made in your presentation. You implied that there was some question in your mind as to whether the pictures in this book needed words with them. Or, did you mean that it was kind of a scary thing to undertake doing the words yourself?

MILLER: I was interested in presenting my ideas in the best possible way, whatever was necessary. When it was determined not to use the child development specialists as writers, the publisher said, "We've got to have some copy." So, I had to sit down and write, which was the hardest thing I had ever done in my life. Thanks to Jerry's editors, I think the copy makes sense. But, the value of the book itself — the torch I was carrying — was the hope that people would read the photographs and make sense of them. It would take effort and courage for the viewer to read those photographs and make up his own mind about what he saw. Readers typically would much rather lean on somebody else's word interpretation of the pictures. I don't believe, however, that there can be a set of photographs for an audience of this nature which can carry its ideas off without words. When we are involved in picture books, we have to be concerned, given present economic and manufacturing problems, with the realization that the book must sell in order to be born or live.

HICKS: And in order to sell, the book has to have substance beyond the picture?

MILLER: It has to be of importance to the other person, have substance and have a stature of its own which the person can understand or recognize to the point that he wants to buy it. This throws the responsibility on photographers to involve themselves in topics or issues which have substance. There are other picture book markets which are not in this category.

CONFEREE: You say substance. What about Halsman's *Jump Book*?

MILLER: His success in picture books should make the rest of us jump and think about how we might participate! However, the promotion of the *Jump Book* killed the sale of the book. And this goes back to the matter of substance as perceived at the point of purchase by the buyer. The *Life* story took all the juice out of it. People saw the photographs in *Life,* checked the book on the bookstands, finished their reading and it hasn't gone too well since.

CONFEREE: Do you feel that picture books, perhaps more so than books of fiction

and reference, have an appeal to a potential buyer as a gift for someone? If this is so, do you feel that in considering a subject for a picture book, this possible use should be taken into account?

MILLER: I think you answered the question yourself. Yes, picture books are considered a luxury item. People buy them for others as gifts, but seldom buy them for themselves. Most of us wait until a book is available at discount.

CONFEREE: How much did you do on the layout of your book, or was that done by a professional art director?

MILLER: The publisher's art director helped me a great deal. I had the theme, the movement and the concern in mind. This book was laid out three different times, costing about $800 in photostats and the patience of Jerry Mason and his art director who worked with me for six weeks.

CONFEREE: How do you arrive at the number of pages which you ultimately have?

MILLER: This book is appreciably larger than Duncan's book on Picasso. Again, you have to lean on the publisher. In this case he said, "Let's go until we're done or until we think it makes sense."

CONFEREE: What about the profits from the sale of your pictures to advertising agencies? I've noticed quite a few with credit lines to the book itself.

MILLER: That doesn't hurt, either! All the photographs in this book belong to me. The publisher holds the right to publish the book. When I shot this book — it's in my own neighborhood — I made the point to get the names of individuals and small groups pictured, so that I could later ask for their permission. I went back and got releases from these people, and it has paid off.

CONFEREE: Does your agency — Magnum — share in the percentage of the book or on the pictures for advertising? How does that work?

MILLER: The question is based on the fact that members of Magnum pay a percentage of our sales for the mutual costs of operating. In this case the book is the photographer's private effort as far as royalties are involved. When it comes to stock use of materials originally created for the book, I am perfectly agreeable in sharing a percentage with Magnum.

CONFEREE: We all feel that your book is of great value and a wonderful achievement. Do you think either a lack of promotion or poor distribution — or both — were responsible for the comparatively small sale of the hard-cover book?

MILLER: Yes. I learned a bit about how publishers think from an executive at Simon and Schuster. He was a very charming fellow; I ate dinner with him one night. He embraced this book during our dinner and called it his baby. This was the most important thing that had ever happened to him, and by gosh if any book was ever to get a sendoff, this was it. So arms around each other, and staggering a bit, we said goodby. That was the last I heard of him and probably the last he ever thought about the book. The only promotion the book got was the promotion which I created. I can't understand the thinking of businessmen who extensively commit both their time and money, only to ignore the book after it is published.

5

The Photographers:

PERSONAL VIEWPOINTS
AND PHILOSOPHIES

Photographic journalists are unique in the field of mass communications: unique because they have a natural urge to associate, to discuss each other's work and to see what one another is doing. How often do newspaper or magazine writers spend an evening at a colleague's home discussing assignments of the past month, reading each other's stories or considering developments generally occurring in the field?

Ernst Haas identified this unusual trait of the photographer when he said in 1970:

In the ten years that I have been coming here there are generally the same kinds of people, and one has the feeling of being on an island. On an island you know everybody and everybody knows you What we have in common is *photography* It is a pity that our medium, photography, which is practiced by so many, is understood by so very few. Maybe this is a reason why we return to Miami: with the hope of being understood and, perhaps, seen So we come to Miami to recuperate, communicate and show what we have done, or, perhaps, what we want to do.

The result of this continuing dialogue among members of the photographic community is a body of personal viewpoints which leads toward a philosophy of photographic communication. Permeating individual statements is a very deep respect for the photographic image, a belief in the dignity of the photograph. High ethical values are being articulated, as well, with emphasis on the photographer's personal integrity and the validity of his work. Emphasis is toward the goal of an honesty of interpretation in photographic communication, a concern truly the mark of professionals!

Opening this chapter is a relatively young photographer, Burk Uzzle, who defines that "something" which the photographer sells as "essentially what is inside him." Says Uzzle:

This has to be fed, nurtured and developed with life and living, tempered and shaped with knowledge and taste, and given an excruciating birth in the form of a structurally legible, visual form.

149

Then the "elder statesman" of American photography, Edward Steichen, who had just celebrated his 82nd birthday, delivers extemporaneously his thoughts at the Conference. Said Steichen:

> Unless that image becomes *alive,* it's not a photograph When the photographer has something in front of him, chosen with his heart and his mind, and when he has brought to bear all the experience he has ever had, then he's prepared to press that button.

Though a half-century apart in chronological age, each was touching upon that final goal of the serious photographer. Uzzle and Steichen bring great personal meaning to the feeling and emotion of creating a photograph.

The photographer's changing goals and aspirations are next revealed by Eliot Elisofon and Bill Pierce. Elisofon paints a somewhat critical picture of opportunities for self-growth in the photographic medium, suggesting a personal desire to search beyond the perimeters of photographic communication, while Pierce shares an inward penetration and involvement with the medium.

Four very well-known photographers then reveal aspects of their growth and development as professionals as well as their basic approaches to shooting and marketing photographic assignments. David Duncan delivers a most candid and honest review of his start and later achievements, while Philippe Halsman shares his marathon effort in winning 100 competitions for *Life* covers. Margaret Bourke-White and Inge Morath identify their

Burk Uzzle

seriousness of purpose and provide examples of a photojournalist's need to overcome obstacles.

The chapter then turns to the "documentary tradition" with Arthur Rothstein, formerly a member of Roy Stryker's team at FSA in the '30's, defining the approach. Yoichi Okamoto, formerly with the USIA and most recently President Lyndon B. Johnson's documentary photographer, describes that challenging and history-making assignment. Two young documentarians, William Albert Allard and Dallas Kinney then reveal their personal approaches.

In concluding the chapter Ernst Haas of Magnum defines the development of a photographer in terms of his life-long interests and concerns. With all of the feeling and emotion one can discover in a Haas photograph, he reveals with eloquence the philosophy of a concerned photographer. Finally, Cornell Capa, another of the Magnum photographers, delivers a moving profile of three documentary photographers from his group who died while on photographic assignments: Robert Capa, Werner Bischof and David Seymour "Chim." It was in honor of these men and their work that Cornell Capa founded the International Fund for Concerned Photography — an idea which he first entertained as a result of this presentation at Miami!

THE YOUNG, CREATIVE EYE

BURK UZZLE, 1962

Mr. Uzzle is currently a photographer in New York City, handling editorial and other assignments. At the time of this presentation he was associated with Black Star agency. Preceding his active involvement in New York, he worked with Jay Leviton in Atlanta for two years. He is currently a Magnum photographer.

One morning recently I struggled hang-dog-like up to the glossy bank of elevators in our office building in Chicago with a couple of heavy camera cases across my shoulders. To my consternation the elevator operator jerked his thumb toward the freight elevator and superciliously cracked, "Sorry buddy, this one's for gentlemen."

Frankly, the status aspect of the whole situation didn't bother me as much as the later realization that I have unconsciously yearned for some time to be a gentleman. I don't suppose that will ever be possible with my having chosen to be a photojournalist.

As a photojournalist many privileges are mine. There are the many delights in living — seeing and feeling so much and so often in a way of life which has come to totally possess me; being a photojournalist has made inseparable the real, subconscious and personal me and the me which is bared so often and sometimes so painfully in my photographs. As a photojournalist, life with its vicissitudes comes in large doses. Frankly, I wallow in it with the greatest of enjoyment.

There was a time during my earliest development when I thought that a photo-

journalist was basically a seller of photographs. But, I have since come to feel strongly that the commodity a photojournalist sells is essentially what is inside him.

This has to be fed, nurtured and developed with life and living, tempered and shaped with knowledge and taste, and given an excruciating birth in the form of a structurally legible, visual form. You are selling the bread of your life. Your earned right to like or dislike, to laugh or cry, is translated into photographs that hopefully will mean something to somebody.

Life, Courage and Love in Photography

To disapprove or dislike something or somebody and make harsh photographs in the name of objective photojournalism is a damn courageous act if you are a responsible person. Just who do you think you are? What exactly are your credentials? After all, you have no poetic license in the name of objective photojournalism. Men necessarily judge the nature of other men by their own. What about your nature? Do you know right from wrong? Are you morally unassailable?

On the other hand, to love something and take photographs of it with all your heart, as you must if you truly love it, is equally courageous. Here poetic license is valid, but uncomfortable. You are publicly baring your innermost feelings. A good photojournalist probably falls in love with more people per fiscal year than any other professional man. And a fierce love it is, too, an intense intellectual and emotional preoccupation with an individual that takes you over until your presentation of this person is complete on film. Repeated too often, too fast, this preoccupation can strip you of whatever it is that enables you to feel with clarity of personal purpose.

As photographers become more successful and older, it becomes a great temptation for them to do everything that comes along; namely, it becomes a temptation to become wealthy. However, it is imperative to pace yourself, to allow what is inside to replenish itself, to maintain a spiritual home base. It is a photojournalist's responsibility to himself and his audience to be, above all, a stable human being and a man of responsibility. The line between you, the human being, and you, the photojournalist, is fine and indistinct. You, the person, and you, the photojournalist, must be one.

As I see it a photographic essay is I. It is something I stand for or something I dislike. Above all, it is something I have thought about. And, it is something in the nebulous, unruly chest of human experience which manifests itself as a photographic catharsis.

Your feelings about living are revealed by the moment you select to make a photograph. "I am a part of all that I have touched and that has touched me," to quote Thomas Wolfe. He believed that from all the chaos of accident the inevitable event came at the inexorable moment to add to the sum of his life — his mind picked out in white, living brightness these pinpoints of experience. When you select the pinpoint moment in time to make a photograph in the white, living brightness of your mind, heart and soul, you are obeying an almost instinctive impulse, an impulse precipitated by and founded on the sum total of your life, your intrinsic integrity, your taste and your intellect. Your picture is you. You are a man. The photographer is a man, but he is a man before being a photographer. A photojournalist's fuel is life. Don't be afraid to be yourself; after all, it's the only thing you are.

On Photographic Responsibility

But, you are additionally charged with the responsibility and power of mass communication, communication with an incredible instrument: a spear that can plunge past intellect instantly, intuitively reaching for the soul of your audience; as in music, the heart is the bullseye. The photograph can communicate, can say something powerfully and conclusively. To reach seven million people who read the pages of *Life* magazine is a monumental responsibility.

On an assignment, you look for something, perceive something. You see a fleeting perfection of form merging with a significant substance, and you make a clicking noise only a hairbreadth away. You have then judged and reported something, ostensibly as truth. You have seen something through your eyes, about-faced and represented it as a truth in a medium generally accorded to be one of hard reality.

A photograph is a chemical fixation of tangible images seen through a mechanical device; in its preservation of an instant the camera provides the viewer with an assumption that what he sees is real. But, the photograph can be a most astounding sorcerer.

If you were skilled when you made that clicking noise, perhaps the image you captured said something eloquently. Eloquence is a powerful force; unscrupulous eloquence is tragic. Eloquence in the hands of a great man is divine. Photojournalism must be invaded by great men who also have the capacity to make moving photographs.

After all, a photograph is a thing on paper, the tangible reality of an idea or creative thought. The potential of photojournalism is not in its photographs, but in the world of ideas. There can be no phonyism here.

This presupposes a technical philosophy of essential simplicity. Of what use is technical gimmickry if you have something to say? Is there any validity in the image of a 21mm lens, the fisheye lens, the 1000mm lens, infra-red film or the crotch shot? If they are of practical necessity to solve a physical problem of communication between you and the viewer — and that is extremely rare — then OK. But, does not gimmickry indeed come between you and the viewer, thereby defeating your purpose? If you are a photographer not in the conceptual, but button-pushing sense, of course, these gimmicks are indispensable. They are also an admission of mental incompetence. Photojournalists formerly competed in the world of bizarre images. Now they have to compete in the world of knowledge!

Just suppose, for instance, that a man of Bertrand Russell's wit and intellect had chosen to be a photojournalist. Visualize, if you will, the photographic essays J. D. Salinger would produce. Incidentally, do you think such a photojournalist would need advertising accounts to remain solvent? The medium is now ripe for an invasion of great men.

Is photojournalism an art form? Perhaps it's more nearly a truth form, a reality form, as practiced by a man with an artistic soul.

A sense of the common good of mankind suggests that art and poetry, because they are independent of the rules and standards of daily life in the community, play an essential and indispensable part in the existence of man. Man cannot live a genuine human life except by participating to some extent in what is eternal in him. He needs poets all the more desperately because they give testimony to the freedom of the spirit; they bring to

men a vision of reality beyond reality and insight into the secret meanings of things, without which man could not live morally.

A photojournalist, however, is a photojournalist and not an artist-substitute. The artist is expected to appear after dinner in our society. Unfortunately his function is not to provide food, but intoxication. In a society which has little time for reading, but will condescend occasionally to skim through a picture magazine or look at television, it is the photojournalist's responsibility to provide something gutty as well as a staple diet of meat and potatoes.

Reason and Intellect: Necessary Ingredients

Perhaps photojournalism is the perfect union of the spirit of man and his intellect. The photojournalist must be possessed by a fierce preoccupation with what is eternal in man; but this inner spirit has to be governed by a rational intellect which holds as guidelines reality in photojournalism and objectivity.

Creative intuition need not make superfluous the rules of reason. When discursive reason is used as a resource of creative intuition, it is composed of an indispensable arsenal: prudence, shrewdness and taste.

Taste is a virtue of the practical intellect, but this is in no way a science, even a practical science. Taste cannot be defined with a ready-made set of general truths and rules.

Thus, the photojournalist is both a madman guided by irrational inspiration and a craftsman exercising the shrewdest operative reason in his medium. The photojournalist-craftsman is vitally concerned with the construction of and the dedication to form and substance. Form is his sense of aesthetics, his taste, the cumulative capabilities of his eye, his congeneric relationship with visual art. He must communicate in a visual medium, which owes its power to form and artistic beauty.

Substance is what he photographs after it has been enhanced by, filtered through, interpreted by, or tragically blocked by the consummate, inner him.

A photojournalist must be a self-disciplined man. Personally, I think that self-discipline is indispensable. Any time I let up on a story — relax for a second when I should be tenacious — I inevitably miss the picture I've been looking for. More often than not, I don't get a second chance. This is a business for people who produce: people who produce exceptional photographs under pressure on assignment after having produced the stuff inside them which motivated the assignment, or people who have produced and are motivated by a philosophy, a point of view, which permeates the photographs and gives cohesion to the story. This is intellectual discipline as well as hard, physical discipline.

Life magazine recently changed its format, and with that change some staff photographers' names were dropped from the masthead. Both the format change and the abbreviated masthead caught the imagination of a younger generation of photographers and produced disdain among the older. A rather disgruntled older photographer described his feelings this way: "These photographers simply were not used correctly. A sensitive, creative photographer absolutely should be prodded and guided, and, above all, should be given good assignments" An incredible statement! Interpreted by me he was saying, "A photographer can succeed and continue to succeed if he is only given good assignments and can thus manage to make attractive photographs — if, of course, he is prodded and

guided." This is a man who long ago forgot self-discipline, who forgot how to think, and who long ago forgot about imagination and creativity. His concept of photojournalism has been cast out, not only by *Life* magazine, but by other serious, responsible publications as well.

It is my fervent hope that in their wisdom editors will finally succeed in closing the doors of photojournalism to no-talent photographers. If you are a photographer who knows you don't have talent, but you think of yourself as a shrewd operator, then get out of the business! Photojournalism should not tolerate you.

The fledgling photojournalist first reads the Nikon manual — then Spinoza, Wolfe and Salinger; he realizes this may help him to determine when and why to trip his shutter. He should not have and cannot survive with a Sunday Supplement brain. He should not be concerned with cats or dogs or a fast-selling filler story. He is on guard against vulgar attractions of easy executions and success. He takes himself seriously, sometimes too seriously, but what responsible, creative person doesn't?

He never jazzes up the essentially simple, intuitive, beautiful language of vision with gimmicky fluff. He mastered that long ago in an apprenticeship darkroom.

And, if he pauses momentarily on a platitude, do not despair, because he is thinking, searching and finding out something for himself and, ultimately, his audience. He is being himself, humbly, with premeditation.

WHAT MAKES A PHOTOGRAPH GOOD?

EDWARD STEICHEN, 1961

Mr. Steichen's experience and contributions to photography as art and as communication began before the turn of the century and continue to the present. Born in 1879, he was an activist in the Photo Secession. He advised the Army in techniques of aerial photography during World War I and in World War II administered the Naval photographic program as Captain Edward Steichen. His achievements in fashion photography for Condé Nast and in portraiture are well known. Steichen photographs are exhibited in the nation's finest galleries. Following World War II he became director of photography at the Museum of Modern Art and directed many important exhibitions, the most notable being *The Family of Man*. The remarks which he delivered at Miami were extemporaneous following his being given an award of recognition by the University. He lives and continues photographing in Connecticut.

I've been at photography a long, long time. As a matter of fact I have photographed actively for 65 years. When I came down here, I was promised that I would not have to make a speech. It would be enough if I stood to say "thank you" and sat down. But Wilson knew perfectly well that I wouldn't do that.

Now let's get on with our knitting. Ever since I began photographing — as a matter of fact, ever since photography began — there has been vigorous discussion as to whether

it was an art or not. Furthermore the question as to whether it was a *fine* art has also been raised. We at the Museum of Modern Art never use the term *fine art* for painting, sculpture or anything. The Museum is devoted to art, whether it is painting, sculpture, industrial design, architecture or photography.

I have never maintained except possibly in my youth that photography was a fine art. I always referred to it as the art of photography. That puts us in the same class as the art of the hairdresser, the art of the manicurist, and possibly the bootblack. That's the way I like it.

As to my personal feelings, I get a much bigger kick out of someone saying to me about one of my prints, "That's a fine photograph," rather than "That's artistic." Let us take pride in what we are: photographers. Let us take pride in photography and let the rest take care of itself. There no longer is any question, nor has there been any question in 50 years, that photography is entitled to the same consideration as other art mediums. As far as that is concerned, I don't think any medium is really an art medium. The only thing that makes any medium an art is the artist who makes the picture. And there are not too many of them, which brings me around to another point.

You all know or must have known that there is discussion going on throughout the world about the population explosion. Too many people are populating the world. Let's shrink that down and look at the population explosion of photographers. There probably is not a home in the United States but what harbors a photographer or an incipient photographer. God knows how many thousands, perhaps hundreds of thousands, of these photographers think they are going to be professional photographers. How do they become professional photographers?

A Word for the Beginner

Most, if not all, of the recognized good photographers today — top notchers let's call them — never went to any photographic school or had any photographic instruction. My own instruction consisted of a little slip of paper that came with a box of plates. It told me how to mix the developer and so on. Everything else I worked out for myself. Now I don't say that is the best way, but unless the young person who is planning to be a photographer has that kind of — let me call it "guts" — and unless he will sacrifice anything and everything to become a photographer, he won't succeed. I think the biggest mistake any young photographer can make is to try to make his living by photography before he has matured enough to know why he is photographing and what he wants to photograph.

May I share with you a little experience I had the first year of the 15 I was at the Museum. A young fellow came in one day with a portfolio of pictures. He had photographed children on the streets of New York. He photographed them in the slums, on Park Avenue, in Central Park, and he did it with a fine sensitivity. I asked him whether he had ever shown these pictures to a publisher, and he said, "No." Was he interested in having any of these submitted to a publisher?

"No."

I asked, "Why not?"

He replied, "I don't want anybody to tell me what I should photograph or how I should photograph."

I said, "That's fine. What do you do for a living?"

"I'm a plumber and I make more money than most photographers."

That set me thinking. My recommendation since then to all young people who have talent is for them to devote two or three years while growing and developing to making their living at something other than photography. If they feel that their work must be related to photography, then they should develop x-rays at a hospital or sell photographic materials in a store. But they must fight clear of involvement in professional photography. And the reason is that a young fellow is quickly molded by his early experiences.

I told Hicks a little while ago that I could mention four photographers who, 14 or 15 years ago, were among the most promising young men I met. Good photographers. I exhibited their work and bought some of their things personally to give to the Museum for its collection. These fellows went immediately into commercial photography, and they are hacks now. They trot out photographs which they made 10 or 12 years ago and send them to exhibitions that they hear of. That is a tragedy.

We have schools of photography that are a dime a dozen. They have various courses in photography: how to become a fashion photographer, how to become an advertising photographer, and then what they call basic training. Their basic training consists of how to thread film in the camera and how to develop a negative — tripe that any school boy 13 or 14 years old will learn from a photographic demonstrator in a shop in five minutes. Basic training in photography should be basic. What is basic in photography is for the youngster to learn and realize what photography is, what it is about, and above all why he wants to photograph.

If he wants to photograph for a profession, to make a living, I'd say good. I have no quarrel with him, but I haven't any time to waste with that. There are plenty of sources. But, if he wants to make good photographs, to express something, to contribute something to the world he lives in, and to contribute something to the art of photography besides imitations of the best photographers on the market today, that is basic training, the understanding of self.

A Good Photograph: Alive

You probably have contributed as much as I have to the acres of film that are being exposed daily in the United States which do not get us anywhere. What makes a photograph good? Anytime you point the camera at something and press the button, you can create an image. You've got to. You can't help yourself. But, I don't call it a *photograph* unless it's something more than that. I used to use the term *alive*. That's correct, because unless that image becomes *alive*, it's not a photograph. It's just a record, a mechanical record. The machine has produced the object. But, when the photographer has something in front of him, chosen with his heart and his mind, and when he has brought to bear all the experience he has ever had, then he's prepared to press that button. And like "The moving finger writes; and having writ, moves on," the moment you press that button that's it, you're through. What you can do afterwards is very limited.

Where we have the advantage over painters, sculptors, and other people is that once you bring all that you've got, all that you've learned, all that you are to the thing, and you press the button; you've got it. You don't have to correct it and change it. You have it,

providing you used your head. So, instead of being at a disadvantage over the painter and the sculptor, photographers have a decided advantage in the overall outlook of the picture.

When you have brought all of those things within you into the making of the picture, you are also organizing that picture. If you just point at the landscape and shoot, you get an image, but that's not a photograph. It's not a photograph until it is organized. It doesn't deserve the dignity of being called a photograph until you organize that subject so it speaks the language which you saw it in, that you felt it in, that you experienced it in, that was a part of you. Now don't get that mixed up with trying to put your personality into the picture, because the moment you try to do that you are left at the post.

I know nothing more deadly than trying to create what's called a "style" by putting your personality in; that's a mannerism, not a style. A style grows out of hard, hard work and years of work, years of struggle to do just the things I've spoken about. Then the style develops. Everything that looks like a style I wouldn't class as such.

I feel as though I've been trying to lay down the law here. I am not. There isn't one man or woman in this room who is as eager to learn as I am. The farther along you get the harder the road becomes, the more exacting you are of what you have to say. Oh, the hell with it!

GROWTH AND CHANGE
IN A PHOTOGRAPHER

ELIOT ELISOFON, 1966

Eliot Elisofon, who joined Life's staff in 1942, quickly found himself covering World War II: Finland, North Africa and the Navy in the Pacific. He had just passed 30 when he began in photojournalism at Life, having worked professionally as a commercial and illustrative photographer. Earlier he had studied photography on his own while a philosophy major at Fordham. Mr. Elisofon is a color photographer of unusual technical proficiency. He is also a dedicated student of anthropology and an authority on primitive art. He has taught photography at the Clarence H. White (Sr.) School of Photography in New York City, has lectured at the Yale School of Fine Arts, and has had one-man exhibitions at the Museum of Modern Art. Recently he has served as a color consultant in motion picture film-making. He has authored books on Africa, the Nile, the South Seas and food. Mr. Elisofon also wrote Color Photography.

When Wilson asked me to come here for the 10th anniversary of this conference Ernst Haas and Philippe Halsman were also going to come and the three of us were to do a retrospect of our work since our appearance a decade ago on the first Miami program Now I discover that my two colleagues, both of whom I admire enormously, are not here and I can bear the brunt of such an assignment only on a very personal level.

The question of what I've done in the last 10 years is not quite fair, because I began as a photographer in 1935. I opened a small commercial studio in New York City with

another photographer. I carried an 8 x 10 camera, tripod, 10 plate holders, and one lens in a case along with three 500-watt lamps, their reflectors and stands in a second case. Into the subway I'd disappear to go to Brooklyn or Long Island to photograph furniture shots for $5, then $7.50 and $10. Other assignments included gas ranges, chairs, and carpets — all following the tissue tracings of an art director.

Although I began in photography this way, I turned to photojournalism because I became bored with advertising photography. For that matter, I have not been satisfied with being any one kind of photographer. Maybe the reason I have tried things besides photography is that I felt it wasn't the perfect medium for me.

In contrast are men like Ken Heyman. Ken's pictures come out of his heart, out of his soul, out of his guts, and they are a total concept of humanity as seen through his heart. There are very few photographers who can ever achieve this. Maybe if I could have done with some particular subject what Ken Heyman has done, I wouldn't have scurried about trying to become a writer, or research fellow in African art at Harvard, or painter, or a motion picture color consultant, or, now, a film director.

So I've confessed that I'm unhappy with my photography and am not satisfied with what I've done, even though I have been a successful photographer. I cannot get everything I want from the photographic medium, which may be an insufficiency on my part. I find myself groping now in many directions for self expression. It has occurred to me that maybe I ought to look around a bit to discover whether or not it was entirely my fault that I reached this position in life after 30 years as a photographer.

Is Photography Unchanging?

Why should a photographer who is successful and in demand want to do other things? Perhaps my avenues of expression have changed. It isn't that I've seen and done everything, but we are dealing with a medium, photojournalism, in which few new contributions have been introduced. If we were to look at all the issues of *Life* or *Look,* we would discover that there hasn't been very much new in photojournalism. When you look at the first series of pictures by Dr. Salomon in Germany in the early days of magazine photojournalism, you realize that photographers to a great extent are still doing the same thing.

There have not been the changes and innovations which we have seen in a sister art, easel painting, for example. Painting has evolved from representational at the end of the century toward analytical cubism, synthetic cubism, surrealism, abstract expressionism, and futurism. We are seeing stick-out paintings with pieces hanging from them, paintings that move, and sculptures that move and make music. Granted that there is experimentation with photographic images in color which move through projectors on wheels, yet, a long time ago, Moholy-Nagy talked about projecting images in color onto clouds in the sky to make the greatest possible color display. We photographers have really done very little.

What have been the advances? Dr. Roman Vishniac has made absolutely extraordinary photographs through a microscope. Ernst Haas has used the blur and color in motion to reach an expanded photographic dimension. Gordon Parks used the double exposure to achieve a new dimension in his particular visual expression. I've used filters — first on a film called *Moulin Rouge.*

Where have we traveled since the invention of photography? I think we're probably in the slowest moving medium that man has invented! We have become so fascinated by this little mechanical monster with a lens, the camera, that we're all doing the same thing. Maybe it's in the nature of the medium.

Have enough artists gone into photography? Are the present photographers simple craftsmen — shoemakers, cabinetmakers — who are not looking for tremendous personal expression? Who is trying to transcend the mechanical qualities of the medium, and produce from it something which is intensely personal and moving?

Now I used the word craftsman, and one of the things I want to talk about is craftsmanship. Ten years ago when I was here I must have made a plea for craftsmanship. I think that a good deal of photography is suspended from this tiny thread. If you're not a craftsman in photography, then you are really nothing, because photography involves a technique. Without technique you can't begin to say something visually.

Photographic Technique a Necessity

I am very very tired of meeting photographers — especially young ones — who have bought a Leica or Nikon, use fast film, push it to the limits of its endurance, who are very proud of available light, and who would rather photograph a beautiful woman in dim light at 2000 ASA than use strobe lamps or floods. They wouldn't know how.

From *The Nile* Eliot Elisofon, 1965

From *The Nile*

I can't tell you how many photographs I see every year which indicate there has been a decline in craftsmanship in photography. We are inundated with people who have no respect for photography as a medium. None whatsoever. Many people don't know their craft; they are too lazy to carry one tiny strobe light for bounce light against a ceiling. They wouldn't know how to use one; they have never heard of using a touch of spotlight to pick up the tonal value of someone's hair. We are surrounded by amateur photographers who call themselves professionals because someone bought their pictures. They manage to get away with this incredible primitive technique. How long can these photographers last?

I was recently in Washington and met Dean Conger, a photographer for *National Geographic*. One of the significant qualities in Dean's work is the incredible scope of what he has photographed. He is able to photograph inside the theater, ballet, people, factories, as well as outdoor scenes. Yet you never become conscious that he was required to accomplish difficult technical tasks to achieve the photographs.

I think we have to have some sort of a renaissance in photography. Once in a while young people or their parents ask me how they should proceed in becoming a photographer. Although I did not study in a photography school — I actually majored in philosophy and picked up photography on my own — I recommend a school of photography within an art school. There are two important requirements: to know the techniques of photography; to develop as an artist.

If I were a young man, I would want to have basic training in photography and in art, because photography is not simply making a snapshot; photography is design. So we're dealing here with photography as one of the many visual arts along with lithography, easel painting, and even architecture.

Ten years ago I also talked about color. As you probably know, I am principally interested in color photography. Maybe it's because I have the painter's instinct.

Last summer I was faced with the problem of going to Egypt to do some photographs on the Nile and on Egyptian art. As I'm sure you know, color films vary among each other and all differ from reality. It was time to experiment. I took Ektachrome X, High Speed Ektachrome, Kodachrome II, and Kodachrome X with me to my home in Maine where I was going to have plenty of time. On the first rainy, gray day, I shot all four films. I had four Nikon bodies with me, but I used only one lens so the color of the lens would be consistent. I shot the emulsions within seconds of each other, bracketing exposures so there would be no question about a variation in density determining color rendition. I shot trees, the fog, and the sea. I photographed my daughter who had normal flesh tones, a white building, green grass, and a garden with yellow, red, and purple flowers.

When we looked at these pictures, the variations were shocking. I showed them to Herbert Orth at the *Life* color lab, and to George Karas, chief, *Life* photo lab, as well as some of the other photographers at *Life*. Of course, people have done this experiment before, but I hadn't done it lately. The assignment was important enough for me to make the tests because I had to choose the emulsion or emulsions which would best suit the job I was going to do.

I don't know how many photographers would go to this extreme, but of course *Life* magazine always tests an emulsion when a new supply of film is purchased. *Life* can't take the manufacturer's word for the corrective filter which may be necessary. *Life* decides through controlled tests, constant across time, which filters are necessary to bring that film as close to "normal" as possible.

For me color film is neither reality nor romanticism. It is far from ideal. We are dealing with material which varies enormously. In working as a color consultant on the motion picture *The Greatest Story Ever Told,* which was a $20- million venture done by George Stevens, I was given two months to make tests. I shot with a still camera and with a motion picture crew for a month. We photographed the costumes to be used in the movie, the kind of paint used on the set walls, and we experimented with filters, because George Stevens also believes that color film straight out of the can is a damn primitive vehicle.

What is so sacred about color film in a motion picture? Is it different than sound or the movement of a camera or the script or anything else? Color in still photography and the motion picture has simply been accepted because it was there, without control. I can't understand why. Would any artist, any painter, come into this room and do a drawing in color as a facsimile unless he were a hack, a commercial hack? Wouldn't he introduce his personal feelings? Color, just as any visual aspect of photography, must be consonant with the subject. This is of key import.

Better Cameras Needed

Finally, I'd like to say a few bad words about the camera manufacturers. There has been very little progress recently in the mechanics of photography. We were all pretty

excited about the single lens reflex, but what's been done since the Nikon F? My Nikons from four years ago are in good condition, so there's hardly any reason for me to buy new ones. The shutter and mirror still make enough noise to scare one out of his wits. When I photograph a movie I have a sheepskin pillow with a hole in it to wrap around the camera. It looks like a muff, but it eliminates about 80% of the noise of the camera which offends movie actors, the director, and myself. Who wants to hear that bang?

It's about time photography be simplified — almost to the act of seeing. Why should photography be such a mechanical thing in which you lift it, crank it, set it. We have been experimenting with photoelectric cells and automatic focusing, but I really think photography is still primitive. I once suggested to Eisenstaedt that we ought to try to find a way of threading film through one ear and click, click, with the eye, only to have the film emerge from the other ear! This would indeed reduce photography to its essence: seeing.

Wouldn't it be rather extraordinary if we could go around and make photographs without having to move our hands, without having to pick up cameras? You could see something rather beautiful and click one eye, or grit your teeth, or shake your shoulder, or who knows what, but you could make a photograph. You can imagine what kind of human documents one could make if he could capture life, so unaware, and with no intrusion by the photographer's equipment.

A PERSONAL PHILOSOPHY

BILL PIERCE, 1970

Mr. Pierce delivered his extemporaneous remarks as a conferee during a panel discussion. He is a photographer and writer, his work appearing in *Photography* magazine as well as other national publications. He resides in Princeton, New Jersey.

For a long time I made my money as one of the mechanics in the photographic industry. Then about two or three years ago I started to earn my living as a photographer. Thus, very recently I faced the same question which you're asking at this moment: what is "in it" for you? My first reaction is that it is a very silly question.

You see, if you love your subject so much that there's no question about it, there's nothing else that you can do but take pictures. And, if you can't live and breathe those images, if they don't give you some kind of food and support, then you should not be a photographer. If you put the time and effort required to become a competent photographer into some other field, no doubt you could make much more money.

You see, some of us have no choice because of our commitment, and we're happy. My first year in photography I made $7 a week and I was happy. I didn't worry about whether the magazines were dying or anything; I just wanted to take pictures. Now, my mortgage is paid; I have two kids whose college educations are paid, and for my age

I am a very rich man. I am rich not because I worried or was concerned about making money, but because I was so happy to get up in the morning and do what I wanted. There was no will power or discipline involved. It was the easiest thing in the world.

If you have to ask the question of what is in a life of professional photojournalism for you, I think perhaps you ought delay your commitment for a year or more. I don't mean this unkindly, because there are so many other productive and rewarding things to do. You may wish in a year to come back to photography, but if there is any question in your mind, don't be embarrassed to keep looking!

THE WORLD IS MY SUBJECT

DAVID DOUGLAS DUNCAN, 1957

Mr. Duncan is a freelance photographer and writer of international reputation. He has served as a staff photographer on *Life* and *Collier's* and has authored eight books: *This Is War!* (1951), *The Private World of Pablo Picasso* (1958), *The Kremlin* (1960), *Picasso's Picassos* (1961), *Yankee Nomad* (1966), *I Protest* (1968), *Self Portrait U.S.A.* (1969) and *War Without Heroes* (1970). A 1938 graduate of the University of Miami, he returned often to the Miami Conference to pay a visit to his *alma mater* and his former chief, Wilson Hicks, who had hired him at *Life* after World War II. Duncan lives in France, but travels the world on assignment for magazines and television.

Last autumn I traveled to Russia with John Gunther to do a job for *Collier's*, which I had joined a few months earlier. I went there hoping to photograph the Volga, which had not been covered in black and white or color by anybody from the West. I was optimistic, but naive, for I found out that no one who had traveled down the river to photograph — not even Russians — had been allowed to publish his pictures outside the Soviet Union. The situation was really hopeless.

The second night I was in Russia I crashed a diplomatic function, and there was Nikita Khrushchev with an interpreter right at his shoulder. I said, "Look, you run things in this country; fix it up." He didn't.

I looked around for a second subject, and what I found seemed so obvious I was surprised it still existed as a picture essay. It was Moscow's Kremlin, which had never been photographed inside to show its treasures. I had thought of the Kremlin as the center of political intrigue, which it was and still is. But, it is also one of the greatest art museums in the world — a fact known by very few people in this country. Surprisingly, I cleared permission to do this story, but had to shift gears from the concept of doing a vast river story to an art story. It was necessary to work quickly, for I had only a 30-day visa, and I was there as a tourist, not as a photojournalist.

In shooting the photo essay I try to take a subject, tie it together and end up with a package which can be sold. I'm very interested in telling the story, enjoying the story, but

also in keeping a decent home for my family. And, I enjoy buying paintings and lots of other things; this is my way for getting them.

Now I'm going to try to say something especially to the younger ones which hasn't been said here. It's how I started as a photographer. You have many important photographers and editors in this audience, but no one has told you how he got here.

I'm a freelance, so I'm just like you guys. I've had more experience than some of you — maybe some have had more. I make my living with my hands and my eyes and my camera — it's very simple — and my background.

A Fire and My 39¢ Camera

I was a student at the University of Arizona, Tucson, in archeology before I came here, and at the end of my first semester — examination week — the radio came on to announce that the biggest hotel in town was burning down. I said great! I had no exams that morning, so started to rush out the door. Then I stopped, because the day before it had been my birthday and my sister had sent me a little 39¢ bakelite camera . . . a thing called a Univex. I thought, "God! A fire! It's a camera; it's a gift. I'll make pictures with it." So I did.

I went downtown to the Congress Hotel in Tucson. It was a brick building, three stories, gutted completely. I tried to cover different aspects — to show the people involved, the firemen, and the smoke and all. While I was standing there watching this thing I noticed at one door a man trying to convince a fireman to let him go back inside. The fireman wouldn't let him go in, and I made a shot of the two. But, curiously enough, the fireman went in only to come back in a few minutes, choking and spitting and full of smoke, with a suitcase. This guy tried to get in to get a suitcase, and I made a shot of him.

It could have been the start of a wonderful story — but it wasn't. It's the start of my life as a photographer. Three days later the newspapers carried a screamer headline that John Dillinger had been captured in Tuscon. He was the character. He had been in there, holed up with his gang, and the fire flushed him at 7 o'clock in the morning. That suitcase had all his money, his pistols, and loot and the whole shebang . . . and I had photographed the son-of-a-bitch right in front of me! Truly, yes! When I saw this story, I went back and processed the film and there was the man. Of course, it was a kind of Johnny-come-late story on how you didn't succeed as a news photographer, but I learned about deadlines and how to cover news later. That was the start of it.

I used that bakelite camera for months. It was Steichen who once said that no photographer has ever lived who has exhausted the possibilities of the cheapest camera ever made. But, for what I wanted to do, I had exhausted its possibilities.

I bought a slightly more expensive camera, a Kodak, for about $30 and used it for the next year. I didn't like school very much, so I often traveled into Mexico to hunt, and I wandered around on expeditions — anything to get out of school. The only purpose for using myself as an example is that you young photographers might find a key some place; you might be experiencing some of the same pattern.

I switched from Arizona to here, the University of Miami, and at the same time purchased another Kodak, a folding Kodak, for $35 or $40. It had an f/4.5 lens, but was a good camera. I'm sure I could make my living with it today if I had to. I used it for the next three years.

Photography, the Sea and Travel

When I came to the University of Miami I was very interested in marine zoology; I was fed up with archeology, for I had been studying with a professor who believed that all students should spend most of their time in the lab, an idea of which I took a dim view.

At Miami I began taking pictures of deep sea diving expeditions, later managing to make some trips into the West Indies as well as the Everglades, and thinking at that time of how I could put a series of photographs together. A single photograph is all right — and I wasn't yet thinking in terms of the picture essay, believe me — but I was thinking in terms of individual shots tied together.

One morning in Acapulco I saw an Indian coming around the end of the waterfront in a canoe, throwing a cast net. I grabbed my camera and ran out on the end of the jetty to make a shot of this character as he came past me. I was very lucky, for at that time the travel adventure shot was fresh. My picture won second prize in Kodak's National Snapshot Contest. I took the $250 cash award and bought a Speed Graphic. After using the Graphic for a while, I traded it off for a Graflex. I was thinking in terms of pictures all the time.

In those days I traveled pretty light in an old Ford touring car. I was risking any profit I made on taking more pictures which I thought might pay off.

Mexican netcaster, Acapulco, 1937. David Douglas Duncan

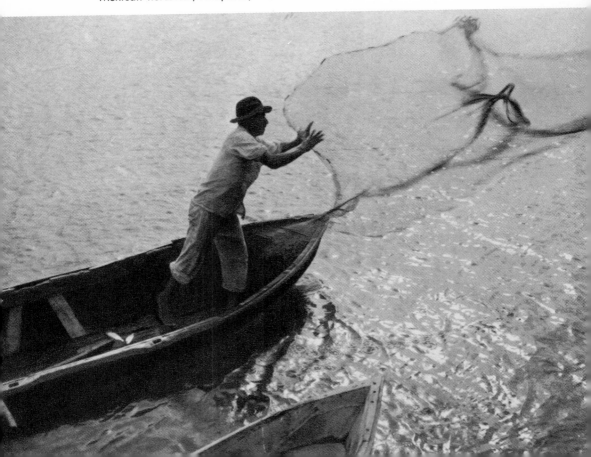

I didn't want to work in Miami; I wanted to travel around, so I went to the public relations office of Pan American where I saw Roger Wolin, their press director. I said, "Look, I think I can photograph some of the islands to where you fly clippers and make interesting photographs for your company's promotion as well as for feature pieces of interest to the roto page editors." The roto page was my goal at that time: I needed an outlet which would buy and publish my work. I also wanted the fun of taking the pictures.

All this time a friend in Miami was letting me use his lab, which reduced my overhead to almost zero — just the cost of chemicals and paper.

I talked Pan American into transportation for two trips into Latin America. Many of the pictures were published later as spreads in the Miami *Daily News* and in my home town of Kansas City.

Freelancing

One thing led to another as the years went by. Freelancing was really a deal — I was taking picture stories here, catching rattlesnakes or deep sea diving in the West Indies, and pearling off Mexico. I'd take a selection of negatives from one of these trips and print each negative about 35 times, 8 x 10 glossies, making packaged stories out of them — 8 to 15 prints per package — hoping I could sell a spread or two. Then, when I had all of the sets ready, I'd get in my car and head for the markets.

With no sense of frustration with or dislike for picture agents, I think the best possible contact is your own face at the door of an editor's office, at least for the first couple of sales. You learn who they are; they come to know who you are. There is a direct knowledge of you and your work in the editor's mind when your next story hits his desk.

I'm a freelance; it's been 20 years since the start, but again I'm a freelance, and the many small magazines and other markets are still here. But, I'm convinced if a beginning freelance were to find four, five or six fairly tight picture stories — and you can get your ideas by looking at magazines — they can be sold almost any day. You begin by supplying the demands of an editor who must have editorial material in his magazine every day, or week or month. Very simple.

Then follow right on through. Do it yourself, though; don't expect others to do it for you. As Ray Mackland, *Life's* picture editor, pointed out the other day — he wasn't blunt; I will be — just because you bought a camera, don't think you joined some sort of a holy order. It can be a hobby or a profession. It's up to you. But no editor on earth owes you a damn thing! Nothing! He might buy your pictures, but he doesn't owe you anything. You can make your living as a freelance photographer if you want to, if you have the touch, if you know how to put things together. Find a formula for yourself.

I want to carry my own experience a bit further, because there is a definite profession. I took an extended trip on the Caribbean in a 100-foot schooner, later printing 35 sets of photographs and covering the local picture markets. Then I realized the story had national market value, too. So I went to *National Geographic* to see Kip Ross; he purchased it, provided that I also write the copy. The *Geographic* probably was not aware that my story had been seen all over the United States in local publications. Every major city had used this story, but I sold it nationally. It's not unethical. The *Geographic* knew their market, but I knew it too, and I was teaching myself as I went along. I learned

there was a double market for picture stories; they could be sold locally and nationally.

For the life of me, I don't see why so much emphasis is placed on the freelance always aiming for markets such as *Life, Look,* or *Holiday.* Aim first for the local markets You can sell pictures all around, for we're living in the most graphic and visually conscious world ever. There are markets just waiting for you. It's a set up.

I'm forgetting one very important thing, probably the most important. I haven't credited the editors of different newspapers and magazines who are some of the most gracious men I've known in my life. They'll cover themselves in their own territory and hope that you'll sell your story only to them in their area. But they'll be the first ones to help establish you or your work with the next editor. If you're selling in Chicago, they'll send a note, or a telegram or they'll telephone an editor whom they know in Detroit Cleveland, Buffalo, New York, Baltimore or Washington — right along the belt.

I can assure you of sales if you will take the trouble to package your stories — I'm assuming you do have stories you want to sell. You're all here for that purpose; you want to find a market for them. Well, gamble on it a bit! God, you can't do anything unless you have some confidence in yourself.

Go out and meet these editors, and you'll find how each one will pass you along to the next. And it will pay off. The third or fourth time you have a story for a specific editor it won't be necessary to go back; just mail the package with a letter. He'll know who you are.

One of my greatest lucky breaks was my name, because it has a ring which editor like to use. Many times, when I haven't deserved a credit line, they would print it just to decorate the page.

The Yankee Nomad Joins Life

At any rate, time went by, the Marine Corps came and World War II went. After the war, I went to the Time-Life building to see J. R. Eyerman, who was then chief photographer at *Life.* I was still on terminal leave from the Marine Corps. Several day earlier, I'd photographed the daughter of a man who had been very kind to me. He had asked me to make the portrait, but I had no darkroom. I remembered Eyerman from the last days of the war in Tokyo Bay and the surrender. We'd shared some experience together. When I went to see him at *Life,* I asked if I might use the lab to print the portrait.

He replied, "Of course, What are you doing?"

"Going on a long, long vacation." I had not vacationed since the days in South America before the war.

He said, "Would you like to work for *Life?*"

I replied, "You know, that's not the sort of opportunity you answer casually. think every photographer would like to have a crack at *Life.* It's a great outlet for pictures."

He said, "I've just been talking with Wilson Hicks, and there is trouble in Persia The Russians are threatening to take over Teheran. Tanks are 20 miles north of the town. Hicks wants coverage of Persia — now. And most of *Life's* staff photographers a

married; our wives tell us that we won't have wives if we go overseas again so soon. Why don't you try to make a pitch for that assignment?"

The war was just over. I was single. He said, "I'll make an appointment with Wilson for you." And Mr. Hicks and I got together on our terms.

So I went to work for *Life*. When the Persian story was over, trouble had begun in Palestine with fighting and murders in the streets, explosions and illegal immigration. These were all stories. The Turkish Straits were to be photographed, and Bulgaria was sinking under Communist domination.

And I was pretty naive. I thought that every photographer on *Life* who worked overseas saw all of his stories published in the magazine. So I kept shooting them, and they kept appearing, because I had luck. I had a bit of a flair for getting into and then quickly out of trouble, and for staying in one piece. I've been lucky that way too. I had met a young lady in Persia who was of Turkish-Egyptian extraction, and a year and a half later we wanted to get married. I was then shooting a story in India. I had written to Wilson about this, but unfortunately the riots of India had started at that time, and the mail was not moving. I didn't know about that, however. I'd been out on the frontier of Burma and what is now Pakistan and India. I wanted to leave India on a specific date. I knew that Margaret Bourke-White was coming to do her work in India, too.

No answer came from Wilson, so I sent him a cable which said I would be leaving the magazine as of October 15.

Oh, I missed a key element. I had received a cable from the managing editor asking me to do a double job on India and Pakistan, the birth of two nations. Well, I believed that I had already done that in a story which *Life* had already printed. I had covered the partition of Pakistan and India, and photographed Mountbatten, Gandhi, Nehru and all of them.

I cabled back that as indicated in a cable to Mr. Hicks, I was leaving on the 15th of October, that I thought I could freely express myself, that I had no personal ax to grind, but I thought the story had already been done. I received a cabled reply saying that in view of my leaving on October 15, my service was terminated effective September 30. Well, that was early September.

I read this thing and thought how very kind of him — I was thinking of October 30! Lee Eitingon, who later became the assistant picture editor at *Life,* was with me, and I showed it to her. She half read it and then said, "Oh, good, let's go have a Chinese dinner." We'd just come in from Burma, and we were really badly beaten up. I had lost 40 pounds during the preceding six weeks in that tropical heat. So we were eating — God! She can really eat; we ate two straight hours. All of a sudden she blurted out, "You've been fired." I had been fired.

Fired — Rehired

I sent Hicks a cable and said, "Possibly you did not get my letter which explained why I wanted to quit, and you think I'm walking out on a job. I'm sure you'll understand when you get the letter, if you get the letter. Meanwhile I'll try to backstop it along the way, but I'm still leaving. I hope things do clarify themselves." Of course they did.

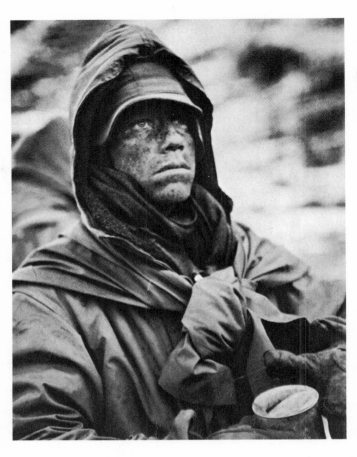

First Marine Division, Kot'o-ri, North Korea, December, 1950. David Douglas Dunca

Opposite page: Life goes on, Korea, 1950. David Douglas Dunca

When I reached New Delhi on September 10, a sad, lucky break in a way, I ra right into the beginnings of a Hindu-Moslem riot. I followed it through, but I couldn use my camera. It was impossible; I would have been killed if I'd tried to use it. But, observed it all as a reporter. As I was leaving for Cairo to get married, I sent Wilson cable from Karachi — Delhi was impossible; people were killing each other everywhere and you couldn't get to the cable office. I told him, "You possibly have not yet received th letter. It doesn't make any difference, but I have had an extraordinary experience today I have been through a riot, a communal riot, from the beginning, where people wer chopping each other to death — grandmothers, grandfathers, babies, mothers, everyon I think it's a text piece for *Life*. If you'll cable me in Cairo if you want it, I'll try to writ it before I get married.

When I got to Cairo a cable was there. Wilson had received the letter, and he sai "We've gotten your letter explaining why you want to leave the magazine. We unde stand thoroughly. Best wishes for your marriage. As to the story, we want it day aft tomorrow." So there it was.

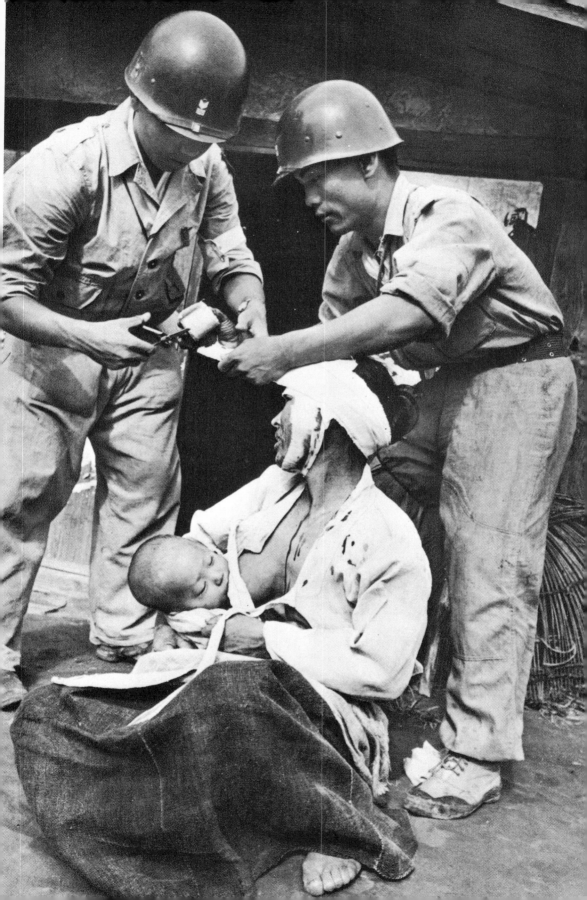

I returned to New York about mid-October, 1947, and agreed with Wilson Hicks on going back on staff after a long leave of absence on salary, a vacation, the whole shebang. But I didn't check with J. R. Eyerman, who really knew the ropes at that time. I had been overseas and didn't know anything about New York operations.

I still thought every magazine photographer had all of his stories published! I should have hit Hicks for a 50 percent raise, but I didn't. So you learn lessons as you go along. I joined *Life* again and we went for 10 more years before I quit for personal reasons to join *Collier's*.

I was on assignment in Russia for *Collier's,* and while enroute back in Vienna, the word came that *Collier's* had collapsed. I was lucky, for at the time of my signing on with *Collier's* we had verbally agreed that property would be mine after first publication. Well, I had all this material. There was no first publication. There was no *Collier's,* so the material belonged to me.

Wheeling and Dealing

When I came back to New York to try to put the pieces together, I found that *Life* was interested in the Kremlin story. John Gunther, who was also working for *Collier's* in Russia, had come back. He sold his piece to *Look*. They needed a cover, so I went over and saw Arthur Rothstein, Dan Mich, and Ben Wickersham. They said that there was practically no space for pictures to illustrate John's story on Russia, because Phil Harrington had been there. But they needed a cover. Fine. And then Dan Mich said what a shame it was that the Gunthers, John and Jane, had been in Russia for seven weeks, and no one had made a shot of them in Red Square. I said, "Except mine!" And God, his face hit the table, because he'd already showed his hand.

Now there was a very simple lesson for the freelance. The cover picture was good enough; it went for a decent price. But I was tough about the color one of the Gunthers, because I had the only shot. I was a professional freelance. *Look* needed to prove its author was in Moscow. The color picture was horrible, made with practically no light late in the evening. They played it for a third of a page in black and white and paid me a thousand bucks for it!

When Ben Wickersham was editing the pictures he asked to see the Gunther slides. He didn't know anything about what I was asking for one picture. He just tossed them on the table. I said, "Maybe you ought to put them in an envelope so they don't get lost."

He answered, "Okay. Now, what do you want for them?"

I shot back, "A thousand dollars for one."

He looked right at me and said, "I'll remember."

But getting back to the main course of the conversation, I don't feel that any editor here owes me a damn thing. I'm qualified to go out and earn my living with my camera right now. And, there are lots of stories around. I have fun doing them. The other guys feel the same way. That's it!

100 LIFE COVERS

PHILIPPE HALSMAN, 1970

Mr. Halsman, who was born in Latvia and served a stint at *Vu* in Paris, emigrated to the U.S. in 1940 and shot his first cover for *Life* on assignment from Wilson Hicks two years later. Author of numerous books (including *The Frenchman, Halsman on the Creation of Photographic Ideas, Dali's Moustache* and *The Jump Book*), he is noted for interpretive portraiture and his ability as a creative picture maker: one who can create abstract ideological solutions for visual communication problems. Mr. Halsman was elected the first president of the American Society of Magazine Photographers and fought for the recognition of the photographer and his rights. He has been an active member of that organization since its founding.

I should like to give a digest of the 27 years of my work for *Life,* which culminated in my making 100 covers. I am aware that most listeners came here to get something useful. And, the logical question for us to ask at this time is whether it is useful to hear about the problems involved in making magazine covers, when we are not certain whether there will be any magazines left! This question is so important that it merits and must receive our serious examination.

I don't believe for a moment that because I am the only photographer who has made 100 *Life* covers that I am better than a photographer who has made either one cover or no covers at all. The value and talent of a photographer is not measured in numbers. But, there is a great difference between making a cover for any magazine and making one for *Life.*

I remember *Life* once dummied 100 pictures, any one of which could be a future cover, and hung them on the managing editor's wall. From these the editors selected the one which was to become the next cover.

At other magazines if you are assigned to shoot a cover and if you don't bring back a really bad picture, the cover will run. And so the 100th cover does not represent that I was assigned 100 covers to shoot; I was assigned 200 or 300, many of which didn't make it. But, the 100th cover means that 100 times I have won the *Life* cover contest!

What has helped me to win it? Number one: I came from Paris to this country with a thorough artistic and technical background. Number two: I did not shoot simply hoping that one photograph would eventually make the cover. No, I thought about it; I meditated, deliberated, cerebrated and cogitated.

Analyzing the Medium and Its Audience

When you shoot a cover, you must ask yourself whether the magazine is sold on newsstands or sent only to subscribers. If it is sold by subscription only, you face a captive audience. In that circumstance any good photograph can be used as a cover, and

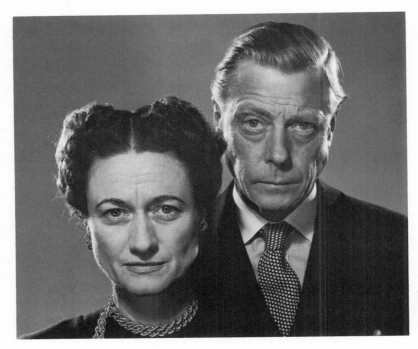

Duke and Duchess
of Windsor

you don't have to worry whether a cover will stimulate a desire to buy the magazine or not. You can be as original and unusual as your editor will allow. This is the bane of our profession—that between our work and our audience there is always an editor who sometimes is a stimulator, sometimes a fine judge, but usually a censor applying his personal prejudices.

When, however, the magazine is to be sold on newsstands, the situation is much more complex. The cover must compete with other covers; it must have a poster effect. It must be recognizable from afar, but should not disintegrate into unsharp blobs when examined closely. It must have impact to fight the other covers. Finally, it must have this undefinable quality which will make the onlooker want to read the magazine.

Here a new question is raised. Should the photographer be so mercantile as to consider whether his photograph will help to sell the magazine? Let us transpose this question. When a dentist makes a beautiful set of teeth, but the patient cannot use them, has he performed as a good dentist? Or, when a photographer makes a beautiful picture for a magazine cover and the magazine cannot use it, has he performed as a good photographer?

The trouble is that the word *photographer* straddles two concepts: one as professional; one as artist. During the Renaissance, every artist worked as a professional for clients, creating paintings, poems, or musical compositions to order. The idea of "Artist," only working and suffering to express himself, is a romantic, modern idea.

Without trying to solve this dilemma for you, let me share how I solved it for myself. When I work to express myself, I try to please only myself. Of course I hope eventually the result will be published, perhaps in my own book; or perhaps it may be exhibited. I refuse assignments which are in conflict with my convictions. But, when I work on an assignment or on a cover, I am a professional trying to produce a photograph which can and will be used. What are good magazine covers? Poster effects and impact are pre-

Philippe Halsman,
1947

requisites. A cover must also interest, intrigue, attract; it must not repel. A cover must be a promise that one will spend an interesting hour with the magazine. If the cover is a portrait, the subject should not have an empty, blank or repelling expression.

The first story I was assigned to shoot by Wilson Hicks for *Life* magazine was on hats. And since I came from Paris, he thought that I would do well with hats. To the great surprise of everybody, one of the pictures was selected for the cover. I think the reason was not the hat, but the model's expression. And, it is the photographer who is responsible for the expression of the people he photographs.

Very soon after that I was asked to photograph the Duke and Duchess of Windsor. They came to my studio; I arranged their pose, putting their heads close together. They looked at my camera like two hungry hyenas. And, being a photographer—photographers are mean—I took the picture and then said, "You cannot look at my camera like this; you are the most romantic couple in the world, the king who has given up his crown for the woman he loves." It took seven to ten seconds to say those words, but what a change they produced.

Another very early cover I shot for *Life* was of Judy Garland. When I arrived there Judy was terribly upset because she had just returned from court where she had been granted her first divorce. She was almost in tears, and I knew that if I showed any sympathy she would dissolve into tears. I would not get a glamorous *Life* cover. So, very harshly I said, "Judy, you know the first divorce is the most difficult; after a while you get used to them." She looked at me with hatred, but the crying spell was over, and I got my picture.

When you shoot a cover you try to avoid blank expressions. You try to get an expression that means something. And, as a matter of fact, I usually try not to get the expression that happens in a minute, but to get an expression that sums up the personality.

I always think that I make the cover; the art director and the subject always think they make the cover; the managing editor thinks he makes the cover!

Dali Atomicus Philippe Halsman, 1948

I was once asked to photograph the chief of the Air Force, Hoyt Vandenberg, for the cover as well as the man next in line, Lauris Norstad, for the opening picture of an article on the Air Force. I went to the Pentagon; Hoyt Vandenberg said he'd give me two minutes to take his picture. He was very self-conscious, but I made as good a picture as I could. Lauris Norstad gave me one hour to shoot the picture. Lauris Norstad was on the cover; Hoyt Vandenberg was inside.

About 20 years ago, I became very much interested in trying to break the barrier of expressing abstract ideas in photography. It involved double printing, double exposures and many other techniques. One day I made a picture of Dali to show that, as in an atom, everything was in suspension. It took me a very long time to shoot this picture. We had to throw the cats 28 times. I would develop the film and then come down to say I didn't like the composition. We would wipe off the floor, catch the cats and throw them again, and Dali would jump again. Finally the picture was produced. I showed it to Wilson Hicks.

Showing Hicks a Photograph

One of the most pleasant memories of my life was Wilson Hicks' reaction to an unusual picture. He'd laugh; his eyes would light up; his hands would tremble; and he would look like a miser who had discovered a treasure! It was better than anything; there was excitement. We all tried to produce this excitement in Wilson Hicks, for his excitement was one of the great influences in our work.

The picture of Dali was published in *Life* magazine as a double truck, eventually being shown in the 50 greatest pictures of the first half century.

During one six- or seven-year period every famous person whom I photographed I asked to jump for me. I had discovered the fact that while a person jumps, one can see his character reflected in that jump. The meek person will jump meekly; the energetic, energetically; the ambitious, ambitiously; the sensuous, sensuously; and so on. So *Life* magazine printed some of the pictures which were part of my "jumpology," the science of jumping.

Whenever I shot a *Life* cover, I always did some thinking about it. One has to plan, for if one just shoots hoping to make a cover, chances are he won't.

The 99th cover I made for *Life* was of Mae West, but breaking the 100 mark went slowly because *Life* had become even more a news magazine, and I am not a news photographer. Sometimes I thought I would never make my 100th *Life* cover, so I photographed myself with 99 covers, leaving the 100th blank. Then I was asked to photograph Johnny Carson. The story was that behind the smiling man lies a very complicated and serious human being. The issue sold better than any other issue of the previous six months!

Yvonne and Philippe Halsman with 99 covers

Philippe Halsman, 1969

PHOTOJOURNALISM NOW AND TOMORROW

MARGARET BOURKE-WHITE, 1958

The late Miss Bourke-White joined *Life*'s staff in its pre-publication era following a successful career as an industrial photographer and *Fortune* magazine staffer. She photographed *Life*'s first cover (November 23, 1936) and its first lead picture story: "10,000 Montana Relief Workers Make Whoopee on Saturday Night." Multiple flash and a large camera were her tools then. Author or co-author of 11 books, including her autobiography *Portrait of Myself* (1963), she estimated she had traveled about a million miles for *Life* and shot some 250,000 negatives. During World War II she documented night bombing in Moscow, fighting in Italy and Germany, and the horror of Nazi concentration camps. Her battle with Parkinson's disease began about the time this speech was delivered in Miami. She underwent surgery and continued to lead an active life at her home in Connecticut until her death on August 27, 1971.

It is a very moving thing when you love your profession as I do — and as I'm sure all of you do — to meet with a group of people who are really trying to learn more about it, to improve their own work and to improve the work of others. It is especially important these days because the little black box with a hole in it is entering a new and more noble role. None of us who has been taking pictures for a quarter of a century would have guessed 25 years ago that this little instrument would become one of the chief recorders of history as well as a vehicle which could move others, affect their actions and influence them.

I remember someone once asked Wilson Hicks what makes good photographs. He gave one of the greatest one-word answers of all time: *photographers*. But, the photographer now bears quite a new responsibility. Whether we like it or not, because of television and other new media, photography has suddenly entered the world stage. We are in a position to influence millions. It now becomes more important than ever for us to learn to discover the truth and then learn how to show it in photographs. But, finding the truth is often an involved and unsure process.

A few weeks ago *Life* had a most unusual opening page and lead picture in its newsfront section. This was a single black page with nothing but one line crossing it. Of course every reader knew what that line meant: Sputnik had been fired into orbit around the earth, and that became the biggest story in the world. Just think what a new sort of public — an informed public — we have when one realizes that at least 26 million people saw and interpreted that photograph in *Life*. That's how the world has advanced. To some readers it had political implications; to others, scientific. To photographers it was a very difficult problem of light: how to capture that star, that line on film.

Fortunately I did not have to make the photograph, but, nevertheless, I went outdoors early that morning just before it was light, hoping to see Sputnik. I had awakened

early enough to brew my little pot of coffee and swallow it before running up a little hill nearby. As though it had been by appointment, I saw a group of stars, one of which seemed to be moving. Then this great thing which looked like an enormous planet came walking down the road toward me. If I had been in a pagan land with an earlier form of culture, I probably would have dropped to my knees and worshiped this strange new god. Here was this great star, seemingly moving right down my country road in Connecticut, passing over my head and going toward Long Island Sound. That was the rocket. I was just about to leave to make a second pot of coffee when I saw a bright little circle which appeared and disappeared; that, I suppose, was Sputnik. But, just think what it means when a single line taken with a camera can carry so much symbolic meaning to millions of people.

As the years go by, I continually evaluate my mistakes and wonder what I can do to improve. I think it is a great temptation for the photographer to just perceive and photograph the highlights of a situation, because we are accustomed to reacting very quickly. Many times we do not have a chance to properly think through or digest our experiences. But, adequate time for evaluation and interpretation is becoming more and more important for us.

Assignment India

I remember when Wilson and I first discussed my assignment in India. We worked out a few topics which we both thought I should cover, including the caste system — and how we suffered through that one. I didn't know enough about the system to determine what to show, so I had to buckle down and learn about it.

My first assignment in India was to photograph a group of the political leaders. I went first to Mahatma Gandhi, expecting to find a simple peasant who would be glad to have his photograph taken for *Life* magazine. To my complete surprise I quickly learned that Gandhi had five secretaries. Well I managed to get through four of them. Then I reached the fifth secretary, who was very taciturn. I explained that I had come all the way from New York, from this enormous magazine *Life,* to take a photograph of the Mahatma at his spinning wheel. The secretary asked, "Do you know how to spin?"

I replied, "I didn't come to spin with Mahatma Gandhi; I came to photograph him spinning."

"Ah," said the secretary, as he began a series of rhetorical questions, "How can you possibly interpret the heart of this great man? How can you possibly show his soul and the principles that have guided him? How can you possibly take a picture of the Mahatma at his spinning wheel unless you first master the principle of spinning?"

I argued that I was a member of the staff of a mighty magazine, that we had deadlines to meet, that the negatives would have to be sent halfway around the world, and that at each of *Life's* far-flung offices a messenger would meet the airplane carrying those films, take the package to the next plane until finally it reached La Guardia airport in New York. There *Life* messengers would again pick up the package and rush it to *Life's* photographic lab for overnight processing and enlargements of the best

Gandhi Spinning Margaret Bourke-White, **Life** magazine, © Time, Inc., 1946

films. They would be fresh on the desk of Mr. Wilson Hicks and other editors by means of this elaborate chain of events. It made no impression at all!

The secretary continued to insist that if I were to photograph Gandhi spinning, I must first learn to spin. Well, as a photographer you know when you're licked. I carefully inquired, "How long does it take to learn to spin?"

The secretary answered, "That depends on the quotient of one's intelligence."

With weariness I finally said, "I'd like to learn to spin, please."

"Come back next Tuesday," was the response. "I'm editing Gandhi's newspaper and have a deadline to meet!"

I used all the means of persuasion that I had, and finally, then and there, he was persuaded to give me a lesson in spinning.

You know, it looked so easy when I saw other people doing it, but I was terribly embarrassed, because I kept breaking the thread or knocking the spinning wheel over. I was awkward at this new skill. Finally I tried to joke about it and said, "The *charkha* — that's what they call the spinning wheel — and the camera are both handcrafts."

"Yes," said the secretary, "but the greater of the two is spinning."

Finally — he either became very bored with my slow learning or he was convinced I had learned enough — the time was approaching when I would be allowed in the

presence of the Mahatma. From the outside I had cased as much as possible of the location where I would make the photograph. It was a little hut with only one small, square window. As a source of light that window would not be adequate. I picked up my equipment and began pouring peanut flashbulbs into my pocket.

"The Mahatma dislikes flashbulbs," the secretary observed. Again I argued, and finally the secretary allowed me to take three bulbs. As I was about to go to the hut, the secretary cautioned, "Now you mustn't speak to the Mahatma. Today is his day of silence." On Mondays the Mahatma spoke to no one, having communication with his soul, praying and resting.

I was delighted not to have to talk to him and agreed to work in silence. I stepped into the little hut, and just as I expected, there was one tiny window right above his head. This was a severe available light problem, because all of the light struck the back of his head. There he sat, this little brown man. I set up my cameras and started to work.

Perseverance Demanded

I don't know why, but most of the time my shutters function very well; that is, until they're put in front of some important personage. Then, it seems, they stop functioning all together. I was all ready to shoot and had inserted one of the now-precious flashbulbs. Then Gandhi made a beautiful movement, bringing his hand up with the thread in a lovely slanting formation. I pushed the trigger. But, I could tell by the bright flash of light and the long shutter lag that things were not working properly. I hadn't gotten that one.

Again, I set up the camera very carefully, but determined that I ought to save that second flashbulb for a while. I would use available light — we didn't use that term then — and take a time exposure with the camera on a tripod.

All of you no doubt understand exactly how I felt when I tell you that one tripod leg froze at its minimum length and two at their maximum. No shot could be made by available light. I decided to risk the second flashbulb. This time I used extra care, and again Gandhi made the beautiful movement with his hand. Again I pushed the trigger. It was perfect this time; everything was in synch — then I noticed I hadn't pulled the slide! With the third bulb I got it. Still it is hard for me to explain to you how much India changed my life, not exactly in the spiritual sense, but because it was so demanding. There was so much I had to learn; the difficulty with comprehension of the caste system was just one example.

While in India I started to work on a book about the country, later returning to the United States to write it. Half through, I resolved that I just didn't know enough about India to complete the book. After studying the photographs made on the first trip, I decided that a story had to be built up with much more thought and with more seeing of both sides of the question. It was too easy to go to India and be drawn into the "country club" set where you receive manufactured opinions which must not guide you. It takes longer to go out in search of your own definitions, but it has to be done that way.

There were so many important things happening in India. First was the question of the princely states. Would the maharajas be allowed to keep all their pearls and motorcars? What was going to happen in a social way in India?

I developed a kind of technique which was fun to use and very useful, too. I would visit a maharaja and take pictures, which was easy, because it is always easy to meet people at the top — it's much more difficult to meet people who are farther down on the scale.

Then I would take a second trip to visit an entirely different group: it might be mainly made up of farmers. It gave me a chance for comparisons.

The photographer must learn and know more all of the time, the issues behind the issues, because there is no limit to the information and knowledge which he can use. In addition to the camera the photographer must use his heart, his feelings, and the "hunch" system, too. He must feel that things are right, that things are true.

I think the camera can be regarded as sort of a little treasure house of its own; it has its own little sparkling jewels, the beautifully polished lenses. The camera is a strange little box which will do almost anything you want it to do. But, it can do nothing unless rays of light are let in, and it is the photographer who determines which rays shall enter.

Commanding Photographic Technique

While it is not necessary for us to return to the photography of 25 years ago, I think students of photography should work for a while with the view camera and do their own lab work — enough at least to understand the possibilities and controls. There is something stimulating about the view camera as you compose a picture. You feel a little as a sculptor who is reaching out his hands, who wants to mold something with both hands. The camera seems to do that for you. If you can learn to use many different focal lengths, it becomes a little like your verbal vocabulary: when one has a large choice of words he can talk more clearly and interestingly. Somehow the view camera does that for the photographer. It is very easy to chase around with a little camera, shooting all over the map, and saying, "Oh, they can fix that in the darkroom." But, that's not the place for fixing. Photography is a creative medium, and the creating should be done as much as possible right on the spot. When it comes to what will appear in the picture and what will not, you are trying to simplify your image; that is good composition. Every single detail should be excluded if it doesn't support the statement.

Photography in the hands of some is a fine art, and in the hands of others it is a competent means of showing what is going on in the world. Both functions are extremely important. But, I do think the youngster must master the habit of thinking, seeing and feeling for himself.

It is a serious mistake to imitate others; an imitation is never as good as the original. A habit of creativity and selection should be self-taught. When the famous color pictures by Ernst Haas were published, they gave us great insight into how creativity could be used in color photography. It was as though the world had been waiting for a photographer to discover those new techniques. I remember when a very competent

Life photographer said, "Oh, these photographs by Haas, if I'd only thought of the technique myself, I could have done it so easily." These words were spoken by a man who is very good in his own field and should have known better. The important point is that his development of Ernst Haas' blur-motion techniques would have had no value, because photography of that sort must come from the individual heart. It is a highly personal thing and it can't be imitated. I don't know Haas very well, but I am certain that by the time he took those photographs, he was boiling inside with this new thing. It had to find an outlet of expression. Everywhere he turned he must have found inspiration for it. And that is what counts.

For a long time color photography was used as an imitator of reality. Black and white pictures are not improved just by adding color. Another photographer who did a great deal along this line was Elisofon, because his color was controlled; none of his images was an accident.

The photographer must learn his technique; he must develop a kind of extra sensitivity toward his tools. Some photographers are using the new, extremely fast films for ordinary work, too. But, why not use the technique or the material when and where it needs to be used? Many times I have been taking pictures along a sidewalk and someone will come along, look at my lens and say, "My, what a slow lens. Why don't you get one of the fast f/1.9 lenses?" If you are taking a picture at f/11 or f/16, an f/6.3 lens is fine. Why carry all the extra glass of an f/1.9 around?

More and more specialties are developing in photography, and since I love airplanes and airplane photography, I am especially happy that we are able to work with that "moving platform." It adds to the camera itself and becomes part of it. Many times as I am taking pictures, I sense that the camera is an extension of my fingers. I really want to grab the world and pull it through my lens. Recently, when working with a helicopter pilot on a story, I asked, "How do you feel in this helicopter?"

He replied, "I feel as though it is an extension of my legs."

Aerial photography gives you a chance to expand the possibilities of photography, but it really must be controlled in close cooperation with the pilot.

For years I have wanted to photograph abstract earth patterns in color from the airplane. I spoke about it often at *Life,* and Ed Thompson, the managing editor, once said, "That would be stretching the medium too much. It isn't quite ready yet."

Then color film speed was improved. But, to make the photographs, of course, there had to be a reason — a story line — and *Life's* food issue was being planned.

This was a perfect opportunity to make abstract views of the earth taken from 100 to 200 feet above.

I'll never forget how I felt when I flew over the Montana wheat fields and suddenly saw the landscape break into bright gold and earth-colored stripes. Farmers who have cultivated the ground for centuries have never seen that sight. In fact, as I left on assignment, one of my editors said, "Maggie, we want you to bring back something that only God and a few seagulls have ever before seen."

When it comes to developing a news story, photography can do what television doesn't generally accomplish: scrounge around for background material, pictures which give us a frame for the late-breaking news when the event itself sharpens up.

Wilson Hicks always had a wonderful hunch about things like that. He seemed to know the right time and place for a person to be, and he also knew exactly which photographer could do the job most effectively.

Shooting the Russian War

When it came to shooting the Russian war — I had been in Russia before — it would never have occurred to me to ask for another assignment there, but Mr. Hicks sensed that something would be happening. He moved me through Asia and into Russia at just the right time, and when the war started, nobody else could get in. So, *Life* had one photographer in Russia and an exclusive during the beginning months of the war.

Now I want to tell you something which I have never shared with Wilson. It sounds a little melodramatic, but the story must be told. When Moscow was first bombed, I photographed it. The Russians were very fussy; as soon as a raid started, every person was supposed to go into a cellar, unless he was on fireguard duty, and on no account could he stay in his room. The Russians would bang on every door to make certain all occupants were safely out of their rooms. It seemed that every time a raid started I was developing film in the bathtub. When the Russians came through I'd hide, usually crawling under my bed. When they were out of the way, I'd get out my cameras, put one on each window sill and then focus on the moon to get infinity. I was ready when the planes got closer. My room had a little metal-grill balcony which I could crawl out on. But, there were Red soldiers patrolling the streets below, and I could hear their voices coming up. I didn't dare let them see me. I would crawl on my hands and knees onto the balcony and as soon as the raid started I'd say to myself, "I'm doing this for Wilson; I'm doing this for Wilson." So now you know!

Snow, Mud, and a Lost Pouch

It is a great challenge to a photographer to be assigned a location where pictures have already been taken and he is supposed to come up with something fresh. Here again Wilson's hunches were the right ones. It happened that I had gone through the first year of the war in Italy, and when the front opened up, I worked from Normandy inward. The boys in Italy who were still slogging through the mud were getting letters from their wives and sweethearts saying, "We're so glad you're in a nice safe place like Italy!" Of course it was hard fighting there because of the snow, grime and mud. They'd been struggling through it for two years. Wilson sent a cable saying *Life* would print an indefinite number of newsfront pages on the "Forgotten Front." You can imagine the great thrill I had when this story was going to be done. I hurried to the front, and a very unusual situation existed: snow in sunny Italy. The horses were disguised like Ku Klux Klan horses, if there are such things. They even had a kind of mask over their faces — all very interesting because of the snow. The boys were washing their faces in helmets of water below the waterfalls. You'd get pictures of these extraordinary spikes of ice. I made pictures everybody seemed happy about and took them to Rome. We went through the negatives, captioned them, and off they went in the courier pouch. Somewhere between Rome and Naples that particular pouch was

Nazi bombing of Moscow Margaret Bourke-White, **Life** magazine, © Time Inc., Sept. 1, 1941

stolen from the courier jeep. Upset, I queried Wilson by wire if there was time to re-do the story. He replied, "Yes, we'll print it whenever you can get it done."

I went back to the front, only to find mud and no snow; it had all melted. And, the mud wasn't muddy enough! It's a heartbreaking thing to have already taken the pictures, then go back, and find the story has vanished — especially if you don't even have any fresh ideas. But, Wilson used what I shot, giving me a good layout, which helped to heal the pain in my heart.

When it comes to equipment, I've always been a champion of the big camera. I've tried to become a small camera user, and I must confess that it took me years to use it with any frequency.

A very unexpected thing happened in Tokyo, Japan, on the morning of May Day which gave me a chance to work with the little camera and become more at home with it. Knowing that there would be a big parade, we started to take photographs. The *Life* boys fixed up a station wagon with a platform on top so I could shoot. I brought all my cameras: a big one on tripod, a couple of Rolleis and the 35mm rangefinder Nikons. When we began taking pictures and I heard the first rock whiz past my ear, I laid down the big camera and picked up a Rollei. I shot the Rollei through. Then I picked up a second Rollei and shot it through. Finally, I picked up the miniature cameras. The driver knew how to load them. He would reload each empty camera and hand it back.

I could never have done the assignment in Korea if I hadn't had this experience with the small camera in Tokyo first. When I reached Korea it was again a situation where everything had been taken, and I was very eager to look into the lives of the peasants. With a war roaring over their country, it seemed to me it was impossible for them not to be affected.

I began working in guerilla areas, because I found that many of the little villages had been devastated by these guerillas, who were pro-Communist and were burning villages to make converts among the youth. The situation was desperate. Most of all, I was terribly interested in the fact that here was a country which was in civil war, village divided against village, family against family and brother against brother. I wanted very much to document that situation. I found a young man who had joined the guerillas, escaped and was rejoining his family. I photographed the reunion of this young man with his wife, his older brother and finally his mother.

Again everything goes back to that little black box which we all know so well. We're proud to be able to use it in this new, expanded way because it really has become a recorder of history.

MY LIFE WITH A CAMERA

INGE MORATH, 1971

Miss Morath (Mrs. Arthur Miller) tells the story of her early work as a writer for *Heute* and *Wiener Illustrierte* before becoming a photographer. She joined Magnum in 1953 and was originally based in Paris, making frequent story trips to England, Spain, the Middle East, the U.S. and South Africa. She has done many stories on the fine arts. Her books include *Fiesta in Pamplona* and *Venice Observed*. Inge Morath presently is involved in portraiture and resides in Connecticut.

In trying to prepare myself for this properly, I started reading, since I usually just photograph, which is a very private occupation. I read what John Szarkowski said about Walker Evans and what Lincoln Kirstein said about Cartier-Bresson. Then I read what Cartier-Bresson said about himself. I became extremely confused. I was really very impatient to get to the immediate visual thing instead of all the words, though I do appreciate them. I guess that finally the reason I became a photographer was that I wanted to grab things and express them visually.

What one tries to do as a photographic reporter is to organize existing things — to put them together — into one moment. That's why I continue to work with still photography. It does just that.

My life in photography did not start with a camera, but as a journalist. I also worked in theater, doing some directing, and I completed my studies in the University. Then Warren Trabant, the editor of the first American magazine in Europe, *Heute*, came to Vienna and asked me to work for him. I told him I had never looked at a photograph seriously, and I really wasn't very interested in photography. I loved painting. He took a big table and spread a number of photographs out on it. He asked me to separate the ones I liked from those I didn't and then tell him why. I did this with absolute certainty that I'd never see him again. To my surprise, he hired me. I was to find stories and photographers to shoot those stories.

I worked around Vienna, but it didn't seem to me that there were many stories to be found there. I found stories about cafes and murders — stuff like that. One day an actress I knew remarked, "I have a boyfriend who is a photographer, and I like his pictures." The photographer was Ernst Haas. Ernst showed me his photographs, mostly of his girlfriend, and I liked them; we decided to work together. I was writing and Ernst was taking pictures. The magazine editor despaired of many of our efforts, but finally he published one story in 1948 about returning Austrian prisoners of war from Russia. Bob Capa saw it in Paris.

A Trip to Paris

He wrote inviting us to come to Paris; I was to write stories and Ernst was to photograph. Ernst's mother gave us a roll of sandwiches; I bought a hat, and we traveled third class to Paris. There was Capa, who was a significant force and influence for many people, making them do what they were doing then and are still doing now. He was extremely generous with everyone and tried to understand where they had to go.

He put me in the office and I wrote stories for assorted photographers. All this time I didn't think about taking pictures. Then, I was introduced to the contact sheet, which is a marvelous adventure and a good way to learn about photography. I sat there and edited contact sheets, later writing stories to accompany the selections. Henri Cartier-Bresson was in the Far East and when I started to edit his sheets, I learned a great deal more about photojournalism.

When I was about 23, I decided I ought to get married, because I was getting to be an old maid. I married an Englishman; but, I still wasn't taking any photographs! I didn't like marriage, finding it rather boring. I missed photographers, because I kept on seeing things all the time, but while I could write about my observations, there weren't any pictures being made.

One day I was in Venice. It was rainy, miserable weather, but the colors were really beautiful — everything was beautiful. I rang up Bob Capa in Paris and said, "Capa, could you send somebody down, please, because it's raining in Venice."

He said, "You are such an idiot, because who would have the money for such an assignment, and, besides, it probably would stop raining by the time anybody from Paris could arrive. Why don't you shoot it yourself?"

Becoming a Photographer

I had an old camera which someone had given me, and I had some film put in it because I didn't know how to load it. I pressed the button . . . and the results were absolutely miraculous. It had never occurred to me that one could become a photographer just like that without long, academic preparation. By this time I had become rather well known for never taking pictures, because all of my associates did.

So, I turned my name around and called myself Egni Tharom, which sounded Swedish. My pictures were sent around under that name, and I said that I had discovered this talented Swedish photographer. It was beautiful, yes? And, it worked very well. People were saying that this *man* — everybody thought Egni was a man — had a good eye, but absolutely terrible technique. I promised to let *him* know about that!

Working very hard, I was slowly learning my way. Then I met a man from London with whom Bob Capa had worked as a darkroom boy. Earlier, this same man had worked on the *Berliner Illustrirte Zeitung,* a picture publication of Germany's House of Ullstein. I wanted to learn all about photography, and he was supposed to know all about it. He said, "Sit down, and I'll dictate letters to you." For several weeks I actually typed his letters.

Then one day I said, "Look, I'm not learning anything about photography."

He replied, "If you really pay attention, occasionally I say something very important about photography in my letters."

So that's how it went, and indeed, to this day there are certain things I remember — not too many, though — from that experience. I believe that if you are passionate about something, in various stages of your life you meet the people you should meet who will advance you in certain ways. I was lucky enough to learn the necessary photographic rules along the way, while I was visiting the countries which I wanted to see.

One of the most important and influential persons for me was Cartier-Bresson, with whom I worked a great deal. At that time he refused to take any color photographs. When he was sent on assignments, he would do the black and white, and I loaded his cameras and shot color pictures at the same time. I learned much from him, but he confused me because he said, "It's not good to see anything straight, to see it from eye level. You should see it upside down." He had two very old viewfinders — you can't get them anymore — which reversed the image laterally and flipped it upside down. Seeing things through the viewfinder helped you concentrate on composition. I still have one of those viewfinders, and I like it. It is still useful at times.

Another person who was very important to me was Gjon Mili, because he was absolutely cantankerous about everything and made me angry, but he also made me think. He made me think about quality because I had always used the 35mm. It seemed so marvelous to do things very fast. Mili said, "Why don't you think whether you should take a picture quickly or take time with it?" I found that I could mix those approaches very well.

Associations with Editors, Publishers

Also important in a photographer's life are meetings with editors and publishers. I have met with book publishers more often than magazine editors. There was a man in Paris who did some books and worked with Cartier-Bresson on his. He was an inspiring editor, because while he lived rather well, he didn't seem to want to make terribly much money. He would almost let you choose a favorite subject and then put out a book. It seemed to be no sweat at all. He was really the only publisher I worked with who approached his work that way. He also had a good sense of layout and rhythm. Later I discovered that in doing a book there were frequently quarrels about layouts, space or the way you wanted a caption.

Slowly I made enough money taking pictures to choose the themes I wished to pursue and the countries where I wanted to work. While I love to travel, I always had certain ideas of the things I wanted to discover. These ideas had their basis in literature or were spiritual landscapes — where things had happened to me. I did a great deal of

Adlai Stevenson and Eleanor Roosevelt, United Nations Inge Morath, Magnum, 1961

work in Spain, also around the Mediterranean and in Russia. Since my home was first in Vienna, Russia has special personal meaning because it's very close to Slav things. A lot of very old things which influence us come from Iran and the Middle East, so I went there.

I mainly traveled alone, which I enjoyed. At that time in Magnum most photographers were unmarried, unattached and were traveling alone. When we would meet each other again, it would be as a group. When we were not on assignment and in a group, everybody had time to go to bistros and talk about what we had been doing. I think the exchange of different views and your immediate information, passions and quarrels is terribly important; to be together with other photographers is a nice thing. We had time at any hour of the day or night, and this went on until the late 1950's. Then suddenly everybody got married, and things changed. Really, that may sound silly, but things did change, because people had other lives. Our work became much more separate, and the whole group thing became less visible.

I, too, married at a certain point, and it was no longer feasible to go at whatever time I wanted or accept an assignment anywhere. I had to rediscover the possibility of working in limited space. Now I am working mostly in Connecticut, taking portraits. I always loved to take portraits of people; it probably comes from traveling in trains which gives you brief impressions of people. You have conversation with them, get something essential out of it and then you never see them again. There is something valuable in getting to know somebody and trying to express something essential that you feel and that maybe they feel. That is a great joy. It is a passion of mine.

THE DOCUMENTARY TRADITION

ARTHUR ROTHSTEIN, 1971

For a biographical note on Mr. Rothstein see page 92.

It is indeed a pleasure to be here again at this most stimulating of all communications conferences. We are all image-makers who require media for the transmission of our ideas. Magazines are one form of media. A magazine is a medium for bringing the efforts of creative artists in the form of images and words to an interested audience. To understand magazines today we must not only be aware of the past, but also analyze the present so we may anticipate the future. I should like to share with you some of my thoughts on the background of photography with emphasis on a tradition which has implications for the future.

Modern visual journalism is a direct descendent of a certain type of photography, documentary photography. All photojournalists are documentary photographers. But, not all documentary photographers are photojournalists. The documentary tradition may have started long before photography was invented.

Imagine two cave men of the Cro-Magnon period. One was very fleet of foot and lithe of line, and he ran around the community with bulletins such as, "Henry has just been eaten by a saber-toothed tiger." The other cave man sat around the fire at night thinking about events. He asked, "Why was Henry eaten by a saber-toothed tiger?" In his search for meaning he also drew pictures of the event on the wall of his cave so that future generations might recognize and avoid this terrible beast, the tiger. They could also learn how to structure a society to avoid such problems. This may have been the start of the documentary approach.

Documentary Photographer — A Realist

The documentary attitude dates from pictures drawn on rocks by cavemen. It has been perpetuated in the bas-reliefs on Egyptian tombs, in Japanese wood-block prints and on Greek vases as well as Dutch and Flemish paintings made hundreds of years ago. The lithographs of Daumier and the photographic landscapes of William Henry Jackson are documentaries.

The documentary photographer of today is a realist rather than a romanticist, and these two approaches, that of the romantics and that of the realists, have been divided since history began. A similar division in artistic expression has also existed in music, literature and painting. It is the difference between Tchaikovsky and Stravinsky, for example. There have been similar divisions between the romantic and the realist in many other fields, as well.

More than 100 years ago Mathew Brady and his teams photographed the Civil War in a realistic manner. About the same time a Swedish photographer named Oscar Rejlander made a very famous photograph which he called "The Two Ways of Life." It was an allegory which showed the choices facing two young men. Rejlander created the image by combination printing more than 30 negatives. As men entered this imaginary room in the picture, they could choose the life of Religion, Charity and Industry as represented on one side or Gambling, Wine, Licentiousness and other vices, ending in Suicide, Insanity and Death as represented on the other side. This romantic photograph impressed Queen Victoria so much that she purchased it, an innovation in those days.

There is a place for each type of photography, the romantic and the realistic, but as a realist I believe life is so exciting that it needs no further embellishment. The documentary photographer loves life and accepts his environment, while the illustrator of fantasy is an escapist who is concerned with life's cosmetics. The documentary photographer finds it worthwhile and satisfying to use his camera in immortalizing the common lives of ordinary people. This approach requires high standards and responsibilities. It demands the best of a photographer's ability to see, to understand and to interpret as he selects. The means of perception is his eye, but the guide for selection is intellect and emotion. And that's why the best documentary photographs are more than a record or snapshot.

Interpretation, a Valid Ingredient

The documentary photographer quickly becomes aware of his moral burden as interpreter. Just as the written word influences the course of society, so, too, does the

Georgetown, Colorado,
the '30's

Alabama, the '30's

straightforward, realistic documentary photograph. As a medium of communication photography is very well suited to this approach, because the camera has always been invested with credibility. For the documentary photographer simple honesty enhances the image with the dignity of fact. Insight and emotional feeling give that exposure of a fraction of a second the integrity of truth.

This approach does not mean a denial of esthetic elements which are essential to works of art, but it does give limitation and direction. For example, composition may be utilized to add emphasis. Other photographic devices — sharpness of focus, filtering, perspective and lighting — can all serve the documentary photographer's end, which is to immortalize the present.

In documentary photography every phase of our time, its people and our environment has vital significance. It is necessary for the documentary photographer to know enough about the subject to capture its significance in relation to the surroundings. Although Brady and Atget were documentary photographers, they never heard the term. It was probably first used by a group of independent film-makers who rebelled against the typical Hollywood product of the 1930's. They created films with "real" people as actors in "real" situations with "real" problems. Producers including Paul Rotha, Robert Flaherty and Pare Lorentz created filmic dramas from our daily lives as well as cinematic poetry of our problems.

Of equal importance to the documentary photograph are words which add another dimension of information to make the image more effective. Many documentary photographs include words on signs, graffiti and billboards. Occasionally words spoken by a subject at the time the photographer shoots the image are later added as caption material. Thus, documentary photography can be a true blend of words and pictures.

Documentary also describes a style. There have been many substitute terms suggested for the approach — realistic, factual, historical — but none of these conveys the deep respect for truth and the desire to create active interpretations of the world in which we live which are so a part of this documentary tradition.

In the future I believe that successful magazines must stress realism. The romantic photographic illustrator will find less opportunity for publication; his work lacks credibility with all of its technical tricks. The documentary or realistic photojournalist, on the other hand, depends upon his perceptive eye guided by honest emotion to create convincing effect. It is my prediction that magazines in the foreseeable future will continue to be printed on paper. They will contain a blend of words and pictures and will fill the communication needs of a large, but *special* audience. We have such magazines today: *National Geographic Magazine, Playboy* and *TV Guide* are some. Certainly we will have cassettes, cable, electro-video recording and other formats for audio-visual material.

However, before we dismiss the printed page, let us remember two facts which have been with us for hundreds of years. First, nothing has yet equalled the convenience of a book or any collection of printed pages. You do not need electricity or any mechanical or electronic device for a book, magazine or newspaper. And, you have a record to which you can refer time and time again. You have a permanent, not a transient, image. Secondly — and this is something many people have not considered — human

speech cannot be spoken intelligibly or understood at rates exceeding 250 words per minute. But, most people can read two or four times faster than that. The printed medium can disseminate information with great speed and efficiency.

I believe that magazines will change, but many traditions — especially the documentary tradition — will endure. In the future let us apply these traditions in skill, perception and craftsmanship to all media.

PHOTOGRAPHING PRESIDENT LBJ

YOICHI OKAMOTO, 1969

Mr. Okamoto was associated for many years with the Still Pictures Branch of the United States Information Agency in Washington, D. C. At the time of President John F. Kennedy's assassination in Dallas, Yoichi Okamoto had, in his words, "a desk job" as Chief of the Branch. He was summoned to the White House by President Johnson and gained almost at once a very unique photographic assignment: the President of the United States — for the next 5½ years and nearly 24 hours a day. As Award Dinner Speaker at Miami only a few months after this monumental assignment was concluded, he gives a first person account of his important documentary effort. Presently he freelances for national publications and is based in the Washington, D. C. area.

It all started back in 1961. I had a nice, comfortable desk job at the USIA (United States Information Agency). Years before in the 1930's when I was a press photographer, I had resolved not to be chasing fires after my 50th birthday, though upon reaching age 50 I was to be chasing the biggest damn fire in these United States!

It all began while I was in charge of the Pictures Branch of the USIA. One day my boss, Ed Murrow, called to say, "Oke, we're in the dog house with Vice President Johnson, because we didn't send a photographer with him on his recent Southeast Asian trip. You might get us in better shape if you would personally go on this next trip with him."

I replied, "Okay, when does he go?"

"Tonight, at 8 o'clock!" It was 3 p.m. Has anyone ever tried to get all the shots and a passport from the State Department in one hour? My wife agreed to pack for me, my office staff assisted in readying photographic gear, and my secretary handled all of the necessary papers. The plane — with me aboard — lifted off at 8 p.m. for Berlin.

This was right after the Berlin wall had been built. It was a very emotional time, and the Vice President was representing the American people, coming to support Berliners. I photographed his effect on people, rather than the dignitaries with whom he shook hands. He liked the pictures very much. From then on he asked for me on all his overseas trips.

Needed: A Philosophy of Photography

Now the things I'd like to suggest from my experience are mainly for the younger photographers. I would not advise that you learn as much technique as you can. But, drawing upon this Conference, upon yourself and upon life I beg of you to do the long and necessary thinking which can help you to develop your philosophy about photography. Think of the type of pictures you want to take and present or show to others. Think of the kind of pictures that are meaningful to you and to the audience you wish to reach. I'm talking to the young guys now. Because, if you can develop a philosophy, everything else will fall into shape when you get your big break.

I'm probably the luckiest photographer who ever happened in this town. I was influenced by the Cartier-Bressons, the Ernst Haases and the Duncans. There were, of course, other important influences. Ten days with Wilson Hicks in Germany had a profound effect on me, and I was certainly influenced by a guy who has been like a father, Edward Steichen. He taught me what makes a meaningful photograph. And Roy Stryker, who taught all of us journalists our responsibility to truth. "Stop the posing," he would exclaim. "I mean, if you're going to be a journalist, you've got to tell the truth; you've got to be honest about it." Because of the influence of these people and my thinking about photojournalism I was ready for my break.

The Friday following President Kennedy's assassination, Andy Hatcher called to say President Johnson wanted to see me. I'd never been in the White House, much less ever had the tour. I didn't know which door to use. But, I was taken to the President, and he said, "Oke, you didn't think I'd forget, did you? Now that I'm President, I'm going to need some good pictures."

The President had photographers, men who patiently waited day after day for a buzzer to sound, thus signaling them to go into the President's office, take a couple of pictures, then leave. And if I ever said anything bright in my life, I said it then. That was my break! Thank God I recognized it. And that is what you younger photographers must do — recognize your break.

Instead of the usual, "Yes sir," I said, "Well, rather than just take portraits of visitors with the President, I'd like to hang around and try to document history in the making." Now you may call it vanity — I say that President Johnson had a great sense of history, a role in it — but the President understood exactly what I meant.

He said, "When do you want to start?"

I replied, "I have my cameras out in Juanita's room."

LBJ Assignment Begins

From that moment on I could walk in to the occupied office of the President of the United States without knocking, and there were only two people in the White House who had that access: his appointment secretary and myself. Johnson's personal secretary, Juanita Roberts, couldn't step in without first buzzing. Nor could Mrs. Johnson. He had great trust in me, which, of course, had been developed over a period of time.

When the President left his upstairs living quarters the first thing each morning, a buzzer sounded in my office and I would go to his office before he came in. I made

a point never to say good morning to him unless he said good morning to me, because I wanted him to consider me a part of the furniture. After a while he never said good morning to me. And, this was very important in our relationship. This was part of my training of the President. Then the appointments would start.

As you all know President Johnson was highly criticized for the number of pictures I took. As a matter of fact, some newspapers implied that he continually urged me to keep taking pictures of him. I'd like to set the record straight; that is certainly not true. The number of pictures taken was my idea, not his.

My philosophy, developed within a few weeks after I'd been at the White House, was to make photographs which would be valuable to the historian 500 years from now. Think about that. Think of what it would mean to us if we had candid photographs of President Lincoln arguing with Secretary Seward or pleading with General McClellan. Think of what it would mean if we had candid pictures of Charlemagne conducting court.

The day will come when the way we dress, the way we communicate with each other or the way we travel will look silly to many people. I figured that if I could capture on film peak moments of struggle among very important people, determining vital issues to mankind, and if they were oblivious to my presence, I might contribute something of import.

Now, any photographer knows that to try to capture a peak moment, to get an honest photograph of even four people talking, he must take many exposures. Well, that's why I took a lot of pictures. I was accused in a newspaper story of taking 11,000 exposures of LBJ in the first three months, a fact I never determined for myself. Someone counted the number of rolls I had shot, multiplied them by 36 exposures each, and I got fired by LBJ because of it. And, this was at a time when he was turning the lights out to save money! So it looked ridiculous, of course. But, the reporter was averaging exposures.

LBJ fired me after three months because I became an embarrassment to him. I was unique in that I was the first White House employee to be fired by the President. Then he rehired me, so I became another first: the first one he fired and the first one rehired. Several times I thought I might also be the first he refired! Because the man can get rough.

Believe me, now, when I say one has no idea how rough a job that of the President is. I can't tell you how many times I felt I was making a national contribution by taking LBJ a Coca-Cola. The essence of the job is decision making. Harry Truman had a sign on his deck which said that the buck stops here. Lyndon Johnson developed his way of making decisions.

Presidential Decisions

Someone who wanted a decision would send him a memo. Every night he had a stack numbering between 100 and 300 papers which he began working on when he went to bed. Each memo, whether it came from a member of the Cabinet or one of his personal staff, ended with a space for a "yes" or "no." He could check either one. And, he would go through these papers, making check mark decisions, at least two hours each night.

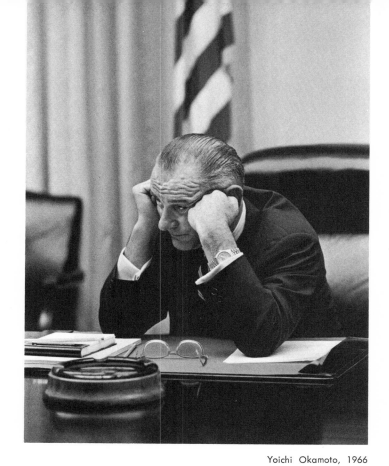

President Johnson

Yoichi Okamoto, 1966

Bill Moyers, Eugene Black (center) and the President Yoichi Okamoto, 1966

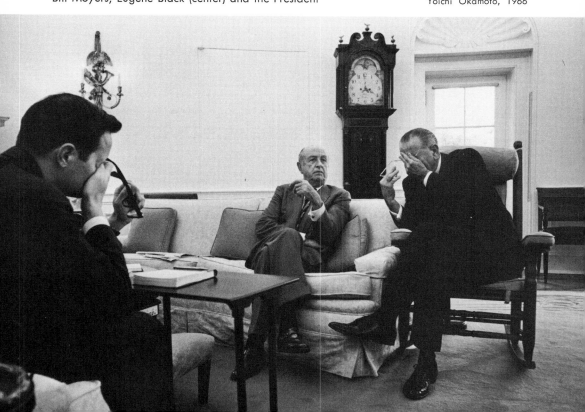

Some of the decisions were easy; some were terrible. But, the tough decisions were the 49-51 decisions, which had almost equal weights on either side. Every big decision he made — every big decision that Mr. Nixon makes — meant he would probably alienate 49 per cent of the people. And that ain't easy.

Mr. Johnson had a fantastic way of cutting through all the grit and getting to the guts of an issue. However, after his decision was made, he still had to sell it to Congressmen, Senators and, most difficult for him, to the people.

So it's a job of decisions, and the President must make them. With these comments you may now have an idea of some of my decisions and what I did with my big break. No one here can tell me whether I succeeded, because only history can determine that. I hope to look down some day in the distant future and see some of those photographs used effectively and with decent credit lines. (I only got two credit lines while I was working in the White House, but there was a good reason for that, of course. If we let AP, UPI or a newspaper or magazine use them, we let them put their credit line on.)

Allow me to conclude, please, with another word of personal philosophy. The young people here must develop a philosophy or approach which will communicate with their age group — the people whom they say present photographers are not communicating with — as well as the older generations. Then they must sell their approach to the older people: editors, photographers, readers. Because, if the older generation can't communicate, then the younger generation must. Let's quickly consider the underground press and some of the student papers we've all seen. After all, *Playboy* has gotten pretty drab. I believe some underground papers will last, and they're going to need pictures. I don't mean shocking pictures, but the kinds of things photographers want to say without shocking. The messages must become palatable for the older generations if you're going to reach us. In other words, the messages must be meaningful to your own world.

When your break comes, and it's sure to come, if you have developed an approach, a philosophy, you'll recognize your break. And, you won't have to worry about whether you can do the job, because all you'll be concerned about is how you're going to do it. You'll know what you're going to try to do.

FROM COLLEGE INTO MAGAZINE PHOTOGRAPHY

WILLIAM ALBERT ALLARD, 1969

Bill Allard began photographing while a sophomore photojournalism major at the University of Minnesota in 1962. Upon graduation in 1964 he became a staff photographer at *National Geographic Magazine* and completed assignments in his first year on the Amish of Pennsylvania, Robert Kennedy's climb of Mt. Kennedy and Sable Island. Since then he has twice won runner-up magazine photographer of the year in NPPA competition and, in 1969, won the Sweepstakes Award of the White House News Photographers Association. He presently is a freelance, basing in Washington, D. C.

First — An Involvement with People

Somebody once asked me what I really wanted to do in photography, and I don't know if that's possible to answer. But, I have a hang-up for photographing people! I enjoy photographing them. And, I'd like you to know something about the people I photograph; I want to introduce them to you.

There's no formula, and there's no way you can be sure how you're doing. But, after looking at a photograph, I want my audience to say, "I know this man, or I know this child, or I've walked on the grass on which he stands; I've sung the same kind of songs." This is what I want to accomplish. Sometimes I think I'm successful; quite often not.

One of the ways to approach people in a strange locale is to start out in a bar or a neighborhood pub, to learn by listening or talking to them. You are always the outsider, the intruder, no matter how softly you walk. My feeling is there's a big difference between standing in the corner of a room and watching somebody, as contrasted to going over and sitting down with that man, having a drink with him, or arguing with him, or fighting him. But, getting to know him is what we're talking about. You're never going to be able to introduce this person to the reader or viewer unless you, the photographer, have actively tried to know this person.

(*Ed. note:* Photographer Allard then showed a slide-tape presentation entitled "Palombiere" on the Basque country of Spain and France. The story had appeared in the August, 1968, *National Geographic Magazine.* Allard had spent two-and-one-half months shooting the story which was given 37 pages in the magazine. In the question-answer session which followed that presentation, he further developed his personal philosophy and criticisms of photojournalism.)

CONFEREE: How do you approach a story and its people in a foreign country, given the language barrier and the image of the "ugly American?"

ALLARD: Well I think David Duncan probably is a good example. You look at Duncan's pictures and you know that he wasn't just there as a photographer; he was part of a thing.

My Approach — Like Walking on Eggshells

Now with people like the Basques, the Amish and also the Hutterites, you get rid of your coat and tie; you don't go out and grow a beard and stuff like that. You don't try to con your way in. You try to find some common ground, and if it's an ethnic group that exhibits characteristics like the Amish or, in some ways, the Basques, you're walking on eggshells all the time. You keep very much in mind that you are the outsider. You're in their backyard. You're not in New York City or Chicago. They could not care less what your name or reputation might be. You're talking to the farmer and the sheep herder. You just use a little understanding. You don't sneak pictures. I saw many pictures when I was working with the Amish which I couldn't take. If I had shot some of those, whatever *rapport* I had established would have been destroyed in making just one grab shot.

William Albert Allard, 1967

Basque Country, France

CONFEREE: You must walk everywhere you go; you must be the weary traveler, stopping in these people's homes to partake of their meager bread and cheese. It seems to me like a terrific thing to do.

ALLARD: It is. It's a gas! I hope to do work for *Geographic* each year because what I call the real adventure of photography is the exploration of your subject, of people — the wandering around and not so much the producing of the picture, but seeing, experiencing. This is how I like to work best. You partake; you don't turn down the local food; that's the last thing you do. You don't bring in your own chow.

CONFEREE: Can you tell us how this assignment was conceived and what preparations you made? Did you read considerably about the subject?

ALLARD: It depends on the nature of the subject, the kind of assignment, the size of it, and the geography involved. A long time ago I told Bob Gilka, the director of photography at *Geographic,* that I would as soon not know what my next assignment was going to be until shortly before I was to depart, because I respect that freedom of mind. I don't think you should go in blind, knowing nothing, because if it's a story on the State of Alaska, you will need briefing and a lot of research. But, on the other hand, I don't want too many opinions and impressions, as good as they may be.

Assignments at *Geographic* are conceived by various editorial boards, conferences and their research desks, too. Bob Gilka is very concerned; he usually picks the photographer for the assignment.

GILBERT GROSVENOR (ASSOCIATE EDITOR, *National Geographic*): This is the type of story the *Geographic* is trying to publish. This is the type of story we hope to reach the younger people with. We're not interested in political news stories; there are plenty of publications producing that type of story which are very competent.

ALLARD: What you said brings to mind another question. The work of David Douglas Duncan, Cartier-Bresson and the late Bob Capa was what really turned me on to photography. And, I wish that I could have had a piece of their action 10 or 15 years ago because the situation was different. Yet, I'm very grateful for the work that these people did and for the publishers who published them. Without it I probably wouldn't be here today; I wouldn't be involved in a profession which to me is still a gas and not work.

Where Is the In-Depth Story?

What comes to my mind, though, is the statement Gil made, a statement about the kind of audience he's trying to reach with the *Geographic.* Thank God for people like Bob Gilka and Gilbert Grosvenor; who else is publishing the in-depth story with words and pictures? These are the stories which can be important. Since leaving the *Geographic* staff, I've been on assignment for other magazines in Mississippi, and I've covered a coal mine disaster. Ninety-nine per cent of that work didn't get published. I don't expect *Geographic* to do those sort of stories. I respect the magazine for what it is.

But what comes to my mind is another editor at *Geographic* who is a friend of mine. I was talking to him one day about Gene Smith and the "Spanish Village." I asked, "Why can't we, of any magazine in the business, go out and do the 'Spanish Village' of today? Instead of taking the all-encompassing story, we should go in there and groove into a small scene and do it. We have the ability to do this as well or better than anybody else."

And, again, I'm not slanting this to put down the *Geographic* or this editor. But, I'm putting down now just this total state of shock that he put me in when he looked at me and said, "Well, Bill, that's old hat!"

Damn it, a fine picture is a fine picture; it was a fine picture then; it's a fine picture today; and, if that was the old hat, then my question is what's the *new* hat, and what's killing us? It must be the new hat that we're wearing! And that's enough.

In that respect the "Spanish Village" may be old hat; the "Country Doctor" may be old hat, because there aren't many of those cats around. But, there's the village of 1969, and the subject matter is here. What's happened to the approach? Now I was brought up in school on the picture story. Well, I've never had a picture story published in my life, though I've had a fair amount of stuff published in *National Geographic* and other magazines. The picture story simply does not exist anymore for the most part. I'm not saying we must bring it back, but something is lacking.

I, for one, have attended too damn many wakes, and I personally hope this is not going to be another one of them. If I go to lunch in Washington, D. C., with a bunch of photographers, they moan and groan and cry. Well, damn it, maybe things are bad, but who is to blame? That is what I want to know.

I'm a late comer; I just got into this, and somewhere along the line we've gone wrong. Somewhere along the line we've let somebody talk us into doing something that we shouldn't have done.

What I showed you is a very bad stepchild of a motion picture. Most of these slide-tape things are. They can be effective and interesting — I did "Palombiere" just for kicks one night because I didn't want to show images with a clacking projector; I wanted a little more mood. I suppose if I had any brains I'd be going into motion pictures. But, I refuse to leave one area out of fear and go into another. If I did that, I wouldn't be worth a damn; my motivation wouldn't be right. There's something wrong; we're reaching out and grabbing at every straw. And, ultimately we end up aping something of which we're really not a part.

Now there's nothing wrong with the single photograph. A fine photograph can stand by itself. We don't have to jazz it up; we don't have to reach out and try to make it move.

CONFEREE: The still photograph requires my imagination to work. I'm not being told everything as in a film where the child reaches out with flowers or the wedding couple kisses or the old man turns to hobble away. I can use imagination in reading the still photograph. I can't with film; that is why I think TV is so dull. It tells me everything there is; I'm robbed of using my imagination.

Television and Magazines: Now and Tomorrow

ALLARD: I agree, but we've got to recognize that TV is, in a sense, like China: it could suddenly awaken, and then we have had it. Television producers don't know their own medium. Meanwhile, the magazine photographer is losing what he used to have. A classic example is David Duncan, who placed his coverage of the political conventions and Vietnam on the tube. The magazines used to present it very effectively. Mr. Duncan shared some of his feelings about the magazine markets with me this morning. I guess I agree with him, but I'm just not quite willing to accept the situation. He feels that television

is the future market. David, how do you mean that? Will television provide still photographers with the opportunity to present what we want to do on its screen instead of on the magazine pages?

DAVID DUNCAN: This is what it's all about; this is what we're talking about here; where does one go? As far as magazines, there's nothing wrong with magazines; it's what's wrong with the editors and photography in the magazines. There's been no communication at *Life* for many years — and I speak only of the outfit I know best. There's still a place for the photographic essay at *Life,* at *Look* and the others. I feel very deeply about it.

I don't believe that the magazine is the end of the road — or television — but there's an area of photography that's reached the end of the road. Most of it is dull as hell. Now, I thought your closing series of slides here was absolutely fabulous: it took timing, an eye, and patience —beautiful. But, talking about individual pictures, where do you place them? That's something else.

ALLARD: You said it's the fault of the editors, but I'm glad you added that it's also the fault of the photographers. Somewhere we've sold ourselves down the river, so to speak.

DUNCAN: Look, this morning, despite all the work that went into the films which we saw, I didn't see one foot that penetrated the subject. I saw billboards going by. That's all that happened to me. I got no emotional response from it. And that's not what I'm in this business for.

Wilson Hicks and I were talking about the strangulation of these great cities. The garbage men go on strike; the cops go on strike; the firemen go on strike; the snow comes; they can't haul it away. Jesus, stories everywhere! But, it's a hell of a business to be in and it's a very challenging life. You can't do it on your tail — that's for sure — or run the editors up the walls. If they don't like your work, find another market. Think about smaller magazines. That is photojournalism; it's what it's all about. That's my world.

ALLARD: I don't do much news photography — maybe that's good, or is it bad? Perhaps I'd make more money if I got assignments from *Newsweek* and others. But, I sympathize with the fellow who is shooting for *Newsweek* or *Life.* I don't know what took *Life* so long. I think *Life* is just now starting to realize it can't compete with the tube as far as getting communication to the front door. It has been so apparent for so long that what we have to do as still photographers is interpret. It's no good anymore to go to a political convention and show the balloons coming off the ceiling. Nobody gives a damn, because they saw it on television in color with sound and motion the night before . . . or a week before.

So what you do is you find a guy that supposedly, hopefully, has got an eye that's a little better than somebody else. You let him go in, and then you accept his or a number of photographers' interpretations. But what you do is get down on the printed page something with some guts, something that you can pick up a year later — and this is asking for the ultimate — but the ultimate in a fine photograph is something that you can continually explore and find new exciting things that you didn't see before. This is what we're striving for, and this is what we should be publishing in the magazines.

How do you make yourself known to the editor? I made a big mistake shortly after leaving the staff of the *Geographic* to become a freelance. An art director of a major magazine assigned me to a story. He said, "Give us a little 'Arnold Newman' treatment on these

things." Well, I'm not Arnold Newman; I do my thing and Arnold Newman does his. He does it very well. But, I was foolish enough to go out and to try and play Arnold Newman. Those images were some of the worst photographs I've made, and they ran. I was very ashamed of them.

But, we make bad ones and we're as responsible for them as we are for the good ones. It's too easy a crutch to say "they" published all the bad ones. "They" really don't do that very often. You should hope to work with an art director who will look at a roll of film and appreciate your visual explorations, that you are trying to find something. Maybe you have and maybe you haven't, but he looks for that frame where you came the closest.

WINNING THE PULITZER

DALLAS KINNEY, 1970

At the request of David Douglas Duncan, Dallas Kinney, then current winner of the Pulitzer Award in photography and a conferee in the audience, delivered these extemporaneous remarks about his start in photography and his assignment at the Palm Beach *Post* which led to the award. He left the paper's employ in the fall of 1970 to travel and freelance.

I've been in newspaper photography approximately five years. I started on a very small paper in Iowa, working six days a week, setting type, pulling copies, cleaning up and carrying coffee to the boss. I'm going to tell you this for a particular reason. In my first year of photography I had a lot of freedom. I didn't know anything, and the editors didn't know anything about pictures, so there were no hang-ups. I had a reasonable amount of success relating to the community.

Then on to the Dubuque *Telegraph-Herald* in Iowa. It's quite a picture paper. I was hired by James Geladas. This man put me in a box, and he put me in hard: multiple lighting and setups of a particular nature. There were three basic variables within the setup concept: spatial control, lighting, and point of view. And there was a word, a word that I wish I had heard more often at this Conference: the feeling of *responsibility*. Any time I was relating to an individual with that camera, intending to publish what I photographed, I had a responsibility. This person would have no chance to defend himself in relation to the image I produced. That was my responsibility.

After a year of this very tight situation, a lot of sleepless nights and fear, he suddenly opened the barn doors; and baby, I was ready.

He let me have a great deal of freedom on projects that I cared about. The picture story is basically my bag, and in the first two months I would come back from a story with seven to 17 rolls of film and submit 20 prints. Without criticising the basic content or point of view of the subject matter he would simply say, "Fine, when are you going to finish it?" And once again, I had to introspect; go back and see what I had missed.

Opposite and overleaf: Front page and inside spread showing Dallas Kinney's Pulitzer prize winning photographic series on migrant workers. Palm Beach *Post*, October 10, 1969.

WEATHER
Partly cloudy. Shower probability 40 per cent. Predicted high 85, low 75.

Weather details, C10.

The Palm Beach Post

SERVING THE HUB OF FLORIDA'S FABULOUS GROWTH AREA

Complete
Stock Market
Pages C7-9

VOL. LXI. NO. 172 WEST PALM BEACH, FLORIDA, FRIDAY MORNING, OCTOBER 10, 1969 56 PAGES—PRICE TEN CENTS

High Court To Rule on Integration

WASHINGTON (AP) — The Supreme Court agreed yesterday to decide whether public schools in Mississippi — and possibly throughout the South — must be integrated immediately.

The court will rule on an appeal by the NAACP Legal Defense and Education Fund that demands immediate desegregation of 222 public schools in 33 Mississippi districts.

The Justice Department had advised the court to reject the appeal or postpone action until desegregation plans were filed with a federal court in Mississippi. By order of the U.S. Circuit Court in New Orleans these plans are due by Dec. 1.

But the high court shunned the advice and granted a hearing to the fund on Oct. 23.

The court reached this decision during a private conference in which the justices considered hundreds of appeals that have accumulated over the summer. An announcement before Monday was unexpected and lent an extra measure of urgency to the court's view of the dispute.

The appeal asks the court to discard its "all deliberate speed" formula for school desegregation and to demand immediate abolition of racially identifiable schools across the South.

The court declared racially separate public schools unconstitutional in 1954. In 1955 it recognized school districts faced problems in desegregating, but said they should comply with the 1954 ruling with "all deliberate speed."

In the Mississippi case the circuit court in August lifted a deadline that schools in the district have workable desegregation plans by the start of the current school year. The circuit court postponed the deadline until Dec. 1 after Robert H. Finch, secretary of health, education and welfare, said the time was too short in view of "administration and logistical difficulties."

The fund then appealed to the Supreme Court in behalf of several Negro families. The 222 schools involved are attended by 135,700 Negro and white children.

Finch's request for a delay was the first such request in a schools case by the federal government since the 1954 ruling.

The court's timetable apparently precludes any possibility that Judge Clement F. Haynsworth will participate in this major case. There seems no possibility that he could win final Senate approval by Oct. 23.

The decision to hear the appeal — contrary to the advice of both the Nixon administration and the Mississippi officials — was the first major judgment reached under the new chief justice, Warren E. Burger. As is customary the court did not indicate whether any justices disapproved of the action. The granting of an appeal normally needs the assent of at least four justices. Without Haynsworth there are eight.

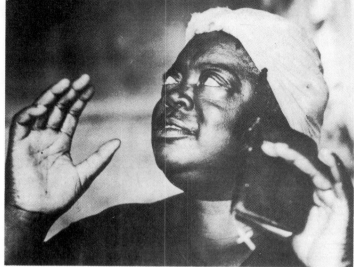

"I'm not afraid to die 'cause I'm a child of God"

Staff Photo by Dallas Kinney

An Elderly Migrant Who Waits to Die

Sixth in a series

By KENT POLLOCK
Post Staff Writer

Lillie Mae Brown is waiting to die.

Her tired body let her down five years ago following an abusive life of migration from state to state as a farm worker.

She hoed cotton, picked beans, pulled corn. She harvested food for an affluent nation.

The work all but killed her.

Now she is forgotten.

She just sits in a decayed one-room shack in South Bay. There is nothing else to look forward to.

She is not a lonely person. She has her faith in God.

The hot water heater doesn't work because Lillie

Migration To Misery

Mae can't afford to turn on her electricity. But the rats behind it don't seem to mind. You can hear them scratching and gnawing day and night.

There are so many Lillie Mae Browns in the migrant world. They travel everywhere, but belong nowhere. No community outside their world really accepts a migrant.

The traditional rejection continues when migrants grow old. They exist in a subculture all their own, separated from other impoverished Americans.

"I have no one but myself." Lillie Mae says. "If it wasn't for the Lord what would happen to me today... he's my mother, my father, my sister my brother."

The thought brings tears to Lillie Mae's eyes. She wipes her cheek with one hand. The other holds a vest-size edition of the Bible.

Lillie Mae was born in 1906. Nine years later, she began working in the fields with her family.

Turn to SHE'S WAITING, A8, Col. 5

Haynsworth Gets Committee Okay

WASHINGTON (AP) — The Senate Judiciary Committee approved the Supreme Court nomination of Judge Clement F. Haynsworth Jr. yesterday but other developments deepened the uncertainty about Senate floor action on the appointment.

The committee action came in the morning on a 10-6 vote with Republican Charles McC. Mathias of Maryland abstaining.

Some hours later Mathias in a letter to the committee chairman asked that he be recorded in opposition to the nomination, making the final count 10 to 7 and moving Mathias from the ranks of the undecided.

Meanwhile, the American Bar Association Committee on the Federal Judiciary disclosed it will meet in a few days to review its position on the Haynsworth nomination.

There was no indication whether this means the committee is seriously considering withdrawal of its warm endorsement of Haynsworth before the Judiciary Committee Sept. 18. But it obviously opened that possibility.

Judiciary Chairman James O. Eastland, D-Miss., said it would be at least a week before members of the Turn to HAYNSWORTH, A9, Col. 1

Inside Today

A SHAPELY, BLONDE Australian booking agent testified at a Senate subcommittee yesterday that NCO club supervisors demanded girls along with their kickbacks ... Page A2.

THE U.S. SENATE passed a bill to exempt shotgun and certain types of rifle ammunition from the Gun Control Act ... Page A7.

Fights Flare In Chicago, Guard Alerted

CHICAGO (AP) — Gov. Richard B. Ogilvie ordered 2,000 members of the National Guard to active duty in Chicago yesterday after street battles the night before between police and some 300 young radicals.

Ogilvie said in Springfield that Brig. Gen. Richard T. Dunn, who has been in Chicago for two days, recommended that the Army-affiliated guard be activated as a result of the fighting that took place on the Near North Side.

The governor said he talked with Mayor Richard J. Daley about the plans of the radicals Tuesday and Gen. Dunn was asked to observe the situation.

Turn to FIGHTS, A5, Col. 3

...How Loose It Is!

MIAMI BEACH (AP) — Jackie Gleason melted off 61 pounds—reducing his 54-inch middle to a mere 42—using a diet of meat, eggs, fish and "all the booze I wanted."

The beefy entertainer is down to 209 and claims. "If I lose any more the television viewers will think I'm dying."

Gleason's attack on girth began March 20 and much of the fat is gone.

"It wasn't too bad," Jackie said. "I ate all meat one day, all eggs the next and all fish the next.

The no-no's were vegetables, breads and sweets. I ate scrambled eggs, boiled eggs, and omelets along with every kind of meat and fish imaginable. But that was all.

Gleason illustrated his weight loss backstage before rehearsal for his Saturday night show on CBS-TV. "Gimme those Ralph Kramden pants," he told a wardrobe man. "They'll show."

The outfit Gleason used last season in Honeymooner scenes is the Brooklyn bus driver measured 54 inches. "And they used to be tight." he said.

Jackie pulled on the trousers and held them out, showing enough space to stuff Mickey Rooney inside with him.

"The last time I was under 210 was in 1956," Gleason said, beaming over any mention of the famed waistline. "All that diet and I still glugged down all the Martinis I desired—even ate the olives. How sweet it is."

DIET MAKES A DIFFERENCE

AP Wirephoto

"It wasn't too bad, I ate all meat one day, all eggs the next, all fish the next ... and all the booze I wanted."

Reed's Letter to Minister on Elections Rebounds

Related story, D1

By MYRA SCHWEBEL
Post Staff Writer

A letter opposing Sunday elections and the scheduled music festival from Rep. Don Reed to the ministers in the county has been called by one pastor an attempt to gather votes.

"I can hardly interpret your letter as anything other than an attempt at garnering votes for re-election or election to a higher office," the Rev. John D. Rose, pastor of the First Unitarian Church of Palm Beach County, wrote in answer.

Reed said he sent 100 letters, maybe more, to the ministers in the county to see if his views are in line with theirs on Sunday elections and the festival.

Rose's letter said, "I do regret that an official of this state should use himself and state money over inconsequential concerns.

"You are straining at a gnat and swallowing a camel; you are majoring in minor virtues. This may get" you votes but it gets my concern. Rock music is important to our youth; if you don't know this then you don't know what is going on in the world."

"The same rules that apply to a Billy Graham revival should apply to the rock festival. If people engage in illegal acts at either a revival or a rock festival, then they should be arrested. If either Billy Graham or Dave Rupp make money in this county it is none of my business."

Rose's letter also said peaceful assemblies should not be outlawed because of the whims of a local office holder, and that the subterfuge of zoning rules should not be used.

On Sunday elections, the letter stated: "Doesn't it occur to you that many poor people have a better chance of getting to the polls on Sunday than on a Tuesday. Also there is implied arrogance in your oversight of the many Jews in our neighborhood to whom Sunday is not

a holy day; there are also Seventh Day Adventists."

Rose challenged Reed to speak out on important issues specifically, migrants, whom he said live under conditions revolting to people who truly try to live with ethical purpose and sensitivity, the black minority who are held down in education, jobs and housing, and the pollution of Lake Worth and the ocean.

Reed said he would have no comment on the letter until later. He said he strongly opposed the Sunday elections and wrote to the ministers because he felt they are one segment of the population which would be effective in opposing the practice.

"I ain't got too much longer to wait. God's going to let me know when He gets ready for me. I'm already ready."

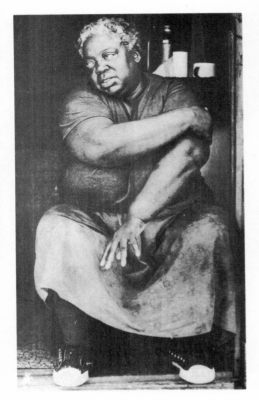

She's Waiting to Die

Continued From A1

She was born "up the road" near a bean field in Charlotte, N.C.

"I been working ever since I was big enough to know it. Field working all my life. I worked when I was too young to work. I used to go in the woods and cut cord wood when there wasn't no crops."

Lillie Mae's past is not a happy one, but she enjoys reminiscing anyway.

She sits on a milk crate. The only light inside her 10-foot square shack rushes through a decayed doorway. At night, she lights a kerosene lantern.

She jokes about her fat body. It is the product of illness and a poor diet.

"I been heavy all my life. I weigh 268 right now. I've been fat all my life. I guess I was born fat as a baby, yes sir."

She doesn't remember when she left home, exactly, but she remembers why she left her family of 22.

"When I left home my daddy was mean to me. He treated me like I was a dog. I left home to keep him from beating on me, knocking on me."

Whatever happened to young Lillie Mae Brown — the young woman who worked by day and played by night; the woman who landed in jail four times on morals charges?

"I'm just tired and old, that's all. You see, I's been just a poor little girl all my life, yes sir. I never had nothing. I had a hard way to go, that's right."

It was in 1965 that Lillie Mae's body finally quit on her. It could work in the fields no longer. Her heart, her lungs, her back all quit.

"I took sick and never worked no more."

Sad, perhaps, but it was while Lillie Mae was in the hospital that she became "a child of God." It was there that she gained the faith that keeps her alive today.

Her words tell the story well:

"I know I'm a child of God 'cause I've been born and been healed by the spirit. Praise the Lord, I know it 'cause Jesus come into my room and told me when I was flat on my back in Belle Glade hospital.

"And God came and stood over my bed and I asked Him to heal me and he told me that He would. And I knowed it was Him 'cause He had His hair parted in the middle and coming down on each side.

"And I looked at Him like I'm looking at you. I said Lord I know it's you. And He had three trains running in and out. Each one of them trains had eight coaches on each side, listen to me good, and the train in middle, it had 11.

"He said pick out which one of these trains want to ride. I said I want that train in the mid that's a fine coach. And He said this is the train to r 'cause that's the one I drive and I am Jesus. Hallelu hallelujah, I know I'm all right."

Lillie Mae Brown is crying now.

"He's my God, Dr. Jesus. He's my God. He st on my bed with his hair flowing to the floor and healed me."

You listen to Lillie Mae, the child of God, and wonder why she has to be poor.

Her washtub is opposite you under an unste shelf. Beside the shelf is a kerosene stove sitting o orange crate.

Why must this woman of faith live in this Hell earth? Will death be kinder to the old woman?

"I'm not afraid to die 'cause I'm a child of God let God handle it like he wants it. I know I got to d was born to die. I'll die when God gets ready for me."

She raises both hands to the air, her Bible clut tightly in the left hand.

"I ain't got too much longer to wait. God's goi let me know when He gets ready for me. I'm alr ready. Whenever He calls me I'm going to be all rig

Heaven to some, is a very personal thing. It reflects a person's innermost feelings.

Many people look to Heaven for personal be ment, but not Lillie Mae.

"Heaven is going to be a beautiful home for e one. It's a beautiful place, a level country. Every is living happy. All the human beings is living tog and the Holy Ghost, he'll be on the inside and the can't get in. And the gates will be open when I there."

This is Lillie Mae Brown. She was a migrant a life.

Her worldly possessions sit at the foot of raggedy bed in a wooden chest. On the wall above calendar inscribed with the Lord's Prayer.

The food she eats is contained in four tin There is lard, flour, corn meal and rice. A hu cheese sits in the sink.

The meat she occasionally buys is stored friend's freezer. Lillie Mae doesn't even have a pl put a block of ice for food storage.

Lillie Mae Brown picks up her small Bible begins reading it to herself.

She is waiting to die.

TOMORROW: A migrant escapes.

Staff Photos by Dallas Kinney

"And God came and stood over my bed and I asked Him to heal me and He told me that He would."

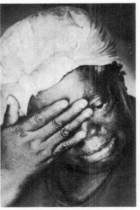

"And I looked at Him like I'm looking at you. I said Lord, I know it's You . . . listen to me good."

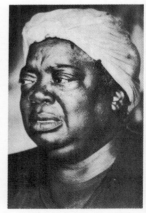

"He's my God, Dr. Jesus, He's my God. He stood on my bed with his hair flowing down to the floor and healed me."

Children of Misery

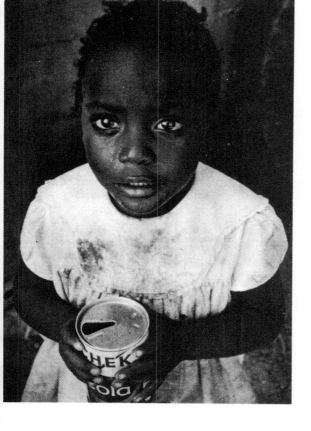

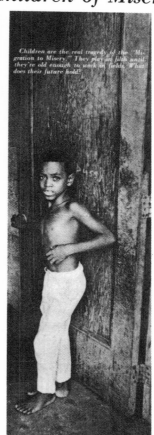

Children are the real tragedy of the 'Migration to Misery.' They play in filth until they're old enough to work in fields. What does their future hold?

Staff Photos

By Dallas Kinney

Migrant, Belle Glade, Florida

From there to the Miami *Herald* for a very brief time and luckily then on to the Palm Beach *Post,* where a very unique situation existed — two young editors who believed in presenting something in photojournalism in Florida which had not been done.

Ken Pollock, who won the Ernie Pyle award, and I had come to the *Post* from the *Herald,* and during an assignment ran across the Belle Glade area, which is the "home base" of Florida's migrant workers. Coming from a farm background myself, and Pollock coming from the Salinas valley area of California we were aware of agrarian problems and were shocked by what we saw.

We literally dragged the editor and managing editor out to the area. From then on it was *carte blanche.* We were given time, a hell of a lot of time, to develop and do the stories as well as they could be done.

The basic presentation was three pages daily, eight days in sequence, a total of 24 pages of copy. Each day's package included a double truck inside and one picture page.

These pictures were not for a national audience. We went in on a local level; the migrants had been completely neglected in this area. We went in for our readership. We might have scored that much, I don't know.

That was the basic premise, to get to our readership who lived 40 miles away in a very affluent area, but had no concept of how some very proud Americans were existing.

WHAT I'VE BEEN UP TO LATELY

ERNST HAAS, 1970 (Excerpts) and 1967

An Austrian by birth, Ernst Haas joined Magnum in 1949 following widespread publication of his story on the homecoming of Austrian prisoners. First basing in Paris, he came to the U.S. in 1951 and began to concentrate on color photography with essays on New York, Paris, Venice and bullfighting. Haas has worked with such motion picture film directors as John Huston and Stanley Kramer. He has just completed his book entitled *The Creation*, a color epic published fall, 1971.

1970

I am very glad that in his introduction Wilson mentioned the photograph I made of the little Austrian girl waiting at the train station, hoping for the return of her father, who was a prisoner of the Russians. She was clutching an old snapshot of him in one hand.

I am pleased to be reminded of that photograph, because it was in black and white, and it was of human beings. Many people ask me why I have become so abstract. Yet, they suggest that this picture of the little girl was abstract, too, because I was seeking a certain universality. I wasn't interested in a specific little girl, nor did I want to know her name — I always hated to write captions. I simply wanted my subject matter to be universal. This girl became the idea of all little girls who are looking for their fathers.

The most tragic thing about that situation was that the little girl carried a picture of a papa whom she had never seen. The papa had probably been in Russia for years and could have looked quite different. Maybe the mother was dead. But, here she was, trying to find her papa. This really moved me. It was not the homecoming occasion which I saw, but rather the suffering women and children of every war who are left in the dark, wondering if someone will return.

Abstraction: A Means Toward Universality

About my shooting in color, people always ask why I become· so abstract. It is the same idea. There is really no abstraction; it is only that you want to become more universal. You see, in photography we have the wrong concept of the term *abstract*. If I look out at you in the audience I recognize many friends. It becomes very personal, and it bothers me. But, if I squint, you become abstract, a totality; you are universal.

I came here unprepared in specifics, but I am not unprepared in my universality. Lack of preparation can be a certain challenge; this is the same challenge with which I like to photograph. I hate to prepare myself for an assignment, which is one reason for my never having wanted to be on a magazine staff. The magazine provides its staff photographer with a researcher who prepares him so completely that he can't see anything but what he is expected to find.

Coming to Miami in the airplane I was thinking about our worries and why we all come here. We come here for sentimental reasons — at least I come here for sentimental

reasons. I have come here for many years, and times have changed. One really expects that when he visits a place annually time will not have brought very much change. In the 10 years that I have been coming here there are generally the same kinds of people, and one has the feeling of being on an island. On an island you know everybody and everybody knows you, which provides a certain security. But an island is not only positive, it is also negative. Our water is getting higher, and because it is getting higher, we have to come closer and gather together. We exchange experiences. But, I don't know how long I could stand it on this island with all the people I know and by whom I am known. There are at least two possibilities: either we learn to swim, which I think is the best possibility, or we wait until the water goes down. I don't want to wait until the water goes down.

Seeking Understanding

What we have in common is *photography*. However, I don't think photography can be your life in totality. Photography is too broad to be a totality; it is always a part of something else. For one person it is an extension of sociology; for another, an extension of his frustration as a painter.

It is a pity that our medium, photography, which is practiced by so many, is understood by so very few. Maybe this is a reason why we return to Miami: with the hope of being understood and, perhaps, seen. No longer is there any great stage for the photographic medium. There are magazines and exhibitions, but in many ways they are out of proportion.

Once when I was photographing Frank Lloyd Wright he said, "Here we are: I am in front of you with 10 minutes to talk. What shall we discuss? Let's talk about one thing we all have in common: the sense of proportion." And, he was absolutely right. We come here because we speak the same language, everything seems in proportion. When we return to everyday work, everything is out of proportion; it bewilders us. So, we come to Miami to recuperate, communicate, and show that we have done or, perhaps, what we want to do.

I am and want to be a still photographer. Even if I become involved in a film production, I go in as still photographer. I can make still movies. But, I have more personal statements to communicate in stills than in movie productions. Don't forget, in film you have a whole crew. You are not your own master; you can't dream away. You have a production manager calling you everyday, and someone cuts and edits for you. Compare that with the still photographer.

A Beautiful Experience at Look

I generate my own ideas; often I edit my own work. Recently I had a beautiful experience after shooting a story for *Look*. I had the great pleasure of being invited to work with the art director, Will Hopkins, on the layout. There was a little tension before I came because in magazine traditions a photographer is rarely invited to do the layout. Will Hopkins asked, "Do you know the pictures?"

I replied, "Look, I know the pictures by heart. I can do it without even looking at them."

He then concluded, "Why don't you?" and gave me a pencil! I began selecting this picture and that picture, and he crouched more and more; then he looked at me from the

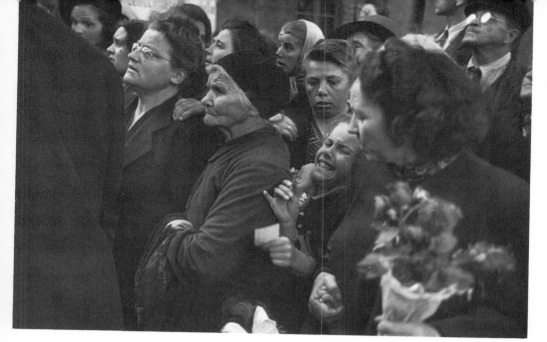

Awaiting the return of Austrian Prisoners Ernst Haas, 1948

side and said, "Go to the light table." Now, I don't like someone to tell me to *go* to the light table, as in *go* to the corner. But he didn't mean it that way. He meant it in a very positive way. So as not to spoil the atmosphere then, I went to the light table, switched it on, and examined what was there for this story of five pages — the beginning page and the second and third spreads. On the table was not only a set of transparencies which represented what he had selected, but the same set of transparencies represented what I had selected! I was gleaming with joy, because this is really how the art director and photographer should think. You condense; and you come to the same conclusions, and you know you are not working against each other.

In our time the biggest problem for one is to continue in the way he wants. We always speak of change. One doesn't say that a life plan changes, but that it grows, which is a wholly different concept. A flower changes from a seed to a flower, and then it decays. But it is always the same flower. And, we are always photographers, still doing the same. Of course, I'm doing the same, though I, too, grow, and later I will begin to decay. But, I am working with the same plan.

In my profession I am still quite happy. I don't want to hear about magazine statistics; dead or alive, who cares, really. Never in my life have I shot *for* a magazine. Never in my life have I had the art director or a double spread or a cover in mind. It is not indolence, but that you fully concentrate on the subject matter. If you ask me what I have done that is new, I can only answer nothing, but I believe I have been growing in many directions.

As a child, I was taught by my papa to look at stones, to be in contact with nature and to keep my body in good shape. The latter is very necessary for a photographer. Fifty years have passed, and looking at my work I can't really see that at any one time I have done anything new. I only know a little better what I knew then as a boy.

You may wonder how I can be reaching the age of 50 and not yet have done a book. It is because I am not finished. I still have an incredible urge that this work is not yet good enough. I still have more to do: this or that can be changed, intensified or re-edited.

Frequently on Saturdays and Sunday I tell my answering service that I am in the country, which sounds terribly chic, but I am at home. I go through my files and have the greatest pleasure. As you grow older you will find that although you have many interests which go in such different directions, suddenly at the end they all come together into one.

I don't want to change my profession, although sometimes I am sad that it is my profession. I really would like to have some money coming from somewhere!

<div align="center">1967</div>

I've got two programs in my hands. One says that I should talk about my achievements with the still camera and with the movie camera. And this other one has a very American kind of title: "What have you been up to lately?" I would like to answer the second one. I have to say either the same, or not very much. And this is really true, because it is at conferences like this that one is forced to go back and make an account of where one stands, what one has done. I made this account and found myself deeply in the red to myself and to my accounting books. But, nevertheless, if you take the latest work, you can do something with it.

I want to tell you of a story I've been working on for a long, long time. It is a story which goes beyond time and space.

On Genesis

If you were to come to my studio you could see two kinds of libraries. There's one library filled with pictures which I call "lately," because these are the ones I make a living with. But then there's another library which is much closer to me and this I call "the sanities," because the photographs here keep me sane. You can also call them the chaos, because they started as chaos. It is really thanks to an assistant of mine who showed me what this chaos was leading to. If you look at the boxes of this library you can read "fire," "water," "earth," "heaven," "clouds," "greens," "flowers" and "animals."

One day I left and when I came back, my assistant said, "Could I project a story from your slides on the creation of the world?" I said, yes, of course. And he really did. What was amazing was that suddenly out of this chaos came not the creation of the world, but a slight attempt.

Since then I have thought about this attempt. In many ways it is really fascinating for it is the only story which is free to be done. You don't have to ask for permission, and you can put in everything that you have learned in your experience as a photographer.

How I came to attempt this work is an interesting story. It was after my motion experiments that General Dynamics came to me and said, "We are a dynamic company and think your motion experiments would fit into our program. We want you to photograph missiles in the same way and all the things which are dynamic in our company." I was a little startled because they didn't know I needed about 20 missiles to make one good picture! But I didn't ever get to the missiles. They forgot that I was an Austrian citizen and wasn't allowed to get close to missile factories.

As I lay on the beach in La Jolla dreaming that I was going to be the first photographer for General Dynamics, making photographs on the moon, I looked and looked very closely at the earth. Suddenly this earth started to transform, and it became the moon, and

it became the universe, and it became everything you wanted to imagine. It's the story of the genesis, or the creation. What else is a creation but a transformation from the real to the fantasy and from the fantasy to the real? From the fact to the imagination, and back to the fact.

The reward of thinking like this came a little later when I was sitting in my studio and asking myself the eternal question of a photographer, "What shall I do next?"

I got a call from John Huston, who said, "Ernst, I'm going to do a movie on the Bible and I need somebody to come up with some really great images on the creation of the world. Do you think you could do something like this?"

And, like God, I said, "I've done it!"

He said, "What do you mean, you have done it?"

I replied, "I can show you a few attempts." I showed him my work which led directly to the film assignment.

So here we really talk about a story which I started in still pictures, then worked on as a movie, and am still working on in still pictures. Thus, when you ask, "What have you been doing lately?" I wouldn't say I've photographed the creation of the world; I'm still trying.

It is really quite amazing that this creation in the *Bible* is not so very far off from what we would call a genesis or a creation today. Life comes from water, and develops, and the beauty of it is that I was free to go from reality to fantasy, from fantasy back to reality.

Arizona from "Genesis" series Ernst Haas, Magnum, 1955

I would like to talk a little bit about the past. I always thought that it was very unfortunate to be brought up during the War. If I look at it today, this is not really quite so. In photography a period has passed. I call it the period of discovery.

Today we are confronted with very big problems: that we know too much and that we are a little bit desperate. Not only the world, but also photography goes through a transition. Immediately after the War when the magazines were hungry for new material — and it is always after a war that people are hungry for something new — they were really going out of their way to make new discoveries.

Today, this is not so much the case. But, I don't want to complain, because it is not anyone's fault.

Time for a New Beginning

Times have changed, and with them the magazines have changed. Photography has changed. But what has not changed is a human being who wants to be a photographer. As long as there are young people who are willing and trying to do interesting things, in spite of it all, and not always because of it, things will go on. I, myself, sometimes have deep depression, and I think I will run away to the movies, for it is very exciting to work with the big screen. But, it is really a pity that all the dreams which we have, and all the things we have learned, and all our experiences cannot go into the magazines.

Talking about the future and talking to young photographers, I can only give this advice. Be as flexible as possible; learn everything; go into television; learn the camera; learn movie making. But, don't forget the hand over the finger — draw, paint, let yourself go. Become a universal visual man. And read, and listen, and live, and don't be afraid. Even if a period is over, that means it's an end. But every end is always a new beginning, and this new beginning is really in your very hands.

I have a surprise for you, and this is really a surprise for me too.

A "Rejection Slip" for Hicks

Mr. Hicks mentioned that he offered me a staff position on *Life* after my story on the homecoming of the Austrian prisoners. I have just found a letter which I wrote to Mr. Hicks [1] almost 19 years ago. As I looked at this letter I remembered it only vaguely. And I asked the agency why this letter was in their hands? The agency replied, the letter was there because at that time it was considered too fresh. One didn't talk like that to a picture editor. Wilson, I will give you this letter, but first permit me to read it. I wish this would be myself now, though I don't think I would have the guts! It was really quite amazing that after the War one had this incredible belief in what he wanted to do.

London, 1949.

Dear Mr. Hicks:

Today came Capa's letter and your nice offer to work for *Life* on a certain basis. There are two kinds of photographers. The ones who take pictures for magazines, and the ones who gain something by taking pictures they are interested in. I am the second kind.

[1] But the letter had never been delivered. A picture agency which then represented Mr. Haas had retained the letter in its files through the years before returning it, unmailed, to Haas shortly before his Miami appearance.

I don't believe in this "in-between" success of becoming famous as quick as possible. I believe in the success of a man's work in becoming a real human who obtains the idea of life in its connection with earth and cosmos and who is able to understand the mistakes and admires the achievements of other people.

I don't consider myself so important that I say I don't need the discipline of working for a magazine — which means to photograph cooperatively what they need and not what I need. But, not only a magazine has a plan. I have one too, and is it not also a discipline to decline a chance such as you propose just to keep the aim you have in your mind? But for me it is always a better feeling to risk something for what I believe in than to go the more pleasant way. I'm young enough to do it, and I'm filled with energy to see it through. And some day I will prefer to be noticed for my ideas as well as for my good eye.

Maybe you will think I am not quite on the earth with both legs. If you want an overall shot as a photographer, you have to try to get a little higher than usual. I just want to keep my liberty and further my own ideas. Mostly I have found that stories I did from my own ideas were published more often than those done on assignment.

I don't feel misunderstood in this world, but I also don't believe many editors would be able to find quite the right stories for me.

I should like to thank you very much for the opportunity you have kindly given me and which I greatly appreciate. And I hope you will remember me more for the stories I will do in the future than for the words of this letter.

> Sincerely,
> Ernst Haas

Is photography an art or not? We live in a century which is in transition. So are the concepts of this century, and concepts are often mixed up with words. Very often you first need a concept and then you develop a word for it. But let me tell you what I think about it.

Painting is an art if it's done by an artist. Music is an art when it's done by an artist. And, I would say photography is an art. But I think we've made a mistake looking at this word *artist*.

An artist for me is a man who can build his own vision, his own world, and force others to live with this vision. It doesn't matter how it's done. It's done in science — and I would consider Einstein an artist, because I'm absolutely sure that he knew his formula before he found it, before he could prove it. This is very much the same in any art form. You don't really search all the time; you find.

The same is true in photography. You go out and you find things which you think were waiting for you, though you never expected them. This is a beautiful paradox of life.

In this way I think we have to reconsider the word *art*. I think it is obsolete. You can be an artist by not doing a Goddamn thing — by just being, just looking. You don't have to prove anything. I think that there are possibilities of people using other people, and these users of people are artists too. We have very, very few of them. We call these people catalysts. In our field we need more discussion and we need more catalysts to whom we come. They feel our desires and our longing and tell us what to do. This is what I think about art and artists.

CONFEREE: Mr. Haas, you have used the word *discipline* a number of times. And this would seem to take a very important part in your life. You are a photographer, but

obviously from the things you have said, you're also a philosopher. Do you have a philosophy about discipline?

HAAS: Yes, I think that there's no liberty without a discipline. Because liberty gives you too many possibilities. In order to come to a discipline you have to wall in your liberty. It means you only come to a subtlety within the same, not within the different. Beethoven works with differences, and is very dramatic; Bach works with sameness. These thoughts are in a little 30-page booklet which I wish everybody would read. It is by Stravinsky and is called "The Poetry of Music." It is fundamental and fits any art form. He says in music we have liberty — all of these sounds, all of these possibilities — and yet we have to narrow ourselves, not take all the liberties. It is this narrowing of the self that I call discipline. Many photographers discipline themselves and have a very intellectual explanation for it. Edward Weston did not make enlargements. What a pity, because it would be beautiful to see his images very huge. But that was his discipline. Cartier-Bresson said despite the wide angle lens I will only shoot with the 50mm. He let himself see it only one way. After one has worn out a discipline, he should put himself into another one. But you always arrive at any liberty by putting yourself into a new kind of discipline.

ROBERT CAPA,
WERNER BISCHOF and
DAVID SEYMOUR "CHIM"

A Tribute by
CORNELL CAPA, 1958

Cornell Capa, brother of the late Robert Capa, joined Magnum in 1954 following eight years as a *Life* staff photographer. Mr. Capa photographed Adlai Stevenson through both Presidential campaigns as well as John F. Kennedy, coordinating Magnum's photographic coverage for the Simon and Schuster book *Let Us Begin: The First 100 Days of the Kennedy Administration*. His penetrating photographs of President Kennedy reveal exceptional photographic involvement. He has photographed in Latin America, with concentration on the Auca Indians of Ecuador. Most recently he created the exhibition *The Concerned Photographer*, edited a book by the same title, and established The Fund for Concerned Photography in 1966. The Fund is in memory of Werner Bischof, Robert Capa and David Seymour "Chim." Writes Capa, "In a way, that speech in Miami may have had something to do with its genesis."

I would like to share with you some of my thoughts about Bob Capa, Werner Bischof, and David Seymour "Chim." Bob and "Chim" were really discovered in America by Wilson Hicks, who knew how to prod photographers. During the 12 years I was at *Life* he prodded me several times, and each time it would make me mad. But, he always made me think. He helped photographers to face up to themselves as persons.

Death of Loyalist Soldier, Spain Robert Capa, 1936, Magnum, from **The Concerned Photographer**

In 1936 Bob Capa went to Spain during the Spanish Civil War without the formality or protection of a passport. And, it was Wilson Hicks who later organized a "rescue" for Bob from Barcelona. I have a letter which I'd like to read to you so you can appreciate what Hicks really meant to many of us, and in particular to the people whom I'm talking about. It was dated January 31, 1939.

Dear Mr. Capa:

We here at *Life* were very concerned about you as Franco's troops neared Barcelona and then captured the city. It was a great relief to us when Mrs. Chambers cabled, "Capa safe Perpignan!" You must have felt as I did that after the picture job you did in Loyalist Spain, you would not have been treated so kindly by Loyalist enemies had you fallen into their hands.

The last push against Barcelona transpired so quickly that we had short notice on which to take steps to facilitate your escape. The day before the "Omaha" sailed for Marseilles we petitioned the State Department on your behalf, and they advised us that if you would go to the American Consulate in Barcelona, either of two Vice Consuls remaining there would arrange passage for you on the U.S. destroyer. Through both our Paris office and the New York *Times* we undertook to get this message to you. But apparently you had already chosen to head north into France. While our efforts to help you get out did not succeed, we are, of course, extremely glad that the course you took did. I have cabled Mr. de Rochemont in our Paris office suggesting that now is the time for you to go to Russia. Doubtless the office will be in touch with you about this, but please do not leave before getting detailed instructions on which pictures to get.

Life has been well pleased with your pictures both from China and Spain. I know your modesty will not lessen when I tell you that you are the "Number One" war photographer today. You have the best wishes of all of us for your future safety and success in your assignments.

Sincerely yours,
Wilson Hicks

The kind of relationship which Wilson developed with Bob and "Chim" was similar to his way with others later on. Wilson had an appreciation for the work Bob had done, concern for his safety and plans as to how he could push him to new heights.

Capa, "Chim" Get the "Hicks Treatment"

Bob came to America as a celebrated war photographer only to receive a second dose of the Hicks treatment. Of course his only link with America had been Wilson Hicks, so he went directly to *Life*. Months passed. Bob was cooling his heels outside Hicks' office. Hicks could not see him. Finally he gave him some assignments, the cats and dogs variety. After six months, Bob could not take it any more; he picked up his cameras and went to China. He had played right into Wilson's hands, soon producing some great war pictures, which was what Wilson wanted, of course. To some extent it was good for Bob, too. Looking back on Wilson's act after some 20 years, you can see how well Wilson understood photographers' motives and the conditions under which they would produce their best work. He conceived his job to provide the necessary frustration for Bob "to do what he was meant to do: to take war pictures."

Bob's later work for *Life* developed in a similar pattern, a honeymoon with a fickle lover. He quit many times, would fume in between, then make up, and go on to produce more great war pictures.

As for "Chim," he received a different and much less pleasant Hicks treatment. His "Barcelona Under Siege" had been published by *Life* in 1937 as an eight-page spread. There then came a hiatus of 11 years before "Chim" again made *Life* magazine, and even then only on the basis of a story which he had undertaken independently and which had not been purchased until complete. During those 11 years, "Chim" was bothered tremendously about why he had not been able to crack *Life* again. Wilson made him think, too.

I believe in these years "Chim's" photography matured. This period of gestation was helpful to him, because he spent time figuring out what was wrong.

I find it terribly difficult now to talk in memoriam about these three photographers, because they have left a body of work, an approach to photography, which is quite alive. You and I aspire to do the same job that these guys were doing. Everywhere I go — from Oslo to Vienna to Paris to Tokyo — I see the same images that they have seen and photographed. They have left images which are not only before my eyes, but also are in the very air wherever I am. I can feel and see what stimulated their thinking in a specific situation or place where they have been. It is not a mechanical thing. Each time I get into a situation, I ask what would they have done? Have they done it? And, if they have, is it valid now? It is a living thing; I can't escape it, and the air around me is somewhat permeated by their presence, a presence which is a constant guide and a challenge, a thinking and feeling one. They have sensitized my eyes, my emotions and my thought processes.

They were quite lucky because they were pioneers who had the good fortune to work in the first two decades to be really covered by the camera as a recording instrument. Wherever they went, they were the first ones; their impressions were fresh.

Magnum is Born

They created Magnum. It was a natural child whose father and mother are somewhat hard to determine. We know that Magnum was born out of love and necessity. They knew

what they needed as photographers, and this is how "Chim" explained the reason for Magnum's existence. He wrote this introductory piece for the 1956 Photokina exhibit in Cologne:

> Magnum was founded to give its members the opportunity to organize their own photographic life in accordance with individual desires. It was to be a joint solution of the business and operational problems confronting the individual photographer. Magnum also derived partly from a need for a close contact and friendly exchange of ideas between photographers dedicated to their work.
>
> A group of five got together to found Magnum. We knew the staff position on a picture magazine was not the best solution to our own creative needs and problems. Our original aspiration was to enlarge to ten members and then remain at that size, limited in numbers as an exclusive photographic club. Very soon exclusivity disappeared. We found out that was not what we wanted. We were quickly confronted with the problem of young talented photographers who came to show their work, asking for advice, encouragement and help. We understood Magnum would fail if it continued to keep its doors closed. We began to absorb some of this young talent. Some of the new members liked the idea of working together, while others stayed but a short time. We kept on growing.

That was "Chim's" way of putting it. To Bob, Magnum meant to live in pursuit of great pictures, the joy of a substantial bottle of champagne, and a joyful getting together. The meaning is the same, even if the words are different.

"Chim" and Bob had no children; Werner has two sons. Somehow, wherever these three men went, they took pictures of children. But, they were not the kind of children whom loving parents like to think of as their own. These children were children in trouble, their lives marred by poverty and tragedy. Yet the pictures show a joy that only children can have under such circumstances.

I know that Bob and "Chim," as two founders and successive presidents of Magnum until their deaths, lavished concerned love on their brain child, Magnum. It received a tremendous amount of their thought, effort and money. Fortunately, they wrote a lot, talked a lot, and made enough money to keep the idea alive. Daily we meet the same problems which they faced, and many times we make the same mistakes which they made. I guess it is part of one's own growth to make mistakes.

Bischof: Graphic, Gentle, Swiss

Of the three photographers, Werner was of my generation, but I did not know him very well. During the years when he roamed Central Europe, India, Indonesia, Japan and the U.S., I was sometimes traveling on the same circuit, but at unsynchronized times. Our paths hardly crossed, and by the time I joined Magnum, Werner was dead.

Since then, I have traveled in many places where Werner has been. I arrived one day in Luzco, Peru, loaded down with cameras and quickly found a taxicab. The driver looked at me, and somehow in broken Spanish I made him understand that I was looking for a certain man in town. After a while he asked if I were a photographer. I said that I was. He asked if I had known any Swiss photographers. I wondered how many Swiss photographers might have been around there. Then I remembered the pictures Werner had taken in Luzco, where he had spent a few days. As I described Werner to him, he broke in,

"Yes, that is the one." I assured him that Werner was a very close friend and colleague and the driver was, at once, a friend. From that time on I had no more difficulties in Luzco. He told me he had taken Werner to some Indian villages and explained how careful Werner was in his work, how he handled people and how gentle he was. Then his voice fell as he said, "Isn't it too bad that he had to end up that way." In Peru, news travels very slowly; to some places it hardly travels at all. Werner died in a different part of Peru, so I would not have expected news of his death ever to reach Luzco nor that this man should have noticed it. He did not remember Werner's name, but he remembered his mannerisms.

Werner Bischof came from a good middle-class family in Zurich, his father the manager of a pharmaceutical factory. Werner wanted to paint, but his family insisted on a more substantial occupation — that of a drawing master or sports teacher. In 1932 he began taking general applied arts courses in Zurich, spending four years in photography, lettering, layout, graphics and nature studies. This training was evident in his later work — very strong design and color consciousness. During the first years of his career he applied himself to meticulous studio photography and the graphic arts, designing exhibitions in Switzerland and working for *Graphics* magazine. The war shook Bischof up — though Switzerland was neutral — and on its conclusion he traveled through the Balkan countries for the Swiss Red Cross. Naturally he took his camera. From this trip came the publication of his story in *Life*. Through the application of Werner's sensitivity to design, the pictures had a new dimension, enhanced by compassion and journalistic meaning. From 1945 through 1949 Werner worked as a photojournalist throughout Europe. In 1949 he married and joined Magnum, whose members were Robert Capa, Henri Cartier-Bresson, George Rodger, David Seymour and Ernst Haas.

Almost all of Werner's work was done without assignments. Relying on his Swiss mountain toughness, his sports training and his simple needs, Werner traveled throughout the Far East on a shoestring, supported by the then shoestring operation, Magnum. While Werner's burning desire was to search the world, his love for home and family provided time for the editing of his work. The minute he would return home, his grapic bent would surface, as evidenced by his *Japan* book and the Far East issue of *Du* which he laid out. He also created an exhibition from his Far Eastern travels.

While Bob Capa admired Werner's thoroughness, he urged him to limit his public appearances and get back into active shooting. In 1953 after nine months of work on his Far East material, Bischof traveled to the United States. An assignment from Standard Oil's *Lamp* gave him the opportunity to see America. Intriguing patterns of American highways, skyscrapers and the marvelous span of the San Francisco bridge provided subjects to combine design with journalism.

In New York he bought a jeep and set out for South America with his wife. In Mexico they parted; she was pregnant and hurried home to Zurich. Werner hurried too. He flew to assignments in Chile and Peru, writing, "Winter is coming, and life is generally sad. It is no comparison to the Far East. I am sure to stay no longer here than I must." A few days later, high in the Andes, Werner Bischof was the victim of an automobile accident.

Erich Hartmann, Magnum

Werner Bischof, Magnum,
1916-1954

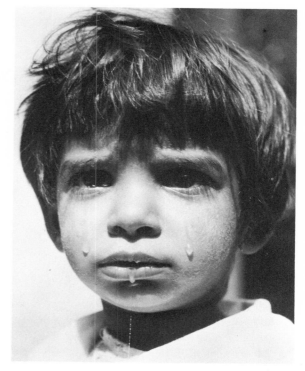

Hungarian girl

Werner Bischof, post World-War II, Magnum, from **The Concerned Photographer**

Werner Bischof, 1950, Magnum from **The Concerned Photographer**

Shinto priests, temple garden, Meiji, Tokyo

"Chim:" Intellectual, Owl-like, Polish

Next I wish to talk about David Seymour, whom we all knew as "Chim." This is a report from the New York *Post* by William Richardson, datelined Port Said, Egypt, November 14, 1956:

> A French army Rabbi stood in the bright November sunlight and said the last sad rites over the body of David Seymour. An honor guard of paratroopers, infantry and naval commandos stood at attention as a bugle blew. The French were giving a brave man they knew as David Seymour, American photographer, full military honors. They never knew him as "Chim," one of the quietest and gentlest of all men, whose enormous compassion translated itself through a camera lens into some of the most human and touching photographs of our generation.

Some two years before that there had been a similar dispatch, a similar ceremony, also with French troops and bugles — the end of Bob Capa, "Chim's" closest friend. This was an end of a long parallel. "Chim" came from Poland; Bob from Hungary. They both left home to escape confinements of their native lands.

"Chim" first wanted to be a pianist. His hands were fine and sensitive, but he did not have absolute pitch. Instead, he studied graphic art in Leipzig. Then to the Sorbonne, where misfortune hit twice. Economic depression took his family's fortune and Hitler took his family.

Bob and "Chim" met in Paris, both freelance photographers, one camera each. Their circle of young expatriates from many lands included only one Frenchman, Henri Cartier-Bresson. From friendship and pooled resources came the unconscious birth of an idea, the non-profit international cooperative that was to become Magnum, founded in 1947. When "Chim" went to Spain in the '30's, his big break was publication of the Barcelona story. Then things went bad. France fell, and "Chim" came to New York. His English was poor. He felt quite out of place here and was too shy to continue his former professional work as a photographer, so worked in a darkroom. He learned English rather quickly, and while it was somewhat weak in grammatical structure, it was understandable. "Chim" also had command of French, German, Russian, Polish, Italian and Spanish. Drafted early in the war despite his extremely poor eyesight, he did a stint at the multi-lingual Fort Ritchie and then was assigned in Europe. His experience as a photographer was utilized in a photo reconnaissance and interpretation section of the U.S. Air Force Intelligence.

With his cap pulled down to his thick, horn-rimmed glasses, the little owl-like man, speaking quietly and knowledgeably, cut the most un-military figure as he briefed officers of the highest echelons on the results of our bombing raids over Europe.

A few days after the Germans fled Paris, a U.S. Army command car stopped in front of a cafe on the Boulevard Montparnasse and "Chim" descended. He was returning home after five years. In a few steps he encountered a friend who invited him to a party where he met his two long-parted friends, Cartier-Bresson and Bob Capa.

From a post-war renewal of the pre-war friendship came the official formation of Magnum Photos in 1947. It began bravely as the incorporated dream of the freelance photographer — independent, international, intriguing. Capitalized on a shoestring,

David Seymour "Chim," Magnum, 1955, from **The Concerned Photographer**

Art historian Bernhard Berenson
at Borghese Gallery, Rome

David Seymour "Chim," Magnum,
1911-1956

Elliott Erwitt, Magnum

Magnum survived into May, 1954, thanks mainly to a spirit of cooperation, luck and Bob Capa.

Then luck deserted. On two successive days came the news of the deaths of Werner Bischof and Capa. A new era had come to Magnum and to "Chim's" life. "Chim," whom all knew as a shy, gentle-humored man, was Bob's closest friend and fellow-photographer. He always lived in Bob's shadow, the world's greatest war photographer, the *bon vivant* and the great extrovert, a legend which Bob had to live up to.

In the crisis that followed those two deaths, "Chim" exhibited his quality of greatness. He knew what Bob wanted to do with Magnum and was able to add "physical and administrative clarity" — one of his favorite phrases. Serving as Magnum's president during the next few years, his time for photography was somewhat limited. Nevertheless, he produced some of his best work, including stories on Toscanini, Ingrid Bergman, folk festivals in Italy and Greece and many images of his beloved Italy.

"Chim" was an intellectual photographer and for a very long time he had difficulty breaking into the major markets. Some of the difficulty was that he couldn't capture with his camera the emotions he felt. His series of photographs taken in Israel marked the beginning of a new era for "Chim" in photography. Suddenly he was ready to share all he had kept hidden away in his former years: a knowledge and love of art, history, religions and food.

During the weeks that preceded the Suez crisis, "Chim" went to his newly discovered archeological paradise, Greece, for a well-earned rest from Magnum affairs and for the private joy of taking photographs of things which interested him. When the Suez crisis broke out, "Chim" wrote a letter in which he defined what Magnum's future role should be. He urged a continuing journalistic coverage of great events by Magnum's members, as contrasted to their going into the "commercial" market to do assignments which paid well but had no permanent value. He was distressed by the events of Poland and Hungary, where we had accomplished only scant and late coverage. "Chim" then made a personal decision which backed up his belief.

He had no assignment, but was accredited to the Anglo-French forces in the Suez Canal area. When he arrived, most of the fighting was over, so he shot "mopping up" operations as well as civil life in Port Said. With a truce supposedly in force, he and a *Match* photographer left to cover the first exchange of wounded. As they crossed from Anglo-French lines to the Egyptian side, where the exchange was to take place, Egyptian machine-gun fire crackled. Their jeep was hit and plunged into the canal. "Chim" was dead. Having lost his parents, his country and his youthful hopes and ideals to violence, it seems almost inevitable that "Chim," himself, should have died violently. For a man whose wish was peace, there was no peace.

Bob Capa: Leader, Bon Vivant, Hungarian

For me, to talk about Bob could possibly have been the most difficult, but it is not. Bob did very well in talking for himself, and *Slightly Out of Focus,* a book he authored after the War, received many good reviews. The book is really Bob's autobiography.

I should like to read to you from a book review of *Slightly Out of Focus,* in the New York *Times* by Charles Poor:

> Writing the truth being obviously so difficult, I have in the interests of it allowed myself to go sometimes slightly beyond and slightly this side of it. All events and persons in this book are accidental and have something to do with the truth. Mr. Capa's own history reaches deep into the suburbs of improbability. He's widely known as the only genuine Hungarian enemy alien ever to serve as a war photographer and correspondent with the American army.

> His publishers tell us that he was born in Budapest in 1913. Due to a disagreement with Admiral Horthy's oppressive dictatorship, he left Hungary and for a short time became a photographer in Berlin, Germany. In 1932 due to a disagreement with Hitler, Capa left Germany and found his way to Paris, France and then to Spain. It was while in Paris that he met Henri Cartier-Bresson. Due to a disagreement with Franco, he left Spain in 1939 to come to America. Here he gave authorities the idea that he was a farming expert on his way to Chile (pure invention, of course). In the summer of 1942 he found he was a displaced person in Manhattan, and the Department of Justice regarded him with a beady eye.

Robert Capa, Magnum,
1913-1954

Ruth Orkin

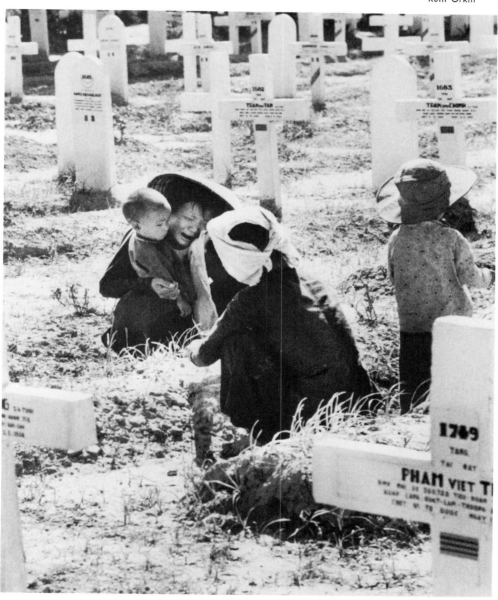

Robert Capa, 1954, Magnum, from **The Concerned Photographer**

Soldier's grave, Indo-China

Unaware of this problem, *Collier's* regarded him as a great war photographer and sent him a $1500 advance to do a story on a fast convoy to England. Not wanting to disillusion or disappoint anyone, and having only five cents in available funds at the moment, he did some extraordinarily fast footwork, and after some harrowing experiences, he got to London. Thereafter he had frequent brushes with authorities who questioned his accreditation. Eventually he got a special pass signed by General Eisenhower. No pass would help him, however, when he found himself without a sponsor the day after he had photographed the airborne troops invading Sicily. And, when he tried to get into Bastogne with the Fourth Armored Division, his accent was downright unfashionable.

Capa did get around, though, for occasional visits to a girl in England. And, in North Africa, he photographed Generals Patton, Teddy Allen and Theodore Roosevelt, Jr. leaning over the edge of a fox-hole. In Sicily he saw the desperate Battle of Troina and made two simple pictures which showed, "How dreary and unspectacular the fighting really is." For scoops, Capa says, "Depend on luck and quick transmission! But, most of them don't mean anything the day after they are published." The soldier who looks at Capa's shots of Troina ten years from now in his home in Ohio will be able to say, "That's how it was."

Bob Capa saw the children of Naples, whose fathers had fought the Germans for days while the Allies were pinned down outside the city. He saw the mass funeral for those who had fallen, children old enough to fight and be killed, but too big to fit into children's coffins. That was the ultimate reality of his return to Europe. "Those," he said, "were my truest pictures of victory — the ones I took at the simple schoolhouse funeral."

He landed on the Anzio beachhead, and in due course he found himself pinned to the shore of Normandy on D-Day, asking a lieutenant what he saw. "I'll tell you what I see," the lieutenant whispered, "I see my ma on the front porch waving my insurance policy." But hasn't that story been used before?

Later he was a member of the EHEF, the Ernest Hemingway Expeditionary Force, and was one of the first into Paris riding in a tank.

During Bob's lifetime he acquired a reputation for being a very bad technician. As most of his supposed weaknesses, he made a strength of that in time. He didn't mind the reputation, but it's really a half-legend, perhaps based on some truth. In the early days he owned but one camera. While I was in Paris during the Spanish War days, I never heard anyone mention the name of a repairman, and I think Bob's Leica might have been *slightly out of focus*. But, you could only detect that in his desert pictures!

The developing was done in Spain, or he'd send it back to Paris, where he had a very convenient hotel closet. If his 35mm negatives were slightly out of focus or somewhat scratched, it may be true, but it was not because Bob did not care about technique. He kept his lenses clean; he packed his equipment well; he cared.

In later years, especially when he came to America, he was confronted with the 4 x 5 camera. For a while he tried a Plaubel because he was told it was the right camera to use. He quickly gave it up. Next he tried a 4 x 5 Graphic because that was simpler. That wasn't usable for Bob, either. Then he tried the Rolleiflex, because there was some need for larger color transparencies in that period when 35mm color was unacceptable. But the natural camera for him was a 35mm with *eye level* viewer.

It's interesting to see the negatives he brought back from the D-Day invasion. Even on that trip, he took a Rolleiflex along. He used it on the boat, but left it there because all landing pictures are 35mm again. Yet, when he got back on the landing boat, he once again shot with the Rollei.

He had an incredible energy to take part in anything he was to photograph. He was the most effective photographer I have ever seen in blending with the background while taking a completely active part in talking, dancing and participating in whatever was going on. He really lived anything he did.

He hated to be classified as a war photographer, and he tried photography in peaceful areas many times. He never was able to devote significant concentration to such assignments, though. As a photographer his real peacetime activity coincided with the birth of Magnum — activation of the group, ideas and finances — an entirely different field of activities leaving only a small place to the practice of photography. I recently found a letter written by the woman who was Magnum's bureau chief at the time of Bob's death. She sums it up:

> My belief in Magnum is in a great part my belief in Bob. My loyalty is to his ideas and to him as a person, as a great energy, a creative force and a source of love. This loyalty extends to anything he believes in. When I came here, I gave my entire heart and mind to Magnum; I still do.
>
> For me, Bob was a champion of ideas and ideals. If any one of us found self-expression as strong or stronger outside the group, he would be all for it. He did not want a family of conformists, but one of open-minded learners. He was delighted when anyone did more than a literal translation of his job. If Bob could imagine the circumstances in which we find ourselves now — of course he couldn't, for he was far too living a person — he would still mean just what he meant: affection and guidance to those on any level of endeavor, who had potential to do the thing that would get them up and into the light where they could see beyond themselves and be seen, that eventually each should go out in full steam himself, able not merely to keep afloat, but to swim healthily.

Why was Bob's life a true one to her? There are many other views of Bob and they're all true to the individuals involved. As for me, his younger brother, Bob Capa has done one thing: he has given substance and meaning to the time-honored expression, "He was a brother to me."[2]

[2] In 1971 Cornell Capa appended the following to his remarks of 1958:

Magnum is in its 24th year — still in pursuit of great photographs — and it is still "the incorporated dream of the freelance photographer — independent, international, intriguing."

As a follow-up of the talk in Miami in 1958, in 1966 the Werner Bischof-Robert Capa-David Seymour Photographic Memorial Fund was established "to foster the ideals and professional standards of these three men who died a decade ago while on photographic missions."

A year later the fund was broadened and renamed as The International Fund for Concerned Photography with its goal thus defined: "The Fund seeks to encourage and assist photographers of all ages and nationalities who are vitally concerned with their world and times. It aims not only to find and help new talents, but also to uncover and preserve forgotten archives and to present such work to the public."

Established in 1966 in Memory of Werner Bischof (1916-1954) Robert Capa (1913-1954) and David Seymour "Chim" (1911-1956).

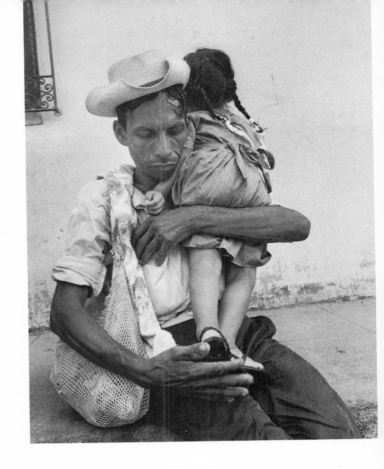

From *On the Margin of Life*, 1971

Cornell Capa, Magnum

6

Toward Professionalism:

CRITICAL COMMENT AND CURRENT PROBLEMS

When the photographer began shooting occasional assignments for the newspaper or magazine of the 1890's, he was quickly stereotyped as a gross fellow with a press card in the band of his battered hat and a big cigar in his mouth. It was, of course, the period of sensational "yellow" journalism involving the great circulation wars between William Randolph Hearst and Joseph Pulitzer in New York.

Nevertheless and unfortunately, the image of a photographer was then established in the public's mind and has been slow to change, though his professional standards have undergone substantial growth, improvement and development in the past 25 years. One has only to witness photographers' goals and aspirations as set forth in the preceeding chapter to verify his achievement toward becoming a professional communicator.

Today a man or woman in photographic communication is assuming significant responsibilities beyond "snapping" a picture. Many work as freelancers, originating ideas, getting an editor's affirmative assignment, gathering both word-facts and pictures and then preparing the entire package before its delivery to the editor's desk. Others provide added services in graphics, layout and design. Some are producing multi-media "custom" communication packages which contain slides, sound track and motion pictures. They research, script and photograph, later combining sound and pictures into finished form. There are photographic communicators who have turned to film-making as well as still photography; others have become book authors who write and photograph. The field of photographic communication demands broad contributions from talented, sophisticated and sensitive men and women who can perform as professionals in the full sense of the word.

There are two professional organizations which are devoted to photography in communications: the National Press Photographer's Association founded in 1945 and the American Society of Magazine Photographers (A Society for Photographers in Communications) founded in 1944.

NPPA's membership consists of photojournalists connected with the nation's newspapers, wire services and television stations as well as some magazine and freelance photographers. It is not a labor union, nor does it become involved in labor relations. The organization has been particularly effective in establishing a continuing dialogue and relationship with colleges and universities which offer courses of instruction in photographic communication. A "Flying Short Course" has brought leaders in the field to many sections of the nation annually for a series of one-day presentations.

The ASMP includes among its members a majority of freelance editorial photojournalists and magazine staff photographers. Another fraction of its membership is involved in studio and advertising photography. The Society has been concerned primarily with establishment of economic order in the field and has adopted "minimum standards" to cover rates of pay and rights of use for photography in the media. Its president in 1969, Toni Ficalora, describes in this chapter accomplishments of the Society in its 25-year history, its on-going activities and future plans for expanding the scope and interests of its members.

While there are limited codes of ethics in the national organizations, a broad general code of ethical standards, subscribed to by the entire professional body, must become a goal of high priority. Not only should it cover practices and fees in the client-photographer-agency relationship, but it should also deal explicitly with definitions for the assignment of rights, relationships and responsibilities among members of the profession and ethical norms for the relationship of photographer to his subject, including right-of-privacy guidelines.

One issue of great and continuing concern to photographers in communications — especially magazine photographers — has been the economic "crisis" in magazine publishing. Because this has been urgently discussed since the early 1960's, four presentations from the Miami Conference are included in this chapter to provide in-depth facts and trends. Wilson Hicks leads off with his 1962 keynote, "What's the Matter with Photojournalism?" *Life* staffer Howard Sochurek continues the investigation with "The Crisis in Photojournalism." Then, Philippe Halsman presents his 1970 keynote, "The Dilemma for Magazines and Magazine Photographers." That the topic is still very much alive in the thinking of editors and publishers as well as photographers in 1971 is evident in Gilbert M. Grosvenor's "A Look at Magazines in the '70's."

At a time of economic and technological change when professional photographic communicators must ask penetrating questions of possible directions in their future careers, a panel concludes the chapter as it explores various roles of the photographer — "Specialization or Versatility."

As those in photographic communication strive toward professional status in the 1970's there are further issues and considerations which should receive attention. For there to be a viable and meaningful professional dialogue, there must be active critics who develop a body of serious criticism in the literature. The field of photographic communication is unusually barren in this respect. Can there be a profession without internal (and external) evaluation?

PROFESSIONALISM

IN PHOTOJOURNALISM

MORRIS GORDON, 1960

The late Mr. Gordon served as co-director of the Conference from its founding in 1957 through 1971. His photographic career began in the early 1920's when, as a teenager, he assisted Hearst International Newsreel photographers in New York. Within a short time he was shooting motion picture newsreel footage! Later he worked on the first all-sound and all-color film, "Shadows of the South Seas" starring Monty Blue, a picture filmed in Tahiti. He worked as a newspaper and freelance photographer, completing assignments for the Associated Press, *Life* and many other publications, before joining the Western Electric Company. There he directed photography through the mid-'60's. Mr. Gordon died in New York November 13, 1971.

The American Society of Magazine Photographers is dedicated to the intellectual and economic growth of its members. I am extremely proud to be its president. During my administration I have dedicated myself to add another dimension which is equally important: professionalism.

More than 20 years ago, Dr. W. E. Wickenden, president of Case Institute, wrote "The Second Mile," an important article on the subject of professionalism. Here are the widely accepted criteria Dr. Wickenden set forth as the marks of professionalism.

First, it is generally an activity with a high degree of individual responsibility: the handling of problems of high social utility on a high intellectual plane under a code of ethical responsibility, and the use of skills and techniques not commonly possessed.

Second, the motive of service is distinct from that of profit.

Third, there is also a motive of self-expression which implies joy in one's work, imposes an austere standard of self-criticism and leads to a single standard of workmanship — one's best.

And, fourth, there is a conscious recognition of social duty to be fulfilled by sharing advances in technological knowledge, guarding the standards and ethical codes of one's profession and rendering a fair share of gratuitous public service.

Photojournalists will recognize that their achievement of professional status in any fundamental sense depends upon the fulfillment of these admitted idealistic criteria. Photojournalists will also recognize that according to such standards the term *professional* cannot be bestowed on the basis of arbitrary minimums in education or experience, including membership in a trade association or labor union.

In a word, to be professional we must act as professionals. Scientists, physicists, engineers and medical doctors regularly conduct seminars for the free exchange of information. There can be no trade secrets. The sharing of knowledge and techniques is one indication of professional behavior. Any definition of professionalism which we espouse must be in accord with the view which we desire to project of ourselves.

THE ASMP AT 25 YEARS

TONI FICALORA, 1969

Mr. Ficalora was serving as president of the American Society of Magazine Photographers at the time of his presentation, the 25th anniversary of the organization. He is a photographer in New York City who specializes in motion picture assignments.

Over the years the American Society of Magazine Photographers has stood for the individual photographer, protected his rights, and established policies that have been accepted as working practices in our profession.

On October 12, 1944, a group of magazine photographers met informally to discuss the organization of a society to promote and further the interests of established workers in their profession, according to the opening paragraph of the first bulletin of the Society of Magazine Photographers.

By a second meeting, 30 men and women, staff and contract workers from *Life, Look, Click* and *Pic* as well as agency photographers from Pix, Graphic House and Black Star along with freelancers working for *Collier's, Parade, Saturday Evening Post* and the *American* had gathered to: (a) safeguard and promote the interests of magazine photographers, (b) maintain and promote high professional standards and ethics in magazine photography, and (c) cultivate friendship and mutual understanding among professional magazine photographers.

Among those first members were Philippe Halsman, Arthur Rothstein, Fritz Goro, Andreas Feininger, William Vandivert, Fritz Henle, and W. Eugene Smith. John Adam Knight is given credit as founder and friend.

By October, 1945, the society had grown to 120 members and had hired its first executive director as well as its first lawyer. In January, 1946, SMP moved to its first official office at 1476 Broadway, where it remained until 1967. In April, 1946, SMP elected its first honorary member, Edward Steichen, and on May 10, 1946, the first meeting of the West Coast chapter was called to order. In June, 1946, SMP became the American Society of Magazine Photographers.

Contract negotiations opened in 1947 between ASMP members and Pix, Inc. whereby the photographers would receive 55% of the proceeds from the first sale of black and white photographs and the photographer would no longer bear the expense of flashbulbs and film. Color proceeds would be divided on a 60-40% basis. ASMP also held its first symposium on February 17, 1947, at the Museum of Modern Art, and for the first time assisted in a legal case which determined that in the absence of an agreement to the contrary, negatives belonged to the photographer and not to the customer. That was the beginning.

In 1969 ASMP celebrates its 25th anniversary and during those years has established guidelines and practices of the trade to assist the photographer in his relationship with industry.

Rates and Rights

Probably the most outstanding of these guidelines has been the Code of Minimum Standards, accepted in 1952, which for the first time defined a minimum on rates and rights for the photographer; this has been updated periodically.

Hand-in-hand with the minimum standard definition went the ASMP Stock Picture Code, and since then, ASMP special bulletins: a guide for photographers in the book market, photographers' representative contract form, guidelines and practices in advertising photography, photographers' rights, and a standard editorial contract. ASMP has formed the framework of photographer-client relationships throughout the industry.

ASMP's fight against photographic work on speculation put an end to blatant exploitation of photographers by publishers and their need to compete in the open market. After tragic deaths and accidents suffered by members, it was through ASMP's efforts that magazines were forced to accept responsibility for photographers' safety while on assignments. ASMP itself now carries accident insurance for each of its members. Through its various programs it also makes available additional insurance to its membership at reduced rates.

ASMP participation in the Joint Ethics Committee along with the Art Directors Club, the Society of Illustrators, the Artists Guild, and the Society of Photographers and Artists Representatives has supported photographer and client alike through providing a forum for fair mediation or binding arbitration.

The Society has worked for an improved copyright law, retention of photographic rights by the photographer, and against travel restrictions imposed on photojournalists.

Today ASMP numbers over 700 of the top professional photographers throughout the world. There are ASMP chapters in Southern California, San Francisco, Chicago, Gulf South, Ohio and Northern and Southern Florida, with others pending in Europe and Canada.

Widening Interests

The Society which only a few years ago opened its ranks to advertising photographers as well as photojournalists, has now voted to accept photographers working in communications, a change which more clearly defines new areas of involvement for the photographer.

We hope the March, 1969, symposium, "The Photographer in TV and Film," will be the first of a new series of programs and workshops dealing with new markets and areas of creative development. This implies no neglect of our beginnings in photojournalism.

Recent programs reflect the scope of ASMP: "Responsibility of the News Media," "Photography as a Tool of Science," "The Underground Film," "After the Photographer," "Animation and Animation Equipment," and "Optical Effects and Laboratory Controls."

ASMP memorial awards have over the years honored outstanding individuals and companies.

Two years ago we moved to new headquarters in New York's Lincoln Building, where telephone and comfortable working space for our out-of-town members is now

available, as well as an ever-expanding library of photographic books, magazines, and resource material. Our publication *Infinity,* which began as a part of our membership bulletin, is now well-known throughout the field.

We look forward to the next 25 years with excitement and the hope that the foresight of the hardy group of individuals who started ASMP will remain with those of us who continue to work toward the betterment of the industry and the individual photographer. We look toward an expanded Society. We welcome new members from among the ranks of talented, creative men and women whose work in this age affects the thinking and behavior of our entire world. We hope our efforts to safeguard the creativeness and livelihood of photographers will continue to bear fruit in the talent and integrity of the individual.

WHAT'S THE MATTER
WITH PHOTOJOURNALISM?

WILSON HICKS, 1962

I think I should say a word about why I am the one who will attempt to strike for you the keynote of this sixth annual conference at the University of Miami on use of the image in communication. The reason is this: photocommunication has reached a stage in its development at which more critical questions about its present and future are being raised than ever have been raised before. Some of the comments I shall make are of such a character as might not prove becoming for a working editor, writer, art director or photographer to express as keynoter. In other words, some things need saying which, in the opinion of Morris Gordon and myself, may be said with more fitness by a spectator of, rather than a participant in, the actual business of photocommunication.

So I have the responsibility of holding up to the light of critical examination this subject in which all of us here assembled are so deeply and vitally interested. I appear before you not as a teacher, but as a student of the media which use the image in communcication: newspapers, magazines, industrial publications and television.

I quite realize that I am about to say some things with which many of you might not agree. However, out of the lively discussion which should result if this conference is to be successful, from whatever stimulation the speakers may provide, we may be able to get at some sense-making answers to questions with which we are confronted.

Before I proceed further I should like to tell you how much I appreciate the opportunity to address you. You did not invite me to do so; indeed, in the realest sense, you are a captive audience. With this fact very much in mind, I ask your patience. And I still am grateful for being here, even though as keynote speaker I was chosen by the Conference co-directors, Morris Gordon and myself, in strictest collusion!

But let me get on with my explanation of the title of my speech "What Is the Matter with Photojournalism?" When you have heard that explanation, you will have heard my speech.

You have noted that I used the term *photocommunication* a moment ago. The word *photojournalism,* I believe, is dead and doesn't know it. So much of today's communication by image is being done by television that to combine *photo* with *journalism,* which means ink-on-paper journalism, is to ignore the electronic image. What with its progress and potential, television, which has adapted many ink-on-paper techniques developed by the mass picture magazine, is increasingly the concern of all of us interested in the published photograph as conveyor of news and its interpretation, and other subject matter.

Functions of Mass Media

As we know the newspaper, magazine and television media each play three roles: (1) communicator of facts and ideas, (2) entertainer and (3) merchandiser.

You note that I put communicator as No. 1. I doubt whether anybody in this room would take exception to the flat statement that the primary function of all three mediums is to tell the people the *news* and to interpret that news for them. This is their main responsibility. Who today would presume to doubt that keeping the people informed of events and matters of moment is the newspaper's, magazine's and television's first, foremost and all-compelling reason for existence?

I am aware that you might argue with me about the order of the next two roles — No. 2, entertainer and No. 3, merchandiser. Which is more important? Both are important, so perhaps the order doesn't really matter.

Francis Williams, a British newspaper man, said in his 1958 book *Dangerous Estate: The Anatomy of Newspapers:*

> [The] dual role of the press, to inform and entertain . . . has always existed. The journalist is traditionally an entertainer; he must entertain or find another trade Whosoever would influence the public must first learn to entertain it.

Mr. Williams makes his point in a very telling way, I think. The journalist must anesthetize the reader with the laughing gas of Abigail Van Buren or Al Capp to induce him to "take" the sober facts of Vietnam, the European common market or the cost of living spiral. These news subjects are not fun. If the reader is to cope with them, he must find comic or other relief elsewhere in the medium where he gets this "hard news."

Now let's think a minute about the third role, merchandiser.

J. Edward Dean, Director of Advertising, E. I. du Pont de Nemours & Company, in a recent speech made this point:

> The vigor of our advertising and sales effort is a manifestation of something very basic to the American economy — the intense competition which affords our consumer such a wide option in his choice of goods and services.

I don't expect to get into a fuss with anybody here about the value of advertising to our particular economy. Furthermore, the simple answer to one fundamental question about the mass media and advertising in a democratic society is that to *be* at all, a newspaper, magazine or television station must be *solvent.* And at this juncture we might well remind ourselves that any business involved in news communication doesn't

attract advertising unless its editors and their staffs know how to get through to the mass mind. Editorial and advertising departments have a hand-in-hand mutuality of dependency and interest, each in the other. Whereas a news communicating business can not *be* without solvency, it also can not *be* without the creative work of editor, writer, art director and photographer.

If you ask me why I go into this subject of the three roles, you lead me right into the first part of my answer to the question, "What Is the Matter with Photojournalism?" For not only do I hold that there is something wrong with photocommunications, but also I hold that some of the wrongness lies in certain imbalances among the elements of communication, entertainment and merchandising.

The Problem is the Proportion

What I mean by imbalance is that the ingredients of news, fun and selling are not mixed in the right proportions. *Proportion* — what a beautiful word!

Consider, if you like, the newspaper, the great and grand foundation of all news communication. We might say — let's do say! — that the greatest proportion in its mixture of content is advertising. Well, advertising is a kind of "news," isn't it? Product news, price news, sales news. Such "news" doesn't, however, help achieve any delicate balance we might be thinking about.

You might say information and entertainment are about the same, proportionately, in the newspaper, though I believe if you took measurements you would discover that entertainment had the edge. In this latter area you find photographs of babies, brides, bathing girls, homes, kittens, socialites, the put-out at second base, puppies, baked turkeys, apple turnovers and flower arrangements. Some of these subjects suggest that the newspaper has become magazine. Exactly. It has.

Newspaper has become magazine in more than one sense. It prints many things which once only the magazine printed, which means that newspaper and magazine are definitely in competition. But, in another way, too, the newspaper has taken on a magazine cast. It tries and succeeds pretty well in being more a magazine than a newspaper by selecting the *best* of today's news — *best* not always necessarily because it is significant, or has public service value, but *best* primarily because it is easy to take or, to put it another way, *best* because it amuses the reader rather than forces him to do a little thinking. A pleasing main edition, that's what we are after. We must create a favorable climate in which the merchandising process can take place. Essentially we want the non-advertising content to provide short-term pleasure. If this seems a kind of huckstering of the news, you could be right.

By now you doubtless have perceived another implied point. The newspaper through recent years has been adjusting itself first to the competition of the magazine and next to the competition of television. These adjustments have been made for the most part with the idea of improving the newspaper as a merchandising vehicle. What about the news? Ah, yes, what about the news!

Also, what about the newspaper's using more photographs to compete with television and its multiplicity of images? But no. Few newspapers have picture pages. Few use picture stories. And when will the newspaper give itself the cure for its chronic

ailment of one-columnitis, which means using two-column and three-column photographs in one-column space? When will it make consistently serious use of the photograph? I ask you.

The *surest* way to transmit certain kinds of knowledge is by picture. My plea is for more use of the photograph to transmit knowledge and correspondingly less use of the photograph merely to break up that expanse of gray type, to dress up a page, as the saying goes, or to help create an environment in which the advertisments can feel more at home. Why, indeed, can the newspaper not use the photograph in all those ways together?

For Magazines, An Economic Struggle

Now, I think, we can move on to the magazine. Certainly it is no secret that for the consumer magazine this is a time of trouble. By trouble just what do I mean? Permit me to give you a list of particulars:

(1) The magazine has one problem in common with the newspaper, and that's the competition of television. Television has had and is having a profound effect on ink-on-paper journalism. The effect has ranged all the way from rendering obsolete the newspaper extra to bringing pressures for change, the nature of which only the future will reveal. We are aware now of these affects:

(a) Television has made radical encroachment on the magazine reader's time.

(b) When television devotes saturation coverage to a big news event it leaves the magazine editor in a quandary about what to do with still photographs. Perhaps the editor has yet to learn certain basic values in and of the still photograph in comparison with television's image-in-motion. Expanded knowledge of the medium of the still photograph could provide some answers in this one respect.

(c) To put it quite bluntly, television is cutting down the magazine's advertising revenue. This hits the magazine where it lives.

(d) Television increases the incidence or severity of the editor's ulcers, high blood pressure or just plain worry, affecting his creative efficiency.

(2) This is a time of change, as all times are. Does the editor "actually know what is hapening in the American mind?" David Cort raised this very crucial point in a recent issue of *The New Republic.* Whichever of the two mediums, magazine or television, succeeds in finding the solution to this puzzle, and acting on its findings, that medium will win this gigantic battle.

(3) Another problem of the magazine editor is that he is in constant, highly-charged competition with his own advertising pages. The advertising image — what a many-splendored thing! And how well Madison Avenue has learned the lesson of marrying picture and word. More and more advertising calls on the news and important personalities in the news for ideas or testimonials. If we believe the newspaper and magazine give disproportionate significance to a news story to produce a sensation which they hope will sell their product, how about the Madison Avenue fellows? In advertising, sensation is piled on sensation until we wonder how they can ever come up with some-

thing yet more sensational. But they do. What, we may ask, is the editor to do to persuade his reader to allow a fair proportion of his time for the editorial pages, beset as the reader is with basic psychological drives which urge him to look at the ad for a Pontiac, live in eternal spring with a Salem or leave the present for the past and have a shot of Old Crow, vicariously, with Daniel Webster? How would I, if an editor, find my way out of this dilemma?

(4) Were I an editor again, I would have still another problem. How would I go about competing with other magazines in my same general category? Here again we might repeat David Cort's question, "What *is* happening in the American mind?" with emphasis on the *is*. What *do* people want — *Now?*

(5) How does a magazine get advertising? It's through circulation, of course. And how should it get circulation? The answer is only too obvious — through the quality of its editorial content. An old principle in general interest magazine publishing was that the more circulation a magazine had, the more its advertising volume. But, with rising costs circulation can reach a point where to produce and deliver magazines is so expensive that the economic law of diminishing returns takes over, and the advertiser no longer sees the purchase of space in the magazine as desirable.

(6) The sixth and last problem I shall state here is what I look upon as editorial ivory towerism. The editor operates in an office high above the crowd, experiencing life secondhand through word and picture delivered to him from hither and yon with masterful logistics. I raise this question: Isn't the editor who puts together a magazine for and about people really disconnected from life except for that little bit of actuality in which he, himself, moves daily? He lives upon a tiny segment of the vast world which provides his sustenance of fact and idea. Doesn't the editor's isolation from life beyond his immediate horizons produce sterility? Isn't that one of the main reasons why Hollywood as we once knew it came to the end of its tether? The artificiality of an editorial office is much like the artificiality of the movie studio. Doesn't this sterility lead to an oversophistication which in turn causes the editor to edit for himself and his colleagues rather than for his readers?

This completes my interpretation of the consumer magazine's time of trouble. The magazine may have other problems; in all probability it does have. I have set forth only those which I have heard or read about, or divined myself. And now I'd like for you to ponder with me for a moment the question of today's still photograph as taken for and used in the magazine.

For some of the reasons I have given, the magazine from time to time seeks a new approach to the use of graphics, particularly photographics. Changes in photographic approach have recently come to occur so frequently that they are in an almost continuous process.

Why does the magazine look for new approaches in photographic use? First, it must do so if it is to keep itself differentiated in visual appearance and appeal from other magazines. Then, to repeat, there is the responsibility of the editor to outdo, if he can, his publication's own advertising pages.

Magazine Photography Goes "Far Out"

Let's say that by long-standing preference a magazine has been using — specializing in — the so-called straight photograph. But for one or a number of the reasons already noted, it thinks it needs visual change. Among possible new approaches it has several alternatives. It can decide to throw out its straight (and sometimes dull) photograph and try the far-out photograph: the blurry photograph, the grainy photograph, the "abstract" photograph, the vaseline-on-the-lens photograph, the color-to-interpret-emotion photograph. What variety of opportunities at our command! Now the magazine can be different from any other magazine. It can bring about such a subtle interplay between editorial matter and ads as is sure to put the editor on top in this bit of family rivalry.

So to far-out photographs the editor goes. What a new look the magazine takes on as a pay-off on his decision. "Why," exclaims the old subscriber on seeing his first copy of *Peek* or *Poke* in its new guise, "this isn't the *Peek* I've read for so many years." Or, "This surely can't be dear old *Poke*." I am facetious here to make a point: do you think the legendary "average reader" understands the abstract photograph, that dizzy cousin of the Upset Stomach School of Painting? Muse on that query a while, if you will.

We have raised the question of what is happening in the American mind. Why don't we now narrow the inquiry to ask what is happening in the American photographer's mind? I'm not at all sure it's a simpler piece of research. To make a point or two more clear in this question, I'd like to go back into history ever so briefly. Since the photographic image was fixed by Daguerre in 1839 and men began using actual picture-taking cameras, some photographers have gone the art way, others the chronicle way. I use the term *chronicle* because for a long time after the image was fixed, it could not be reproduced directly in newspapers or magazines.

Some photographers chose to approach the photograph as art. They made pictures in the tradition of and in imitation of painting — the classic, romantic, realistic, naturalistic, impressionistic, post-impressionistic, expressionistic, futuristic, cubistic, dadaistic — the you-name-it painting. As painting has changed, so, too, has the approach of art photographers. We are now in a period of the abstract or Upset Stomach photograph.

Every photograph is, in fact, an abstraction, for it represents a segment and approximation of reality. It differs from its original subject in size, tone and color to some degree. The image does not move. But, the photograph is capable of recording man and nature more realistically than any other graphic medium. So, when you get right down to it, what a contradiction there is in the words *abstract photograph* and what a contradiction there is in art photographers striving to achieve abstraction in what is a realistic, detail-recording medium.

I don't for a minute believe that photographers will stop taking far-out pictures any time soon or that editors will quit demanding them. In fact, so that you won't put me down as an old photographic fuddy-duddy, I want to say I admire some far-out pictures immensely — some, I said. I am all for experimentation with the camera. There is not nearly enough of it being done.

The naked truth is this: as long as a far-out photograph creates a sensation, which is what the magazine editor is searching for, and as long as continuing innovations

in far-out photographs can start vogues among photographers, just that long will there continue to be grainies and blurries printed in the magazines. In my view there is a place for both the far-out and the photography-for-photography's-sake picture. Two more points: (1) wanton overuse of the far-out photograph guarantees it a short life, and (2) I believe we are selling photography short when we do not take fuller advantage of its unique power, which is the creating of sheer and utter realism.

On this point Franz Roh, German writer on the photograph, has this to say:

> The copying of nature, the clear-cut, objective reproduction of fascinating slices of reality, is and will always be the essential sphere of photography.

Needed — The Perceptive Picture

To what Herr Doktor Roh said I'd like to postscript this:

The editor demands the *different* picture. Why not take instead the *better* picture? The more *perceptive* picture? The more *penetrating* picture? The clearer, sharper, more effectively composed, mor*e knowing* picture?

I sometimes feel that today's photographer should be more a writer than a painter. More than in painting, he should find his creative stimulus in literature — in the quick image of poetry or the narrative and descriptive meaningfulness of prose.

Moreover, it would seem to me that the photographer who can't or doesn't care to go far out might try answering the cry for sensation by using his camera for what it really is. It is conceivable that a photographer might go far-out because he is not sufficiently a journalist to know what is really going on in the world, so he evades the whole issue of fact, idea and event by becoming a "painter" with his camera.

The camera's basic and implicit value is for the photographer who indeed knows what is going on in the world. He is the photographer who can take a picture which can *inform* people, which can alter their beliefs and attitudes, help in the molding of their opinion. Here, I think, is the greatest challenge and opportunity for the photographer.

I began by talking about imbalances. I submit there is an imbalance in today's photographer. He is too much artist, too little journalist. Of course I want him to have artistry, but it seems to me that when he emulates the painting art he produces pictures which are first of all entertainment, and not information. This serves to compound the problem which I undertook to describe in the beginning of my talk.

And now, if you will, a word or two about television. I hold this medium in great respect. In my view most of its creative future lies ahead. Of course! When it really gets under way, think what it can do!

It pains me to know that the television station considers the people in the area it serves not as viewers and listeners, but — you guessed it — as a *market*. It isn't necessary for me to point out that if you analyze television's mixture of news communication, entertainment and merchandising, you find that news is only the tiny pinch of salt in the recipe. But let's not pursue the point too far. I believe that television is, indeed, growing up. I have every confidence that it will work out of its troubles. Better balances must be found.

I shall close with a message of comfort. The three "mass media" — newspapers, magazines and television — are each simply a means of transmission — a *means,* a mechanical means of transmission. The *mediums* they transmit are the image and the word. Image and word are the common denominators of all three of these "publications." A good story is a good story by whatever means transmitted. Write or picture a better story and some of the problems I have defined may resolve themselves or not rise up to plague you.

THE CRISIS IN PHOTOJOURNALISM

HOWARD SOCHUREK, 1963

Mr. Sochurek joined the *Life* magazine staff in 1950 at age 25, following active involvement with photography through World War II in the U.S. Army. He served as a combat photographer on Guam, Aka Shima and Okinawa and was Photo Assignment Officer for General MacArthur. At the end of the War he became a staff photographer on the Milwaukee *Journal,* then freelanced in Detroit before moving to New York City. He has won the magazine photographer of the year award and the Robert Capa gold medal award of the Overseas Press Club of America "for superlative photography requiring exceptional courage and enterprise abroad." His important story on "Outer Mongolia" published in 1963 required great perseverance to get the necessary travel visa — a continuing effort of five years — and was a significant in-depth view of the land where Russia and China square off. He presently freelances and is based in New York.

Fifteen years ago this month a neophyte photographer with knees quivering, hands trembling and courage slipping away took an express elevator to the 19th floor of the awesome Time and Life Building, Rockefeller Center, New York. He had come to the East from his home in Milwaukee, Wisconsin, and his first big out-of-town assignment was to photograph society girls at Radcliffe, Wellesley, Smith and Barnard. He decided to seek an appointment with the executive editor at *Life* magazine to show some of his work, to seek guidance and to get a freelance assignment.

The executive editor was Wilson Hicks. I was the photographer. The state of nervous panic which I endured at the time prevents me from recalling details of that meeting with Mr. Hicks, but I came away with two clear recollections. First was the promise of an assignment; second was encouragement. The encouragement to me was that what I thought, what I experienced and the comment I could convey was the most important contribution I could make in my photographs.

At *Life* Mr. Hicks is remembered for many things. He was at times a very controversial figure. But, there is one compliment to him that is universally accepted. Wilson Hicks inspired photographers by challenging them to think. I have not since found anyone in the field who has been as provocative to the photographer's mind.

My hope and challenge today is first to alert you to some of the things that are

going on in the field of photojournalism — events which could be called the crisis in photojournalism because of the nature of the flux — and second, to challenge your own thinking about a possible direction that photographic journalism can take, if people like ourselves so desire. The idea I propose is not an exclusive one. It has been said before, but to me the biggest story in the world today is that of change.

Fifteen years ago when I stood trembling at Rockefeller Center, *Life* magazine was the richest, most successful weekly in the publishing business. It had turned over $100-million in profits. Television was neither a threat nor anticipated as one for advertising dollars. Elmer Lower, now a vice president of news and public affairs for NBC who will address you here later, was a *Life* reporter in the Los Angeles bureau. Let's just pause to consider some of the other changes which have taken place in this country in the last 50 years. Population has expanded from 97 to 187 million people. The labor force alone has grown from 30 to 71 million. During the same half century the move from rural to urban communities has reduced the number of farm workers from 13-½ million to 4-½ million people.

Just in the past ten years, while all of this has been going on, profit margins of the 35 largest United States publishers has dropped from 4.3% in 1950 to 1.7% in 1960. The same ten years has seen the demise of several magazines including *Collier's, Picture Post* in England and *Coronet.*

The past half century in this country has seen us move from an internationally isolated nation with a predominantly rural population to a very internationally involved country with an urban population. Defense spending alone has expanded from $250-million in 1910 to well over $57-billion in 1963.

Changing Needs in Communication

My thesis is that the crisis in photojournalism results from the fact that we, as photographers and editors, have not kept pace with the communication needs of the age, and the needs are spawned by change. Since the magazine business is, itself, internally competitive, and since it has been deeply affected by television competition and changing ad budgets, magazines seem to have been hit the hardest. As a result long overdue changes are being made in this business.

In the past 18 months, for instance, *Life* magazine has changed its managing editor and retired its picture editor and nine photographers. There have been sweeping changes in *Life's* bureau system. Most recently a regional supplement of New York news and pictures has been added to the New York area editions. Several *Life* staffers lunched last week with vice presidents, media directors, and creative directors of a powerful advertising agency, and agencies are composed of men who are terribly important to the life and death of a magazine. The day before, this same group saw a presentation by members of the *Look* staff. One of the most exciting developments in magazine journalism, as brought out in this meeting, was the concept of the regional edition. The *New York Times* has started regional editions; *Life* has its New York regional supplement which resulted from the newspaper strike.

The *Saturday Evening Post* is in a real life-and-death struggle for survival. This week there was an attempt to win a greater confidence in financing, and long-overdue

changes have taken place. That magazine has had two "new looks" in a very short time. It has gathered on its staff top talent, much of it from *Life* magazine, including Clay Blair and Hank Walker, a *Life* photographer who is now assistant managing editor. He is attracting other photographers with very liberal financial offers. They have also attracted John Zimmerman and Burt Glinn.

One of the most exciting developments of this crisis is that there are many new freedoms for the photographer which now exist that never existed before. The photographer must take advantage of that freedom.

But, what are the needs and directions of photographic journalism today? To me the greatest challenge for picture journalism today is to help people become aware of the changes which are taking place, for the photojournalist to expose and explain the great, important issues of our time. Certainly there is a need for balance, and entertainment is not only welcome but also, perhaps, necessary in the pages of mass circulation magazines. However, a preoccupation with entertainment — a diet of fluff — insults and underestimates reader sophistication.

Picture journalism by this time should have developed maturity to handle the great issues: quiet revolutions in laboratories, civil rights, social revolution in Latin America, the relation of an individual to society, technological unemployment, population explosion, big government, and many more.

What is News?

Recently in an address at Columbia University, James Reston commented on the functions of news gathering in general. "Part of the trouble," he said, "is that we have not really thought through a modern definition of news. Nobody questions that a splashy revolution in Guatemala is news. But, file a thousand words on social and political conditions there which are leading to a probable revolution next year and see what happens. Maybe you will get it in if it's a dull day; maybe you won't." His next words seemed particularly appropriate to me, "Sometimes I think we'll do anything for Latin America except read about it."

In my opinion one of the very important roles of the magazine and the newspaper is to point up the great local, national and international issues, to comment on them, regardless of how controversial they might be, to search out those things which are happening, but go unreported, and to be covering stories on locations of present or future import which no other reporters or photographers are yet telling about. Too often American newspapers and magazines reflect our country not as it is, but in an enameled, manicured image. I believe Americans want and welcome thoughtful, responsible reporting on the great issues and changes which are happening daily in our society.

Recently in New York I had the opportunity to discuss some of these ideas with Cartier-Bresson, a man who is certainly one of the most intelligent in our profession. About newspapers and magazines he said, "Many have failed to keep up with the sophistication of the audience as the *New York Times,* which stays ahead of its audience, and the *New Yorker.*" Cartier-Bresson continued, "In picture magazines many stories represent machine precision and formula. Technique at the service of what, may

I ask? Editors must touch the earth to regain their strength. Times have changed," this man concludes.

Flying down here I picked up the report of a speech that John Glenn delivered to the American Newspaper Publishers. He said, "Too many Americans are in a state of universal weightlessness: fat, dumb and happy with a poly-unsaturated diet of the coming 35-hour week, the fly now — pay later vacation and all the fringe benefits. They live in a chromium-plated world where the major enemy is crabgrass."

Needed: Thinking, Perceptive Photographers

Stan Kalish, formerly of the staff of the *Milwaukee Journal* and a distinguished influence on picture journalism who has since joined the United States Information Agency, says, "There are just too few educated photographers." To me it seems that there are just too few photographers who are moved to action, who interpret, who care, and whose experience compels them to convey information through their cameras, to comment on the new and changing things which affect us all so deeply. In a recent television appearance President Kennedy was talking about the issues and challenges of his particular job. He said that the issues with which he was now dealing were the same as those he would be concerned about were he not the President. These concerns provide the ingredients for great stories, the ingredients which photographers ought be concerned about.

Journalism in this country has great stature, great impact and a great responsibility. I am reminded here of my recent experience in Bolivia where riot and even death resulted a few years ago from a single paragraph in a magazine news story which suggested dividing the country. However, I am also reminded of a quote which Reston recently borrowed from President Wilson, "If change isn't reported people are certainly not going to adapt to change. And every civilization and all of us must either adapt or perish."

I should like now to be a little more specific as to the directions we can possibly turn in visual journalism for newspapers and magazines. The crying need in our profession is for thinking people. In a world that increases in complexity each day, its changing societies cry out to be explained. There just aren't enough men in our business who know the world, are thoroughly based in experience, and can interpret. Too many journalistic photographers have the same outlook and feelings — or lack of them. There is little variety. Pictures lack conscience. The crisis is really a crisis of the human situation with too few photographers or editors who can see with feeling. My thoughts and statements have already caused considerable controversy and some heartache at times. One critic of my ideas recently wrote to me, "Photography will never do all the things you want it to do — not in a million years." Then he added, "The pencil is the true transmission belt of the mind and eye."

I hope some of the things I have said give some point toward the challenges in this profession — the challenges which will remain. But remember it's a profession in which only the brain survives!

THE DILEMMA FOR MAGAZINES
AND MAGAZINE PHOTOGRAPHERS

PHILIPPE HALSMAN, 1970

For a biographical note on Mr. Halsman see page 173.

While I would have preferred to talk only of artistic concerns, I must address myself to economic aspects and problems which occupy such a priority in our thoughts. Magazines are not sick for artistic reasons, but for financial ones. Many of them, with the exception of magazines catering to special interests, are fighting for their existence. This fight affects us and our future.

Some persons believe that general magazines are on their way to extinction, but the situation is very unusual. Magazines are not sick because of lack of readers; the readership was never higher. But, they are sick because advertising money is going into television.

In many European countries only a limited number of TV commercials are permitted during any day. Advertising money is thus also available for magazine advertising. Magazines there are fat and prosperous.

The only general interest magazine in the U.S. which is fat and prosperous is *Ebony*. Yet, I can remember when it was a half or a third as thick as *Life*. Now it is twice or three times as thick. Photojournalistically it is so-so, but almost every American advertising firm buys space in it. How does Madison Avenue explain? *Ebony* reaches a specific segment of the public, the black audience. So we see the paradox of a formerly struggling minority magazine flourishing, while majority magazines — *Life* and *Look* — fight for their existence.

Newspapers and magazines are possibly the only products on the market for which the buyer pays less than the costs of production. You know they are funded by the advertising they carry. Roughly one advertising page supports one editorial page. But, of the advertising dollars which go into direct mail, billboards, newspapers, magazines, TV, and radio, the fraction for magazines is shrinking, while the television share increases each year. In March, 1970, TV advertising had increased its billing 9.2% over March, 1969.

What are the reasons? Advertising people say that a picture which moves and talks sells products better than a still picture. Common practice is to value a TV commercial at four times the impact of a print ad. But, if you are close to the advertising scene, you notice that the reason is psychological. Agencies seem to have the feeling that TV is a more modern and progressive medium. For an advertising executive it is more glamorous and exciting to be in charge of a TV commercial than a magazine ad.

Madison Ave. is the Villain

Here is an interesting parallel. Madison Avenue's initial purpose was to be similar to that of Wall Street — to serve as the middleman. Wall Street was to facilitate the trading of stocks, while Madison Avenue was to facilitate the placement of ads. Now we see that Wall Street controls the stock market, and Madison Avenue controls the flow of advertising money. Thus, it will be the advertising agency which ultimately decides whether the magazines survive or whether we will have to rely solely on the tube. This decision will influence the direction of our civilization.

Already, through control of television programs, advertising agencies exert a powerful influence on the political, social and moral attitudes of ourselves and our children. It is a tragic paradox that in our great civilization the controllers of cultural development are not men of great intellect or creativity, but a group of middlemen. Try to visualize them, and ask yourself what justifies their right to determine our future?

But, let us return to the argument between partisans of the tube and the magazines. Magazine people argue that a magazine ad brings more information, and if one forgets its message, he can retrieve it. They contend that often one can remember the content of a television commercial, but cannot recall the product name. I have directed several television commercials and know how important these problems of retention and identification are.

The whole situation reminds me of my college days and the students at the university where I studied engineering. There were two very gifted fellows, both passing their exams with flying colors, both fluent in many languages, and both surrounded by admirers. There was a hidden rivalry, though, between the two, each eager to prove his superiority. Both played chess rather well and could have engaged in a direct contest. But, they never played chess against each other; each was too afraid he might lose.

The two advertising media act in a similar way. It would be easy for them to approach, for instance, the psychology department of a great university and support a study on the comparative effectiveness of the media. But, as my school-day friends, they avoid a direct confrontation.

However, *Life* recently published a two-page ad in the New York *Times* which claimed that *Life* commissioned a research firm to undertake a comparative study of recall in magazine and television ads. *Life* averaged almost twice the advertising recall of television.

Comparing Media Effectiveness

Two days ago *Life* announced another test result. Together with *Look* and *Reader's Digest* a comparative sales test was conducted with products of General Foods. The study used advertising and sales data for the following products: Cool Whip, Shake and Bake, Grape Nuts, Maxwell House Coffee, and Minute Rice. The products were tested for one year. In all, $1,800,000 was involved, and General Foods monitored the research. The results: only in the case of one brand, Shake and Bake, did the magazine not outsell television. *Life* claims that this year the number of ads is running ahead of last year. On April 15th the New York *Times* reported that Armstrong Cork

dropped TV advertising and is putting its entire ad budget into magazines. It will total 300 full-color pages a year.

Does this mean that the tide is turning, that the pessimists who predicted the extinction of magazines were wrong? I don't know. Nobody knows what will happen in five years. This uncertainty is responsible for the amazing fact that Mrs. Dixon's book, in which she pretends to be able to predict the future, has sold 3,000,000 copies. We live in a time of unprecedented change. But, we are like McLuhan's fish which do not know the water in which they live.

It seems to me we have become so blind to change around us that we don't realize we live at the end of an historical era. History is full of these sudden endings. After centuries of standstill and slow disintegration the sophisticated civilization of the Roman Empire with its highly developed legal and transportation systems all of a sudden disappeared and the darkness of the Middle Ages began. The French Revolution was a sudden change of values, the emergence of a new social order, a new kind of army, etc. It was another example of the termination of an era. History teaches an important lesson: people who cling to old concepts become the first victims of change. To avoid this fate, one must have foresight and a mind open to progress.

It is easy to have foresight when civilization progresses in a predictable curve, but we live on the threshold of a completely new era. Who can today describe the morality, the technology or even the way of dress we will have tomorrow? Will the magazines survive and coexist with television? Or will they disappear like horsedrawn carriages? Will they change their form and reappear as weekly audio-visual cartridges which we will view on our TV sets? The Famous Photographers' School is experimenting with audio-visual cartridges as a means of teaching by correspondence. Will we use still pictures or only moving pictures in the cartridges? Do we approach the end of the era of the still picture? Was David Duncan's use of still pictures on NBC television during the 1968 National Conventions the beginning of a breakthrough or only a freak incident?

If the still pictures are to survive, will they be produced photographically or electronically? There is a technology which allows the viewing of an electronic tape of an event and the freezing of any chosen moment. Electronic impulses from that moment can be fed to a computer which can determine halftone dots, the right size, ready for the printing press. The printed image can be instantaneously produced. So why photography?

Another question. Since the photographer will soon produce audio-visual cartridges and electronic tapes, shouldn't he also be in charge of the sound? Shouldn't we start learning how to record sound while shooting pictures?

If only I could show you the key to the future instead of showing you its keyhole. But, then one says that only fools are impressed by the man who knows all the answers. The wise prefer a man who questions.

JOHN DURNIAK: Philippe, I question your homework about the death of the magazine business. Of the top 25 magazines last year, 21 made money, four of them improving their revenue 20% over the year before. There are now 750 consumer magazines, 75 more than we had 5 years ago. That sounds pretty good to me.

HALSMAN: I was talking about the general magazines. Unfortunately, many of my colleagues and all of my friends work for these magazines. Very few of us work for the other magazines. I said that the magazines of special interest catering to special audiences are doing all right. But, even so we have to realize that our children are more and more prone to look at television and movies and are less and less willing to read. There is a change coming; where will it lead us?

A LOOK AT MAGAZINES IN THE '70'S

GILBERT M. GROSVENOR, 1971

Mr. Grosvenor was named editor of *National Geographic Magazine* and vice president of the Society following a wide variety of experiences on its staff. He enjoys working as a photographer and has shot numerous stories for the *Geographic*. In this 1971 keynote he brings his many experiences in publishing to bear on trends and problems in magazine journalism.

As you well know, many photojournalists are convinced that the printed media are in trouble; some feel they are in their death throes — and while the *National Geographic Magazine* has been fortunate in the past 12 years, there are some, even among our staff, who feel the *Geographic's* demise is inevitable. I disagree. I wouldn't be foolish enough to risk a career on a ship that I felt was sinking. However, I'll have to admit that there are some first-class U.S. publications that are in serious trouble today, and to ignore the problems would be fatal to all of us.

Of course, as an editor I ask myself why. For today's discussion I've come up with what I think are six reasons. I'll discuss the first five very briefly. However, the last one I will elaborate upon.

Current Problems in Magazine Publishing

The first and most obvious problem, I think, is probably *the age of television.* There is some truth to the claim that advertising has gone to television in a big way. To understand how television has affected printed media, consider these comparative gross advertising figures covering the past 10 years and reported by the Publishers Information Bureau of Statistics. In 1960, $854-million worth of ads were placed in the top 150 U.S. magazines; in 1970, ads totaled $996-million. That's an increase of only 15% in 10 years. It's tough to live with that small gain.

However, a look at the other side of the coin reveals that the really viable magazines did quite well. For example, *Playboy* in 1960 had gross advertising of $2,300,000. In 1970 it grossed $31,700,000. I don't think many television outlets will match that record. Even the *Geographic,* which is a rather staid, conservative publication — although we seem to have a little sex in it too — increased from $5,000,000 in gross advertising in 1960 to $11,300,000 in 1970. We more than doubled in a decade.

I am hopeful that advertising agencies are learning that the numbers game in rating television audiences is not necessarily conducive to sales. Potential buyers can drool over the latest automobiles in the printed media, whereas TV commercials are limited to specific image-impact time intervals. There is no opportunity to look at a television commercial again — no residual value from multiple or repeated readership. Specifically, I find the net earnings for the tobacco industry in the first quarter of 1971 fascinating statistics. TV tobacco advertising was not permitted in that quarter, yet sales were up. To me this doesn't augur well for the acceptance of TV advertising.

Also, TV advertisers run a great risk of prime-time competition that cannot be foreseen. For example, suppose an advertiser commits himself to $50,000 worth of advertising, and there is an international crisis at that time. President Nixon's speech and the inevitable post-speech discussions can wash your message down the drain. This has happened more than once.

Perhaps I'm a little flip on this subject because the *Geographic* is different from most publications. We are not beholden to advertising. It is not the most vital part of our income. On the other hand, we do have our Achilles' heel: our renewal rate. We are committed to almost 90% renewal — and we get it — 88, 89, even 90%. But we must have that high rate to live.

Also, during the past decade we have inaugurated a program of a planned, reasonable growth rate. We were not tempted to join the circulation war that *Look, Life* and the *Post* succumbed to and that almost brought them to their knees. We have a planned 5 to 8% growth rate each year, and so far this has held up well.

Reading Time — A Shortage?

Television further contributes to printed media problems because of the competition for viewing and reading time. Critics of printed media say that television cuts into reading time. Again, I agree. However, the reverse is true, too. Television stimulates people to become more aware of the world today. They have greater interest and participation in world affairs. Thus, printed media have new outlets to cover. Americans enjoy more leisure time than ever before in history; they have wider interests — travel, golf, participation in riots, *etc.* Television has contributed to opening up these new horizons. It's up to the printed media to fill an obvious void that TV either can't or isn't.

Then, too, critics maintain that TV scoops the printed media, particularly in world and local news. Again, this is true, except that television rarely covers more than the moment — seldom more than the commentator's full-tube face. Good photojournalists should fill that gap. Printed media can produce follow-up coverage in magazines on news stories and in-depth locker-room interviews in sports, for example. People are eager to learn the behind-the-scenes story. Here printed media can present visuals that are competitive with television.

Dig down into your memory bank and pull out some great images of history: Truman's victory over Dewey in the 1948 election. Remember that picture of Truman holding up the *Chicago Tribune?* The headlines proclaimed, "Dewey Defeats Truman." That's what people remember. Adlai Stevenson — who will ever forget the picture of him showing the hole in his shoe? But how many TV films can you recall on Adlai Stevenson?

How about President Kennedy? Who will ever forget the picture of him during the Cuban missile crisis, hunched over his desk, looking out the oval window of the White House? Or in lighter moments, John-John playing under the desk? President Johnson, the most photographed and televised President in history, couldn't make a move without television. Yet, if I had to think of the one image that remains forever of President Johnson, it would be that full-page picture of his gallbladder scar!

How about the last Presidential election? All networks had constant programs, yet the best coverage came from David Douglas Duncan. Even television used his still pictures for a full program — the best, most poignant coverage on television. So I feel that historically the great moments are recorded by the great still photographers. They freeze historical moments forever. TV is a powerful medium, but I don't really feel that more than a fraction of its potential has been utilized. When it is, printed media must be even more innovative than they are today. But, enough of television.

Inflation and Economics

The second reason that the critics give for the impending demise of printed media is *inflation*. I've had a little experience with inflation myself. Printed media really have six basic expenses — all subject to inflation. I call them the "Six P's": Printing, Paper, Postage, Payroll, Plant Facilities, and Promotion. Those six account for 90 to 95% of a publisher's cost. That is what we must control. I'll discuss that later.

The third reason for printed media's downfall is *business department interference*. Critics claim that businessmen try to control publications. The business department usually ends up the scapegoat, of course. Editors always point their fingers at the meddling of businessmen. The businessmen defend meddling in the editorial area under the pretext of editorial incompetence. Almost never does a businessman create and nurture a publication to national prominence. Think of some of the great men — Hibbs, Ross, Luce, Heffner — these were great editors who built great editorial publications. Yet who recalls the editors during the decline of a publication? Nobody. What I'm really getting at here is that often the business department is blamed for situations which the editorial people have created. Today, if he is to succeed, an editor must understand publishing economics. Again, I'll discuss that subject later.

Fourth reason for printed media demise: Failures are attributed to *poor economic conditions*. This country has experienced ups and downs — and always will. But, just as an elderly person is more susceptible to pneumonia than a younger one, a sick publication is more susceptible to an economic decline than a healthy one. So I really can't subscribe to "business conditions" as being the reason for the general demise of printed media. If it can't survive the peaks and valleys of business, it will fold soon, anyway.

Fifth reason for the demise of mass-circulation printed media: *Specialty magazines* with limited circulation are taking over. We all know some of them: *Yachting, Golf Digest* and *Ski* are among the hundreds published today. Certainly they are important. For example, *Yachting* carried more advertising pages last year than any other publication in the United States. The advertising market seeks a specific audience for narrow-interest readership.

I'd like to quote briefly some statistics on magazine circulation in the past 10

years. In 1960 the top 10 magazines in the country had a combined circulation of 68-million; by 1970 they totaled 94-million — a 40% circulation increase in a decade. The top 50 magazines in 1960 had a circulation of 136-million; today they boast 176-million — a 30% increase. That's a pretty healthy track record for circulation. However, circulation is not necessarily a yardstick for a publication's general health.

Editorial Leadership

The sixth and last item I wish to discuss is *incompetent editorial leadership*. I am convinced that one of the major — perhaps the most important — reason for the demise of some magazines today is the editor. Either he has not kept his publication in step with the times, or he has allowed the magazine to lose its identity. Sometimes the editor has lost control through mismanagement or ignorance, or because he wasn't trained to handle a mass-circulation publication. It's not easy. Some editors fail to utilize their brilliant editorial staff. Classic examples of this are *Collier's* and *Saturday Evening Post*. Then there's always the patent excuse that the publication has outlived its usefulness. I just don't believe it. Really what has happened is that the editor has outlived his usefulness. It's the editor's responsibility to see that his publication grows and changes with the times and the interest of his readers.

It is this last reason for the demise of many magazines — the editor — that I wish to elaborate upon today. Since the *Geographic* is my bag, I will stress that publication.

You know where the *Geographic* has been in the past 15 years. We've increased circulation from two to seven million; we abandoned sheet-fed letterpress in favor of high-speed web letterpress printing. Now we are the first mass-circulation publication to commit ourselves to some web offset printing in the future. This is a huge gamble. But, we feel that we've made tremendous progress in offset and that we will succeed. Editorially, we've updated our photography — just thumb through a 1955 or 1960 issue and note the change. Our text has undergone what we consider to be a dramatic change: We've retained accuracy, timeliness, thoroughness and simplicity; we have moved away from the rose-colored glasses.

I stress to you that I believe revolutionary changes in a publication are often fatal; yet evolutionary changes are mandatory if a publication is to remain viable. While the *Geographic* will continue to change with the times, we have no intention of creating a crusading publication. That's not our field. My predecessor, Frederick G. Vosburgh, put it succinctly when he said, "We must hold up the torch, but not apply it." The *Geographic* will remain objective. We will present the facts, but let the reader draw his own conclusions. Basically, the magazine will be edited for the reader's interest — not our own. It's what interests our seven million readers that counts. After all, they are paying the $7.50 each year. We know what they want; we know what they expect; and we intend to give it to them. Important subjects — popular or not — will be published, but I'll guarantee that every issue will be balanced with stories that we know our readers will enjoy. Then, too, we stress yearly balance. Our membership is on a calendar basis, so we are very conscious of the 60 to 70 stories published each year. Certain requirements are met for each issue and each year to maintain balance. When mass-circulation magazines try to specialize — for instance, by publishing an entire issue on one subject — the editor is asking for trouble.

What, then, is the role of a modern editor? Traditionally he's been looked upon as a little old hunched-up man bent over his desk, wearing an eyeshade, hatching copy. Today, it's different. He must know words — and pictures, too, if it's a picture publication. But, today the successful editor must also be a businessman, be clairvoyant, and be an in-house psychiatrist.

Business Concerns of the Magazine Editor

Why a businessman? Earlier I mentioned the six major P's: Printing, Paper, Postage, Payroll, Plant operation, and Promotion. Why must the editor be concerned with mechanics and money?

PRINTING. The photographs we choose for a magazine would not necessarily be the same photographs as for a book that is printed offset. The two processes just don't print the same way. I must know the different printing characteristics. I must know that I can use 150 lines per inch on an offset plate, whereas on a letterpress plate I am lucky to get 120 lines (and only 110 with yellow plates). This may not sound important, but if you are a photographer and your pictures are reproduced poorly, you will certainly tell me about it.

The printing industry has made great strides in the offset process for the magazine, yet businessmen want to stick to letterpress. Why? They say we have good, economical printing today, so why rock the boat. Editorially, we say no. We print better quality books today by offset than we do by letterpress for the magazine. *We must have the best printing possible.* So we're willing to sweat the problems of offset. It was the editorial division of the *Geographic* — the printing and engraving people, Dee Andella and his group — who forged ahead with offset. The business people had little to do with the initial research. However, businessmen are flexible and realistic. At the *Geographic* we work closely with them. Once we demonstrated offset feasibility, they thoroughly researched the financial aspects. Together we committed the *Geographic* to an offset press.

Another example: map production. We budget $1,500,000 yearly to produce maps for the magazine. That budget is spent as we see fit. Traditionally, we have printed four or five maps a year on multicolor sheet-fed presses — one side only. Recently our cartographers and engravers climaxed five years of research by developing a technique of printing these maps on both sides — by utilizing the high-speed web presses. We drop down from eleven to five colors, yet maintain quality! Our Southeast Asia map is an example of this new look. Instead of five maps a year, we now can print four double-sided supplements — eight maps for the same cost! Our Southeast Asia map — particularly the cultural side — published in March is one of our most important contributions to knowledge this year.

PAPER. If paper price increases two cents a pound, it costs the *Geographic* $2,500,000 a year. Right now, offset paper is four cents a pound more expensive than letterpress paper — that alone could hurt us severely. As editor, I must help solve that problem. I must understand printability, paper weight, opacity, gloss, fiber content and all the other variables to get the most for my money. Yesterday editors did not concern themselves with that problem. Today we must.

POSTAGE. We cannot control postage. Congress, with the stroke of a pen, could

wipe us out. For example, rate structures before Congress today would increase our postage by 142%, costing the *Geographic* several million dollars yearly over a few years. One item — a per-piece surcharge — buried in the fine print, could cost us $900,000. While I can do nothing about postage, I must budget for rate escalations during the next five years.

PROMOTION. Even with a near 90% renewal rate, we must replace 700,000 members just to stand still. We need an additional 420,000 members to increase at a 6% growth rate. I assure you this is not easy. Constantly we must work with the people in promotion to help convince readers that they must have our magazine. To sell books, we promote only our own members. Each promotion piece costs ten cents an item — that's $700,000 for each promotion mailing! It must be right. A 1% change in promotion returns can dictate the success or failure of a publication. Thus, if we produce a great book, a poor promotion piece can kill it.

Naturally luck is involved. One year our book promotion arrived the day the Egyptian-Israeli war erupted; another year Robert F. Kennedy was assassinated just as we promoted a new book. Both of those promotions pulled poorly. On the other hand, a few Christmases ago, our promotion just preceded a snowstorm that blanketed the country. Our members said, "Ha, ha, the solution to Christmas presents!" Orders swamped us. So there is luck involved — I'm the first to admit it — but editorial people must minimize luck and accentuate a first-rate decision-making process. Thus, I have discussed several aspects of business-oriented responsibilities of the editor. Frankly, inflation of the six P's worries me more than any other aspect of printed media because it is difficult to control and fatal if left unchecked.

Knowing Readers

The editor must be clairvoyant. This is in part a misnomer, because being clairvoyant is really a matter of doing one's homework. Fifty per cent of it is knowing your readers. How can you know those seven million members out there? I maintain that it is possible, but it takes valuable time. For example, we receive 10,000 letters yearly from our members. Believe it or not, we read or scan each of those letters. If someone merely says, "I think you're great," we put it aside. If they say, "I think you're lousy," we put it aside. But, if they say, "I think you're great *because*" or "I think you're lousy *because*" we stop to read it carefully. By scanning thousands of such letters, we derive much valuable information about readership trends.

Our advertising division, like those of other publications, prepares hundreds of computerized surveys to persuade clients to buy space. I read every report and learn a bit more about our members.

A major census was taken in the nation in 1970. The results are invaluable in helping to predict our audience five to ten years hence. A few statistics: By 1985 half of our total purchasing power will be concentrated in the 25-44 age bracket. Twenty-eight million additional Americans will reach their teens, 30's, and early 40's. However, the 45-65 age bracket will be virtually the same. Loud and clear, this tells me that the *National Geographic Magazine* must reach younger readers. Today our readers' median age is 39 — down from 43 about five years ago. Our reader age drops about

half a year each calendar year. I would like to lower it faster, but not at the expense of losing older readers. Our readers today break down as follows: 25% under 35 (nationally, 36% are under 35); 35% in the 35-49 bracket (nationally, it is 27%). An encouraging statistic to me is that only 36% of our readers are over 50 — exactly parallel to the national average. I had thought we had more elderly readers. We also carefully watch educational levels, median-income, metropolitan-rural distribution, etc.

Readership interests naturally are of concern to me. At random I will give you a sample of our readership. Last year 3,400,000 in-home readers camped out overnight — now that really surprised me. One million six hundred thousand own cats and 2,400,000 bought cat food last year. I can't help but wonder what happened to the other million cats!

All this may sound irrelevant to you, yet the more I can absorb about our readers, the better I can communicate with them.

To be clairvoyant one must be a crystal-ball gazer. We try to publish timely articles. This means anticipating world events a year in advance. For example, consider Southeast Asia. Last spring, when this government moved into Cambodia, several things were obvious: First, the U. S. wasn't leaving Viet Nam until Cambodia and the Ho Chi Minh Trail were neutralized; second, we knew very, very little about the people of Southeast Asia. Therefore, last August we decided to publish a definitive cultural piece on the area. We spent half a million dollars on a political wall map, backed up with a cultural map of Southeast Asia locating the major ethnic groups. Research time alone took six months. Yet consider the risk: Suppose Viet Nam had quieted down and the Middle East had flared up before publication? Last year we gambled that the Administration would try to neutralize the Ho Chi Minh Trail before pulling out. In this particular instance we were right — almost to the very month. I might add that we are not always successful. About a year and a half ago we published a story entitled "The Friendly Irish." That day the Irish revolted!

What's planned for the future? A similar map treatment on the Middle East with a major story on the Arab World, to be followed by an article featuring the Jewish people. The coverage will take us a year to produce. Other stories include the North Slope, in-depth coverage of the Arctic tundra, etc.

Just as important as knowing what to publish is knowing what not to publish. Like all publishers we test titles. Two years ago, three months before the Apollo 11 flight, readers indicated a great interest in the moon, tempting us to produce a moon book. We held back after the moon landing, then tested again. The title rated number one. Still we hesitated. Another test three months later indicated virtually no interest in a moon book! Unlike some publications, we cannot turn out a book overnight; eight to nine months lead time is necessary. We could have been badly hurt by that crystal-ball gazing. But our survival, and the longevity of an editor, was at stake.

Editor and Staff

The third role of the editor that I mentioned earlier — together with businessman and clairvoyant — is that of an in-house psychiatrist. Perhaps of all his responsibilities

this is the most important, oftentimes most difficult, to do well. Creative people are the most delicate, the most fragile natural resource an editor has. He must know when to praise them, when to kick them; he must know when to hire them, when to let them go — both for their sanity and for his. Sometimes you do a man a favor — and yourself-too — by encouraging him to leave. Sometimes he, himself, makes that decision. An example is Bill Allard, formerly of our staff and one of the ablest photojournalists in America today. Bill grew so restless with us that one day he told me, "I must leave." Initially, I was very disappointed. Thinking it over, I realized that the things Bill wanted to document simply did not fit the *Geographic* format. So I did not fight him or try to convince him to stay. In bidding him farewell, I assured Bill that we would welcome his contributions any time. Consequently, Bill Allard works for us about eight months a year. His stories today are infinitely superior to those he produced while on the staff. Intellectually, he has grown tremendously. He photographed in Appalachia; he photographed riots; and he documented socially important issues in America today. He feels better about it; he feels he has accomplished something important — and surely he has. I am convinced that had we persuaded Allard to remain on the staff, he would not have developed as rapidly as he has as a freelancer.

Every day the editor must judge creative people, know their limitations — what they can do, or equally important, what they can't do. Few people excel at everything; most have specific limits of excellence, while others have no excellence at all. Some photographers are fantastic scenic photographers, but can't cope with people. Others communicate with people, but they apparently don't see scenery. Ultimately, I feel that 75% of the success or failure of a story depends upon who the editor assigns to it. For example, Tom Abercrombie, whom many of you know, ranks with the best on the staff. Several years ago he produced a great Alaska story — really first-class. When we wanted another Alaska piece, we naturally turned to Tom. He laid an egg — for him, that is! Our first temptation was to query Tom, but in retrospect I realized that it was our fault — Tom should not have been sent back to Alaska. Naturally he gravitated back to his close friends and the places he knew. Alaska was not a bright, new world for him. The mistake was clearly in the assignment.

Another example: For the Alaska North Slope assignment we considered both Tom and Bill Garrett, another veteran Alaska hand. Fortunately, we had learned our lesson. We sent a writer and a photographer who had never set foot in Alaska. The result is coverage that is fresh and brilliant.

The director of photography, Bob Gilka, working with the editor, can make or break a photographer. Again, an example. About eight years ago staffman Bob Sisson told us he was finding it difficult to compete with our younger photographers; he felt his photography wasn't moving with the times. Bob Gilka discussed the problem with Sisson, who has been with us for 20 years. Gilka discovered Sisson's interest in natural history, so he gave Bob a year to perfect his natural-history photography. And Sisson did perfect his technique! Today he is one of the best nature photographers in the country. His coverages are outstanding. Additionally, he has discovered animal behavior that is new to science — and he's documented it on film! Bob Sisson might be retired

today except for very sympathetic understanding from Bob Gilka and the editor, then Ted Vosburgh.

Everyone has heard the expression "Joe so-and-so is burned out." Well, I don't believe it. Probably the editor blew out Joe's candle, or he may have failed to relight it for Joe after a bad experience. If a man works his guts out on a story for six months — or even a week — then watches his film decay on the shelf and nobody tells him it's good or bad, or will run or not run, he loses interest. To be really good a photographer must be hungry — for recognition, for money, for publication, for *something*. I know when I take pictures and they are not published, I brood about it, just as anybody else. Oftentimes when we write someone off because "he's burned out," it is we who have erred.

I will not take your time to summarize, except to say that when you ponder the future of printed media, look at the strong, viable magazines today. Analyze the editorial content; then analyze the financial record. Viable publications are usually financially healthy. However, a magazine struggling for editorial identification almost without exception is in trouble today. Oftentimes, incompetent or outmoded editorial leadership is at the root of the red ink. Frequently, this has been compounded by greedy businessmen who expanded the publication beyond a normal, reasonable circulation growth rate.

I'm the first to admit that perhaps I am the most fortunate editor in America. I was handed the reins of a very healthy horse. Now, if I mistreat this horse and he falters in the next decade, I have no one to blame but myself, probably because I have not moved with the times, have failed to communicate with my readers or was not successful in motivating creative people.

On that note I will conclude. During the break please pick up a copy of the May *Geographic*. I think you'll find it of interest. I had planned to put it on your chairs before this talk, but I realized that as a speaker if you thumbed through that magazine I would be very unhappy; conversely, as an editor, if you did not thumb through it, I would be even more unhappy!

SPECIALIZATION OR VERSATILITY

PANEL, 1966

Chairing this discussion is John Whiting of Hearst Magazines; Arthur Rothstein, then director of photography, *Look;* Eliot Elisofon and Gjon Mili, staff photographers, *Life;* and Wilson Hicks, University of Miami.

JOHN WHITING: This tenth anniversary is a very memorable occasion of an important Conference, but it's time we tore some things apart. What are the things we can find fault with in photography?

ARTHUR ROTHSTEIN: I've noticed generally in the development of photography during the past 10 years a trend towards a certain degree of specialization. We've just seen a wonderful collection of pictures by a lady who photographs spiders. That's all she photographs, spiders. On the other hand, we have many photographers who take great pride in their versatility in being able to take pictures of anything, as Gjon Mili has pointed out — being professional. They are required to take photographs of many different types of subjects under varying and different conditions, whether they like the assignment or not. To what extent is a degree of specialization desirable? What are the advantages and disadvantages of specialization? Is it more important for a photographer today to concentrate on one special area as Jerry Greenberg who photographs only underwater, or is it more important for a photographer to develop a wide spectrum of activity?

ELIOT ELISOFON: I've certainly had to be what Mili calls a professional photographer. I've done Hollywood girls; I've done food; I've done exploration; I've done architecture; I've done anything that *Life* has asked me to do — and with great pleasure. Maybe this has been a fault. I'm going to speak now for specialization once a photographer knows himself. I think if I were a young photographer I would like to know that if anyone ever needed the best possible medical photograph he would come to me. If someone wanted the best science photograph, he would go to Fritz Goro, and if he wanted the best fashion shot he would use Penn. Now that doesn't mean each and every photographer could become a top man in his particular field, but it does mean that by being noted or one of the best in a particular field you have a certain command of that field. You develop a knowledge and an ability to produce on a higher level than the man who does everything.

WHITING: Well, yes, in the sense that it's true that a person who knows only photography and never has time to learn about the subject matter cannot get far. However, I would like to ask Mr. Hicks, who helped bring into being the greatest photographic staff that any magazine or organization has ever had, what he feels about specialization. Did it help or hinder photographers in their development, Wilson?

WILSON HICKS: Some photographers specialize in certain subjects because they are interested in them. Each semester some students tell me they want to become a photographer, but they aren't sure what kind of a photographer or what they want to photograph. Should they be versatile photographers or specialized photographers? And I ask them, what do you want to say?

I am thinking right now of a man whom I like to call a versatilist, Ralph Morse. Ralph can photograph anything you ask for and do it extremely well. He has made quite a career for himself. But, if I'd ask you to name one Ralph Morse picture, I wonder if you could? Nevertheless, when I was picture editor of *Life,* he was a very useful man. I don't know that there is any set answer. The main point is what does the photographer want to say.

GJON MILI: Take the man who is passionately interested in a subject and uses photography as a tool. Perhaps photography becomes his hobby. In this specialized area he does exceedingly well, because he learns as much photography as he needs to express his passion for the subject. If he is gifted with taste and understanding, he or

she may become a great photographer. There's nothing wrong with that; it's wonderful.

But in my thinking the true photographer is someone who makes a way of life out of photography. He may be either broad or narrow, but he is a person who expresses himself through his photography.

What I'm saying is that there are hobbyists and humanists in photography. The urge to communicate starts somewhere inside the man who has a philosophy of life, whose life has a meaning. Out of his background, knowledge, interests, and observations he somehow transmits his feelings through his arm and then to the little instrument called a camera. Given a fortuitous circumstance, his finger presses the shutter at the right time. This to me is a photographer.

Photographer, Subject and Esthetic Moment

HICKS: I just want to make a quick point here. I was asked some time ago to write a little statement for a French magazine on what makes Gene Smith a great photographer. So I put on my thinking cap and wondered. I'd been reading on esthetics and had learned about what the late Bernhard Berenson called the esthetic moment. Other estheticians chose to call it something else — for example, the esthetic transaction. What it means is simply this. Suppose you are in the Louvre or the National Gallery in Washington and you come upon a certain painting. You stand before it and something happens — the esthetic. You and the painting become one. You're not right up against it physically, but you have what I heard called here an "almost physical contact." You are fused with the image; you and it become one. When that occurs you have experienced the esthetic moment, or there has occurred an esthetic transaction.

So I wrote about Gene Smith and why I thought he was such a good photographer. The one thing that was significant about Gene Smith and his camera was that Gene Smith could bring about the esthetic moment with his subject matter. Gjon Mili earlier today said it in another way, that the photographer has to become so attached to his subject that there is almost physical contact. You have to become physically connected. In Gjon's little movie of Cartier-Bresson there was such an intensity everytime Cartier-Bresson lifted that camera to his eye. He became another man, you know? To me this point has tremendous significance — it is, perhaps, one of the most significant points to come from this Conference. Whether you're specialist or versatilist you come closer to making the camera do your bidding when you can bring about that relationship between you, the machine, and your subject.

ROTHSTEIN: I brought up the subject of specialization and versatility — the typing of photographers — for another reason, too. It's directly connected with the economic survival of photographers and their ability to work in the field of journalism. What is taking the place of some shrinking areas and markets in journalism? There are, of course, some areas of expansion. But, how is the photographer — no matter how connected, how dedicated, or how anxious to identify with a subject — to find a market for his pictures? What can that market be? We've been operating on a very high plane during this Conference, but maybe we ought to get to some elementary facts which are critical at this point.

ELISOFON: I feel that photographers, especially the photographers who attend this

Conference, have ability to work in the film medium, whether it's for television, teaching films, documentaries, or whatever. A number of men already work with both the still and movie cameras. Gjon Mili demonstrated this quickly without making any point about it when he showed his beautifully conceived and executed short film on Cartier-Bresson. As far as I'm concerned, there has to be movement toward expressing oneself in more than one visual medium. Film is as visual as the still photograph.

WHITING: That's certainly the opposite of specialization, Eliot.

ELISOFON: Not necessarily. There are people who can do both. For example, I shoot still pictures for *Life* magazine, but last year I directed a 30-minute film. It didn't hurt me to put one down and do the other. In fact, I took many stills for the film. I combined still photographs with motion picture footage where I couldn't shoot movies. In one museum there wasn't enough electrical current and I didn't want to pay $2,000 for a generator. I made still shots of the statues with strobes and cut them into the movie at greatly reduced expense.

ROTHSTEIN: Would you say that photographers are being paid properly for their work at this time, John?

WHITING: Not as soon as you get away from the top three or four magazines — *National Geographic, Life* or *Look*. It's very difficult to work in the present economy. This problem deserves attention. We have a selling job to do.

ROTHSTEIN: When will the photographer be recognized as a person of talent so his work will have the same economic value as that of the hand illustrator, the man who illustrates a piece of fiction for a magazine?

MILI: I don't think that the professional photographer is, as a general rule, under-paid. I think you have to first analyze who the photographers are. Photographers fall into many categories. A photographer is essentially a free agent, unless he is employed by a company. He is a contractor, and it is his innate wit, his initiative, and his ability to deliver that makes him a highly paid man. It is obvious that if one were paid by the piece of work, the photographer is paid less than an illustrator. But, an illustrator takes a longer time to complete one drawing or painting. An illustrator who is on a *Life* series, for instance, does four or five paintings for one installment. If a project takes six to eight months he may receive $10, $12, or $15,000 for the shebang. A photographer of equal caliber gets that or more for the same six to eight months.

Scope of Photography

But what we don't keep clearly in mind is that because photography is universal in its use today, the title "photographer" covers a multitude of personalities, people of varying intelligence, and differing initiatives. Each photographer establishes for himself a certain value depending upon his abilities.

Receiving a college degree in photography does not make you a photographer. It makes you someone who has learned something about photography. A college graduate in engineering will earn about as much and sometimes less than a young photographer who is hired as an employee in business. You must not think of being a photographer only in terms of *Life* magazine. There are only about 20 who can live there. But, there are any number of companies which have learned the value of publications photography for them-

selves, for their employees, and for the public. Corporations provide a tremendous market if the photographer can accept the idea of being an employee, and there are many who can. Surely photographers should be able to make a good living, but I don't believe the answer is simply setting norms or saying the pay must be higher.

One solution is to accept being part of an organization, submitting to disciplines which involve group mentality, becoming an artisan, a cog in a wheel. If you prefer to be on your own, may the Lord protect you if you don't have the wits to protect yourself. There is no point arguing the case beyond that.

But, it is wrong to presume that because you are a photographer you must fit a certain standard of living. You start by yourself and say you're going to get there. Many do.

Times are a bit harder for the photographer today than they were 30 years ago, for there was a talent vacuum then. Thirty years ago was like the gold rush in Alaska. There was such a need for photographers with the expanding picture market that almost anyone fit in. Editors made mistakes in selection of talent, but they had no choice. Today an editor will not take a chance. He wants the proven photographer. And that's why it's tough for the younger ones to come along and displace us.

The market, though is really much larger than when there were just *Life* and *Look* magazines. Now there are any number of magazines using photographs. The compensation for being a photographer need not be defined only in terms of money and a satisfactory standard of living. Cartier-Bresson maintains his position as an individual and a human being because he says, I shoot what I *can,* not what I please. Frequently he doesn't know what he is going to shoot. He shoots what he can. A publisher may like it and publish; if he doesn't like it, he won't publish. And so that photographer must live within very simple and narrow means. He accepts a small flat in Paris and a bag to travel throughout the world. He may be in India. No food; no comforts. It's a possibility that what he is doing might be sold, but he has no guarantee. You have to approach each assignment that way if you want to be in the freelance business. If you can't, you ought to get into harness in a social organization, which may help you function very well. There's nothing wrong with being, let us say, one of three photographers who works for the Ford Motor Company. Forget that you must *be somebody;* that comes almost unexpectedly.

MORRIS GORDON: Gjon Mili, Eliot Elisofon, and Arthur Rothstein work for national magazines. They cover the whole world. But, Gjon said there was nothing wrong with a photographer working for industry. I began working for industry after many years on a newspaper, but I did not lose my independence. I know freelance photographers with no independence and staff photographers with a great amount of independence. Whether you work for a magazine or industry makes little difference — it's the human being.

Photographer as Remote-Controlled Eye

MILI: Mr. Hicks made a virtue of the work of Ralph Morse a short time ago. He made two points, one of which I think is very good: that a photographer like Morse is the answer to an editor's prayer. The editor uses him when he must be assured of a safe solution to a photographic problem. Then Mr. Hicks mentioned memorability of photographs, and he said Morse's photographs generally weren't memorable. Which of those points is worse for the photographer? To find that his photograph is not remembered? That's right.

However, not everybody is born to be a photographer whose work is remembered. The case in point is a good one. Ralph Morse is one of the most successful contemporary photographers. He's liked; he's loved; he gets along with his subjects. He takes anything and does it well enough so the magazine publishes it. That is a standard of excellence not attained by many.

If you aspire to climb to the mountaintop, be careful in selecting what to do. Search yourself for an answer. It may not be what the editor wants you to do.

WHITING: Perhaps we ought also to distinguish between amateur and professional photographers. The professional is one who can perform even on days when he really doesn't feel like it. He's dependable and can regularly and successfully perform his professional tasks. An amateur accomplishes great things because he feels like it. Many of the great photographers are thus, in a sense, amateurs; yet, they may be above the professional in their contributions to fine photography.

MILI: No, no. The great photographer is a great photographer. To say that Michaelangelo is an amateur because his work is now rated as the greatest is cockeyed. Michaelangelo at 68 painted the ceiling of the Sistine Chapel while lying on his back high above the floor. If that isn't professional, I don't know what is.

WHITING: I think he was working for money.

MILI: He felt compelled to do the work and to do it effectively. It is this same drive which makes a photographer profesionally important. He must be effective. He may not feel his best, but he must be effective. He must deliver. The challenge is there.

ROTHSTEIN: It seems to me that given the future opportunities for photographers in the fields of visual education, in combinations of books and television, perhaps there is a move away from photographer as entrepreneur, the freewheeling individual who can afford to be an artist. Aren't we moving toward a man who can adapt to an organization — a man who goes beyond operating a television camera and becomes the guiding genius in determining where the camera goes. This is where our visual talent should be.

ELISOFON: I think we should expand more upon the remark about the soul in photography. If you're a young photographer your own development as a human being is very important. Regardless of what kind of artist you are — poet, writer, photographer, filmmaker, or teacher — it is your development, your cultural self, your integrity which is going to finally come out in your work. An artist only mirrors himself in the final analysis. That is something important for you to think about as you read, watch movies and television and — in short — live. Beware of a photographer who is narrow in his total viewpoint, knowing only his little camera and darkroom.

CONFEREE: This Conference has emphasized that we must do what we feel and want. Eliot pointed out specialization; we argued about versatility. But I should like to suggest if you're a young photographer or a photographer with a future you ought to think more of becoming a director who stands behind electronic equipment which takes and transmits the picture of tomorrow. The director can create a hologram which simulates this whole room and everybody in it. It's that director's viewpoint which creates the hologram. This is what the young photographer may find in the future.

7

Education
For Photographic
Communication

Many young men and women have a dream about their future with the picture. They enjoy making photographic images of life about them — in the city or country, on the campus or in a foreign land. They also experience a personal reward in following that image through all of the steps in the lab, finally holding it before themselves, just as they wished it to become. Photography is an art, a science, and a craft.

How does one become a *professional* photographer in communications? How or where can he learn the photographic "technicals?" How can he learn about the image itself — what it says, means — or a series of images, all laid out? Later there will be questions about that first experience of approaching an editor to show one's work. Will it interest him? What should the photographer do or say? Can he get that first assignment?

There are probably as many ways one can become a professional photographer as there are questions about what he ought to learn. There are successful photographers in the field who received no formal training of a technical or liberal arts nature before working professionally. Some may have learned the techniques while experimenting as amateur photographers, getting occasional advice from professional friends. Others served apprenticeships with established photojournalists, learning the business from the ground up. There is an increasing number of professionals who studied photography as art and communication in the classrooms of colleges or universities. They may have been graduated with a major in art or journalism or in as specialized a topic as photographic communication, now offered by a few American universities. Whatever their major, it is certain that no more than 25% of their academic work was devoted to photography. The other 75% was devoted to the liberal arts, to help in the development of a broad background, an important tool for the "mentals" in photographic communication.

What are the specific needs of the young photographer as he enters the field? Eliot Elisofon of *Life* contributes a very thoughtful and helpful essay on the "Qualities of a Photojournalist." Elisofon says that the entering photographer in communications must

263

be prepared as a journalist, as an artist and as a human being — with perseverance, self-discipline and other necessary character qualities. And, says Elisofon, the young photographer must be equipped to command his medium: he must know photographic technique.

With a sufficient number of those qualities in hand, the question remains of how a young photographer gets started. Two panels, including photographers, editors, agency executives and a teacher, search the question in depth. They describe in a straight-forward manner the frequent difficulties young photographers experience in "getting in" to see an editor. They warn against his becoming discouraged — or ego-inflated — by a single evaluation. Sometimes he may be getting a brush-off. They also urge him to develop an impressive portfolio.

If a photographer can "intern" for a period with an established photographer, the experience will probably be of great usefulness, in terms of his future handling of assignments as well as business contacts and methods.

The chapter concludes with one of the most moving contributions of the book, "What Photographers Need Are Standards," presented by Aron Mathieu, a publisher of photographic and non-photographic magazines. In what Wilson Hicks believed was one of the "great" speeches in Conference history, Aron Mathieu demands that the photographer or editor acquire and protect the highest in *craft standards.* He also urges that the photographer or editor who wishes to reach the top — and stay there — acquire as a "union card" *intellectual and cultural standards,* a difficult task, he concludes, but the most important advice one can heed if he wishes to become an educated photographic communicator.

QUALITIES OF A PHOTOJOURNALIST

ELIOT ELISOFON, 1957

For a biographical note on Mr. Elisofon see page 158.

It is a great responsibility for any one person to come before a group like this and attempt to give advice, counsel or stimulation to people who would like to become, or who already are, photojournalists. To my colleagues I must indicate that my remarks are not for them; I don't mind their listening, but I hope they will understand that I am addressing myself to the conferees, rather than the faculty. I don't know if I would ever welcome trying to teach even if only for as long as a week. I once taught photojournalism at the White School of Photography in New York. Once each week I lectured on the subject, and even with 15 sessions, we never seemed to cover all there was to discuss.

Photography has enriched my life greatly. We are all aware that photojournalism today offers the successful photographer an opportunity of experiencing a very rich life. Who but a photographer meets the people we do, goes to the places we go and then communicates opinions and feelings through images from his camera and heart which reach millions of people? For me, as I said, I am rich beyond belief, not in money, but in friends,

places I've seen and experiences I've had. That opportunity is open to anyone. Of course one's personal sucess finally depends on what he can do. A man may be very happy as a photographer on a small employee publication for an aircraft company. Or, he may teach in a school, college or university. Perhaps he works for the government photographically documenting the Indian situation. Though a photographer may work in a somewhat limited area, he is in a new and extraordinary profession. Just stop and think about it; practically the only new professions are nuclear science and photojournalism.

In preparing these remarks I tried to think of what I could say that would be thoughtful as well as helpful to people like yourselves who are planning to become photographers or who wish to improve your status.

John Morris quoted Ernst Haas as saying that the qualities of a good photojournalist must include the eye, heart and brain. I believe that there are four important criteria involved in being a career photojournalist. I should like to discuss them with you, though not in any particular hierarchy of importance.

Being Journalist and Photographer

One is to be a *journalist:* knowing what is happening in the world, knowing the people you work for, knowing what they want, knowing how to produce a satisfactory job, how to recognize a story, how to beat the next fellow — these are but a sample of the knowledge and skills which journalism involves and requires of the journalist. Journalism also involves a knowledge of layout and the ability to photograph a story so it can be laid out afterward. One of the ways you can become a journalist without attending a journalism school is to read carefully and analyze magazines and newspapers. To be successful in journalism one cannot be a sloppy character who goes three days without seeing a paper or who doesn't look at the national magazines. I am not here to hawk *Time* or *Newsweek,* but if a man is going to be a successful photojournalist, he must be a careful student of current affairs. He should really know what is happening in Nicaragua and Honduras; he should know about European trade barriers. He must be a student of "what's going on" — it is part of his business.

Right here I should add an "escape clause," because there are exceptions to every rule. We might think of a photographer who lacks many or all of the criteria I'm discussing, but nevertheless has achieved stardom. My address is aimed toward the general, not the exceptional, case.

Imagination, a Priceless Gift

A second criterion deals with *artistic ability*. Are you or can you learn to be an artist? Of course I am referring to the act of creating, to make something of nothing or to make something from yourself: to make a photograph which comes from you rather than the subject, which becomes personal and is recognized as your own. This is a quality people are either born with or without; it is very difficult to develop. However, I believe that anyone who is competent and possessed of average intelligence can develop a style and personality in his work. The most priceless gift that a human being can have is imagination. That is the ultimate. Everyone wishes to have some or wishes he had more.

When I left commercial photography for magazine work, I carefully studied the work of Eisenstaedt and Bourke-White, who were then leaders in the field. I also studied Edward

Weston and Man Ray. I pored over the work of other photographers, too, because I felt that my work lacked a style. I didn't know how to approach making the kind of photographs for magazines which would establish my individuality. So, I studied the work of people I considered masters, analyzing their style, trying to discover what made them tick.

To be an artist really means to be different, not to copy. Yet, there have been very few artists who have not started by copying someone else. Van Gogh, for example, was never ashamed of copying artists he considered masters, and some of those very paintings are worth a great deal. In art school some students of painting begin by copying the paintings of others. I do not think it is wrong for a young photographer to copy another photographer's style for a while until he finds his own; maybe he should consciously copy several to find his means of expression. If he is a genius, his work will spring out as a bird coming from a canebrake. Of course this won't happen to everyone. But, I believe one can almost train himself to be a competent artist. However, I don't mean to suggest that this training should include the study of every book on pictorial composition — of which there are practically none — or the memorizing of a great many rules of composition. There are more genuine and subtle ways.

Technique as Means Toward End

I have a third point: *photographic technique.* Everyone will soon think I'm a real grouch on this question of technique and craftsmanship, but there can be no art without some minimal quantity and quality of craft and technique. A man cannot write a book unless he can use the English language or some other symbolic system. Nor can he write fiction unless he knows how to develop a plot. Similarly, a man cannot photograph Venice or do a photographic book on Frenchmen without knowing the techniques of the photographic process.

I don't want to give the impression during this Conference that it is a crime to use only a 35mm camera. Many of the best photographers in the world use only a 35mm and wouldn't be caught dead with a big camera. But, the 35mm camera is a shortcut, and I think many young photographers of today have become sloppy in their tremendous desire to discover and utilize shortcuts. Their approach with the 35 is a sort of photographic shorthand, a quick, crisp, almost calligraphic way of photography. How does a young photographer determine if he might do better in the studio? Or do better as a great photographer of still life? Or be successful and fulfilled as a fine portraitist with the big camera? Or work as an industrial photographer?

Before a medical doctor becomes a brain surgeon, he learns generally and broadly about diseases, medicine and surgery. Similarly, in photography a photographer should learn how to work with the 5 x 7, 4 x 5 and 8 x 10 — how to shoot and process sheet film — as well as how to work in a studio and how to do studio lighting. Techniques of existing light are also very important. These experiences for the surgeon and the photographer provide a broad, general background.

Young photographers should learn technique so solidly that the mechanics of photographing become almost as effortless as seeing. Technical mastery doesn't have to be apparent or rigid. Nor should the photographer become a technique lover, seeing it as an end in itself, for then he is being swallowed by that mechanical monster, the camera. The

man who stops to ask himself, "Did I expose that right? Should I shoot that? Should I use a 50mm lens? Did I have enough light?" is so harrassed with humdrum questions of simply getting a negative or a transparency that he never considers the creative act of image-making. It would be the same as a novelist trying to find keys on the typewriter or wondering which letters he was striking. You can't be a top photographer without a technical command of the medium. Now that doesn't mean that photographers of the caliber you've been listening to during this Conference don't have qualms about technique, camera failures and other technical problems. These problems occur all the time, for the tools of photography are rather imperfect. I doubt if there is a top photographer who has ever been completely satisfied with his camera. People like Halsman have built their own. The professional photographer should know how to work with the tools of his medium and try to perfect his technique so he doesn't have to give it conscious thought.

Human Qualities

Fourth is the human being, the *photographer himself*. One can be a competent journalist, artist and technician, yet still fall short of being an outstanding photographer. I have often thought that regardless how gifted a person is, in the final analysis the work of a man is the mirror of himself, whether it is dancing, music, literature or photography. You see, you can only produce what you are, what you have within yourself.

For example, consider self-discipline. Without discipline, the human being won't get anywhere.

Another important human quality is *perseverance*. If one doesn't fight for what he wants to do, doesn't continue pursuing what he believes in, if he doesn't have the guts or courage to stick to it until he reaches a goal, he never will be a top photojournalist.

A photographer ought also to have a *variety of interests,* for the more interests he has, the greater his opportunity to do a full job, and the less limitations he will experience in his career.

Integrity is one of the most important qualities any photojournalist can have. Sometimes photographers must compromise, but it is a question of how much compromise, what kind of compromise, whether the compromise is honest or dishonest, whether the photographer is being used.

Last, but certainly not least, is the question of *energy*. A photojournalist should be a dynamo. The aspiring photographer without energy or drive might just as well give up, for a lazy photographer will never be successful. The man who says, "Perhaps I ought to take this picture," or "I'll wait until tomorrow to take it," or "I'll study that," or "I won't do this now," will never be among the leading photojournalists.

There are many other important qualities for being a photojournalist which don't fit into the classification scheme I have used. Permit me to share with you a word or two about each. One is *enthusiasm*. It is contagious. Someone who is really enthusiastic about what he is doing can often carry along a large group of people and interest others in what he is doing.

Next are *thoroughness* and *thoughtfulness*. Don't be casual or in hurry as a snapshot photographer. Think through what you are doing, what you have done and what you would prefer to do if ever in a similar situation. Without thinking, you are really lost. How

does one learn to think? There is no easy formula. I was very fortunate, for in college I majored in philosophy — the study of man's thinking across history.

And there is *taste,* a quality which I believe can be developed. One of the qualities which distinguishes Ernst Haas' work is taste. There's a fineness, a certain subtlety. Some photographers have never been given help with this question of taste. By and large as one travels across this country and abroad, he is confronted with a plethora of bad taste. One of the most important assets a photographer can possess is sophistication in taste, whether it was given him at birth or developed through a sensitivity to life experiences. One can make a conscious effort to develop taste by studying books and magazines, by carefully observing the home furnishings and decoration of people with a sense of taste, by studying paintings and by attending, let us say, a chamber music concert even though you might think the idea a bore. Perhaps it will contribute something.

At any rate, I don't think it's important whether you're good, great or anything else if you're a happy human being. I'm happy, and that is what's important.

THE YOUNG PHOTOGRAPHER

PANEL, 1965

Panelists include Arthur Rothstein, then director of photography, *Look;* Bill Eppridge, photographer, *Life;* James Karales, then staff photographer, *Look;* Janet Katz, then student, University of Miami; Tom McCarthy, freelance; and Charles Moore, Black Star photographer, New York.

ARTHUR ROTHSTEIN: This panel provides an opportunity to sum up the situation we have today with regard to the young photographer, the photographer who is starting out in the business. As moderator, I'm going to ask a few questions of the photographers assembled here. What exactly is a young photographer? Is being a young photographer something related to age? Do you suddenly stop being a young photographer when you reach the age of 30 or 35? Or is it a state of mind? Can you be a young photographer even if not young chronologically?

CHARLES MOORE: I would rather consider what is the *start* of a young photographer instead of the stopping point. I believe that it can be either a state of mind or a matter of age, depending upon which way you look at it. I think of it mostly as a state of mind and being — the phase of photography you are going through.

JANET KATZ: I believe a young photographer would be so-defined according to what he sees and thinks, his state of mind. Many people don't really see, and if a photographer can see things in a different and fresh way, he would be termed a young photographer.

TOM MCCARTHY: A young photographer is somebody who hasn't given up!

BILL EPPRIDGE: I kind of agree with that. If you want to follow along this idea of the youthful state of mind, you'd end up with only two categories: young photographers and old hacks. I don't think that is quite true. In there someplace is the accomplished, solid

pro who knows what he's doing every time. You don't really call him a young photographer, but I think that age has something to do with being a young photographer or the term young photographer. The older you get, the slower you move around.

JIM KARALES: A young photographer can be a young man or woman — or a 50-year-old — just starting in photography; he's a young photographer, too. But, I think basically what you're asking is whether someone in his 20's is considered a young photographer. That's what a young photographer is.

JOHN DURNIAK (Editor, *Popular Photography*): I think that youth is a definite, saleable commodity. Eppridge was picked for the dope addiction story because he was young — he fitted in with the people, the furniture. He was chosen for the Yale story because he was young — he fitted in with the students and didn't look out of place. Eisie would have stuck out like a sore thumb. I think you can sell youth today better than any other time. That is the important advantage of being a young photographer.

ROTHSTEIN: Generally speaking the panel thinks the young photographer is a combination of youth in the sense of thought, reflexes and physical ability.

I'd also be interested in learning from this panel who or what has influenced each photographer the most and helped him develop the kind of style or approach toward photography which he has.

Environment an Important Influence

MOORE: I think the work of other photographers has had a great influence on me. Of course, life and the events which I've become a part of or which have become a part of me have influenced my being.

KATZ: I think I was influenced by noted photographers. I've always looked through magazines and picture albums to see what the masters are doing. Imitation of these people is what counts. If you start out doing that, then you can divert and go in other directions, develop your own personality, go your own way. Personally Mr. Hicks has greatly influenced my thinking about a photograph, the idea of what a photograph is, and the importance of a visual image.

MCCARTHY: I was influenced mostly by an editor of a newspaper who I had trouble keeping up with. I traveled from newspaper to newspaper, because he kept getting fired by the publishers when he stood up for what he thought was right.

EPPRIDGE: I was quite influenced by my sister, who is an artist. I've always felt that a person has to make some kind of contribution to society sometime in his life. He has to be able to say that he has done something for somebody else. I started taking pictures and wanted to be a journalist. I got my hands on everything I could. I don't think there was any one tremendously influencing factor, but many of them.

KARALES: I was primarily influenced by fellow students at Ohio University and by my instructors. After leaving there I went to New York and was definitely influenced by W. Eugene Smith. Of course you're exposed to other facets of life, in general.

ROTHSTEIN: In view of the complexities within today's society and the kind of photography that must be done to record events, is special training necessary, and if so, how much and what kind is necessary to be a good photographer, a good photojournalist? In the past, many photographers started out as apprentices or they just kind of grew

into it without any special academic background. How important is it, right now, to have special training?

MOORE: Special training is essential, especially in the technical end of photography. There are many young photographers who have good vision, who have a great eye for the photograph and for telling a story through photographs, and yet many of them seemingly have little technical ability. I think the photographer's eye, the way he sees, what he sees and how he interprets life comes through his own experience with people and things; he develops this himself. People can help in discussing with you about seeing, but seeing must be self-developed. Technique is something which someone along the line can and should teach you. Then you take photography from there. In college you can get technique and then much more than that. Some college programs in photography have forsaken the teaching of solid technique. I once hired a boy who came from college after studying newspaper photojournalism. He had a good eye, but he didn't know how to use a strobe, which is a very basic and essential skill in the newspaper business. He didn't know how to process film — really! He hardly possessed a minimum bit of training in the technical field.

Technical, Social, Academic Learning

KATZ: I think there are three types of education that are essential: technical, social and academic. Students must understand society to be able to look at it with an objective eye . . . or in order to be subjective. I think it's very important for the photographer to know history and literature. You have to have something to say, and the study of history, the humanities and social sciences will provide a perspective which you can apply to your photographing. When you have this perspective you should form a point of view about a subject and then say what you want. Finally you have to be able to handle the tools and know your technicals.

MCCARTHY: Perhaps the technical end could be learned in about a month if you'd use one developer, one film, a high shutter speed so you don't get movement and the reflex so you don't have trouble focusing — standardize the whole process so you can forget it and use your eye.

EPPRIDGE: I take exception to that. With the complex equipment we have today — the radio pack or remote control rig — when it doesn't work, it doesn't work; that's it. You're in trouble. Not too long ago we were in Colorado using remote equipment. Every once in a while the unit would not work, and we finally determined that somebody was pushing a cash register which was knocking it out. Obviously, the units are improperly made; they shouldn't have been sold in the first place. But, you have to learn how to circumvent problems. It's not just enough to know how to develop film. The process of training and educating oneself should go on and on, without stopping. You learn a little bit more from everyone you meet. You pick up new techniques from photography magazines as well as school. Your education is everywhere. It's extremely important that you're aware of this and that you just don't reach a point in your learning and then stop.

KARALES: I don't think this is an absolute, but my formal education was very important to me. It rounds one off as an individual, more or less. You should know technique to enable you to interpret your final image — what you're trying to convey.

Some of the simpler and fundamental aspects of technique can be learned in a relatively short time, but from there on, you must continually experiment with everything new. It is necessary that you experiment with different types of equipment and lenses. I don't think you should limit your photography to one shutter speed or one aperture at all times — that limits your creative expression. At the other extreme, you don't want to become too involved with equipment and gadgets because your concern and involvement then may shift from what you are photographing to the equipment.

EPPRIDGE: At *Life* the department which probably has the most difficulty with stories is the science department. There are two photographers there, Fritz Goro and Ralph Morse, with a third one coming up. Fritz and Ralph are extremely accomplished photographers of science. The technical problems involved in taking pictures for this department are unbelievable. The editors come up with some of the most hare-brained ideas sometimes and want them photographed. There are not enough people who are adequately trained in the sciences, who know how to cope with taking photographs of scientific subjects which are becoming of increasing importance. Perhaps photographers don't want to learn how to contribute in this specialty.

ROTHSTEIN: That brings us to another concern of the young photographer — how to get started in this business of photography. If you're a young photographer, you have to start somewhere, somehow. What is the best way for a photographer who is starting out to achieve some success in the field, to achieve his goals, to find an opportunity?

MOORE: Do you mean how does the photographer begin after a certain period of time?

ROTHSTEIN: Let's assume that somebody has been graduated from a college where they teach a course in journalism — including photography. We're mainly interested here in communications photography rather than advertising, commercial or illustrations photography. Let's further assume that this graduate has certain evidence of an aptitude for his field, and is ready to start his career. How important is New York City — the picture center of the world and center of the communications industry — to this beginning professional? Must he go there to get started?

MOORE: The best example of what a young photographer should do to prepare himself is that of Burk Uzzle, who went to Atlanta and worked as an assistant to Jay Leviton for two years. I'm sure this had a lot to do with Burk's development as a good photographer and as a technically competent photographer. I struggled through for many years, not really knowing in which direction to move, searching for what I wanted. Then I got into photojournalism. Until that time I was really a lost child, stumbling around, not happy. I loved photography, but couldn't find the area I really wanted to work in. If I had to do it all over again, I would gladly give two years of my life to studying and working under one or more photographers. There are so many things young photographers can do today. They can start right out of college, if they have money, working on stories and developing a portfolio — meeting people. As for New York, I think it is extremely important in the development of a photographer. How did you phrase that question, again?

ROTHSTEIN: I wanted to find out how important it is to be conscious of New York as the center of the communications industry.

New York an Influence

MOORE: You can be conscious of it without being there. I think it's very important to be conscious of it, to know the people there and to be able to make a trip there as often as you can. I do not think it's so important to live there.

KATZ: Well, all I can say is that I realize that New York is an important place to go to meet people and to talk to people about photography, but as far as giving any advice, I don't think I'm the one to do it. I haven't had any experience. I'm open to suggestions myself.

MCCARTHY: About all I could suggest is to get some kind of tangible job in photography, no matter what it is, and keep talking to people and trying for different jobs. I started out on a very small newspaper in the hills of Pennsylvania.

EPPRIDGE: As to getting started, you have to know what you want to do. You can be a journalist, a fashion photographer or an illustrator for textbooks — there are many, many fields in photography. Then, perhaps, find somebody to apprentice yourself to. About the importance of New York: I think it's extremely important. During the Renaissance there was a great revival in art because of the orientation in Florence, for example. There were many artists in Florence, and they bred, they reproduced themselves. New York is the same. There are many photographers in New York. It is a photographically-oriented city. Inspiration is an extremely important dimension, the multiplicity of sources. If I were a good composer of music, I wouldn't go to New Jersey. The inspiration isn't there. I think it's in New York.

KARALES: I don't think there's an absolute method of breaking into any of these fields. Everyone finds his own way of working. For myself the experience as an assistant to Eugene Smith was very helpful, though at times it became very detrimental to me because of Smith. But, I think becoming an assistant is one way. If you want to get into the magazine world, constantly searching and suggesting stories, sometimes even completing and showing them to the right people, is necessary. Orient yourself in the type of work you want to do so your images will be interesting to the magazines or fashion industry or to business and industry, itself. I don't have any absolute way of explaining how one can do this.

EPPRIDGE: Many great photographers have started out working in labs. There can be a large source of inspiration there, for other photographers and editors are coming in all the time. A lab is a pretty good place to work for a while.

KARALES: New York is very important; it's the nucleus of everything. It's a very difficult place in which to get started, but I think the contacts there are very important.

DEVELOPING THE PHOTOJOURNALIST

PANEL, 1958

Howard Chapnick of Black Star in New York chairs this discussion with Yoichi Okamoto, then Chief, Still Pictures Branch, United States Information Agency, Washington, D. C.; Inge Bondi, picture editor, Magnum; Roy Stryker, photographic consultant and formerly in charge of the documentary project of the Farm Security Administration; and Ed Wergeles, editorial staff, *Newsweek*.

HOWARD CHAPNICK: We decided that we wanted to talk about the young photographer just coming up in the field, the development of the photojournalist. And, we want to ask ourselves whether we are really helping to develop photojournalists. This applies not only to the picture agencies, but to the picture editors and picture consultants. When a young, unestablished man comes to New York, does the magazine actually have somebody who will sit down with him and discuss what's right or wrong with the pictures he has to offer? We also want to ask for what function — or medium — are we developing them. Most of this conference has been devoted to display of and discussion about material for magazines like *Life, Look* or *Sports Illustrated*. But, there are other areas available to photographers in which they can express their creative energies, and we want to share with these photographers our knowledge about the other areas which they can exploit.

ED WERGELES: We have talked about this before; the editors just don't have enough time to talk to guys who come around with pictures and want to know if there is a job or what we think of their work.

CHAPNICK: I don't know if it's that they really don't have the time, or whether it is that they are very busy and just don't want to trouble themselves with going out and talking to somebody about his work who comes unsolicited into the anteroom. I know of a 14-year-old boy who had to argue for half an hour with the receptionist to talk to an editor on the phone, and then, when he finally spoke to this person, he advised the boy to leave his pictures with the receptionist and he would write a note after having an opportunity to look at them.

What I'm trying to suggest here is that maybe we all ought to look at ourselves and question whether we are really giving these people the time of day. Maybe when they come on recommendation of Inge Bondi of Magnum or John Morris or someone else active in New York publishing, editors are more receptive because they have had the advantage of many years of personal relationships with these people. But, what about the guy who comes in from the country, cold. Do they really give him some time, sit down and talk with him about his pictures or tell him where he is going wrong? I think more often than not a telephone switchboard operator who has been promoted to third

assistant picture editor comes out, looks at the pictures and says they are wonderful, but doesn't — or probably can't — give any constructive criticism to the photographer.

ROY STRYKER: I recently had a short stretch at *Life* magazine — they sort of suspected that I gave off a strange odor which would somehow quiet the staff photographers, I guess. My job finally turned out to be seeing people who came to *Life,* but to whom nobody had the time to talk. It was one of the most interesting jobs I had. Nevertheless, I recognize the problem which Ed mentions; it's a serious problem for the big magazines. I have a similar problem in Pittsburgh at the moment. I get letters every so often from people who say that they are coming to town and want to see me. We don't like to run a hotel, but I realize that probably I can keep my youth by talking to photographers. I realize how serious and essential it is. But it's got to be done on an individual basis.

Just one more point. Last year on the last night of a workshop a young chap graduating from Ohio University at Athens, the photographic school there, asked, "Will you look at my photographs?" Before we got through there were about 15 guys gathered around. I realized how much I'd failed, how important it was to help him individually to select a portfolio, and to give him some pointers on how to get into the office, how not to bother the guy, what not to say, how to lay his photographs on the table, not to hand the editor pictures and things of that kind.

When Howard raised the question, he probably raised some of the most serious questions which a young photographer faces: whom can he talk to and where can he find him. Now, what are we going to do about it?

Should Editors See Photographers?

INGE BONDI: I don't know if it's the responsibility of the picture editor at a magazine who's got his own pressures and troubles to "grow" young photographers. Isn't that the responsibility of the older photographers?

STRYKER: I think it is the responsibility of many editors in this country to devote a little of their time. I don't think editors are quite that busy. This is a human relationship which has to take place. When editors get so busy that they can't take a little time out to see young photographers, they have failed themselves and also lost an opportunity which could yield fruit in the future. Don't they realize that?

WERGELES: I think you're wrong, because I'm an editor now and was a photographer. You just can't spare the time to see every guy who comes around with a batch of pictures. If they have something which will help you do your job, that's fine. If a guy comes in with a good idea and a good batch of pictures of something that will make a good cover, that's great. He's doing me a favor. But, I'm a busy guy trying to do my job. Most editors feel that way. I think Wilson felt that way when he was at *Life.* He was too busy to see every guy who came in with a transparency or a batch of pictures.

WILSON HICKS: I wake up screaming in the night for two reasons: For the photographers whose photographs I didn't look at and for the guys I fired. Sometimes I felt as I imagine the executioner at Sing Sing must feel. Photographers would come in, and maybe I wouldn't see them at all. Then they would go on. Two years later somebody would bring in a set of pictures and I'd buy them. I might say, "Hey, that name rings a bell!" and it would be that guy I hadn't seen two years ago. It would catch up with me sometimes.

You know, there ought to be a job for old picture editors. Maybe you put them in a corner office at a magazine and then these young fellows can go in and sit down. Then it is not the receptionist nor the third assistant nor the telephone operator, but somebody who knows something about pictures who talks to them and encourages. You can't do it, of course, Ed. You are too busy. You've got your job to do, as you say, but isn't there some way that this function, this service, could be done? The magazines are always hollering, "Where's the new, young talent with a camera?" Maybe we've just identified one of the reasons why we don't see more of the new, young talent.

CHAPNICK: But, it isn't only the picture editor, Mr. Hicks, it's the picture agent, too. I'm not trying to make a case against everybody here, but I think we're all a little too busy. We don't take enough time to talk with these people and tell them where they're going right or wrong. I think we all ought to look a little bit into ourselves and wonder if we're doing the job the way it should be done.

YOICHI OKAMOTO: I think we ought to get away from this theme of what's wrong with the people who are in the business and start talking about "Developing the Photojournalist."

BONDI: I, too, would like to talk a little about young photographers, because they happen to be and have been my special preoccupation for the last two or three years at Magnum. We have realized for some time that there was a tremendous problem at Magnum, not only with young photographers, but with older, more experienced photographers who wanted to come and show their photographs. When someone wants to show you his stuff, you may not have a deadline, but you do have the orders and assignments to manage for about 18 photographers and you know that if you see the guy for only five minutes or so, you're doing him an injustice. You'd have to flip through the photographs very fast, and he would feel you were not considering his work seriously. So, you have the responsibility of giving him half an hour or a full hour of constructive criticism.

To be Seen and Criticized

The problem is how to criticize, but not kill them off. All you have to do is be terribly unkind to a young photographer and if he is working entirely on his own without the benefit of discussion and friction with other photographers, he may just disappear and give up. But, we also should not treat young photographers as if they are in a nursery. They have got to be just as tough — perhaps a lot tougher — than the first or second generation of photojournalists. They have to learn early in the game that unless they have something very definite to say with the images they make, unless they have some definite contributions to make and unless they're going to discipline themselves, there isn't anybody in the world who can really help them.

Actually there are very few young photographers who come back after an initial visit. We ask them to come in with three picture stories and some contacts. This is a concept which was worked out at a Magnum shareholders meeting. Cartier-Bresson feels very strongly that the contacts are important. Very rarely will a photographer come back after six months and show us what he has done in that time.

HICKS: Young photographers have several problems. One of them involves technical proficiency. They all think that they can shoot at ASA 2000, overdevelop and get wonder-

ful golf ball effects with 35mm. They haven't learned the basic techniques of photography. We've been talking about the "poor little photographer" and that the editor is so nasty. Maybe there is something wrong with the little photographer, too! One of the absolute, basic requirements is the capability of taking clear, sharp, good pictures.

Another problem is that so many young photographers today whose portfolios you see are trying to do the photographic essay. They start in, but what do they want to say? It's just like the young writer who wants to write the Great American Novel; the young photographer wants to do the Great American Essay.

CHAPNICK: We've been painting a pretty tough picture, but I'd like to say that photojournalism probably is one of the easiest businesses anybody can get into. A man who decides he wants to be a photojournalist can become an individual entrepreneur by purchasing a camera, some film, and announcing, "I'm in business." There may be many reasons why he wants to go into this business. Perhaps he is enamoured with the essay form of the picture story, or maybe he believes that this business holds a glamorous life for the future.

Say the Significant

I think he needs more than a camera, film and dreams of glamour. The photographer has to make his personal investment in the future. He has to go out and create something of photographic significance so that when he comes to New York he can present a portfolio to agents and editors which will knock their eyes out. He has to find some subject which is stimulating to him and when completed will stimulate the people to whom he shows it. It has to be good. If I wanted to be a photojournalist, I don't think I'd want to be another hack. I'd want to be someone whose work would be recognized. Oke, you have people coming to see you all the time. Don't you have the feeling that this is something you would like to see?

OKAMOTO: Yes, absolutely. Now, what does it take? Anybody who is going to try to become a photojournalist has really got to boil this thing out. Is it a form of living? Has he got the basic enthusiasm and the guts? I think becoming a good photographer as contrasted to a hack is very closely related to becoming a significant actress or actor. Everybody knows how tough it is, and you've got to be really hardboiled. To be an outstanding photojournalist you've got to train yourself much more broadly than for the difficult task of taking good pictures. All photographers should learn how to use words, to be articulate. When you're selling ideas, you have the problem of communicating with words something which you can imagine in your eye which will come out in images. Therefore, you've got to learn how to write a letter which will attract the editor's interest, or you've got to be able to talk to him so that he gains a feeling, an understanding, for the story. You also need to be able to gain rapport with him. If you can't accomplish those tasks with words, you're never going to get the jobs to photograph. I wish you'd tell about Kosti, Howard.

CHAPNICK: I was talking at lunch today about Kosti Ruohomaa who would go up to Mr. Hicks' office on a Saturday morning in the old days when he was at *Life* and he would say, "Fog." As soon as he would say, "Fog," Mr. Hicks would relate fog to the kind of work that Kosti did. Now 99 other photographers could come in and say the

word *fog,* and there would be no reaction. But, knowing what Kosti could do with mood and with the feeling that he had for this type of interpretive essay, Mr. Hicks would send him to Maine, and Kosti would sit there for two or three months just waiting for the fog to roll in.

On Editor-Photographer Rapport

OKAMOTO: As I was saying, the photographer must learn how to gain *rapport* with an editor! Most aspiring photographers dream about *Life, Look* or one of the big magazines, and they try to hit the top market. But, that's the toughest type of competition. Why not train yourself? Look down your list of specialty magazine markets — the smaller magazines. Take a little market — I don't care if it's the local rotogravure section — and go to that editor with some material that will knock his eyes out; then begin gaining that certain *rapport.* Once we editors get an idea, one of the toughest jobs — and I feel it very much, because I'm using taxpayers' money — is to select the best photographer we can find to put that idea over. I only know a few photographers, but I don't feel I can gamble on a photographer whose work and skills I don't know. Therefore, as a beginner you should show the editor of a rotogravure section something you have done and then shoot a few jobs for him. When he gets a certain type of idea and says, "Bill can do it," you've gained professional *rapport* with that editor. Then try to establish yourself with a few more editors. I think that is the approach, rather than trying for the top market and becoming a star overnight, which is very rarely done.

HICKS: I've heard the word *tough,* and somebody used the word *guts.* Just to point this up a little more, I've been studying for years, and I haven't figured out yet why the photographer is the individual that he is. Some people look at him and laugh; some say a photographer doesn't move around in polite company. He's not in the editorial department of any publication that I know of. Not really. But, why? He's got the reputation of a cigar in his mouth and a press card in his hatband, even if he is Photographer X from *Life* or Photographer Y from *National Geographic.* He is still considered that way.

However, when he comes into the editor's office, this tough guy, this strange creature, this other breed, this *photographer,* he's got a tender side. And out of that tender side comes his creative gift. The great requirement in this world is for him to do that thing which is all pragmatic and practical. But if you can touch the something in him that brings out that self-expression, you get a bonus, you see.

OKAMOTO: Don't get me wrong. I didn't mean tough — hard; I meant tough — perseverance and enthusiasm. He's got to be able to take a lot of disappointments and then bounce back. That's what I meant by tough.

STRYKER: You used the word *rapport.* Now how does a young chap who's not too experienced about the world — he's a little insecure and scared — just how does he get *rapport?* Will you explain that since you've used that word? And let's be practical about it.

OKAMOTO: When you as the photographer gain the confidence of the editor by showing him that you can be an extension of his thoughts, that you can make money for him, you've gained *rapport.* Somehow that's a quality worked out between individuals. All editors and photographers are different, but *rapport* is the photographer's establishing an editor's confidence in that photographer's abilities. That is a vital problem for all editors and photographers.

CHAPNICK: But that takes time, Oke. I don't know about the rest of you, but when I go in to see somebody for the first time, my stomach turns over a thousand times. I'm nervous. Sometimes I strike a spark with the guy, but other times I feel as an intruder. He can't wait to get rid of me, and I can't wait to get out of there. I don't have any *rapport*.

HICKS: There's something else about *rapport*. You can build up such a *rapport* that nothing happens. This may come close to something that Roy Stryker has got in mind. I'm sure he'll say so if it does.

CHAPNICK: I'll tell you that today was the first time I ever had any *rapport* with you!

STRYKER: I think there are a few really basic things about *rapport*. First, the photographer should find out something about the habits and weaknesses of a potential editor and client. There are people around who could provide additional insight. Find out what some of his desires are as related to the things you're going to try to sell him. Then you'd better develop manners and conversational habits and a presentation technique. Hand him the *pile* of prints; don't hand them to him one at a time. Don't lean over his back and point out things in the photographs that he ought to see.

OKAMOTO: And don't show a single photograph and then lean back with that look of, "Isn't that the greatest damn thing you ever saw?" That is the most repulsive attitude.

STRYKER: Those are simple things, but they are the start of *rapport*.

BONDI: I would like to suggest that the young photographer stop worrying about everything except his work for a long period of time. I'd like to come back to Wilson Hicks' point about technique and schooling. This panel is talking about who has the responsibility for the next generation and how to encourage young photojournalists. First he has got to learn his ABC's and there are many schools in this country where he can learn them well. Then, he has got to learn to be practical. There is a tendency for young photographers to come in with essays, and I think it is the responsibility of anybody who sees the young photographer to emphasize that it's easier to make a small statement, another small statement and then another small statement. As Cartier would say, "Don't make an essay, just make a little story which is one pearl, and then string all the pearls together and you've got a necklace."

HICKS: Maybe you'll have an essay.

BONDI: Exactly!

CHAPNICK: What's wrong with coming in with an essay?

BONDI: We're talking about young photographers who are just beginning, whose approach is being shaped.

CHAPNICK: What's wrong with even a young photographer coming in with an essay?

BONDI: Well, it depends. If the essay is perfect, there's absolutely nothing wrong. It's just about 99 times in a hundred that he gets lost in the process.

STRYKER: Then let him get lost.

BONDI: And what after that?

STRYKER: Why shouldn't a man get lost. If he can't find himself out, then we just have one man out of the way. If he finds himself out, that's wonderful.

BILL GARRETT (*National Geographic Magazine*): Assume a guy opens the door, runs in and throws his pictures on the desk. Now what are you going to do about it?

STRYKER: Talk to him. I don't know why I got into this!

HICKS: What about Bill Garrett's point? What happens when he comes and throws the pictures in.

CONFEREE: Assume he gets in the door. Let's go from there.

CHAPNICK: Ideally that man should be able to come in and sit down with Okamoto at the United States Information Agency or Mr. Stryker or Mr. Hicks or Inge Bondi at Magnum or myself at Black Star or Ed at *Newsweek* and have a reasonably intelligent discussion about those photographs. Whoever he is seeing should look at his work and give him an honest evaluation of it. But, more often than not, he doesn't get an honest evaluation. He gets a brush-off; the man says, "Yes, your pictures are very nice."

This may sound very sentimental, but I could have cried a couple of weeks ago when a guy walked in. He had 15 pictures which he had shown to a very large magazine's "third assistant picture editor" who looked at them and told him how wonderful they were. I had to make a decision when I saw them. Was I going to make myself unpopular with this guy and tell him that those pictures weren't so wonderful? That I didn't think he could get inside an editor's door and get an assignment based on them? If I'm honest, I have to tell him that. And I did. Maybe I was wrong.

BONDI: What else do you tell him?

CHAPNICK: I tell him to go out, do something else and then go back to the editors with something good. In this case the man said he had come in contact with a woman who ran a finishing school, and she had won $146,000 in prizes. He wanted to do a story on all the prizes that she had won!

I said, "You've got a perfect idea there, the finishing school. I can't get you an assignment on that; I don't know you from God, and I can't show those 15 photographs that you brought in here and expect that any editor is going to give you an assignment. I can't represent to them that you can do this job. So, you have to go out and do it for yourself. Why don't you go back to that woman and tell her that you would like to do a story on a finishing school, which is a great idea. I've never seen a good story on one."

He went back to this woman and told her that if she would subsidize the expenses he was willing to come down there for a week or two to shoot it. She agreed. I haven't seen him since, and I don't know if I'll ever see him again, but I believe he'll have something to show should he come back.

The Value of "Editorial Credit"

STRYKER: This is addressed to those of you who are ready to invade the market. Remember that you have a credit, if I may put it in those terms. You have a chance to see and show your work to some of the editors of the magazines. Don't use that credit carelessly. Don't go in with bad pictures, because if you show bad work the first time or the second time, you won't get in so easily the third time. Remember that you are dealing with a credit and handle it judiciously. Those contacts are valuable.

MORRIS GORDON: How is the truly young, beginning photographer to know whether his pictures are good, bad or indifferent? Often they come up to show you the pictures and want you to tell them they're good. They don't want any criticism.

WERGELES: That's very true. A young fellow came to see me about two weeks ago and said he was an assistant to Nina Leen. He showed me several prints, for I had

time that day to look at his stuff. I said, "You're terrific." And, he was. But, what was I going to do with him? I didn't have any assignments for him, and I couldn't hire him. We have a budget and an allotment of people who work for us, just as with every other magazine. I said "It looks pretty good to me; I think you've got a good start. Your pictures are good photographically and you've got good ideas." We shook hands and he left. That's it.

CONFEREE: Instead of talking about how to sell something or how to get in that door, we might go back into our own experiences, each of us telling how we have developed a photojournalist.

CHAPNICK: This man is right. Unless we're making some contribution to the development of photojournalists, then there's no justification for our existence here. I agree that we should take up that subject.

HICKS: The problem was different in my earlier days on *Life*. I devised the retainer system whereby as an editor I'd spot a young photographer whose pictures looked good and start giving him some assignments. I'd give him so much money a day or a page, whichever was greater. Photographers then were very hungry and the hungry photographers were the good ones. I don't know whether they still are or not. Finally, they would get so good that you could put them on the staff. Then they settled down, bought big homes, had six kids and bought three cars!

OKAMOTO: I'd like to disagree with Howard on just one point. I don't think the idea of saying go out and do it again is enough. Regardless of whether you are a photographer, an editor, an agent or just a human being, anyone who is involved with young photographers has really got to understand the seriousness of this. If you're any damn good at all in your profession, you've got to take the responsibility individually if we are all trying to upgrade this business. You've got to handle most photographers pretty damn sensitively, because if he's any kind of a photographer at all, he is a sensitive human. You've got to really talk to him, get to know him and find out what qualities he has in his personality and his photographs. You start off that way. Then, you come up with the "buts;" then you can talk to him as a peer.

The Freelance — Sensitive and Tough

BONDI: Yoichi, could I answer your question with an illustration? A photographer is sensitive, but I think if he wants to be a successful photographer, he's got to be schizophrenic: he's got to be both sensitive and extremely tough. I'm talking of a freelance because I don't know anything about the staff photographer. The freelance photographer is probably the loneliest man in the world; he has to rely completely on himself. Now as to your point about bringing the photographer along, it sounds good, but I remember when Ernst Haas came to this country. Although his pictures had already appeared in *Life,* he was hungry for about a year and a half. There wasn't anybody who was interested in his sensitivities. In a way that period did him a tremendous amount of good, because he got very busy on his own projects. It was extremely agonizing, but at the end of that year and a half, he was making the magic images. Now to return to Mr. Hicks' point, unfortunately the young, hungry photographers seem to stay away from Magnum. I don't know why. Unfortunately, it seems

to me that the business has gotten so tough and perhaps at the same time, so glamorized that the only young photographers whom I see making any kind of headway are those with some kind of financial backing.

STRYKER: There is such a thing as helping to create a photographer. It involves a lot of simple little things. You find a young guy who looks good and you get after him. He brings his pictures in and you raise the devil because they're not good. You encourage him to get busy and send his first photos to the annuals, the camera magazines, every place they can go; you stir him up to go looking around for pictures and markets. When the young photographer gets thoroughly disgusted, you can kid him along, and when he gets too cocky you should kick him in the pants.

CHAPNICK: I will tell you about a young fellow who is in this room; I won't even mention his name. This young man came to New York about three months ago with a couple of stories. One was a story on his mother who made a wedding dress for his future wife. This was a simple little story, not something we could sell to a major magazine, but we did sell it to a specialized publication. The other story was about a bully, a kid who had dominated the school yard, but finally got his come-uppance in the final picture when somebody turned on him and restored him to his proper stature.

This photographer came in cold. I had never known him. I took a little time to see his work and talk. Since then we've been in correspondence and discussed several story ideas. With the exception of the most recent two things which he has done, we've sold four of five stories. Incidentally none of these sales has been to what one would call the major documentary markets.

One of the stories was sold to *Parade*. It was a very simple story about the shortest boy in the class. He was a head shorter than anybody else, and the pictures reflected that. I had lunch with this man the other day to talk about his work. I told him that his ideas were very good, that to be able to sell four out of five of his stories was a terrific batting average, especially since these were his first attempts to enter the national magazine market. But, I also told him that some of his work was technically sloppy. There was too much attention to candidness without enough attention to technique. He wasn't concerning himself enough with composition; he thought he was making up for any deficiency in composition with unusual expressions.

Maybe this man will never be a great photojournalist, but he has started on the way. Maybe he will never be successful with Black Star; we've had both failures and successes. Maybe there will be a time when he as a photographer will outlive the agencies and be better off on his own. Well, good luck to him. But, I think you have to talk to a young photographer and help him in that direction. I think that's part of developing the photojournalist.

CONFEREE: I think we're on the track now. There's been a great deal of discussion about pampering the photographer. I don't think that is necessary. As freelances, we know what we're in for; we don't expect pampering. But, we do want to know what the editors expect of us and how we can please them. Ultimately we want to sell to them. What do you as editors or heads of agencies expect?

WERGELES: The only way to determine that is to just look at magazines. It's easy to buy *Newsweek* or *Life* on the stands.

HICKS: I think that we've been nasty about the editor; now maybe we can be a little nasty about the photographer, God love him. In answer to the question about what editors want, let me ask you photographers a question. Has the photographer got ideas or a new way of seeing things? Or, have we a great mass of photographers all seeing things pretty much the same way?

Should New Talent be Encouraged?

DON ORNITZ (California freelance): I'd like to question the basic premise. Should we be developing young photographers? In my association in Los Angeles I know about a dozen qualified photographers. They're competent men who have done some very interesting work. Very few of these men are really making a living at it. So, I think it's more important to buy pictures from and encourage people who are presently in the field and who need to continue than to search out a man for an occasional job. I think the important point is to find the right people and develop them and not make this a glamorous profession in which everybody wants to get into the act.

CHAPNICK: Well then, Don, we don't need any panel. Are we to say as the brick-layers that nobody can come into their union because they were there first? Do you mean that any young fellow who wants to get into the field should be denied that right?

ORNITZ: I don't mean that at all, but I don't think people should go around encouraging others to become freelancers. If a man really has to take pictures, that's fine. He'll do it. I don't like the fact that schools turn out photojournalists when there is practically no profession of photojournalism, when you can count the photo-journalists on your fingers.

CHAPNICK: It's not true that there is no profession of photojournalism. This isn't a dying industry; this is a dynamic profession. This is a profession in which there are new uses for the photograph all the time. There's a conferee here from a medical magazine which represents a new area of specialized publications which are coming into the field. Photographs are being used on record jackets, which is a new market for some of the most exciting photography that has been produced in the last couple of years. What about book jackets? What about industrial publications? What about annual reports? I could go on to list a dozen other outlets. This is all photojournalism. Sure, we have a restricting magazine editorial market, but it is a fraction of the big picture.

WERGELES: I know what Don Ornitz means: he wants to operate like the Department of Agriculture and pay the photographers *not* to make pictures.

CONFEREE: One of the real problems is to find who the really good photographers are. One of the reasons that I'm here is to find out just how good a photographer I am and just how far I can expect to go in the future.

BONDI: You want to know how good a photographer you are. Do you have any friends who are also photographers? I don't mean co-workers; I mean friends.

CONFEREE: Exactly what do you mean by friends?

BONDI: I mean other people whom you respect and who are also photographers, young men or women like yourself. I hope nobody here is offended, but I would like to throw out this whole panel and have the young photographers get together and

show each other their work. That way you would know just how good you are. In other words, criticize each other's work. That is your greatest need; don't look outside.

ORNITZ: Someone from *National Geographic* was kind enough to give me words. He said that we need more fixation and less development. That's what I was trying to get at. We need to know who the qualified photographers are, and there are many of them throughout the country. These people have got to be helped to earn a continuous income. We should not make this business so very, very glamorous and attractive, because for most of us it's a way of making a living. And to my mind we should be more down to earth about it.

WERGELES: Don, I just don't go along with you on that. I'm not for making photography glamorous; I've tried to chase several guys out, but that is not my job. I'm not a deity who can tell a guy that he has no business being a photographer. I'm not going to be a party in the suppression of the potentials of a young guy who has his rights in a democracy to go ahead. I'm not going to do it to protect you or anybody else.

Survival of the Fittest

CHAPNICK: This is a tough racket where you survive by your wits! Most people play it safe with few really original and exciting ideas being subsidized. That's an important point.

BONDI: I would like to contradict you. I think it's a tough business, and you're going to survive if you have something to survive for. If you really want to succeed photographically, just go ahead, and you can crack the top markets right away.

Today there are a few young photojournalists who definitely have something new, something very exciting and who are a definite contribution to all of photojournalism. But there is a danger, a greater danger than in the glamorous generation of Cartier-Bresson and Bob Capa. And, the danger is that these young photographers will be spoiled in no time at all, because they're going to make so much money they might easily give up and be lost. You know as well as I that today the markets in photojournalism are not only in the magazine field, but also in advertising. And perhaps the advertising people are more guilty than the magazine people of discovering a hot potato, making it work, and running it dry.

Now perhaps we could take this discussion away from the young photojournalists, because I think you keep on developing even after you've sold your work for two or three years. An equally difficult problem concerns the photographer who is established on a certain level. One day a terrible desperation overtakes him, and he thinks to himself, "I'm making a living; I've got a wife; I've got two children; where do I go from here?"

CHAPNICK: You're right. Every time a photographer comes to New York, he feels these tremendous frustrations. The fault not only lies with us, the picture agencies, or with the editors or with limited markets, but it also lies with the photographers. The photographer very often is not as creative as he thinks. He doesn't have the guts or, perhaps, the ability to go out and do something which will establish him as a top man

in the field. Certainly we have to address ourselves to the photographer who has been in the field, for his frustrations are tremendous. And it bothers me; I stay awake at night and we talk about it at home. My conscience bothers me. I can't do enough for these people.

BONDI: All right, I'm with you. I think we've made the point that at least some of the picture agencies feel the responsibility of developing photographers and of trying to help them along professionally — not just with money. I think the time has come to attack some of the magazine editors who are so terribly busy that they haven't got the time to talk to young photographers, nor even to look carefully at something new a photographer has developed. Editors get into the trap of having a problem to solve and being too busy either to think about other ways to solve it or to gamble on a photographer's new approach because he's got to play it safe. A great many developments in photojournalism are getting lost.

CONFEREE: Hi! My name is Thomas Abercrombie, *National Geographic Magazine.* I just wanted to throw in one thing. I get the feeling that you people are being just a little too polite up there. I know in these days of social democracies there is one nasty word that nobody mentions anymore, and that's the word *talent.* There have been several theories advanced which I think hold a lot of water. But, if a guy has got a combination of talent and guts, it doesn't matter if an editor will let him in or not; he'll walk in!

WHAT PHOTOGRAPHERS NEED
ARE STANDARDS

ARON MATHIEU, 1960

Mr. Mathieu founded *Writer's Yearbook, Modern Photography* and the *Farm Quarterly.* He has worked as writer, editor and publisher. Although he could have based in New York, he chose to remain in Cincinnati, home of his publishing firm. When he delivered these remarks in 1960 Wilson Hicks introduced him as "one of this land's wonderful men."

I feel like a guy with a violin solo following the Marx brothers. They made me anchor man here and clean-up hitter, and I don't know if I'm just another one of the comedians on the platform or if I'm supposed to leave something with you. But, I really cut my heart to see if I could tell you something worth keeping. And maybe if a dozen people can get something out of it, it's worth it all.

When a physicist wants to tell you something, even if he's an Indonesian or Chinese, it's so simple. He puts an equal sign in the middle, a few symbols on each side and other physicists know what he means. He can use a square root sign or a symbol that carries a number to infinity, and physicists all over the world know instantly what he means. A photographer sometimes has the same wonderful ability to speak so

clearly. Maybe he's lucky. He sees a gull flying and this prompts him to tie a red rag to the foot of another gull. The sea gull takes off into the air, and 75 other gulls fly after it. They will tear it to shreds and to pieces. The photographer grabs this as a symbol and everybody knows what it means. Those of us in the idea business can't talk in symbols. We have to erect an edifice. We have to take some mortar, make a rock and then another rock. On top of the rocks we build a bridge. We make our little edifice so it doesn't sink in the sand. And so, I've got to do all this rock laying, because I can't talk in symbols. I wish I could set a few symbols on the platform and then sit down. How nice to say $E=MC^2$ and go home.

An Horatio Alger Story

So that you can feel what I felt when I came into publishing, let me take you back. I had just left college, and I was walking down the street. There was a sign in a window. It said, "Boy Wanted." It was a printing plant. Well, I'd read Horatio Alger, and I knew what to do. I came in by the freight entrance. I got the sign. I went in the office door. And there was a portly guy, rimless glasses, bald head. And he was sitting there. I walked up to him and gave him this sign, "Boy Wanted," and I said, "Sir, I'm applying for this job."

Well, he had read Horatio Alger, too. He was my generation. He wasn't surprised. He didn't think this was effrontery or corn, even gilded corn. He just took it naturally. And he looked at me and he said (this is the God's truth coming out of me — this is exactly the way it happened), "Are you a college graduate?"

Well, this is the moment in your life, you know, the moment of truth. What to say? Actually, I had been kicked out of college because I was an editor of a paper and so forth, and this happened just six weeks before graduation. I answered, "No Sir. I'm not a college graduate."

And he said, "That's swell! These bastards around here think I don't talk right. They don't think I know anything. I'm going to make you editor-in-chief."

This is no joke. I didn't know whether to think this was unusual or whether this was the way it should happen. But, I decided that this was reality, and I had one foot in fantasy and one foot in fact. I think I've moved like that. So, although I became editor-in-chief that day, I still was the office boy, because this man had a short memory. I would run and get beer; I would get cigarettes, but the fellow who hired me loved me. When he died, he left my daughter her freshman college education paid in full. He never told me he had bought this. He gave to me his entire life. But he did one thing that was hurtful, and although I remember the thousand acts of love, I want to tell you how he hurt me. Because that is the only thing I have to say that will help you. I know I've got a mike. I know it's being transcribed. And this is one of the reasons that I'm here, because I'd like not to happen to you what happened to me.

Importance of Standards

My friend, my employer, my otherwise teacher, put me in a cage. It took me a long time to get out of it. He used to make a sign — it was the symbol that almost cut

me down. A dozen times a day he would flash it to me. And it meant, "It doesn't matter that much." And what he meant was, let's put three colors on the cover instead of four, make three-color plates. Let's use 50 pound paper instead of 60. Let's run 80 pages instead of 88. Let's do it for less. Take the money you save and print more copies. Now these were the days in the communication business when there wasn't a lot of competition, as we have today. And you could really make a lot of money and not be very smart. And I made a lot of money, and I wasn't very smart. But, I was boxed in by this man who told me, "It doesn't make that much difference." And let me tell you, *each detail matters!*

Now, I knew vaguely in my mind something was wrong with the way I was running my business. Nevertheless, in 1933 I was earning $90 a week. That was a lot of money. I was living well. We had two servants. We don't have two servants today. But somewhere I knew it was wrong.

Some of you know Marty Siegel, who was one of the two people who bought *Modern Photography* from me in '53. Marty was my roommate in college. He lived with us for a while in Cincinnati. When I hired Marty to come to work for us, he left school to join me. He also was just about to graduate. I was then publishing *Radio Dial*. When Marty came to work for me, I tried to think of a tough job to test his mettle. I want to describe this job to you because it indicates the falseness of my thinking, a method of thinking I had to learn to overcome. I was 10 years in overcoming it, and most of the low-down crap that reasonably educated and intelligent people publish today comes as a result of their not overcoming this kind of thinking.

There were two major errors in my thinking. First, there was a general idea in publishing that the public doesn't know the difference between quality and so-so performance. Nothing I was taught at journalism school attempted to separate the characteristics that differentiate quality from lower-level production. No really competent human being ever explained to us what makes a great layout desirable or revealed the differences among a junky layout, a good one and a great one. It was easy, then, to believe that the trick was simply to make it cheaper and in that way make more money. The other wrong value in my apprenticeship was the idea that if you sell a bill of goods, you're pretty damn good. There was no investigation of what happens to your reservoir of good will if you sell the bill of goods, but the product is imperfect.

Back now to my story about Marty. Across the river from Cincinnati is a cluster of Kentucky cities. Does it matter what their names are? We didn't have many subscribers to *Radio Dial* in those cities, though a few people in Cincinnati did buy the magazine on the stands and take their copies home across the river. I said to Marty, "You sell advertising in *Radio Dial* in Kentucky and that will prove you are a salesman." He did. God only knows what he told the advertisers. Now this is not the way you run a business. But, no one told me that. I felt all the way through that I was wrong. I had a feeling of dissatisfaction, but I didn't know what or whom to take it out on.

A New Magazine Widens the Riddle

I was already running the publishing plant, a snot nose of 24- or 25-years old; I was the boss — just like that. There were many people working there. And I knew how

to cheapen and print more. We were making a lot of money. But in my heart, I felt it was wrong, and I was groping, groping, trying to find where I was wrong. So, one day, I created a magazine that didn't exist out of thin air. It was called *Cannibal Digest*. I picked up the telephone — I am usually a courteous person on the phone; I try to be — and called the P.B.X. girl, the girl who runs the switchboard. I said, "Virginia, these long distance calls from *Cannibal Digest* are not coming through." Then I yelled, "Damn it, why not?"

She said, "Well, Mr. Mathieu, I am ringing the phone; I'm ringing the phone."

I then put a call through to the foreman of the printing plant. I said, "Jordan, for two days I have been waiting for corrected proofs on *Cannibal Digest;* will you get the lead out?"

He said, "Aron, a boy is proofing it now; a boy is proofing it now."

I called the press room and said, "Harry, this is Aron."

He said, "Hi, Aron."

"What do you mean, 'Hi, Aron?' Where are my press proofs on *Cannibal Digest?*"

He said, "The paper is on the freight elevator. I can't print until I get the paper. The paper is on the freight elevator." Incidentally, my employer, the owner, would never let me use the elevators in the building. I ran up and down the stairs; I wasn't allowed to walk. I came to work at 7 a.m. — I would have come earlier, but the doors weren't open. After work, I would come back, because I loved it. No one told me not to. I worked nights; I worked Saturdays; I worked Sundays; I took no vacations. Every time I moved around, my boss would say go to Europe, have fun. I didn't want to. I had all I wanted: my love for publishing.

Anyway, to conclude my story of *Cannibal Digest,* I next arranged to have a telegram sent to me the following morning. I ran down to the second floor where the owner was sitting at his desk, staring into space. And I waved this telegram and said, "Guess what!"

He answered, "What?"

I said, "Here's a double-truck in color for *Cannibal Digest.*"

He concluded, "That's not enough."

Now in exposing the fact that in a big shop everybody has a private alibi and that they don't think, I thought I had done something. I thought I had broken out of the thing that had been done to me. But, it wasn't that easy. In time, the owner passed away. His children, who were my closest personal friends and with whom I had gone to school and grown up and whom I loved, took over. And they said, "Aron, you run the publishing business, and we'll run the printing business." And all the years I worked for them, they gave me only love and affection. And you could just cry when you say something like that.

Craft Standards Came First

I began to move out into the world of publishers, and I began to learn what I thought were standards. I began to realize that making it cheaper and thinner was a cruddy way to run your business or your life. But, I also found out that to manufacture or create with quality was one hell of a tougher, harder and infinitely more difficult job

than to produce cheaper on lower standards. Bit by bit I met people who instilled the values of quality into me. Why didn't I get this at school?

I met Agha — you know, the Turk who for some 17 or 18 years was art director of Condé Nast. Agha taught me certain things. For example, imagine a double-truck. On one side is a full-bleed, four-color picture. Agha taught me that you can't fight color with color. *National Geographic* hasn't heard that yet. But, if you are going to publish a right hand page in full color, then, unless you are trapped by production, which sometimes happens, throw the left hand page away with a black and white picture and allow more white space in the gutter. A simple thing! But, no one had ever told me that. Agha spent a lot of time with me. This was one little fragment he taught me. To people here, this is kindergarten stuff.

Wilson Hicks, who was and is a guy I care for, offered a gift. He said, "If you got a 'must' picture and the darn picture is no good and you've got to use it, there is only one thing to do with it: blow it to a page. Give it the dignity of a page, and you can get by with it. If it is a bum picture, you can't use it small. A fine picture you can always reduce. But a bum one, if you have to use it, blow it or throw it!" But this, too, is a little detail. You folks know Alexey Brodovich, the art director of *Harper's Bazaar*. I showed him one day a copy of *Modern Photography* with some photographs of Man Ray in it which Nancy Newhall had obtained for me. That absolutely illiterate art director of mine had taken the pictures of Man Ray and had lines going out, curlicues with ornate borders, etc., and Brody said, "Aron, when you have pictures of a wild man, you want a simple lay-out. When the picture's plain, you can fuss it up." This, of course, you know. There are 500 things like this. Now I thought that these were standards. I thought I was finally getting what was missing. Now I knew 30 of them. I could get 30 more and 30 more and 30 more. I will know it all! But, alas, these were not standards. These were the "F" stops, the filters, the lenses, the paper. These were not standards; these were vocational tricks. I am here to talk to you about standards, and how I was misled and very slowly came into an understanding of standards in publishing.

The Ultimate Standards

What then are the ultimate standards which we seek? Surprisingly enough, the ultimate standards which matter for the individual are his acquiring a personal cultural background in depth. This is what no one told me. I came out of college with no education; none. I had worked my way through college, had been married at school and had the best damn time anyone ever had. It was just a great ride, but I didn't get an education. Now, how does the task of assembling and enjoying a glorious cultural education get you in? Let us discuss two photographs, both of which you all know. Here is this fellow sitting in a chair. He's got these big glaring eyes — they look like the headlights on a locomotive train. I have seen this picture a thousand times. The man is wearing this coat with a gold chain across it, and his hand is on the chair arm. The guy who took the picture rigged the highlight on the arm. It looked like Morgan was just running a dagger into you — you God damn so-and-so piece of jerk public, to hell with you! Now this is a great picture. Morgan offered Steichen $5,000 for the negative

and 6,000 other things. But, the picture was never bottled up. What made this picture a great picture? Just think about that. Steichen laid Morgan out, like nobody was ever laid out. He gave it to him.

Now let me give you a second picture. It is the one Arthur Rothstein did. Franklin Roosevelt had said that one-third of the nation is ill-clothed, ill-housed and ill-fed. And, as Roy Stryker tells it, FDR hired Stryker at FSA to prove this thing with photographs. Then Roosevelt could go to Congress, get the dough and pass the social laws that he wanted. This was the background which the photographers may or may not have been told. I don't know. One of the pictures that Arthur took was of the little shack and the farmer and his two kids leaning against the wind. Their home is covered with dust swirling around. And what the picture means is what Arthur meant it to mean: that lack of conservation is ruining the land. Other people felt it was an indictment which said we don't take care of our brothers. Roosevelt, FSA and the New Deal group used this and many other pictures to say we have to take care of our brothers and do something about it. Now, what has all this got to do with what I was saying, that without a cultural background, you are nobody?

Let's consider a hundred photographers with equal technique, equal energy and equal good fortune. Ninety-seven of them read *Reader's Digest,* the Book Of The Month Club and Literary Guild. Only about three of them have a cultural education in depth. Ninety-seven are the guys who work in newspapers and deserve everything that Bruce Downes said about them. But three come through big. Curiously, this is true not only in photography, but also in electrical engineering, carpentry, linoleum and glass making and in everything.

As a little example of this, my kid writes music. When he was 13 years old, he wrote a junior symphonic jazz piece and directed Stan Kenton's orchestra at Coney Island. After Bill had directed the orchestra and played his little symphony jazz, Kenton got together with us, and he said, "Aron, keep this kid out of Juilliard. Don't let this boy go to music school. Don't let him run away from home, lie about his age and get in my orchestra or somebody else's, either. Otherwise, when he is 20, if you let it go that way, he will have about three divorces, will take marijuana and dope and will have syphilis. His blood will be thin and he'll come to me for a job. I will taste his blood and spit it out, because it has no salt! Send this kid to Harvard or to the University of Chicago, but keep him away from Ohio State, the University of Indiana and that kind of stuff. Give him the finest cultural education that you can give him, and there is a chance for him. More carpenters we don't need."

My boy did what Kenton asked of him. Bill is now 21 or 22 and has been writing for Kenton. When Kenton disbanded his orchestra, Bill went back to Chicago and met Duke Ellington. Duke asked him to come to Pittsburgh and do some work for the band. Bill spoke to his mother about it and said, "Mom, Duke is an educated man." And Rosella said, "What did you expect?"

Obtaining a Personal, Cultural Background

Now, here are the three things which a photographer needs to know — also an electrical engineer — just three things. First, there are the basic cultural ideas that

moved the world forward. The basic ideas in the arts and sciences. There is no substitute for knowing them. You have to know them. It's just as if you're a photographer and you never heard of *Camera Work*. You are magnolia. Ain't it the truth, Bruce and Beau?[1]

Next, in addition to knowing the basic ideas which changed man, you have to know when certain of these ideas became trite. Who wrote "American in Paris?" By 1940 many of the musical phrases from "American in Paris" were trite, because they had been repeated and repeated and repeated. You not only have to know the basic ideas, but you have to know either when they became trite or when and why they were rejected. Consider for a moment what Aristotle did to us. What did *he* ever say? He said, "What is is, and what was was," and for 1,500 years he held education back as if it were encased in steel and everything else; it couldn't move. Any idea of evolution was stopped by Aristotle. You not only have to know the good things he did, but also how he straight-jacketed science up to Bacon. He straight-jacketed it. Yet, you must read Aristotle. You have to know how long he was accepted, when he was rejected and why. Aristotle's ideas are among the 20 or 30 you need to know in depth. You know this is very hard, but this is not for school boys. I am not talking to people who want to earn nickels and dimes and be somebody's assistant. I am talking about the guy who wants to go to the top, stay there and run it.

Third, you have to take a position which is original, personal and your very own on each of these ideas. This third point is the difference that matters, for the other two are just knowledge. Let me say it again. *You have to take a personal position on each of these ideas which is unique and your very own.* Just let me give you one single example. Let's take Thorstein B. Veblen. As you know, one of his points is conspicuous consumption. Let's consider this example on the screen. This girl is getting into a car and wearing a mink stole, an Emba mink sole. Veblen says this is conspicuous consumption. She could have worn a cashmere sweater; she could have worn denim pants or something. Now, what is the attitude *you* have toward this?

First, you have got to know Veblen. You don't know Veblen? Then you don't belong in a situation where people are going to be the intellectual boss of anything that matters. Second, you need to know the point in life at which he rose and the point, which is relatively recent, at which he changed and was rejected or accepted. Then you have to have your own attitude toward Veblen. What would be an example? You could say, "Conspicuous consumption is good for business; you have to buy the stoles to keep the needle workers in business, fund the advertising and everything else." Or you could say, "Boy, I wish I were that girl to have a mink stole like that." That's an emotional reaction. Finally, you might say, "Parasite." You could have any kind of reaction — brighter than mine, I hope. But, if you don't have a reaction and just know Veblen, then, in this instance, you aren't worth a damn.

So "A" is a cultural background in depth, "B" is your personal attitude toward life, and, of course, this includes the technique to express that attitude with your camera, a skill which is assumed. You get no credit for technique. In this business it is assumed!

[1] Bruce Downes, then editor of *Popular Photography*, and Beaumont Newhall, then director, George Eastman House, Rochester, New York.

I am only speaking now of the people on the top, not the guy who wants to run a ten-cent job in Wichita and be paid only for technique.

Guided Entry into Eight Books

How does one get this cultural education? I'm going to give you a few things to read. First you want to read a book entitled *The Sleep Walkers* by Arthur Koestler. He also wrote *Arrival and Departure* and *Darkness at Noon*. He's a good writer. *The Sleep Walkers* gives four or five basic ideas that have changed man — all in one book! This is a miracle! You can't read it in 10 minutes — or 10 days — it takes a long time. It's sweat and work, which is why most people have no education. They don't give a damn about it; they haven't the energy and they'd rather play something like golf, tennis, pingpong or go to bed.

One of the things that you see in Koestler's book is the basic idea of Pythagoras. Pythagoras, you know, invented the idea that the pitch of a note, all other things being equal, depends only upon the length of the string. And he discovered the business about a right angle triangle: that the sum of the squares of the ideas equals the square of the hypotenuse. From this he developed a bigger idea. He said, "Everything in the world responds to a number." Some years later Jesus Christ said, "Everything in the world responds to love." Still later Einstein said, "Everything in the world responds to 'E equals MC^2.' " Pythagoras didn't regard a number as a neutral thing but as a revelation of the cosmic order. Though he was worshipped, adulated and had disciples, he was a rebel, always a rebel. He opposed the Greek establishment. So what did his enemies do? They took a rectangle and drew a diagonal, thus dividing the rectangle into two right angle triangles. Then they applied Pythagoras' formula. When they squared the two sides, added the sums and then squared the hypotenuse, they found that the two sides of Pythagoras' equation did not come out precisely equal. But, if you divide 30 into one hundred and it comes out 3.333, you have an endless number. So his enemies said, "This guy Pythagoras is a fraud! The world doesn't respond to a number or the Pythagoras formula could be translated into numbers that would be precisely equal." You only have to make one hole in the bucket and all the water comes out.

Pythagoras tried to answer his enemies by going back to Plato and saying his formula was right, that it was only reality which was imperfect. But they nailed him — not so much because of the discovery of irrational numbers, but because he opposed the Greek establishment, and his enemies disapproved of his life style and his morals.

The world is responsive to numbers that reveal the whole world structure. Today, we are still trying to work out a formula where the world does in fact respond to a number or a formula such as "E equals MC^2." In *The Sleep Walkers*, Koestler takes five or six ideas that changed our world and gives them to you.

The second book I recommend is *The Golden Bough* by Sir James Frazer. It is a history of religion. I love the Frazer book, and if you just read the first hundred pages and the last hundred pages, you'll get it. You don't have to read the middle. This man wrote a 17-volume history of religion which had its start in his searching for greater understanding of a legend he once heard. The legend goes that there was a high priest who was handed the virgins of the tribe, the fruits, the game and the wild

nuts, the sweet grasses — every prize in his community. He was also given a sword, and he walked around a tree, day and night, carrying that sword. He was succeeded by whoever slew him. And, it was this legend which Frazer decided to investigate. Fortunately there is a one-volume edition, which is what you want to get. And remember, it is not just knowing this book; you have to take a position or get out of the boat.

Third is *In Search of Adam* by Herbert Went. It is an easy entry into anthropology and you can go from there.

The fourth is *The Rebel* by Albert Camus. This is no easy thing to do; it is bitter, mean, lousy, stinking work.

Fifth is a novel, *Ulysses,* by James Joyce. Maybe Joyce isn't a great novelist — we are too close to him — but certainly he is a catalyst. Either way, you have to read it. You put a catalyst in something and the catalyst doesn't change, but everything else does. So, you have to be exposed to this catalyst, and if you are not, you just don't exist in this world of communication.

Sixth is *Basic Writings of Sigmund Freud.*

The seventh and eighth are together, and that is the end. The seventh is a little book called *Saints and Sinners,* and it tells about the people who came over on the Mayflower and who they were. Some of them were indentured servants. Yes, they were indentured servants, but when they got off the Mayflower everybody was given a gun because there were Indians around. The indentured servants held that if they could shoot a gun, they could also buy needles and pins and toys and stuff. And, they were also going to sit — you know where — at the lunch counter or whatever they did in those days. So they said, "You give us the gun, and we'll fight, but no more indentured servants in America!" And that's how indentured servants gave the slip to their debtors in America. You have got to know about it. You just have to get into the original.

The last work is the Declaration of Independence, which you should read after the other seven, phrase for phrase. And think about it! Take a couple of months to read it. Takes time. You can't get a cultural education in a year.

Now this is no package I have given you, it's a labyrinth! Each one leads to more exploration, and the end result is that when this culturally educated great photographer walks down the street, he is a great man.

8

Photographic Markets, Freelancing, and The Picture Agent

The life and work of a freelance differs remarkably from that of the staff photographer. There are those times of glory when he makes it "big," and others when he feels alone, without associates or assurances of future assignments and income. In return, he works with unique freedoms: to accept only those assignments he prefers (or is willing to do), for whatever the reasons; to pursue those themes and stories of interest and of personal importance to him; and to say what he wants to say through the photographic medium. David Douglas Duncan has remarked that there are but three prerequisites for the freelance photojournalist: "Know your camera; know your subject; know your market!"

Already in preceding chapters photographers and editors have revealed, explained and discussed their philosophy and viewpoints on the photographer and his medium. This chapter is devoted to the third in Duncan's trio: the marketing of the photographic image. Leading this examination of markets is a discussion with former art directors of *Look* and *Life* as well as the editor and teacher, Wilson Hicks. Identification of the impact and importance of a photographer's personal bargaining in the sale of his material sets off a variety of responses and case studies, for as a kind of river-boat gambler, the freelancer may win or lose in this marketing process.

How one magazine — *Life* — expects freelancers to package and dispatch materials to its contributions editor, Ruth Lester, in New York City has general as well as specific values.

In an examination of the photographic agent and the services he can provide a photographer, two "senior" picture agents, Franz Furst of Pix and Henrietta Brackman of Brackman Associates, describe the functions of various kinds of agents, define typical professional arrangements generally included in agreements between photographer and agent, and discuss agents' professional fees and aids. The agents agree that one of the

freelance photographer's most important decisions is *which* agent should represent him, if he determines to utilize an agent's services.

A former editor at Magnum and currently picture editor of the *New York Times,* John Morris, concludes this chapter with a profile of the personal qualities which make up the freelancer. If there can be a single word to sum up the freelance, Morris would probably choose *courage,* as evidenced in his interesting anecdotes about great photographers and their courageous contributions to the printed pages of picture magazines and books.

FREELANCING

PANEL, 1967 (Excerpts)

David Douglas Duncan moderates this impromptu discussion with Allen F. Hurlburt, director of design, Cowles Communications; Bernard Quint, then art director, *Life;* and Wilson Hicks, Conference co-director and staff, University of Miami.

DUNCAN: I've been sitting back not really heckling, but trying to add whatever I can to the Conference, and I think I have something slightly special in that I am one of the veterans who has been in this business in several different ways: as a newspaper photographer, selling to the roto pages, and as a magazine photographer. I've been asking myself a question: What's it all about, this Conference? It's very simple. First, it's expressing oneself with a camera or covering a situation. And that covers that.

The second thing is to know your *métier;* know your business. And that means the subject. You search; you shoot.

Third, know your market.

Now, I want to tell just two stories. When I was a kid, sailing out of Key West on a 100-foot schooner (no auxiliary in those days) on a trip around the Carribbean catching giant turtle, we ended up on a place called the Swan Islands off the coast of Honduras, and I caught a couple of iguanas. I brought them back to St. Louis and presented them to the city zoo. Then I hotfooted downtown with pictures of the iguanas I had taken on Swan Island and sold the *Post-Dispatch* pictures of the zoo's latest acquisitions, color and black and white. I covered my bets at $25 apiece in color, which was enormous at that time, and $10 in black and white, which was the top price I could find in Sunday magazine roto.

I'll move the clock up a bit. While working on the book, *Yankee Nomad,* I took one break in '63 and shot Paris through prisms. I sold the pictures to Herbie Mayes for $50,000 which paid all the bills for the two preceding years and the bills until now. I haven't sold a picture since '63. The story that isn't known is that Mayes projected these things in his room with his art director, Otto Storch, and his managing editor, and made a selection, 18 transparencies. And when he finished I said, "You understand it's a one-shot deal?"

"Yes."

"Five weeks protection?"

"Yes, it's okay."

"From date of publication!"

"Yes."

"And I have total right to all the rest of the film?"

"Yes."

"Is that all the pictures you want?"

"Yes."

Out the door I went, up to the *Saturday Evening Post* and sold the discards for $25,000 more, in one day. Now, the story that isn't known is that when I totaled my bank account that night, it totaled $75,083.00. That was it.

Now, about markets, how do you sell this stuff? I know some of the approaches, and I know some of the answers; I know many ways I've struck out. So I would like very much to have some questions answered by Bernie Quint of *Life,* Allen Hurlburt of *Look* and Wilson Hicks. What kind of prints do they want? What kind of transparencies do they want? What do they consider an ideal package — whether it's for the St. Louis *Post-Dispatch, Look* magazine, or *Life* magazine?

Allen, it's no secret by this time that most of the major magazines in the United States are planning something to commemorate the 50th anniversary of the Russian Revolution. Is there any chance that a freelancer might still submit a story to you on some aspect of Russia at this time that would find space in your magazine?

Fresh Ideas Always Welcome

HURLBURT: I like to hope that the door is always open to good ideas and to good photography. I think there's some risk, though, in trying to say what I expect, or what I want to see, or what I want to hear. I think the thing that pleases me most is encountering what I don't expect — for example, the young man who turns up with an approach to photography, or an approach to ideas with something that disturbs me and follows no pattern I could have predicted before he entered that door. I remember Dan Mich once said the thing about editors is that they know what they want, but they don't know what it is. And I think this applies to all of us who sit, trying to turn a new corner with each issue of the magazine, and trying at least to keep up with the times in which we're involved, if not to anticipate them. So, I do tend in my role to look first for photographers, and second for stories and ideas. I like to keep watching the new young photographers and hope that new things will happen to me and to us.

DUNCAN: Will they have access to you, Allen?

HURLBURT: Not always direct access, but if they manage to see the managing editor or specifically the picture editor, and if his screening is good, the chances are extremely good that I will see them. In the course of a year I do see perhaps 30 or 40 photographers and spend time with them. These vary from established pros, who have not done much magazine work, to men new to magazines, some of whom are still in school and some beyond. But there's a lot of luck involved in who gets in and who doesn't because the time is such that I cannot see everyone. I set aside a half-day a week to see not only

photographers, but illustrators as well, and I can't cover a lot of ground with that much time, but I can't give any more time to it.

DUNCAN: What are your page rates?

HURLBURT: Page rate for a color page is $450.00, and $350.00 for black and white, I think. I don't know because I rarely negotiate the prices. I am kept out of it because I have this nutty belief that the prices should be higher, and that the black and white picture is as valuable as the color picture, and several things like that. And we sometimes get around the regulations on this score, too.

DUNCAN: What type of exclusivity do you demand?

HURLBURT: This is getting increasingly difficult because, like all expanding organizations, we get caught in a syndication problem. We like to get rights to that syndication, though we are now making arrangements with outside photographers that they will get 50% of any syndication revenue. But, I'm quite willing to work with a photographer who tells me that the material is going to be published somewhere overseas. I feel that if I can get it at *Look* long enough to get a layout into print, I've really got the major measure of the value.

DUNCAN: Would you consider it a violation of exclusivity if the pictures had been run in the St. Louis *Post-Dispatch* first?

HURLBURT: It's a worrisome point, but it can be overridden. It's sometimes a matter of concern depending to a degree on how I use the picture. A news picture that's being used in a special way is bound to have been used before somewhere, and this doesn't bother me. But, it would concern us if prior North American rights had been exercised in a take that was not part of a news story which had seen wide dissemination.

A Photographer Gambles — and Wins

DUNCAN: There's one point I want to interject right here. I hope it's obvious for a person in my role, and yours. You freelancers have to be like riverboat gamblers when you go to these guys. I remember so clearly that in '56 I came back from Russia, having photographed the Kremlin for *Collier's* which folded. So I sold the bulk of the art material to *Life,* and a five- or six-page spread to the *Post* on the politicians. And *Look* had bought John Gunther's text piece, "Inside Russia Today," and asked me if I had anything for the cover. Red Square — sure I had that. So I sold them that. And while sitting with Dan Mich he made a fatal error. He said, "You know, we have John's story, and we have no shot to prove he was there." As he was speaking to me I could see the shutter go down in the back of his eyes. He realised he'd played his trumps and lost, because I had the shot. It cost him a thousand dollars. And even worse, it was converted to black and white; it was dreadful. But it was a fair deal, and they have all laughed about it since.

HURLBURT: Probably the highest price per square inch we've ever paid.

DUNCAN: It was absolutely a dreadful transparency to start with; made with a wide angle late in the afternoon, you know, the Red Square, St. Basil's Cathedral, the whole thing. But anyway, I had the shot, and they had to have it. So you have to go in really loaded for these fellows, you know.

Bernie, at *Life* you have major stories every week. What can a competent photographer expect if he walks into *Life*? What kind of stories could he hope to sell you? The

format of the magazine changes constantly. It's a highly fluid publication, editorially and in total editorial content. How many stories would you assume a week come across your desk that are shot by outsiders?

QUINT: Well, let's divide this up into the way things happen. First of all, I allow a period from 9:30 to 10:00 any morning of the week to see anyone who wants to see me. And that period of time is usually filled up. You'd be surprised. Some people, young photographers, especially, don't want to come in by 9:30. Yet, it's the best time for me, because once the day gets going, it's rather difficult for me to just sit back and talk to someone unless it's for something that has to close, or something that must be planned and discussed well in advance. So, I set aside that time in the morning for anyone who wants to see me. And that includes illustrators as well as photographers. We publish every week, and therefore our staff tends to be somewhat specialized. We have a director of photography and an assistant, who do most of the interviewing of photographers.

Most of the photographers who ask to see me fall into two categories. One is the freelancer who hasn't been able to get anywhere with the director of photography, or a professional I've known for many years who, for one reason or another, has not had work appear in the magazine. Perhaps it will be a pro who wishes to appear in the magazine, knows I'm sympathetic, and hopes I can exercise some kind of influence for the good. I try to do that, but it is not completely in my hands. The other person who appeals to me is the young novice who reads the title "art director" and believes correctly that he ought to see me.

Thinking Photographers Needed

There is one frequent observation. It is the young photographer who comes with a set of pictures that are quite good — individual pictures which I think have excellent quality. If I were to compare just the quality of pictures I receive today with those received 20 years ago, there's the difference between night and day. The young photographers are so skilled and facile that in some cases they out-do the old timers. But what they lack that the good old timers have is the rarest commodity of all — the ability to think. And this, to me, is the crucial difference. I would agree with most of what Allen has said about what he likes to see in photographic material coming to him. But to be specific, I would say I don't care what technique is presented. I want to know why it's presented and what the person thinks will be done with it in the magazine. I want to know what he wants. The rarest thing to find in any young photographer who comes in is his idea of how he thinks the magazine ought to use it. He thinks that he just ought to present it and we can put it on a page. The magazine is not simply a portfolio of pictures. Every magazine has space limitations. And there are different purposes for different kinds of stories.

HICKS: I'd like to make two points. I think that what you're getting at is a discussion of the eternal question, "How can the photographer make a lot of money?"

An Editor Gambles — and Wins

I'm going to be just briefly reminiscent. When I was picture editor of *Life,* late the afternoon of Christmas Eve before World War II, three men came in to see me in long dark coats and black slouch hats. They looked like cloak-and-dagger men. They said, "We

have blow-ups from the frames of the only pictures (and this was a motion picture) of the bombing of a U.S. gunboat in China during the Sino-Japanese War.

And I said, "Well, fine. Let me see them." So I looked at them and I said, "How much do you want for these pictures?" This was 4 p.m.

They said, "$25,000."

At 9:35, I got them for $2,500. So whereas your negotiator might give a lot of money, it might not always be like Herb Mayes, who said, "Okay, Dave, $50,000."

DUNCAN: There are gamblers on both sides of the table. See what I'm telling you?

HICKS: My other point is this: Whom do you see? I can understand why Allen can't see people all the time. But he does see photographers and artists. He saw Norman Rockwell long enough to assign him to go to some foreign countries to do drawings in a completely different style from anything he had ever done. And he got a wonderful feature for *Look*. Bernie Quint sees them at *Life*. I had a way as picture editor of *Life* and prior to that as executive editor of the Associated Press of seeing people.

One day, when I was with the AP, in the very early '30's, my secretary said, "Mr. Hicks, there's a young man named Alfred Caplin who has just called and wants to see you."

And I said, "Well, okay, I'll see him." My office door was open and I could see a man clomping along. I surmised that he had a wooden leg.

He came in, and said, "I'm Alfred Caplin from Boston; I want to show you some drawings."

AP had a sizeable comic service at that time. I said, "Al, you go back to Boston and draw comics for another year. Develop characters, and then come back." He came back, and of course, Alfred Caplin was Al Capp. I hired him on the AP and started him on his way. So you *have* to see people.

CONFEREE: I want to know from each of the three editors whether you consider it a responsibility of your publication to help your reader adjust to these changing times? And if so, what percentage of your space do you attempt to dedicate to this in addition to regular educational and cultural pictures?

HICKS: Don't you think that the reader gets a sense of the changing times by reading the magazine from issue to issue?

HURLBURT: I think it involves almost everything we do in one way or another — our layouts and the kind of pictures we run today that we may not even have considered running 10 or 15 years ago. *Look* did a whole issue this year on man in which we were very concerned with some of the developing aspects of our time. And I think this has to define itself at all levels as a part of our work; otherwise, we're really editing the magazine for the past rather than the present.

QUINT: I'd like to talk about the future. It requires an explanation. I'm of the opinion that in our society we are on the verge of some rather drastic changes. People who are involved in the field of technology, in the natural and social sciences, are so deeply involved that they see change in small sections. But changes are becoming integrated into the body of knowledge and are affecting government, corporations, and our entire way of life. I think a guaranteed annual wage would have more to do with the development of photojournalism than any single factor in our culture. The recognition of the need for social

planning will have more to do with the development of photographers than anything we say here today.

It's a very simple thing, the idea that one can have democracy. But you must have the affluence to practice it. This is obvious in the world today. You don't have mass media unless you have technology. You don't have mass media unless you have the means to support them.

This culture, which has so many positive and negative factors in it and so many changes going on at one time, is in the process of an almost unspoken revolution. I think that the potential in the future is so enormous, but it is hidden by the turmoil and tension of the present. The questions of what people will do with their time, how to express themselves, whether or not they want to, are questions of meaning which are evident in magazine content today.

DUNCAN: Wilson, how many candidates come to your door whom you think can become qualified photojournalists — ones you'd like to channel toward New York or San Francisco or wherever for a lifetime with a camera?

HICKS: Well, I'll tell you, very few. Let me answer the question with reference to students.

Talent, a Rare Element

Every now and then you find a student with talent. And through the 12 years I've taught, I have found only about five with talent in the hundreds of students I've had in my classes. I hope that answers your question in part. Now, there have been many journeymen, a lot of guys that'll go out to make a living with a camera, but I'm talking about photographers with a make-up, with a biology — whatever it is — that prepares them to face this strange and wonderful world that Bernie describes, and do something about it in a really effective, creative way. Very few. Now that's not discouraging, because if I can send out five talented young men in 12 years it will almost guarantee the future.

DUNCAN: I just wonder whether the germ which grows into real talent isn't somehow present many times, and we simply miss it.

HICKS: Well, maybe so. Maybe I have muffed it, misjudged. Maybe somebody whom I thought didn't have it will turn out to be the best of all my students.

DUNCAN: I wonder, how does one find this special something? What are the special qualities one must have to attract your eye? I know it's an enormous question.

HICKS: I don't want to go on too far with this but I'll just mention one word: *imagination*. Will you settle for that?

DUNCAN: Damn right! And *application*.

HICKS: I think that is true. Diligence and all those things, yes. But, I'm talking about this great, intangible, wonderful thing, *imagination*.

CONFEREE: For a man just trying to break in with a small picture story, what type of photography interests a picture editor? And do you suggest when a story is submitted that it all be in color, or part color and part black and white? Mechanically how should we handle it?

QUINT: When freelancers ask me that, I say if I knew what I wanted I would assign a staffer and you would never get a crack at it.

CONFEREE: But do you want something now, something deep, something about the future? Are you looking for dogs and children? Exactly what are you looking for?

QUINT: I think your question is in inverted order. It seems to me that the first prerequisite is that you have an idea of what you want to say and how pictures should say it. When you know what you want to say you come to the editor. It's a mistake to think that there's some formula. If either Allen or myself saw a set of pictures that had a unique idea in them, something extraordinary that we thought would be of significance to the magazine, we'd naturally be interested. But you can't say specifically.

CONFEREE: I notice a single story in a magazine may be shown in both color and black and white. If I'm going to work on a picture story, and if I want to cover it for sale to the widest market, should I shoot it both ways or one way? Can I shoot it in color and if anyone wants it printed in black and white let them work from transparencies? I've never sold a story to a magazine. How should I insure myself of getting the widest market possibility for the merchandise that I have to sell?

QUINT: I'd start with either one and let the picture sell itself; don't worry about whether it's color or black and white. It doesn't matter at all.

CONFEREE: Do you recommend selling stories to the magazine directly or would you recommend sending stories to photographic stock houses and letting them do the selling for you?

HURLBURT: Well the chances of your placing by personal direct sale an individual single picture that may or may not have appropriateness to a given magazine are not very good. A picture story, a complete visual idea that can be published as it is, could go directly to the magazine. But if you're talking about the scenic, or the picture that could be fitted to text, or a picture of a highly general nature, I think you're better off in the stock files.

DUNCAN: I want to close with a story about a picture story I heard about in the last 24 hours. The daughter of our welcoming speaker told me the story which I think is just great. She sailed the Mediterranean, the Red Sea, around Africa, on a three master. The skipper was a real Captain Bly, you know? And she photographed the whole trip. Off Fernando Poo on the west coast of central Africa the ship sank and this young lady covered the whole thing in color. What a kicker for an ending, you know? Now there must be a market for that story. Any other story on the same topic would show them coming back to the dock and jumping into a Volkswagon or Rolls Royce to go home. Now, Linda, you've got the guys captured up here.

HICKS: Dave, I saw the pictures this noon and they're extraordinarily good, all of them.

DUNCAN: There's a real editor there. Okay.

PHILIPPE HALSMAN: How did she sink the ship?

DUNCAN: Bravo!

THE STRANGE AND WONDERFUL THINGS I GET

RUTH LESTER, 1965

Miss Lester has been associated with *Life* magazine — and particularly its contributions department — since its founding. Photographer Bruce Davidson writes that she is respected by photographers for "serving as a touchstone, someone who takes the time to look at our work, making suggestions that encourage us to look further and deeper into the world, and further and deeper into ourselves, as we grow into the world. This is the contribution that the contributions department makes to young photographers." Wilson Hicks said of Ruth Lester as he introduced her at the Miami Conference, "There is nobody in this country today who knows pictures any better than Ruth Lester does."

Each week over 1,500 photographs come unsolicited to *Life* over the transom, through our bureaus and from our stringers throughout the world. I am here to discuss with you the functions and purpose of a department in our New York editorial office which handles all that mail: *Life's* contributions department.

Roughly 1,000 photographs each week come through the mail, and the rest are brought in by photographers, public relations people and readers of *Life* — from snapshooters to amateur and professional photographers. There are spot news pictures, picture stories, entertaining miscellany page candidates and a goodly number of obvious rejections.

Whatever is suitable for our editorial needs is personally shown or channeled to a particular department editor or to one of the department reporters. News pictures, of course, get immediate attention from the instant of exposure to publication, because *Life* is basically news oriented. While there are pages closing each day of the week — black and white or color — the normal deadline for the entire magazine is on Wednesday.

For example, a New York freelancer took several quick shots of Jackie Kennedy at an opera opening in New York, then came promptly to the office with his pictures. One of his photographs closed for a fast-color page to go with our own news roundup of black and white pictures.

An amateur stationed in Vietnam photographed a bombing in Saigon. The unprocessed film was immediately airmailed to *Life* and reached New York in time to close as a color page in a spread which was on the newsstands the following Monday.

A cover story on a California flood included many "pickup" pictures which were used along with the assigned coverage by *Life's* photographers and reporters who had been rushed into the area. Pickup pictures are either contributed, or in certain cases, located by us.

To be Timely is a Must

Incidentally, when you have important news pictures, it is advisable to promptly telephone either the New York office or one of our nearest regional bureaus. Tell us what you have. We'll instruct you on the fastest way to get the work to us. Our regional bureaus are located in Los Angeles, Chicago, Washington, D.C. and Miami and are listed on the masthead page in each issue of *Life*.

Careful study of the magazine is highly recommended, instructive, and very important to the photographer who wants to submit pictures, because it answers the questions so often put to me about the kind of photographs *Life* wants.

Pictures are used both because they are newsworthy and because they are good. Some are also excellent images; some are perceptive. But, we must get them when they are timely. It's very important. The editors presently prefer to run an important news story as a spread in-depth rather than as a single picture. News events don't often make beautiful pictures, but sometimes with an appropriate subject color will add greatly to the esthetic quality.

The photographer's story should be presented in a meaningful way. He should submit contacts, a selection of blow-ups, a covering letter and captions. Incidentally, it's maddening for us to get pictures without essential information — for example, news pictures with no date! When the photographer takes pictures for possible publication, he is not only functioning as a photographer, but as a photographer-reporter, a photojournalist. He should not forget the reporter's fundamental credo: who, what, when, where, why and how.

I've been asked by our nature editor to tell you that cute pet stories, for the most part, are out; of course there is always the exception. As an example of what is desired, the nature editor would not want to miss a look at a great set of pictures of the wildlife of some hitherto unexplored area.

And, while the sports department staff covers big events and essays, the freelancer at any sports event may be in the right place at the right moment with camera focused to make the photograph we would like to consider.

Our science department is receptive to really good science or medical shorts, because stories and photographs with potential interest are happening everywhere. Yet, very few good science shorts are contributed. Because there are staff stories "in the bank," the science department is not encouraging about submitting a big essay on speculation. Again, there could be an exception. One was the extraordinary and beautiful color essay on the development of human embryos photographed by the Swedish freelance, Lennart Nilsson. The essay appears in the April 30, 1965 issue. Nilsson worked on the project in Stockholm for seven years with the cooperation of doctors and of the hospitals in which he made the photographs.

Finally, pictures submitted on speculation compete with the work of some of the best photographers around, including *Life's* staff and the most extensive world picture roundup of any publication. But, we do welcome and use your contributions. The contributions department is an open door to photographers and their work.

I AM THE PHOTOGRAPHERS' AGENT

FRANZ FURST, 1959

Mr. Furst was associated with the agency Pix in New York for many years. He had emigrated to the United States from Europe, as so many of our great photojournalists and picture editors did in the mid to late 1930's. He continues to base in New York City.

After the intensive discussions of the last few days about the art of photography, self-expression, esthetics and the philosophy of photojournalism, it is my assignment and responsibility to shift your attention to another aspect of this profession: photocommunication as a business.

Any successful photojournalist recognizes and considers his work a business, and he organizes and operates it in a businesslike manner, which means being efficient. As a businessman one of his aims is to earn a profit.

In our professional discussions of the need for high standards in photography we sometimes lose sight of the fact that the market to which photojournalists appeal is a mass-circulation market. While highly artistic, self-expressive photographs form a significant part of the contribution of photojournalism to mass communication, there is also a very great need for photographers who can do an "average" assignment when that job must be done. The mass-circulation magazines with one to 12 million subscribers need photographs which can be understood by their subscribers plus the pass-along readership — usually a multiplier of four. That means a potential total of four to 48 million readers. These are American people of all geographic regions and urban areas, not only New York, Chicago and Los Angeles, but also back into the sticks and country itself. When one includes the Sunday supplements there is such a tremendous variety of markets that it is difficult for the professional photojournalist to find the market places where he can sell his pictures.

We have heard certain gloom about the shrinking markets, which I think is completely unnecessary. I believe that in the last 10 years the market has expanded tremendously. I further believe that the market will expand much more. There are not only dying magazines, such as *Collier's*. Certainly that was a terrific shock to the professional photojournalist. But, that did not happen because the photographic market was bad; there were other factors which had nothing to do with the progress of photojournalism and photography.

Changing Markets

As a matter of fact there are more new magazines this year than there were one, five, 10 or 20 years ago. I came into this business more than 20 years ago when it was very hard to get any assignment from any magazine. We have come a long way from the time

when big magazines used stock photographs to illustrate a story or when a picture sold for $10 and was used by a major magazine to illustrate an important story. The market has expanded and continues. A new illustrated medical magazine has just been founded. There are new magazines like *Horizon, American Heritage,* and I could name quite a few more. In other words, the photographer, professional or amateur, young or old, must look all the time for these new markets.

There is another great difficulty for the photojournalist in finding new markets. It is the continual and frequent change of editors or of editorial policies of magazines, either of which makes it hard for a photographer to analyze properly a potential market to determine the type of editorial product desired. With each change of an editor, there is usually a certain change in the type of photography and stories which are wanted.

But, we are not restricted to editorial material for only the big magazines in photojournalism. In the last years the advertising field has opened a great deal to the photojournalist. Insurance companies have produced wonderful ads utilizing the photojournalistic approach with the 35mm camera. Industrial photography, public relations firms and publicity departments of large and even smaller corporations all have emerged as new and vast markets for the photojournalist. With this in mind any capable photographer can find a great future in photojournalism.

Widening Magazine Horizons

The magazine field, itself, offers tremendous possibilities. We often think of *Life* as a dominating market, as indicated in our discussions here and at other conferences. It is not. For the photojournalist *Life* magazine today is a very small market. The real market lies outside the picture magazines. The magazine field is divided into many different categories. Permit me now to name and discuss only a few. Besides the general magazines — *Life, Look, Coronet, Cosmopolitan, Pageant,* etc. — we have women's and fashion magazines, both of which use photojournalism and fashion photography, which is, itself, a specialized segment of photojournalism. The men's magazines try to do a different kind of job. Each of these magazines has its own personality and its own format. It is in the proper analysis of this personality that the photographer, professional as well as amateur, fails. What is the format? What is the style of photography and stories which will fit these specialized magazines?

The Sunday roto section magazine is a significant market. A new magazine, *Suburbia Today,* just started. There are also architectural magazines, which, in addition to architectural photographs, publish human interest pictures and stories to complement the architectural approach. For these stories photojournalists are needed.

Next are the business magazines, science and technological magazines, an almost-new field of television magazines, movie and fan magazines and religious magazines. There is a great foreign market.

During this Conference there have been remarks about low standards in American editing as compared to the European market. Being an American of European background, currently dealing in the European market with European editors, representing European magazines in this country as well as promoting American photographers and American stories in the European market, I can tell you that I have only the highest

respect for American editors. The standards of editing American magazines are well above European editing standards. The quality of thinking which goes into the editing of an American magazine and the demands which editors make of the photojournalist are at a higher level than for European magazines.

Brain Behind the Camera

The market today has become difficult for the young photojournalist for just that reason. Today's photographer is required to think. It has become more important for him to be a journalist rather than photographer in the limited sense. The emphasis in photojournalism is no longer on photo; it is on journalism and the brain behind the camera, not on the camera itself. Editors of top magazines will tell me, "If your photographers want to use a Brownie, it's perfectly all right with us, as long as we get a well-thought-through story." Higher standards are being articulated for the photograph and photojournalism. We must also see higher standards for photographic agents, too. Only agents and photographers who have acquired and continue to develop their educational background can, in the long run, survive in this business. If you will not be able to meet and develop with these ever-higher standards being set by American magazine editors and publishers, you should seek another profession.

Now I should like to discuss the role of the photographic agent who serves as a middle man and "clearing house" between photographer and publisher. The client may be a magazine editor or art director, a creative director of an advertising agency or a public relations or publicity director. A client is anyone who is in the market for photographs.

Only if an agent has a knowledge of the right market for your individual kind of work can he be an effective agent for you. The selection of an agent by a photographer is probably one of the most important decisions he is required to make. He must find an agent who fits his personality, an agent who is able and willing to find the market for the type of photography which he produces. Only an agent who has belief in a given photographer's work can represent him well. Otherwise, the photographer must find his own markets. Given the variety of publications, the frequent change in editors and continually developing trends in the use of pictures, a photographer accepts a great burden when he chooses to represent himself.

Agencies and Agents

There is a great variety in the kinds of picture agencies. We have agencies which are mainly assignment agencies, an example being Pix, the one I represent. There are stock agencies, which sell only stock pictures, and there are combination assignment and stock agencies. Specialized agencies have emerged. A color agency, for example, has developed and maintains a file of color prints and transparencies. There are historical agencies and news agencies.

A photographer must determine whether he wants an "individual" or a "group" agency. Individual agents represent only one, two or, perhaps, three photographers who work in a certain approach or style. This might fit a photographer's requirements much better than a larger agency. Both have advantages and disadvantages which must be carefully considered. Pix, for instance, represents 125 photographers around the world. An

agency of this type has extensive contact with editors, art directors, agencies, and public relations personnel, all of whom have a continuing need for photographs.

The techniques of selling — especially new ways of selling — differ greatly from photographer to photographer and agent to agent. But, there is always the requirement of analyzing the market. And, I find that photographers in general are poor analysts. There is too much self-deception about what they can or should do. It is one of the responsibilities of a good agent to help the photographer find himself and then locate the markets which best fit his personality.

Selling today is not what it was 20 years ago. The agent can't make calls with a bag of stock pictures. Usually he doesn't even carry a sample book, because sample books and portfolios mean very little to a potential client. The agent is selling confidence, services and the personality of a photographer. Although there are a few photographers who are able to sell their style themselves, they are exceptions. Certainly, a photographer must determine his capabilities for himself. The agent coordinates preparation of the photographer for a job. An editor or art director has specific needs which the photographer must cover. There are also services required by the client after a job has been completed. Unless those services are provided and the photographer or agent runs his office very efficiently, the photographer will lose as many clients as he acquires.

Let's face it, the photographer today has a tremendous work load. I call him a one-man motion picture production company! He is his own producer, camera crew, director, script girl, prop man and casting director. Does he want to handle all of those tasks — as one man — and also be a distribution company? His business of creating fine photography cannot help but suffer. Even the motion picture companies which are supported by multi-million dollar corporations have separated the production of movies from their distribution. I know that the photographer often says, "Oh, I can do that myself; why should I pay a high commission?" Is his assumption of the marketing function a wise economic decision? I believe not.

It almost goes without saying that the out-of-town photographer who lives far removed from the center of publishing — New York — cannot do an efficient marketing job with the exception of local work. A foreign photographer who wishes to market photographs in the U.S. certainly cannot carry on a viable business here without having an agent in this country. And, any U.S. photographer who shoots stories which can be used or resold in other countries certainly cannot make very many of those sales without an agent. While I really am not trying to convince you on having an agent, I want to emphasize that there are certain practical realities in the marketing of photography and that photographers might review their own business arrangements in respect to achieving better selling and better services. In the final analysis, the client is king in this business. Unless the photog-- rapher serves him well, he will find himself without a market very soon.

Ideas and Research

Another element has come into the photojournalist's business lately. It is extremely important and involves the photographer's creating of story ideas and suggestions for the editor. No magazine would have thought of asking a photographer to submit ideas 20 years ago. Then, about 10 years ago editors began asking photographers to submit ideas, generalized ideas. Photographers responded with the submission to editors and agencies of

such general ideas that they were not of value as editors had hoped. In the last two or three years, there has come a practice of the photographer generating "complete" ideas for the editors. This has placed a tremendous and added burden on the photographer as well as on the agencies. We may come to regret it. It increases expenses for both photographer and agency, because a tremendous amount of preliminary detail research is required. Only a few days ago the editor of a leading magazine remarked to me, "I operate with a very small staff; how can I research my stories?" And, the editor wants story ideas which fit only his magazine.

Every editor today thinks, and I agree, that his magazine must have its personality, its format and specialized requirements. Very often I will submit a story to an editor and he will tell me, "Oh, that might be a good story for such-and-such a magazine, but it's not for me." He thinks that the story is not exclusively fitted to his publication. The burden of story-creation is so extensive today that the photographer should not have just a general market or communication goal in mind; he must have one magazine and editor in mind. If he submits a wonderful story idea to a Sunday picture magazine, the editor will tell him to develop the story in only four or five pictures. *Life* would tell the same story in 10 or 12. Every photographer thinks in terms of photographic essays, and *Coronet* magazine gives picture stories from 12 to 16 pages. But, if you submit a story to *Coronet* originally shot for *Life* which has no depth or general human values in it, it certainly cannot run 12 to 16 pages. A story which a few years ago would have been published in *Coronet* with three or four pictures in a clean layout, is addressed to the wrong market if submitted today. When you send story ideas three or four times to a wrong market, you become terribly disappointed and drop the ideas, thinking the ideas were bad. You might have wonderful ideas, but you missed the market. I recently started sending our photographers a monthly circular letter explaining on-going changes in the types of story ideas various editors want.

Words with Pictures

Another development and frequent request which has come into our field of photojournalism is the need for text to accompany a set of photographs. The work of a writer-photographer team seems to be extremely important for the future of photojournalism. I cannot recommend highly enough that you become good writers. Skill with the written word is of great value in the preparation of story outlines, queries and the drafting of finished manuscripts. In the classic book, *Words and Pictures,* Wilson Hicks foresaw this trend when he wrote it in 1952. As a matter of fact picture magazines are not picture magazines any more. The word has become more important. Advertisers found readers were flipping the pages of pictures too fast, so the change was primarily related to the business of selling advertising in magazines. Advertisers reasoned that they would get a better and longer readership if there were good text articles with photographs. Again, the emphasis is on journalism with photography.

Certainly the agent can help a photographer with a professional requirement which the photographer, himself, finds difficult to perform. It is the sensitive business of keeping his name in the minds of editors, art directors and public relations firms without becoming a pest. Let's face it, if a photographer calls on an editor or art director three times in a row

without interesting his client in a set of photographs or a story idea — without contributing something to the editor's product — he will have a hard time getting a fourth appointment. Keeping fresh the photographer's name, promoting him and his work, is another important role of the agency. About 10 years ago, I began publishing a monthly newsletter for editors and art directors in which I told of the work of specific photographers who were covering the country or who were working abroad. I mentioned names, again and again. Almost every big agency today publishes a similar letter.

This service has value to the busy art director or editor, for if he were receiving calls from 200 or more photographers who are traveling every week, how could he ever finish his work? Instead he has a bulletin board with newsletters which he can consult. If he has a job for a specific location and spots a photographer, he can call that photographer's agency.

There is another problem for the photographer. He sends in a story. If the story is not right for the market, he gets a rejection slip. But, he is not told why. Nor, if the story is good, is he told about appropriate alternate markets. If his story is a bad one, what is wrong? What can be done with his story idea to better fit a specific market? The agency can and should help him with these problems. A few weeks ago one of our photographers, a lieutenant in the Navy on the U.S. Aircraft Carrier *Independence,* came into my office and suggested a story on that ship and its forthcoming shakedown cruise. I thought that this idea was too general for any market today. I said to him, "This story wouldn't be appropriate for many magazines except, perhaps, *Life,* and they might do their own story. Any other magazine might be afraid to touch the subject and be beaten, unless you personalize the story. Let's do a story on the captain who has 3,500 men under his command. Let us see the ship through the eyes of that captain." The photographer and I went to a magazine with this combined idea and on the first discussion sold it. It was published in *This Week* magazine. Often an idea requires just a little modification to fit a very particular market.

These are all problems which are a result of the greater maturity of photojournalism today. It is this maturing of our business which keeps us from becoming stale and static. There has been discussion lately that photojournalism is not progressing sufficiently, but with continuing creative ideas and a real enthusiasm and love for the job one does, I am not afraid of the future of photojournalism.

CONFEREE: Would you suggest some means of researching a story, some different or various approaches as to how to do it?

FURST: Researching the story certainly varies on the subject and from subject to subject. Ten years ago I would get a clipping from a photographer or a newspaper with a very generalized idea of a story. Or I would get suggestions such as, "I would like to do a story on a country doctor." Now, the country doctor has been done often, and certainly W. Eugene Smith made those two words famous. But today you will not sell that story to any magazine. You have to come up with an idea which says, "I know a country doctor who has a lovely wife, two sweet children and who does a specialized job." Then you go out and take a few pictures of them to document what the family looks like. You develop an outline of about 200 words. For any chance of success you have to do a preliminary in-depth outline before submitting it to an editor.

THE PHOTOGRAPHER-AGENT RELATIONSHIP

HENRIETTA BRACKMAN, 1964

Miss Brackman, formerly a photographers' agent, is now a photographic consultant and writer in New York City. She was associated with her brother in the Freelance Photographers Guild, Inc., before opening her own agency. During her career she has represented a number of important photographers, including Pete Turner and the late Dan Weiner.

Wilson Hicks suggested that I talk about the photographer-agent relationship, which is an aspect of agency work of great interest to me, more so than markets *per se*. In working with a photographer I try to build a career around him, starting with an analysis of what he is as a person and what comes naturally to him. Only after a lot of talking and the kicking around of things do I really get down to markets. This is a very natural approach, similar to the way actors have been helped into becoming successful by their agents and writers. You have to find the essence of a person, what his unique contribution can be in the field, and then build upon that.

There are two basic concepts in my approach which have helped it to work. First, help a photographer to build an image. This may sound like Madison Avenue, but it really isn't because every photographer establishes, whether consciously or not, a professional image of himself in the mental eyes of editors and the reading public. If a photographer doesn't have a plan — know what he wants to do — his image may become a very haphazard one, which is often true of photographers who say they can do everything. When I talk with photographers who would like me to work with them, I ask, "What do you like to do?"

If they say, "Everything," I then probe with, "What do you do best?"

If again they answer, "Everything," I follow on, saying, "That's going to be very meaningless to an editor at *Life, Look* or the *Post,* because there have been 89 other photographers in every editor's office looking for work during the last three weeks and another 89 photographers with similar credentials whom he has already used." Without some area of expertise clearly defined, a photographer has no point of focus in an editor's mind. The development of an image is of the utmost importance.

An Image and a Goal

When the agent knows what image the photographer wishes to build, his decisions become easy, because then one knows what samples to pull out and show. If the photographer doesn't have a portfolio which will contribute to his image, he may have to do some special projects on his own. New photographers have to do this. Then the agent needs to determine which markets or magazines to visit. If you do get a job or an assignment for the photographer from a magazine, but it is one which won't build up his portfolio, it should be declined. It won't build his reputation in the direction he wants to go. To reach

this goal of image building, the photographer must know himself, and his agent must come to know him quite well — know the most profound aspects of his personality and background in life.

The second part of the formula can be put in a phrase which I borrowed a long time ago from the Russians: a Five Year Plan. I work with the idea and a goal for what we are going to do in the next five years, based upon the photographer's own definition of where he wants to go. Very often in initial talks with a photographer I have to remind him that he is not in photography just for today; this is his life's career. He'll want to build. Where does he want to be next year? What type of work would he like to be doing and for what kinds of markets? How much money would he like to be making? It always surprises me that this question rather comes as a shock to photographers; they haven't thought about it.

One year of association with a photographer provides a guide, and then we think about five years and 10 years hence. I remind photographers that they will be getting a little bit older, that right now they may be climbing derricks and doing daredevil stuff, but they may desire a position with stability a few years later. The only way they can gain that while continuing to freelance is to build a reputation. As one's reputation builds, he gets better prices and is in a better position to select his assignments. Without this kind of long-range planning, many photographers go the route of flash-in-the-pan sensations. They may have gone up very fast, but then other photographers have copied their styles or new photographers have come along and become just as popular — or more popular — than they. In the end they find themselves back doing hack work. They just didn't build properly.

Association with Garry Winogrand

I generally ask a new photographer who wants me to represent him — even if I'm familiar with his work — to let me see everything he has done for the last five to 10 years. I once worked with Garry Winogrand who all but hired a truck to bring me his pictures.

I'd like to tell you how I started working with Garry, who had been stringing with a large picture agency. They gave him supplies and ideas, and when they sold something for him, he'd get paid for it. They didn't have him on salary. When he came to talk to me he had figured out that he had made something like $1.18 a week, the preceding year. The agency had wanted him to do pretty girls, and he just wasn't interested. As I was going over his work, I saw things — which is what always happens — that he had not seen. Most photographers, as other creative artists, are very close to their work. Sometimes they have inhibitions and psychological timidities about appraising themselves correctly. I did what I had always tried to do: figure out what was the essence of Garry and what he had to contribute which was uniquely his own. If I represent a photographer who has something that nobody else has, the availability of this photographer becomes a service, and there's not really any selling to it.

Garry had shot on his own many photographs of sports and sportsmen. Five or six years before Floyd Patterson had become a champion, Garry had shot wonderful pictures of Patterson trotting in Central Park in the early dawn or sitting on a stoop in Brooklyn. He also had some wonderful football pictures, but he had never exploited this interest professionally, never promoted this specialty. I observed that sports was a subject which

came naturally for him — that he loved sports. At that time there weren't too many sports specialists. Sports could be the main basis of what Garry would do. That didn't mean that he would only do sports; he could do anything else and be extremely varied in his work. But, he would have this special base.

Working from there we got Garry into *Collier's,* though it took about four to six months from the time we started until he was ready for *Collier's.* He didn't have the samples. During that period he did a lot of stuff on his own and also some assignments for small sports magazines like *Golf.* When we were ready, it took just one interview at *Collier's* and within three weeks he had an assignment at Madison Square Garden.

I also discovered in his work a strong feeling for things which were earthy, animalistic. He had done some photographs backstage at the ballet, not of girls as ethereal dancers, but as healthy, beautiful animals. We continued work in this area.

The Late Dan Weiner

Next, I should like to share my experience with the late Dan Weiner who was killed in an airplane crash a few years ago. Again, I built a program around a photographer, working from the inner man out, instead of the outside in. I had met Dan at a photographers' club down in the village in about 1951. In talking to Dan I found that he was making his living running a studio in partnership with another photographer. He had been out of the Army but a short time. Dan Weiner was a very fine documentary photographer, terribly concerned with what was going on in the world — the social significance of things — and how people felt emotionally. He was mainly a black and white photographer.

He and his partner had a profitable deal going with the Millinery Institute of America and for $5 a shot were doing hats, 20 in an afternoon. Dan had a good sense for fashion and models and had done some lovely and sensitive things. We felt that the logical extension of his career would involve his introduction to the fashion markets. On the other hand, he had this impressive collection of pictures which were absolutely documentary, as far removed from fashion as one could imagine. His portfolio of documentary photography convinced me that he was a journalist, not a fashion man. But I wondered if maybe he could do both. If he needed to make a good living while getting the experience and developing a reputation in journalism, I could sell his fashions, and then whenever possible, he could get some journalistic stuff in.

We started on that basis. Within three weeks I could see that it wasn't going to work. The mental and physical skills called upon to keep in touch with models, shoot with a larger camera and talk to advertising art directors were entirely different from the faculties he really wanted to use in doing stories that had some emotional content for him. I asked if he could live for two or three months while he built a portfolio in the journalistic area. He said he could.

Our first assignment for him was to do a symphony orchestra and he did a great job. We next visited Bruce Downes, then picture editor of *Collier's,* with Dan's samples, and within a short time he had an assignment. This is the way it should work. The assignment Bruce gave Dan was to photograph sales girls in a Washington, D. C. department store. It was during a time of prosperity and social legislation, the result being that sales girls were not paying much attention to their customers. The assignment wasn't all peaches and

cream. It was filled with compromises. Dan had to hire models because he couldn't photograph the sales girls — *Collier's* was afraid of libel if they photographed just any sales girl.

First Assignment Amiss

When Dan came back from the assignment, *Collier's* didn't feel he'd covered adequately some aspects of it; it was partly because they hadn't transmitted clear instructions. Dan said, as any photographer new to a field might say, "I don't know whether I should go back and redo it unless they're going to pay for a second assignment, because this was really their fault."

I explained to Dan that this was not the time for a show of independence. We had to realize that the magazine editor had not been able to foresee all of the contingencies. Dan had not yet completed a story for *Collier's* and if he didn't go ahead and finish this so it could come out well — even if he lost money and time — it would ultimately be his loss, not *Collier's*. You can't say "no" to anybody until you've been asked, until they want you. They had plenty of other photographers. He finished this story; it came out well, and subsequently he did a great number of good assignments for *Collier's* over a period of several years.

Many photographers debate the question of whether or not they need an agent. It is a hard one to answer. Some photographers don't need an agent. Aside from covering the markets, an agent is very good as a sounding board. A photographer can talk to his wife, but she doesn't know the markets or his problems in the field from the same perspective as an agent. Nobody else can quite fill that function.

Conversation with Allen Hurlburt

When Pete Turner and I began to work, it took a few months until we figured out what Pete really wanted to do, what image he wanted to build. I remember we were getting assignments, but we weren't building toward anything specific. One day we were in Allen Hurlburt's office at *Look* showing some pictures, and he said, "Pete, this is all very wonderful, but what do you really want to specialize in? What do you want to become known for? You'll never make a success doing everything."

Finally the answer came when Pete said, "You know, I love to see my name in print. I like to see stuff published." We'd been thinking mainly about advertising accounts, so later I said, "Your work has to be editorial."

Then Pete said, "I love to travel."

This was my clue; what we had to do was sell travel stories, and we did. A large part of Pete's work has been travel, editorial travel, of course. Later he moved back into advertising.

To go back to how a photographer should approach defining his career, he must decide what he wants — and he has to do some of this himself, whether he has an agent or not. He must decide how far he wants to reach, what he wants to be doing a year or two years hence. Every six months a photographer's goals and program change a little. In the first six months he'll be building just to get his name known. During the next six months he will have developed some accounts and will begin to consolidate them so he may make tentative efforts toward acquiring new ones.

In determining in what direction to develop, ask yourself what you really like. In what do you really find fun? Let your instincts be your guide. Every one of us has some areas of activity that we like because we ought to, but it's a somewhat different reaction when we define the things we naturally and spontaneously like to do. It seems so simple, but it's so important. Garry liked sports; Dan liked documentaries and Pete Turner has an entirely different approach — it is a poetic, lyrical, graphic feeling about pictures.

Pete is one photographer whom I think has been blessed by the gods: he has always let his instincts tell him what to do, and he has the courage to go ahead with it.

Agencies and Reps

I should like now to quickly define the kinds of agencies and agents there are to serve the photographer. First, there are the stockhouses which handle stock material, an important area of revenue for every photographer. They have a slogan: "Stock material makes money for you while you sleep!" It's sheer gravy. Many agencies handle stock.

Then there are the assignment agencies which handle large groups of photographers — for example Black Star and Pix. They have individual arrangements with photographers, some exclusive and some regional.

Personal representatives have formed agencies for one, two or three photographers. Personal reps mainly work in the field of advertising. I'm one of the very few who works in editorial material as well as advertising. The reason for this specialization in advertising is that an agent who represents a few photographers has to make more money on each sale, you see. Advertising is the highest paying "consumer" of photography.

Hints on Portfolios

I find that many photographers, particularly new or younger photographers, don't have a sense of how to edit, and it is important to develop it. An agent who knows how to edit can be of help here. The photographer should never take a batch of pictures that don't have much relation to each other, put them in a folder, hand them to an editor or other client and figure that since he knows his business, he will know what is good. Remember, editors are human beings; their attention may wander; the phone rings; even if they give their full attention, they don't get any impact unless pictures are effectively organized and grouped. When you show a series of photographs you are telling a story. There must be continuity, both within groups and then extending from one group to another so that the total effect is cumulative.

When showing photographs to a client you ought always start with very strong images, something very striking and uniquely yours. At the very first glance a client or an editor says, "This is different from what I see all the time. This guy has something special." It's the principle of vaudeville: start with a strong opener. Then you try to sustain the effect, but consider its pace wherever the excitement drops a little. Bring up the attention and always end with something very strong.

In editing you have to be absolutely ruthless and throw out everything that doesn't hit you right in the eye. I've resisted learning much about the technique of photography for that very reason. A photographer often gets too impressed with the *tour de force* that a picture represents — the difficulties he had taking it. It's a subjective thing.

When I'm building a sample presentation I'll lead off with a story, and then, perhaps,

I'll see a group of pictures that show marvelous technical facility. I'll put those together. Buried among a photographer's samples might be some really great portraits. They should be pulled out and grouped. Then the client or editor who is looking at them has themes fastened in his mind, instead of a scattered collection of miscellaneous things. Three weeks later he has seen so many other people's work. He'd only remember the very best. You want something from that portfolio to stay in his mind: "That was a wonderful portrait" or "This was great color."

Not every photographer has to be a great photographer. There is room in the world for many different levels of work, and a photographer can only be honest with himself and in what he does. Some photographers are half word people and half picture people. Or they're technically brilliant. Not everyone has to become a great photojournalist or a great artist. Sometimes one can have a great deal of respect for his work at a level of expertise which is not that of Cartier-Bresson or Pete Turner.

If you're making a presentation you should have the most beautiful prints that can possibly be made. I feel that 11 x 14 semi-glossy prints are the best. Anybody who shows 8 x 10 prints or glossies is doing a disservice to his work and his craft. The same goes for color. Sometimes photographers will throw together a group of 35mm transparencies and just send them out. We rarely show 35mm without the projector. In a visual field your presentations have to be of top visual quality.

Some photographers will send a portfolio around with battered glassine sleeves and no pacing or organization. These are simple, but important concerns.

CONFEREE: What kind of percentages do most agents work on?

BRACKMAN: It varies from 25% to 50%. Reps in advertising work on 25% of the gross, and the photographer pays all unreimbursed expenses. There is no splitting or taking off the top. The staff agencies very often get 50%. For the regular assignment agencies such as Pix and Black Star there are different arrangements with different photographers, but I think standard is 60%-40%, 60% being for the photographer.

MARVIN KONER: The usual schedule is 60-40 with agencies, and stock stuff is 50-50 out of agencies.

I would also like to make a statement, if I may, about representatives. I haven't worked with a representative for 15 years, though I did work a very short while with one of the agencies. In my opinion there are very few really good representatives around who are willing to take time to know their photographers and understand them. Henrietta is one who does. Pete Turner is not only a success because he has talent — talent doesn't mean anything if it's in a box — but also because his talent is brought to the public. It's terribly important to have somebody who is sensitive to your needs, especially if you're a sensitive photographer and not just a commercial guy who grinds it out every day.

CONFEREE: How many photographers do you or can you represent at a time?

BRACKMAN: It depends on how much I would like to expand. I could represent three or four — possibly even five — photographers if I worked with a partner or assistant who would do much of the leg work for me. I also need an office staff.

CONFEREE: Do you work alone at all?

BRACKMAN: I like to, but I don't know if it's possible. The more successful a photographer becomes, the more detail work is involved. Then I've got to have somebody to help.

I have to represent another photographer at that point to provide adequate input to justify the employee.

KONER: For general edification, the 40% cut which an agent receives is very often made up in resales and stock sales which the rep has time to make. You may pay $40 from $100 but you probably will get back a minimum of $30.

BRACKMAN: Many agents work at 40% with an expenses-off-the-top arrangement. That means if the client doesn't pay some of the expenses, these are deducted before commissions are computed. The photographer knows exactly what he is paying and there are no hidden expenses. The way I have always worked, and it's worked out well, involves also taking experimental things off the top.

WHAT MAKES A GOOD FREELANCER?

JOHN G. MORRIS, 1957

Mr. Morris, who is currently picture editor of the *New York Times*, has long experience in photographic communication. He served variously as assistant picture editor and head of *Life*'s bureaus in Los Angeles, Chicago, London and Paris during Wilson Hicks' tenure. As *Life*'s London picture editor in 1943 and 1944, he was responsible for picture coverage of the invasion of France, thus working closely with Robert Capa and George Rodger, who were to become two of Magnum's founders. Mr. Morris served as picture editor of the *Ladies' Home Journal* following World War II (1946-1953) prior to his joining Magnum as executive editor in 1953. Before accepting his present position at the *New York Times*, he was associated with the *Washington Post* as a picture editor.

Once upon a time some 16 years ago there were two boys, a good boy and a bad boy. They were both working for Wilson Hicks at *Life* as assistants. The good boy, Ray Mackland, finally achieved the reward which comes to all virtuous men: he became Wilson Hicks' successor as picture editor. I'm really grateful to Wilson, however, for providing me with the opportunity to work with those wonderful, crazy people called photographers who are on and off *Life*'s staff. Now you will hear from the bad boy!

There were many things which Wilson tried to teach me, including the art of giving a photographer a decent brush-off. I remember one of the characters who came up from Miami for an interview when I was first working for Wilson was Dave Duncan and he defied all of those new brush-off techniques. But, there were many other things which I had the pleasure of learning at that time. I had breakfast at the Automat in Philadelphia with Eisenstaedt; I went shopping for antiques with Frank Scherschel; I watched Gjon Mili and Dmitri Kessel play gin rummy and Peter Stackpole flirt with the girls in Hollywood.

Wilson finally conspired in the fall of 1943 to ship me off to London and in return he promised to be godfather to a child my wife was expecting at that time. I left for London with nine Canadian Red Cross girls and another Time-Life correspondent on a small Norwegian freighter without convoy!

Why should I talk especially about the freelance photographer? What makes a good freelance photographer? What makes any photographer good? In addition to being a photographer who has an independent income, a freelancer has some other special qualities.

Freelancing — Free and Lonely

There is no question but that a good photographer whether on staff or freelance, must have a tremendous drive and devotion to his work. In addition the freelance must have a willingness to gamble, a willingness not only to take chances in the commercial field, but in other ways as well. What do you gamble on if you're a freelance photographer? You gamble on your talent, of course. And here I think the word *freelance* begins to have special meaning. The freelance photographer sells his talent, which is a very individual quality. Freelance photography as a business is thus an individual thing and often very lonely. It is lonely in the field, for there is no writer or editor tagging along. Nobody is going to rewrite your story when you get back to the office, either. It can also be lonely in the darkroom.

I'll never forget one night in London, the loneliest night of my life, although I was surrounded by people. I was then London picture editor of *Life* and responsible for seeing that the coverage of the invasion of Normandy got back to New York. A few hours earlier I had taken a preliminary look at the really superb negatives which Bob Capa had sent back on the landing, roughly four rolls of 35mm. That was to be the heart of *Life's* coverage. In the middle of the night I received a call from an almost-hysterical darkroom boy who was saying that everything was ruined. There had been a problem in the lab and Capa's images literally floated off the film! As you possibly know if you've read Bob's great autobiography, *Slightly Out of Focus,* we did find about a dozen negatives which were salvageable, and those are the ones which have helped to make photographic history. What a terrible gamble Bob's landing on Normandy had been! There was another *Life* photographer who landed on the same beach on the same day who never forgave me, because his pictures never turned up at *Life's* London office at all. They were probably lost at sea when a packet boat was sunk. But those are the hazards, the fortunes and losses, the gambling, of this game. Staff men sweat them out more easily, but it takes a special kind of perseverance to be a freelance in such circumstances.

I would like to examine three aspects of the photographer's talent, and I must apologize to Ernst Haas for stealing his trinity. I first heard Ernst describe this trinity during a conversation about young photographers in a London hotel room with Bob Capa and myself. Ernst said every talented photographer must have three things: an eye, a heart and a brain. And this is so true. Almost every quality of the great photographer falls into these three categories.

The Photographer's Eye

The eye. Let me see a photographer's contact sheets and I can tell you whether he's got an eye. It's a pleasure to look at the contact sheets of Cartier-Bresson, especially so because Henri doesn't like to lend them out! But, they show his search, his probing of subject matter. It's fascinating to see the way he works.

Last summer when the "Andrea Doria" sank, Gene Smith worked that night to cover the arrival of the survivors, and for the first time in many years I had the pleasure of going out on a story with Gene. In the days when I had worked with him at *Life* many years ago, he only worked with one or two cameras at a time. Now he will work with four or five. And I'd heard other photographers joke about this. Well, at about 5 a.m. I looked at Gene's contact sheets from those five cameras. They represented one of the most beautiful pieces of camera work I've ever seen. It was just poetic to see the way in which he had interplayed one camera and lens against another to get this effect here or another effect there. There weren't wasted exposures in those five rolls, either. Of course, the percentage of pictures which Gene wanted to print was very small, as it always is, but he worked with five cameras as a sensitive musician would play an organ, getting his depth of feeling out of them.

The photographer's eye must be fast, an obvious point in news and sports photography. Somebody like Hy Peskin can catch the crucial moment in sports, and he obviously must have that precision. It's obvious also in the work of somebody like Gjon Mili, who works with complicated stroboscopic equipment, but has an instinctive sense of whether he has or has not gotten the picture when his strobes are flashed. It is also true in portrait work and landscape, I've discovered, much to my surprise. In observing Ansel Adams photograph a landscape, change is obvious, whether it be with a puff of the wind or the movement of a cloud. The eye must also be a light meter. I've noticed that the great photographers use light meters in a rather rudimentary way, the real light meter being their eye. After all, it is the light in the picture which establishes its mood, and can you imagine a sensitive artist entrusting the mood of a picture to a mechanical instrument? This is crazy. Ernst Haas doesn't own a light meter. I remember another photographer who would only look at a light meter to determine that it was wrong. I'm not saying that everyone should throw away his light meter, but in addition to a sense of timing, the eye must also have a feeling for light.

Finally, the eye is a frame. It must compose. It is no joke that a photographer can profit through the serious study of geometry. Cartier-Bresson talks of this frequently. I was interested to note that Steichen, though he left school at the age of 15, later taught himself geometry and genetics. The eye is all-important in giving a photograph form. The eye helps determine how the photographer takes the picture.

Heart and Courage

The heart and the brain determine what he gets. The heart — that's the whole range of emotional sensitivities of the photographer. Steichen's *Family of Man* exhibition was a masterwork of heart. The reason it took Steichen so long to select the photographs and assemble that show was because it was necessary for him to fall in love with each and every one of those images before he could put them in the exhibition. And that took time! He slept with that exhibition, figuratively and literally, in a cot in the loft where it was created.

Every man's heart responds to the times in which he lives. Nations, incidentally, are as passionate as people. A photographer alive during one time in history may feel and react quite differently to his environment than would be true in another time. It was

Dorothea Lange's great heart through her compassionate photographs of the unemployed and the migrants in California which had an impact on the conscience of Washington, and through Roy Stryker contributed mightily to the great Farm Security Administration photographic project. But Dorothea had taken photographs of this power before FSA. Her great picture of the unemployed in a breadline in San Francisco dates from 1933, and her documentary pictures taken in 1935 and 1936 were a forerunner of *The Grapes of Wrath*.

On an entirely different level, Ylla brought her human understanding — her heart — into the photography of animals. She saw them each as an individual character, the quality which made her animal photography so great and gave it a vitality far beyond that of the routine.

Heart, of course, includes the quality of courage — courage which is of many forms. It requires courage to go into many places the photographer must work, and, oddly enough, it isn't only the news photographer who must work in such locations. It's almost compulsory here to say a word about Bob Capa, whose name you all know. Bob was a gambler partly for fun. However, in a serious way he was a gambler for the sake of leadership and because he had courage. You had to be a gambler in the War to command the respect of troops and generals, as Bob did. You couldn't get places without it. It took tremendous nerve.

As one example, I'd like to tell a story of a day in Brittany when I was with Bob at the front lines during the siege of Saint Malo, a little port which was held by a garrison of about 5,000 very stubborn German troops. We had worked our way forward to an observation post, beyond which was the German line. A lieutenant colonel from West Point came to this post, which was very conveniently located in a bar at a seaside hotel. This lieutenant colonel was having difficulty in making up his mind whether he should order an artillery barrage or a psychological warfare sound truck to convince the Germans that surrender was the only answer. Bob despised this officer; he realized that indecision could only become dangerous. When somebody suggested talking directly to the Germans, Bob said, "If you want me to, I will go and talk to them." He took off his Rolleiflex and handed it to me. Someone tied a white handkerchief on a pole, and Bob was about to walk into the German lines. About then I realized that I had the Rolleiflex and if there were to be any pictures, I would have to make them. Fortunately for me some shooting broke out and the whole project fell apart. But, Capa wasn't about to do this for the sake of bravado. His offer was consistent with his character, and it was that character, that courage, which permitted him to be in places where great war pictures were made.

There's another aspect of the heart — the photographer's concern for his subjects, the people he photographs. I remember how Dmitri Kessel spoke to me about a time in Athens during their civil war when a bomb exploded outside the Grande Bretagne Hotel where he was staying. A woman and child were either very seriously hurt or killed. It was a terrible mess. Dmitri was so overcome with emotion that he couldn't take pictures; his concern was only for the woman and the child. This same kind of concern usually returns when the photographer is back in the office with his pictures. I also think of the way in which Cornell Capa shares this quality of concern with his late brother.

Courage is also the courage to quit, to risk failure on one's own if one is inhibited from living according to his principles or according to the true concepts of a story. And

here again, the freelance part of the photographer is important. Outstanding staff photographers on any magazine are very likely those who most often threaten to quit.

Intellectual Penetration

Now let us consider the third in Ernst's trinity, man's brain — and I'm not speaking of formal education. It's amazing how many photographers, very good photographers, have succeeded without a college background. Photojournalism is one of the very few free and open professions in that sense. On the other hand, you find extremely intelligent, sophisticated, cultured photographers like Magnum's own David Seymour, who was killed in Egypt last November. "Chim" spoke seven languages, had studied at Leipzig and the Sorbonne and could discuss Roman archeology with the best Roman archeologists. He was an amateur classical scholar — a highly civilized man. Occasionally his learning got in the way of his photography, but this was not necessarily so, for on the whole, it provided an added dimension. What I am speaking primarily of under this heading of brain is intellectual penetration! Consider, for example, four of the outstanding portrait photographers of our day. Yousuf Karsh studies his subjects from the viewpoint of their place in history. I don't always agree with his historical conclusions, but I think that his approach has intellectual merit. Arnold Newman studies his subjects almost as an architect, while Irving Penn has the approach almost of a basic scientist. He seems to dissect his subjects and his portraits represent pure research in personality. And now we take Philippe Halsman, an amateur psychoanalyst who would put many of the professionals to shame. Philippe gets more than $20 an hour, too.

While I have not previously mentioned it, craftmanship is another important contribution of the photographer's brain. Superb craftsmanship comes through in the work of many a great photographer. Craftsmanship must be consistent with the style of that photographer. It was a keen understanding of the science underlying photography which did so much for Werner Bischof and added a dimension to his work which was lacking, for example, in Bob Capa's. Craftsmanship is important, terribly important.

Too Many Photo-Mechanics

I come now to a rather sad conclusion. If one accepts the criteria I have utilized in defining or identifying the freelance photographer, there are very few real freelance photographers in the United States or the world for that matter. Very few real individuals are taking pictures. Can you tell me, without looking at the credit box in *Life*, who took the pictures for a given story in an issue? Or, can you tell me how to distinguish the work of one AP, UP or even *Milwaukee Journal* photographer from another? The fact is newspaper and magazine editors and publishers have developed a sizeable group of great photographic mechanics — photographers who can go out and "fix" anything! Most of us could more easily identify the source of unseen works by great modern painters than the source of works by great modern photographers.

Nor are there many photographers who qualify as visual historians, yet history is the ultimate function of journalism in the sense that journalism shares a responsibility in creating a document of current events as a source for future historians. There are, of course, exceptions. David Duncan's work in Korea is one of the finest historical documents

of the Korean war. It contributed to the literature on the Korean War as John Hersey's book on Hiroshima documented the first atom bomb. Both works are durable and lasting.

We don't have a single national photographic columnist, neither a Walter Lippman nor even a Winchell. Where are the photographers with a personal viewpoint?

In this examination, freelance photography seems in the main to be an interval in the work pattern of unemployed staff photographers or a business approach for photographers who prefer to earn their living from several sources rather than one — whether for geographical or personal reasons. There's nothing wrong with those reasons, but they do not produce the rugged individuals in this profession who remain really free and are prepared to pay the price! In the final analysis, each individual must ask himself whether the price is worth paying. Is there really some point to being a freelancer? At Magnum we have had to make funeral arrangements during the past three years for three of our greatest photographers. We've done a lot of thinking about the true meaning and value in being a freelance.

I'd like to conclude by reading some of the words of a photographer who has lived about as dangerously in war and in peace as any photographer I know. They were written by W. Eugene Smith, and appeared, significantly enough, in his community newspaper. Gene was reflecting on his work during World War II and his past.

These things I photographed with hating wrath. When I had such subjects, my camera and some film were my only fragile weapons of my good intentions. With these I fought war. But, my camera and my intentions stopped no man from falling, nor did they help him after he had fallen. Yet, all that I could offer of value, whatever that value to the world, were my photographs. And of what parched worth were the photographs to the man whose eyes followed me, he just having lost two arms, a leg, most of another foot, and now lay there still conscious?

Glory, glory, glory, glory in the sands of Iwo Jima and a flag being raised on Surabachi for the world to remember it by and for a nation to symbolize it by. What brass bands precede the political speeches! Photographs be damned if they would bind no wound, for they can cause an emotional reaction, can show and remind. I could not prevent the wounding of the man, yet the image of this suffering might help to show compassion, to soften hatreds, even in hardened minds, and strike up other hatreds not directed against man, but against what is done to man. If I could photograph powerfully enough, I reasoned, I might, just might, help a little to change this.

If my photographs could grab the viewer by the heart, making the enormity of the terribleness of war lodge heavily, they might also prod the conscience and cause us to think. The photographs might cause the viewer to think beyond righteous chips on nationalistic or political shoulders and beyond racial or religious gripes that usually fade when understanding is allowed, is gained or is applied. I had to try to make the viewer think of what war actually is and what it is not a solution of — to help the viewer realize above pride, out of morality and out of practicality that it must stop. That man must search and learn and create a new ethic and new governing mechanics to control both the righteous and the wrongs.

In highest achievement I could do no more than strike another call, for there is not within me the magnitude of brain to guide the way other than a beginning; idealism is not enough. Yes, my attempt, for even when man knows he must fail, there are times he must continue, for he has never done his share.

9

International Dimensions

In the late 1920's most European magazine publishers were selling specialized magazines to audiences of limited circulation. Then, by the early '30's a very significant trend in publishing had begun to define itself in Europe and soon thereafter in the United States: the growth of mass circulation, general interest magazines, including the illustrateds and picture magazines. In the United States *Life* and *Look* were founded in 1936 and 1937 respectively. On the Continent similar publications became important markets for the still photograph and picture story and were to remain so for the next 30 years.

With a broad diffusion of television receivers throughout Europe in the 1960's, general interest magazines suffered great losses in circulation, a fact not paralleled in the U.S. Smaller circulation, specialized magazines once again appeared. The circle was complete!

How has this affected markets for photojournalism on the Continent and the productivity of European photojournalists? In the past decade, as revealed within this chapter, Europe has proved itself to be a shrinking market for documentary photojournalism, most notably because of the decline of large, general interest publications, and also because the specialized magazines have not become substantial users of the picture story. There is evidence, though, of an expanding market for still photographs when one considers industrial, advertising, and single picture editorial uses.

Photographers in Europe thus report their growing interest and involvement in film-making for government television. One Swedish photographer and film-maker, Rune Hassner, tells the story in this chapter of the growth and change of the Swedish cooperative to which he belongs — TIO. When the cooperative was founded, each of its 10 members was involved in the still photograph and shooting picture stories for magazines in Sweden or elsewhere. With further developments in color printing technology in the early '60's and publishers' interests in color photography, TIO's members added the personal capability and equipment to work in that new medium. However, by the late '60's nearly all

of TIO's members were devoting substantial time to documentary film-making for non-commercial government television.

Drawing upon photographers and editors from Holland, Italy, Germany, France and Sweden, this chapter explores expanding opportunities in film-making for photojournalists across the Continent. In summarized round-up they also review new talent and trends in still photography, paying particular attention to the Sunday picture magazines published by English newspapers.

The chapter includes in its two opening presentations a description and discussion of photographic communication as international propaganda. Under terms of a cultural exchange agreement between the U.S.S.R. and the United States, *Soviet Life* is made available on a subscription basis to citizens of the U.S., while *Amerika Illustrated* is sold to Russians. The managing editor of *Soviet Life* and the editor of *Amerika Illustrated* describe the objectives, audiences, achievements and problems of their respective magazines in an unusual exchange.

SOVIET LIFE TODAY

ALEXANDER MAKAROV, 1966

> Mr. Makarov was managing editor of *Soviet Life* at the time of his presentation in Miami. The editor of the magazine is based in Moscow, with his production staff located in Washington, D. C.

The magazine *Soviet Life* is published in the United States under provisions of a reciprocal agreement between the governments of the United States of America and the Soviet Union. Circulation of the magazine is 62,000. The editorial staff is divided into two parts, one in the Soviet Union and the other in the U.S.

A chief editor presides over the major editorial staff of the magazine in Moscow where all copy is prepared including photographs and layouts. Stories in the magazine are first written in Russian or other native languages within the Soviet Union. Then they are translated into English and sent to the U.S. staff. Of course it is rather difficult to translate from one language into another and preserve the same meaning of some notions which are new or which we don't completely understand even in our native language.

When the text, layout and photographs arrive in the U.S., a small staff in Washington, D.C. examines the contents and makes any necessary adjustments in layout. We have excellent communication with Moscow which helps, though the distance is rather great. The magazine is printed in Rockville, Maryland. Some 25,000 copies go to wholesalers and another 30,000 are mailed to subscribers.

The aim of our magazine, as it was envisaged more than 10 years ago when the cultural agreement was signed, is to tell readers what is occurring in the Soviet Union. This

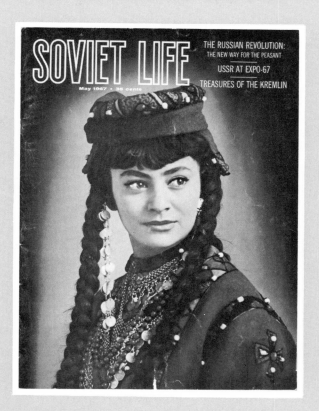

Cover, *Soviet Life*, May, 1967

includes stories about the Soviet people, their problems, our teenagers, education and the economy. We are aiming to establish better communication and understanding between the two peoples. We do not carry articles on what are called "hot" issues, particularly of an international nature. We generally adhere to internal questions and problems.

We live in a world of scientific wonders. Our fathers could hardly imagine that a man could fly. Now men are not only flying, but they are also walking in space. Problems and possibilities of life on the moon are being discussed. It took the people who came from Europe to this Conference only six hours to cross the Atlantic Ocean. As transportation and communication technology has developed, the world has become narrower. The natural consequence has been an increased interest by people in all parts of the world in what is happening everywhere else in the world. They want to know what is going on in the Soviet Union. The Soviet people want to know what is happening in the United States of America, or France, or India. Communication through various media including photography and magazines is very important.

Some of the problems discussed here about relations among photographer, writer and editor are the same problems as are discussed in the Soviet Union.

I am not an expert in the technicals of photography, for I am the managing editor of the magazine. Our art director is in Moscow. But, I should like to take this opportunity to comment on the place of photography in our magazine. We are very optimistic concerning the future of still photography in the magazine. Maybe it is because we do not run advertisements which, in turn, leaves more space for photographs — there are 64 pages in each issue of the magazine.

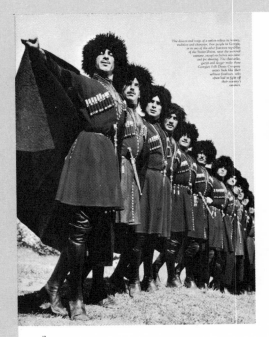

I AM A GEORGIAN

Mikhail Kvlividze
Poet

A story about the people of Georgia, the legendary land to which Jason and the Argonauts came in search of the golden fleece.

I AM a Georgian. I am several thousand years old but I look very young for my years. I have an excellent memory. I still remember that story my ancestors used to tell about their first meeting with the Creator.

Once upon a time, soon after the world was created, God summoned all nations to divide the land area between them. There was 100 per cent attendance. All the nations stood in a long line and patiently waited their turn.

By the end of the day, when the whole globe was divided and the Almighty was dead tired and about to take off his overalls and wash his hands, two applicants came up and asked for their share.

"And who are you?" the Almighty asked.

"We are Georgians."

"Where were you up to now? There's nothing left. I've parceled out everything!"

"The fact is," one of the two began apologetically, "we were a little late. And when we came, there was a long line. So we sat down under a tree and had some wine to while away the time."

"We were drinking your health!" the other interjected.

"Now, what am I to do with you?" the Almighty said nonplused.

"Have a heart," the Georgians pleaded. "How can we go away empty-handed?"

"Well, well," said the Almighty. "You look deserving, even though you didn't show much patience. I'll give you a small piece of land

I've reserved for myself. I wanted to build a cottage there and retire. But never mind that. Take it and live happily! But always remember my kindness, do you hear?" The Almighty looked at the Georgians meaningfully.

"Of course, *ghenatsvali!*" exclaimed both Georgians. "The doors of our house will be always open to you—come and stay as though it were your own home!"

"Good!" said the Almighty and vanished into thin air.

And the Georgians began to live on the land God had reserved for himself.

A familiar Georgian story, this one, but one with a good deal of truth in it—just as there is in this Georgian proverb: "If you put a stick in our earth, a tree will grow out of it." Or in a song everybody here sings, young and old:

*Where will you find
another Georgia?*

But the kindness of the Almighty had its dark side. My blessed land between the Black and Caspian Seas was coveted by every neighbor. Almost from the cradle I had to take up a sword in one hand and a plow in the other to fight and work for survival. I had to fight the Romans, Byzantines, Parthians, Mongols, Persians and Turks for more than three thousand years. Time and again storm gathered over-

(Continued on page 18)

* In Georgia, "my dear!"

PHOTOGRAPHS BY
EDWARD PESOV
DMITRI DONSKOY
VALERY SHUSTOV
IGOR GNEVASHEV

12

13

Spreads from "I Am a Georgian," Soviet Life, May, 1967

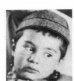

20

Photography, the International Medium

In our world today there are millions of people who are not well-read and well-traveled. They want to learn as much as possible about world events. They want to know, to read and to see. And, the still photograph is a medium which they can understand. In the world there are many interesting and beautiful things to show to readers, and, in my opinion, the photographer is the only communicator who can reach this mass audience. The photographer possesses the medium with a magic eye through which millions of people can see the world and other people. As with other art forms, he may arouse emotions in people: pity, contempt, doubt and pessimism. He can focus their thinking on problems which otherwise might pass unnoticed, or reveal ugly sights to human beings.

In a recent issue we published a story about one of the Soviet photographers. He said, "My photographs show nature as I, myself, see it," and, I would add, he sees it with an artist's eye. On our magazine staff we have a number of photographers, some young and more dynamic, others old but more sophisticated. They have the same discussions as we have heard during this Conference. There is a healthy rivalry of ideas. Some photographers prefer to conceive the story themselves, with the writer following their ideas. Others would agree to discussing the story with the writer before going on assignment. A few do both the story and photography. Finally, and frankly, some do the photographs without care or concern for the story.

But, editors and photographers agree on the role of the photograph in communications and the responsibility of the photographer to his readers and his conscience.

AMERIKA ILLUSTRATED

JOHN JACOBS, 1966

Mr. Jacobs was editor of *Amerika Illustrated* (Russian and Polish language editions) when this presentation was delivered. He is currently based in Vienna, Austria, with the United States Information Service, publishing for Eastern Europe.

This is not only the tenth anniversary for the Conference on Communication Arts, but it is also the tenth anniversary of the exchange of *Amerika Illustrated* and *Soviet Life.* Let me first sketch our beginnings and development as well as our objectives — some of the things we hope to communicate with the magazine and why.

The beginning of *Amerika* magazine goes back a long way. In World War II when Elmer Davis presided at the Office of War Information (OWI), there was a magazine called *Victory,* which was circulated in many languages to our allies. It was about America and the war effort. When victory was achieved, *Victory* became *Amerika* magazine, and it was distributed in Russia until 1951, when tensions made its distribution no longer feasible. The magazine was discontinued.

Then there was the Geneva Summit Conference in 1955 followed by the Second Geneva Conference of 1955, and an agreement providing for the cultural exchange of magazines was one concrete result of that Second Conference. Since then the agreement has been repeatedly renewed, and our magazine is sold on newstands in the Soviet Union for about 50¢ by a Soviet agency which distributes magazines and newspapers there.

Amerika Illustrated is written in English, translated into Russian, printed in the U.S., and shipped to the Soviet Union.[1] Proceeds of this sale are turned over to the U.S. Treasury. There is no censorship, but as part of the cultural exchange agreement, the magazine is non-political. What this has really come to mean is that neither *Amerika Illustrated* nor *Soviet Life* discusses the "host" country where the magazine is distributed. We do, of course, discuss our own politics, our government, and our economy.

So much for the bare bones. But, really, what is international communication? Are people the same all over? If a picture is strong, will it get your message through? Is art universal, or are people of other nations quite different? How much should an editor follow his intuition and how much should he depend on expert opinion? What do the Russians really want to read? Suppose I were in a foreign country, trying to advise that country as to what it should publish in America. How qualified would I be to say what kind of a magazine would be most effective in America? These are all questions which go through the editor's mind each day as he works on a magazine like this. Over the years you make peace with these questions in one way or another.

Limitations Provide Challenge

Every magazine editor feels the limitations of his medium. While you may have a vast quantity of marvelous photographs, when they are boiled down and published on a page, in each step something often seems to be lost. But, that's the problem of the medium; it is the way ballet dancers feel about gravity, painters feel about paint, and the way all of us who try to do something worthwhile feel about our own limitations; indeed, to generalize, it is the way any reflective man must feel about himself and about humanity. It is this tension between what we wish to achieve in our medium and what we actually do achieve that makes creative expression exciting, and that's the struggle. But these are all very large questions.

We do have a great many practical problems — publishing in a foreign language and working in government, to name but two. Our deadline sheet which lists when each stage of the magazine production must be completed before *Amerika Illustrated* arrives in Moscow looks like a cost-accounting sheet for the Chase Manhattan bank. The magazine is organized in six sections. The picture and text sections are the primary creative units in initiating material; then there are the design and production units. Finally, we have two language-editing divisions. Among all of these sections — not just between text and pictures, which are always in battle — there is constant communication and flux created by needs of text for more words, needs of pictures for more space, needs of art for more white space and needs of production for better photographic copy. There is also the constant temptation to revise. The decision you have to make day after day is whether to try to improve a piece just a little more or to go on to something new. More and more

[1] Mr. Erwin van Swol, Office of Public Information, USIA, indicates that in 1971 *Amerika Illustrated* is printed by the USIA in Beirut, Lebanon, and shipped to the Soviet Union.

I decide in favor of the latter. There is the important need also to do long-range planning and not become a prisoner of day-to-day pressures of the work.

On the subject of revision, there is a tendency for each person who works in the assembly-line of group journalism to want to carry his work on into the next section. Photographers want to become involved in picture editing; picture editors want to help with layout and design; the word people want to get into everything, and the language people have their problems. It seems to me that while there has to be understanding among these sections, it is important to define functions fairly discretely and give each person who is responsible for a story his free swing at it. If he mutilates it, then and only then is the time to step in to bring it back to life.

I'm talking about a group operation. Sometimes an idea seems fine as it starts out. But, then each person who deals with it, whether freelance or staff, hits it, and it becomes more and more bedraggled. On the other hand, an idea may start merely as "good" and then get added boosts from each person along the editorial path. Of course the important issue is whether the idea is really viable. It does not matter that you may have invested time and money in a story. If it isn't viable you should drop it and go on.

One of the most important points for both staff and freelance photographers to affirm is that other people on the magazine understand what you are trying to do and that they, too, are really on the team — that they don't have an internal, nagging, passive resistance to what they are or will be doing or feel that the assignment is being foisted on them, that they haven't really had a chance to have their say. In this business people have to be overruled every day, but it is also a very important part of the process for everyone working on a story to have the opportunity for a free say.

On revision, even if you have the resources and time, there comes a point when it serves no useful purpose. Things begin to look fussy. I think putting out a magazine is a little bit like making piecrust. You have to handle it lightly and not knead it too much, or it can get tough and inedible.

One of the reasons why first issues of magazines are often not very good is that the ideas have been thought and rethought too many times. Before I began work on the Russian magazine, I edited another of the agency's magazines which was entirely handled by an editorial staff of four. It was bimonthly, with somewhat fewer pages, but nevertheless, it was a catch-as-catch-can proposition to do it well. The climax of that magazine's production came every two months when I would pack two satchels full of the entire issue and commute to New York on a Friday night. Bernie Quint at *Life* was our art director. We'd have dinner and then come back to work until 1 or 2 a.m. The next day we'd be at work by 9 in the morning. Before the weekend was over we would complete all of the layout for that issue.

What Interests the Russian Reader?

People often ask how we select material for the magazine that we know will interest the Russian reader. We have learned that in the Soviet Union there's a tremendous interest in almost anything that we want to discuss or write about. There is a reservoir of good will there which goes back many years. Then there is a great interest in America because we have technological achievements which the Soviet Union is presently striving to match. We're very aware that Soviet readers, as true of people everywhere, are not particularly

fond of boastful presentations, but we do feel that there is a genuine interest in those areas of our society, culture and economy where we've made outstanding achievements which merit detailed coverage. For example, we sent a writer from *Amerika Illustrated* with a Soviet agricultural delegation across the U.S. She kept notes on what they saw and what interested them. Then we did a story on the trip, including it in an expanded issue completely devoted to American agriculture. My impression is that Russians are a very hearty and enthusiastic people. They don't mind a little boasting; it's only human, and there's nobody more human than the Russian people.

Now while the picture of America which we present is essentially positive, it is also frank. For example, in dealing with Negro equality, civil rights or economic questions, our purpose is to be thorough, complete and trustworthy. When President John F. Kennedy opposed the rise in steel prices, we did an hour-by-hour documentary of that tense 72 hours — what the President did, what he said, whom he called, what other members of the administration were doing, the jockeying for position and power by many involved elements including the steel industry and the pervasive influence of American public opinion. This is not presenting America as idealized or as free enterprise. We are trying to establish a realistic context of communication in which events which occur in this country can be judged. When there is a strike or other individual crisis, we're hoping to establish a real understanding of how such an event takes place. On the question of civil rights, if the national government favors Negro equality, why doesn't it go to Mississippi and do something? In order for a reader to begin to answer that, the whole background and concept of state's rights must be understood. If you are satisfied with a bland and general presentation — if you don't get into the real things that happen — you are obviously not going to present a picture which will be convincing when the going is tough. And that's really what we're trying to do: *to present a picture of America which will stand up when the going is tough.*

"Borrowing" Interest from News Events

One of the problems we have is portraying ordinary Americans, a subject constantly requested by our readers. How does an "average fellow" like me live? How does he get along? How much money does he make? These are facts which we believe are interesting to our readers, but are editorially dull! An American sitting in his living room with his television set just is not very exciting. We developed a formula to combat this problem which we've used on a couple of occasions very successfully. We would watch for major stories — a flood in Louisiana or an earthquake in Alaska — and when the story broke, instead of depending on a routine pickup of *Life's* coverage, we would send our own man in to select a specific subject. He might be a lineman, a policeman, fireman or even, in one case, a man whom we saw working to free the highway of a tree. We followed him through the excitement of the action and then went on home with him for photographic coverage which we would never get from *Life* or *Look*. This technique has been very effective.

We believe our readers are very interested in what we have to say, but we also believe that it isn't enough just to get somebody to read an article. It is the *impact* of what is said. We're looking for impact; we're looking for ways to increase the emotion of the magazine. There are many sources of factual information — the Voice of America, for

AMERYKA

Kwiecień 1967 • Cena 15 zł

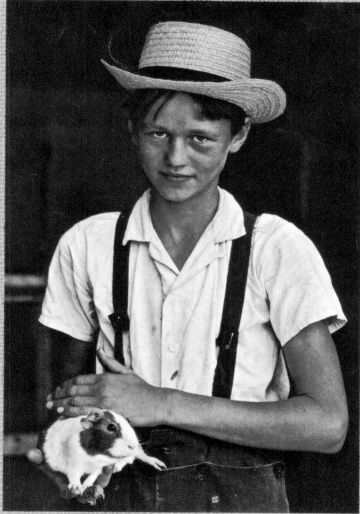

W tygeu narodów—wyspa tradycji

Photographs by William Albert Allard, **National Geographic Magazine**

Amish boy, cover, *Ameryka*, (Polish edition) April, 1967

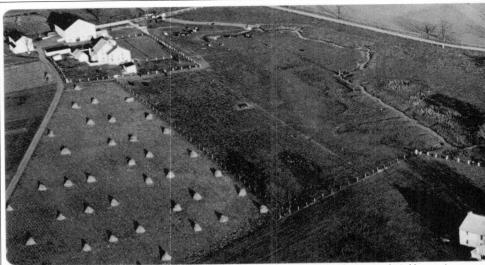

Wzorowe pola i schludne zagrody świadczą o pracowitości właścicieli; sielskiego krajobrazu nie zakłócają słupy z przewodami elektrycznymi.

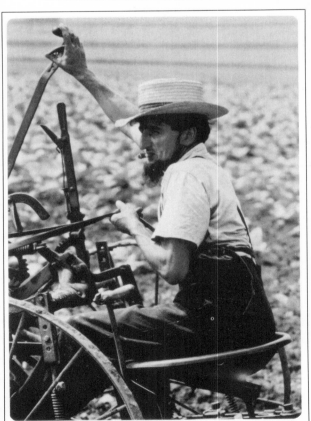

Spulchnianie bruzd pola tytoniowego kultywatorem zaprzężonym w muła wymaga zręczności — lewa ręka stale zajęta jest lejcami.

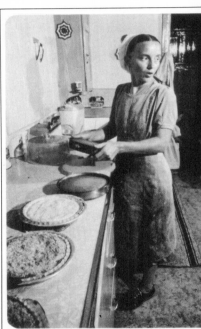

Kobiety „Amiszów" świetnie gotują: przyrządzane przez nie potrawy zdobyły sobie sławę w całym kraju.

Spread from Amish story, *Ameryka,* (Polish edition) April, 1967

Wsi spokojna, wsi wesoła...

Ze wszystkich darów Bożych „Amisze" pennsylwańscy (na terenie Stanów Zjednoczonych jest kilka skupisk tej sekty) cenią sobie najwyżej żyzną glebę i liczne potomstwo. Do ulubionych powiedzeń należy lokalne przysłowie: „Pulchna żona i pełna stodoła nikomu zaszkodzić nie zdoła". Są dobrymi rolnikami — płodozmian i konserwację gleby stosowali w tych czasach, kiedy w powiecie nie było jeszcze instruktorów, którzy teraz służą farmerom wskazówkami i radą. Gospodarstwa są typu rodzinnego; nawet dla starców i dzieci jest zawsze robota przy uprawie pszenicy, kukurydzy, tytoniu i warzyw. Koń przydaje się nie tylko do pracy w polu. Kiedy młody człowiek upodoba sobie dziewczynę, zaprzęga najlepszego konika do „swatnej kolaski", zabiera wybrankę na przejażdżkę i oświadcza się jej na koźle; jednocześnie robią przegląd pól, które po ślubie staną się ich własnością.

wychowują się na łonie natury, są oswojone ze zwierzętami. Młodzież obejmuje gospodar-
odziców; nieczęsto się zdarza, by dorastające pokolenie przeniosło się do miasta.

Photographs by William Albert Allard, **National Geographic Magazine**

example, sends a constant stream of information about the United States into the Soviet Union.

What are our limitations? First, our magazine represents the American Government. I was interested yesterday in the question to Ken Heyman on whether he might have sacrificed his art for the purposes of government. This is a big question, but I think it's a little bit like getting married and having a family. It cramps your style as a big-time lover and an egoist, but you're working on something which is pretty big and important. That responsibility supersedes your own considerations. Second, we're part of a cultural exchange agreement. We do not deal directly with central facts of United States and Soviet relations. The United States and the Soviet Union are the two greatest powers on Earth with many outstanding points of political difference. Every exchange with the exception of the cultural exchange between our governments is intensely political. But, working in a non-political sense can be both a limitation and an asset — the hope of finding another level of discourse, another way to begin a dialogue. Politics is not a particularly exalted level of human communication. and there's some advantage, I think, in being free of it.

Humanity, Not Politics

When I traveled to the Soviet Union for the first time in 1959 I was impressed by the things that I'd never been told about, never really sensed before. Shortly after stepping off the plane, I realized that all my life I had been thinking about the Soviet Union as a political entity, not as a country of living people. I spent the summer immersed in the Soviet culture, and my thinking and feelings will always bear the mark of that experience. I remember a conversation with a Russian who told me that when he first went to New York the city seemed strangely familiar. Then he remembered. He had seen it in *Amerika* magazine. Recently I found a quote from a Russian visitor to Chicago who told his audience:

> When you want to learn what a nation is and what a nation is capable of, when you want to know her ideas, her aspirations and her character, when you want to know a nation's soul, do not study her from the reports of the daily papers or the cheap pamphlets which are written but for one occasion and a month or two. Learn a nation from the precious contributions she has given to the eternal treasures of humanity. Learn from her what she did for universal science and universal art. Learn to know a nation from those men of whom she is proud. First of all, leave politics alone!

Often, when relations between our two countries are the most tense, the reception accorded each other's artists seems the warmest. As the curtain goes down, the applause is deafening. Encore follows encore. I've seen this in Washington and in Moscow. Part of this is reaction to the art, and part is the rosy illusion for a minute that everything is fine between our two countries. It also is the satisfaction that as people we do share so many common values. One of the most delightful sights I have ever seen was the Family of Man exhibit in Moscow in 1959, to see people's faces as they experienced that show — kind of a tunnel of love for mankind. The pictures, of course, were not about America. Many of the images made in America were not at all flattering to the nation, but the exhibit itself was produced by a great American. I am certain that its impact was very significant.

Perhaps the central fact about the U.S. and the Soviet Union is not politics, after all. Perhaps it is that as humans who are all living on this shadowed planet, we must find a dialogue and means of communicating which is not naturally political. We must realize that the world is for people, not politics. Our magazine, I hope, is a small step in that direction.

CONFEREE: I'd like to direct this to both Mr. Jacobs and to Mr. Alexander Makarov, the managing editor of *Soviet Life*. Could each of you comment as to circulation of your magazine? I should also like to know what economic and social class the magazine reaches in the Soviet Union and in America. Would you say that more libraries acquire it than individuals?

ALEXANDER MAKAROV: We've been trying to find the answer to that question ourselves. Last year we polled our readers asking them what particular subjects they would like to read in the magazine, what their profession was, and what they thought would be most interesting to Americans. We found that a majority of the readers are interested in the world and in other countries as a whole. They are the intelligentsia — people from universities and business. There are also many young people, students, who are interested in the Soviet Union and who want to know what is going on there. A certain group of people who read the magazine are descendents of Russian people, whose fathers or forefathers came from Russia. Many of these people do not know the Russian language but are interested in the land of their forefathers. Some of our readers are interested in learning about Soviet thinking on economics; others like traveling. We have about 2,700 library subscribers. Our library subscription rate is $1 for 12 issues. I know that there are many more libraries in the States; I hope at some time they will also subscribe to the magazine.

JACOBS: Our circulation goes to a very wide spectrum of people and interests. To a large extent we're trying to appeal to youth and to people who are thoughtful. Because we do appeal to so many different groups we frequently do special issues with special appeal to one group or another.

JOHN WHITING: I have a photographic question for both men. Do either or both of you use photographers from the other country sometimes in order to get a different viewpoint? Would this be possible?

JACOBS: Since we are portraying America, the actual occasions when this is likely to happen are few. I have thought that it would be interesting sometime to have a Soviet photographer and/or writer tour the U.S. for the magazine and prepare an article — again staying on the cultural level, away from politics. This is a very good idea, but it's hard to accomplish practically.

MAKAROV: We have been using material in the magazine written by Americans who were in the Soviet Union. We do not have any objections and consider it a good idea. We are contemplating printing photographs made by American visitors to the Soviet Union.

CONFEREE: Would the editor of *Amerika* care to say whether he thinks that *Soviet Life* does something better than *Amerika,* and would the editor of *Soviet Life* care to say if *Amerika* does something better? Have they learned from each other? Is there any indirect dialogue? How do they react to each other, magazinewise?

MAKAROV: I think we are getting along very well. We have not only indirect dialogue, but we have direct dialogue between editors because we both have offices in Washington. When the editors of *Amerika* come to Moscow they are always a guest of our editors there.

JACOBS: I think that one thing that *Soviet Life* has done perhaps more successfully than we is address the American people more directly in their articles. They have been more successful in setting up a dialogue. As editors we often find problems in common. We have assaults on our budget from many directions. I can remember some years ago when there was talk in Moscow of whether the paper quality had to be quite so high. About that time I was leaving for Moscow and the Soviet editor said, "If you happen to see a particular Soviet editor in Moscow, tell him that there are concrete reasons why our paper should be so good!"

CONFEREE: I'd like to know, Mr. Jacobs, if you've produced *Amerika* as a consciously American magazine for distribution in the Soviet Union, and if Mr. Makarov produces *Soviet Life* as a Russian magazine, so that each audience sees a nationalistic journalistic approach as well as a nationalistic voice? They each seem quite different to me.

MAKAROV: I'll answer this question by pointing out that our art director is a lady who has never been to the United States of America. She executes the magazine layout. Certainly the layout and photographs of the magazine are conceived by Russians, so whether or not you want it, the magazine will have the appearance of other Soviet magazines. Our magazine staff participates in discussions which take place among various Moscow magazine art directors. In 1964 *Soviet Life* won a first prize for layout. To some extent, of course, we consider U.S. layout.

JACOBS: We try for our magazine to represent good graphic art in America. That is an important part of the magazine. It is an American magazine.

THE RISE AND DECLINE

OF EUROPEAN PICTURE MAGAZINES

ANTOON WEECHUIZEN, 1968

The late Mr. Weechuizen served as editor-in-chief of *De Geillustreerde Pers* (*The Illustrated Press*) in Amsterdam, Holland, from 1939 until his death in 1970. His publishing house is responsible for four illustrated weeklies, three monthlies and books, as well. He was active in publishing an underground newspaper in Holland during the Nazi invasion.

The subject of my speech is "The Rise and Decline of Picture Magazines," for during my journalistic career of almost 40 years I've seen far-reaching changes in the world of magazines.

Specialty Magazines Began the Cycle

In the early '30's there was a great variety of magazines which specialized in all kinds of subjects and catered to everyone's taste. They specialized in art, politics, humor, tourism, women's fashions and child care. There also were illustrated papers. In those papers pictures led a rather isolated life. They were mostly used to liven up pages of text and break long stretches of words or letters. Pictures had no function of their own. So, it is not surprising that the illustrated papers were not very successful.

In the mid '30's there was a radical change. While it has generally been assumed that *Life* and *Look* were the trail-blazers of a new kind of magazine — the picture magazine — I should like to observe that there was a man whose work preceded that of *Life* and *Look,* but who has long since been forgotten by the general public. He was Lucien Vogel, a Hungarian, who lived in Paris in the early '30's. At that time he was struck by "a spark of genius." He founded the magazine *Vu* in which the candid camera was used to produce photographs which depicted unvarnished reality. He showed everyday life as it really was. He recognized the proper function of the photograph in an illustrated paper. But, Lucien Vogel was not very successful; he lacked the financial means and organization to give his picture magazine wider scope.

Practically speaking, it was *Life* and *Look* which gave the impulse of reality to the modern picture magazine in 1936 and 1937. After that, not only in America, but also in other countries, this approach was so successful that the former specialized magazines fell into the background. The circulation of the picture magazine exploded into a volume which, until then, seemed inconceivable. This was the first "turn of the tide" which I experienced during my career. And, in Europe it had a lasting effect until recently.

TV Ends Picture Magazines

The second change in European magazine production made itself felt about five years ago. The great period of the picture magazine came to an end as a result of the impact of television, commercial television, which was responsible for a decrease in enormous circulations. In France *Paris Match,* which until recently sold about 1,700,000 copies weekly, must do its utmost to exceed a weekly sale of one million. In Germany one picture magazine after the other has collapsed, though years ago every major city in Germany had its own illustrated. There are only four left now. It will surprise nobody if this number dwindles even more. In Italy the big picture magazine *Epoca* saw its circulation recede considerably, and in England, as you know, there's hardly one picture magazine left.

On the other hand, everywhere in Europe the specialized magazines are experiencing a revival, and, thus, we find ourselves about in the same situation as existed in the '30's. There is an affluence of specialized magazines.

News and Women's Magazines Flourish

European women's magazines, particularly in England, France and Holland, have developed into mass media which overshadow the circulations of picture magazines. In Holland, for instance, the woman's weekly, *Margriet,* sells as many copies as all Dutch picture magazines. That also holds true for news magazines, which, following the example of *Time* and *Newsweek,* are flourishing publications in Europe: *Der Spiegel* in Germany, *l'Express* in France, *Panorama* in Italy and *Elseviers* in Holland. Several other specialized magazines enjoy an ever-increasing popularity such as the television weeklies, magazines on interior decorating, child education, tourism, sports, and news magazines.

An essential contrast to the '30's is that now throughout the world large-scale concentrations are taking place in the press, resulting in powerful syndicates which a few years ago would have been unthinkable. This not only applies to daily papers, but also, and perhaps more so, to magazines. This concentration of ownership is developing very rapidly in Holland.

Three years ago the two largest publishers of newspapers and books merged into the "VMU," United Netherlands Publishing Company. At that time the company dominated the magazine market in Holland with 75% circulation. Recently it bought one remaining competitor. VMU now controls more than 90% of the circulation of all women's and picture magazines, and 100% of all youth magazines. It sells more than 5,000,000 magazines weekly and publishes monthlies and books as well. I know that such a concentration would be impossible in America where you have anti-trust laws.

In view of the facts which I have just mentioned you'll not be surprised that a syndicate of magazines of which I am the general editor-in-chief, *De Geillustreerde Pers,* is one of the companies which merged into VMU. Indeed, *De Geillustreerde Pers* is a major contributor with two women's magazines, a picture magazine, two youth magazines, fashion magazines, comic papers and books.

I should like to devote special attention to one of these magazines because its formula has become quite outstanding and exceptional. It is the monthly magazine, *Avenue,* which is especially slanted to the ever-growing group of educated young women, who want something more than practical information on housekeeping, and who are quite vividly interested in social and intellectual trends of our time. Many of you know that Holland, which used to be a rather puritanical country, has done away with many outworn taboos and is seeking new ways in religion, morals and culture. In such a climate the modern magazine *Avenue* can occupy a place of its own. It is quite unique for Holland. Next to the three subjects of strictly feminine interest — fashion, food and interior decoration — an important part of the magazine is of general interest. We publish 10 to 20 feature pages in color each month, sending photographers and writers all over the world.

From what I have told you, it is clear that publishing specialized magazines in Holland has now become a very important business, and a very profitable one, at that. That is why we can resign ourselves rather impartially to the disappearance of picture magazines. Nevertheless, it is unfortunate that nowhere to be found is the genius who might give these picture magazines a new lease on life.

TIO—THE PICTURE (AND MOVIE) TAKING 10

RUNE HASSNER, 1960 and 1968 (Excerpts)

Mr. Hassner, a member of the Swedish cooperative TIO, began his experience as a studio photographer in Stockholm at about the end of World War II. He then moved to Paris where he worked and studied photography from 1947 to 1954, moving on through Africa, the West Indies and the Far East including Red China. He returned to Stockholm to help found TIO in the late 1950's. His work has appeared in European and U.S. magazines, and he is a scholar and author on photographic history: particularly on the life and work of Jacob A. Riis, a Scandinavian who emigrated to the U.S. and utilized the photograph as a tool for social action. His book on Riis has been published in Swedish, and exhibitions based on his research have been hung in Sweden and Germany. He produced a series of 11 30-minute TV programs on the history of documentary photography, aired by Swedish Television, which included sound film interviews with Kertész, Brassai, Lartigue, Smith, Hicks, Gordon and Rothstein. Mr. Hassner appeared twice at Miami, in 1960 and 1968. Excerpts from his 1968 remarks reveal recent developments within TIO of documentary and feature film production interests and skills.

<div align="center">1960</div>

I have been invited to share with you a little about TIO (which in Swedish means *ten*), a group of 10 Swedish freelance photographers who have Stockholm as their operating base. A few days before my departure from Sweden, we celebrated a double anniversary in TIO: our second and our tenth. It was two years ago that our cooperative enterprise was officially founded, but the idea of a common organization has been growing in the 10 years since the main body of the group — together with four other young colleagues — had their first exhibition in Stockholm.

That exhibition was partly intended as a front against stagnant pictorialism and traditional salon photography by a group of young, mainly self-taught photographers — men who had just begun to work in photography, having gained first impressions of new trends in postwar photography through some foreign magazines and books. Perhaps the exhibition could be judged as a revolt for the sake of revolt. But, it was also an honest attempt to make a break from romantic "art photography" and impersonal news documentation in the press. Of course we condemned everything, the good with the bad, but our manifestation must also be viewed against this background: decades of national isolation within professional circles and the unfortunate fact that in Sweden there was no — nor is there yet — advanced formal education in photography as a communication art. Such a program could have assured continuous progress and new information for magazine photography.

Our exhibition did, however, coincide with a significant development in picture

journalism: several magazines had begun to devote considerable space to photo essays and larger picture stories. It was also a time of increased activity in other areas of visual communication.

In other European countries, particularly Germany and France, new concepts had emerged in magazine photography during the late 1920's. Editors and photographers in England continued the development of picture journalism during the middle '30's, but Swedish magazine photographers learned little of those findings and techniques through their available channels: the photographic press, exhibitions and libraries. At any rate, our exhibition had its intended effect: it created an intense photographic debate which spread into circles that had never seriously considered the photograph.

After this first exhibition, the participants who were to become TIO drifted apart. Some began solid professional careers, acquired wives, studios and summer houses. Others went abroad to study, travel and work. Some of us left for a short visit to Paris, but stayed there for almost a decade.

Paris — Postwar Photographic Renascence

As it had been in the 1930's, Paris became in the postwar years a meeting place for a new generation of photographers, a center of great personal meaning — the photographers' Saint-Germain-des-Prés. There we met not only the "old-timers," including Sougez, Masclet, Brassai, Paul Strand and Cartier-Bresson, but also Eugene Smith, Avedon, Haas, Capa, Stettner, Boubat and many others whose photographs one sees today in magazines all over the world. Informal schooling took place with improvised teaching. It was far from a formal education in photography, but I believe the training was really more useful than the limited knowledge one could acquire as an apprentice in the darkroom of a portrait studio or as a pupil in most of the existing schools of photography in Europe.

The appetite for seeing new countries and continents developed. Some of us took to the air; others departed on motorcycles or on foot. Short, informal meetings — in London, Cuba, New York or Hong Kong — during the next years kept us in touch, and the idea of a photographic cooperative slowly took shape. A studio in Stockholm emerged as a kind of meeting place and also functioned as bistro, lab and night shelter. The enthusiasm for a cooperative venture was great, but fortunately TIO was to remain only enthusiasm and plans for a while longer. If we had founded TIO in those early years, we would probably have failed. Most of us were quite busy building a personal way of life and finding a meaning in photography. In fact, some of TIO's future members first tried to work together in twos, but those efforts were not successful. They found that two people working together were either too many or too few.

Those who lived like camera vagabonds then began to grow tired of the often failing quality in their work because of incomplete or worn out equipment. They no longer saw the charm in lacking sufficient money to buy more than a roll or two of film at a time. Nor did they enjoy printing their picture stories with second hand enlargers in cheap hotel rooms where the bed bugs would creep over the enlarging paper during an exposure! Many negatives stored in traveling bags or shoeboxes in Paris, Rome and other cities disappeared and were damaged. We found that unlike

wine, a stock collection of negatives filed in a cellar did not grow in quality as time passed.

Those who stayed at home to work in studios or for magazines also faced difficulties. They became more and more involved as businessmen and studio managers with less and less time for so-called free and creative photography.

No matter how differently we worked, we came to recognize that what we all needed was an efficient, common headquarters, a postal address, a first class lab and filing system, and someone to manage business procedures. We wanted these practical assists without having to sacrifice individuality or the freedom to focus on the specific work each one wanted to do. The whole idea was, of course, not new or revolutionary. For example, Magnum had already been established with a somewhat similar organization in Europe and the United States, and in many other branches of industrial and commercial life cooperative agreements had been developed.

Home to Stockholm and TIO

Once the cooperative TIO had been formed and we were at last under one roof, we thought everything would be all right, that we could return to our work. But there were several problems to be solved.

There was the new experience for each member to assume responsibility and obligation to others. We also wanted to create the perfect working center with our own hands: we tore away walls, cut out holes for doors, filled in the openings again, flooded the premises a couple of times — and finally brought in professionals. However, working together closely during that initial period helped to establish a group spirit. Though we discovered some of the disadvantages of the democratic process, the advantages came so naturally I am afraid we often overlooked the opportunity to enjoy them.

Today our unit has developed into an organization not significantly unlike what we first imagined. At the moment our small community functions with a staff of six persons and most of the rough corners have been rubbed away from the administrative organization.

Twenty or 30 years ago a cooperative organization of photographers like TIO would probably not have succeeded, certainly not in Sweden, where professional photographers had generally avoided very close relationships with competing photographers. Formulas for developers and other technical matters were carefully kept secret by the masters — secret even from apprentices and assistants — just as in the early days of photography. Members of amateur organizations and professionals each kept to themselves. There was almost no contact among still photographers and the image-creators of the moving picture industry. Twenty years ago magazine photography was also at its very beginning in our country. A new profession of communicators began to form, men with the whole world as a working place. But, the requirements and the responsibilities of those self-taught professionals to the "image-readers" has still not been clearly defined or expressed.

TIO as a Business

A few words about how TIO functions. As a legal entity we are not a shareholders' corporation, but a producers' cooperative, which in fact means that each member is

economically responsible only to himself. We are all freelancers, but we share labs, offices, knowledge, experiences, services and dreams.

Each member of the group pays a monthly fee to cover basic operating costs. He is charged cost prices only for other services such as laboratory production of prints or film processing rendered for him. Any unexpected profit from these services helps cover general expenses. Proceeds of sales from the stock files go directly to the members, though 25% is deducted by our organization and applied to operating costs. At the moment the monthly fee amounts to $150, but I believe it will decrease to merely a "nominal" amount as lab production and sales from our stock files grow.

Apart from sharing the common costs, each member is entirely his own entrepreneur. He may want to earn a fortune in advertising photography, or he may work on a noncommercial long-range documentary project. He may paint, film or write books. As long as he pays his monthly share, he remains a member of the group. We believe this personal liberty in combination with a basic sharing of common services, costs, and equipment is a practical solution to getting such a special community as ours to function with the least possible friction.

At the TIO center most members have their own darkrooms. The central lab service is operated by the cooperative's staff. Our next step will be to equip a special darkroom for color processing and printing (one of the members recently studied color photography and printing in the U.S. on a scholarship). Three members have studios of their own in Stockholm; one owns a studio in Malmö. One studio is only a block away from our office in Stockholm, and its facilities are available to other members on a rental basis. Within TIO 16mm motion picture production equipment is available, and several members are becoming increasingly interested in TV as a medium for picture journalism at a time when television is only in its first stage of development in our country.

We are also planning for the future a service department to take care of invoicing, tax collection, accounting and insurance — all of those things a photographer really doesn't want to think about when he is working and traveling. Our dream is also to build a central fund to be used when a member wants to concentrate on a time-absorbing documentary project, an experimental essay or simply needs money for an urgent departure to cover an important event. This would be an important step toward an increased independence in our work.

A Forum for Ideas

While the fundamental reason for establishing the cooperative was to simplify administration and thus provide better working conditions for its members, there were also other important reasons for associating. There was the need to create a forum for the exchange of ideas with colleagues and others engaged in different fields of mass media communication, to analyze and criticize our own work and to act together as a group on the vital issues of photography.

The official professional organization of photographers in Sweden is an association of craftsmen working in many different fields of photography. Both employers and employees are to be found within the same body. In its wide scope such an organization cannot, of course, serve the special interests and needs of a minority of magazine photographers, whose fields of action simultaneously include lecturing, writing, editorial work

Mukhmelpur Village, India

Rune Hassner, TIO, Stockholm, 1963

and increasing activities in documentary motion picture and television production. Since there does not yet exist a vigorous organization such as ASMP which represents the interests and concerns of all European magazine photographers without concern for national borders, TIO must serve as a "miniature ASMP" for its members in Sweden. Conditions for magazine work are in many ways different in Europe than in the U.S., and any future European organization must be carefully designed and organized to accommodate our special international needs if it is to function efficiently.

We are sometimes asked how it is to work together in a cooperative of 10 individualists and freelancers. Are there too many complications? What about internal competition? It must be admitted that we, ourselves, are suprised that it works so well! It should be confessed that we have attempted a few, though not very successful, attempts at team production of an assignment. More often TIO members work in different parts of the world, meeting in Stockholm very irregularly. Together we cover most specialties of visual communication: reportage, advertising, sports, animal, architectural, color, industrial, educational and fashion photography, travelogue films and television reportage. Because of TIO's scope of action and knowledge, its members have found regular internal "seminars" for the exchange of ideas and technical know-how most useful.

Although various sorts of assignments keep each of us individually busy at the moment, our intentions are to devote more time to independent and more complete productions — larger picture stories, essays for books or exhibitions and films for television and educational purposes. We have already worked in co-productions with freelance writers and journalists.

Personal Reportage

Slowly we are also trying to change some of the "standard" rules and editorial procedures of communications media. For example, in magazine or television work it has been an accepted — though controversial — fact that a photographer should know his craft and do no more than shoot the images, that someone else should then process the films and select the prints — or edit the reels — and that still others should handle layouts and write the copy. At TIO we believe that the photojournalist who has planned, studied, photographed and experienced a story or an event often is also the most competent judge of what should be selected and presented as his personal, visual report to the millions. Photography is not a medium of sterile, objective "information," nor should it be simply an impartial product of mass media. It is, instead, a medium of personal expression. A photograph can communicate ideas, visual interpretations of facts or events. Unfortunately it is only too seldom that photography is utilized in such a spirit and that the original intentions of the photographer are communicated in the published version of a story.

We find that it is important to keep in very close contact with the tools and materials of photography and that one learns in the darkroom with his own stories when he is working on them. It is also important for the photographer to learn about new materials and techniques. When one returns from a trip, there is great satisfaction in working with the images and story until the package is complete. We believe in the validity of showing the finished work, complete with text, and with a suggested layout. Three members of TIO have published books which contained their own text and photographs.

A myth which is often discussed among journalists, photographers and editors is that a picture should be completely and finally composed in the 35mm viewfinder at the moment of exposure. For many photographers that is impractical, especially when you are working fast and must concentrate on expression or variables in composition. All images do not appear in exact 35mm format, either. And, an editor would find his job difficult if all of the images were in an exact 35mm crop. What could he do in designing the layout? That's why we believe in utilizing controls available in the darkroom as well as cameras with different formats.

We have been working in close contact with one particular Swedish magazine, whose art director sometimes encourages us to go back to the darkroom to reprint images so they better suit the layout — darken, lighten, or change the contrast of a print — and improve the finished story. The ideal would be a camera provided with masking frames, and in the moment of truth — the moment of taking the picture — the photographer could visualize not only the picture and its format, but also how it would be placed in relation to the next picture, to the headline and to the captions on the page!

No doubt some of you may wonder if there are sufficient outlets for the work of 10 magazine photographers in the small country of Sweden. And, we are certainly not the only photographers in Sweden; there are a number of highly competent professionals whose expertise spans the entire photographic field, some of international fame, including Rolf Winquist and Lennart Nilsson. In Stockholm alone the professional listing in the telephone directory includes approximately 500 persons who call themselves photographers.

Market Nears Saturation

Though the use of pictures is considerable in most fields of modern life in Sweden — the political life excepted — we may face difficulties in the future to find employment for increasing numbers of professionals. A crisis in portrait studio commerce can already be anticipated. The boom in advertising photography may quickly change with market conditions. As for editorial work for magazines, there will soon be too many photographers available who possess a "fair" basic knowledge of craft and subject, but too few with higher education and more thorough professional training at the high school or university level. Apprenticeship for photographers in the "guild" may soon have to be changed into a broader, more serious and adequate preparation for work in the mass media of communications. The government may one day discover the importance of such training.

Now, as the television era begins in Sweden, there are still a number of weekly magazines with comparatively large and healthy circulations, considering that the population is only about seven million. One magazine circulates about 600,000 copies each week, and there are 10 which each top 250,000 weekly copies. However, not all of these magazines publish picture essays and photojournalism, a fact also true of several large-circulation magazines elsewhere on the European continent. The growing import of television may further affect the contents and circulation of these magazines. A sizable fraction of European magazines still uses photographs only as decoration or "illustration" for text. Pictures help to sell magazines, so photographers' products are needed. But, few photographers give serious thought to the purpose which their work serves, running from assignment to assignment and seeming to have little care about how their images are published.

One large market for the photographic image is in news reportage — train acci-

dents, football games, princess weddings and visiting statesmen. Our domestic market for serious comprehensive photo essays is limited, which explains why some of our photographers work with international publications in mind. Europe has, as you certainly know, an assortment of magazines. Every country has its own brand of picture magazines, and every magazine editor has personal ideas about those subjects which he believes will appeal to his readers. Editors also work with their own basic layout formulas in which picture stories must fit. At present so-called "human stories" seem to be a popular hit among picture editors, but I am afraid that there are very few magazine editors who have proved themselves really concerned about human conditions, as is evidenced in their selection of material for publication. I cannot think of many magazines which have defined and then consistently published constructive stories on social matters, except when those subjects are believed to increase the circulation of the magazine. Let us admit that the "human stories" published in picture magazines to a very great extent are serving as nothing more than sentimental "entertainment."

An examination of a picture story published simultaneously in several countries frequently reveals very noticeable differences in editing and layout concepts among magazines. Sometimes text and captions have been rewritten in such a way that content is severely distorted. A photograph may even communicate the opposite information of that observed and intended by the photographer. Such handling of picture stories continues because many photographers tacitly accept this practice and look only at their work as a sales product in the trade.

Ethical Standards in Europe

Photographers in Europe still lack a generally accepted code of ethics similar to the agreements among American magazine photographers, editors and publishers. It is difficult and complicated for a photographer or subject to win legal compensation in many European countries without costly law suits. In fact a citizen is only safe from the photographer in his home. Once he leaves his front door he will have difficulties in defending his rights to his own face in the open against attacks of *paparazzis* or the more discreet long-range tele-lenses of *peeping-toms*. Of course, it all depends how the photographs finally are used. The photographer's rights to his photograph are described in the laws of many countries, but the agreements between photographers and international picture agencies or magazines are often very vaguely formulated. This is another problem which is very much the photographers' own fault, since few professionals bother when given an assignment to define clearly the rights, terms and conditions relative to the use and distribution of their work. In TIO we are making efforts to control the presentation and utilization of our work in Scandinavia, but when it comes to other countries, we cannot yet do much.

To distribute material to publishers in other countries photographers mainly deal through agents, but there is a very strange cobweb of agents, freelance distributors and magazine syndicates in Europe. An agency in one country often serves as agent for several foreign agents and each of them, in turn, might represent several others. A photo story is moved from place to place as an anonymous package. In most cases the agency commission on sales is 50%, but it varies depending upon what services are offered. From having once been a personal representative for a few photographers, many agencies have today

Mukhmelpur Village, India Rune Hassner, TIO, Stockholm, 1963

expanded to become bulk or wholesale image dealers. Occasionally such agents may offer a magazine similar material from a dozen competing freelance photographers, all in the same bag. The photographer will probably never see how the material was presented. Most likely it will not bear his credit-line! *Communication* is a word which should not be applied to this kind of image commerce. It must be emphasized, however, that important stories sometimes reach a very large audience through these same channels. At TIO we have decided not to involve ourselves in this system of wholesale international distribution of photography. Instead, we are trying to enter into more personal contacts with exclusive representatives both in Europe and in the U.S.

Although we call our cooperative TIO, 10, we are at the moment 11. The name TIO was never meant as a limitation of members; the door is being left open to other colleagues — not only photographers, but also film-makers, journalists and others working in the communication arts. Our eleventh member is, for example, a teacher in a school of graphics and editor of a photographic magazine who also works in advertising and layout. Thus, we hope to diversify our group as it expands and soon include freelance journalists and writers. Our aim is to produce completed units of communication, whether the unit is a magazine story, an illustrated book, an exhibition or a documentary movie film, even if this goal sometimes may limit our chances to see the unit published.

Our group also intends to introduce and present new, serious works by foreign photographers little known in our country. And, within our capabilities, we'll also try to assist foreign colleagues on assignments in Sweden. We do not have much floor space, but I believe we can manage to provide working facilities for at least a few at a time if necessary.

Perhaps you may think it inconvenient for traveling photojournalists to be based in Stockholm, far from large international magazines and agencies, but we are all Swedes and have several reasons to keep our center in Stockholm. Modern transportation has also placed us in the middle of the world, for it is about the same distance from Stockholm to Moscow, London, Geneva or Vienna, and the flying time to India, Kenya, Brazil or the United States does not differ very much.

<center>1968</center>

It has now been exactly 10 years since TIO was founded. During the first few years most of its members worked as magazine photographers, with some specializing in fashion, wild life, advertising or architecture. Today, without any formal decision by the group to change our field of action, seven of the 10 have moved into practically full-time work for television, cinema or multi-vision productions. Partly as a consequence of these new activities by the TIO members, our stock sales department, TIOFOTO, has opened its services to about a dozen other free-lance photographers and included their material in the files, which now contain a selection of some 200,000 photographic prints, about a million negatives, and a growing file of color transparencies.

Emphasis 1968: Documentaries and Photo Archives

Our current magazine stories as well as our movie and book productions are, in the main, independent productions. We have also been able to reach agreements with magazine publishers which allow us exclusive rights to all negatives even in cases of direct assignments. "First" (one-time) publication rights are assigned to the magazine for one year, after which time the photographer may use the material without limitations. During the first decade of TIO's activity we have thus been able to build a file of about 100 man-years of photographic source material under one roof. During the last four years we have also produced a number of television programs in close cooperation with the Swedish Broadcasting Company. Today our film productions exceed 100 documentaries and two full-length feature movies. Musicals are now in production. Our television contracts are similar in principle to our magazine agreements with TIO's producers usually maintaining all rights to the material and distribution except for telecast rights in the Scandinavian countries. After their initial telecast, several films have also been distributed in 16mm copies to schools, libraries and various organizations.

Of course this conversion from a major emphasis on magazine photography to substantial work in film and television has not been carried through quickly. It has not been just a matter of exchanging one camera for another. In our early films we often worked as cameramen in a team with a writer or journalist. Working with sound technicians and professional film editors taught us their new techniques. As our activities grew we installed several fully equipped editing rooms, and we have also acquired the necessary units of technical equipment for five complete 16mm production units.

One important factor in our low-budget productions has been a TIO member's opportunity to "buy" necessary production time. In order to keep production costs down we have been working in very small teams with each member responsible for a number of functions. My second full-length feature film, released a few months ago, was a three-

person production from the beginning of synopsis to final mixing and subtitle translation. It may sometimes seem inconvenient to work this way, for many problems must be solved in an improvised, unconventional and not always satisfactory manner. But, there are advantages too. You thoroughly learn several of the functions in film production, thus avoiding over-specialization which makes the film photographer feel just as a cog in the wheel of the conventional motion picture production system.

When you are working with documentary material, a considerable amount of production time must be devoted to structuring the story in the editing room. If you are working alone or in a small team you can afford to spend perhaps six months to a year editing the material without driving costs out of range and without experiencing the rush of you and your work by production supervisors of the film industry. It must be admitted, though, that working as a freelancer in film production is by far a more complicated affair than in magazine photography because of costs for equipment, technical processes and length of time in production.

Still I find my cinema work not very different from work as a magazine photojournalist. Methods and techniques of film production as well as the distribution system are, of course, somewhat different than work for the printed page, but the battle is still the same — how to master the techniques and get your message through, how to maintain independence in your work and control final presentation of the material.

Why did a large section of TIO convert from magazine to television work? First of all, when we founded TIO there was perhaps sufficient work for 30 full-time magazine photographers in our country and a greater amount of available space in square inches for photo stories than exists today. Now, in a short period of time and partly as a result of efficient group work in at least one of the existing Swedish schools of photography, about 200 to 250 talented young documentary photographers or photojournalists have been graduated and are looking for outlets of communication. Perhaps only 50 can expect full-time work. Also, every year in Sweden there are fewer photographic books published due to rising production costs and very limited circulations. If you want, you could call it an employment crisis. Young, talented photographers are actually working as lab assistants at the age of 25 or 30. These are some of the reasons why photographers have turned to other media.

Since labor unions do not view freelance film-makers in cinema and television as "unorthodox team productions" as would be the case in the U.S., a number of small-budget film experiments have been carried through within the cinema industry. Development of new, light-weight cameras and sound equipment has helped to bring along a revolution in documentary motion picture production, but new channels of distribution are still needed. I believe a new 16mm and Super-8 "movie industry" will evolve with entirely new structures for production and distribution. A center for distribution of independent film productions is being formed in Stockholm as an alternative channel to cinema-chains and television.

Photographer Controls TV Documentary

In the '30's and '40's Paul Strand, Cartier-Bresson, Ralph Steiner and other still photographers began to work in documentary movies. A similar thing is now happening in electronic picture journalism. While illustrated magazines are fighting their crisis, television

offers journalistic photographers new opportunities. While the result of months of work on a documentary in still photographs may appear as five or six photographs spread over a few magazine pages, you can edit hundreds of images from a similar period of in-depth film shooting into a 30-minute television program. Words and sound can be integrated in exact synchronization with meaningful images. While a photo book may sell a few hundred copies in a year — and a maximum printing of about 2,000 — you can reach an audience of many millions with a picture story in sound film on television.

It is a challenge which also involves an increased responsibility for the communicator. The "elusive image" of the television screen may prove to have more permanent effects than most of the so-called "permanent images" of a magazine which are looked at perhaps twice, though most still photographers firmly continue to believe the contrary. The extensive and serious photographic essays are slowly disappearing from the magazine pages in Sweden as has also been the case in several other countries. Magazines are trying new formulas, but the large and serious visual essays seem more and more to be found on television.

However, competition between magazines and television is somewhat different in Sweden than in the U.S., since our television program service contains no advertising or sponsor support. The competition among all media is more a battle for the reader's or spectator's leisure time. I understand that competition between television and magazines in the U.S. is mainly a battle for the advertising dollar and that the reason for the "magazine crisis" is because such a large fraction of advertising money goes to television that an adequate amount does not remain to support the magazines in existence.

Our monopoly television functions on a modest budget, especially if you compare it to the large advertising-supported television companies. On the other hand, as freelance film-makers we do not have to depend on a sponsor who decides whether your contributions are "selling" well enough to stay "on the air." In the two feature films and a dozen documentaries which I have produced with backing from Swedish television, I have experienced a freedom which I doubt can be equalled in other media. Since no one interferes in the work during production or final editing, you can at least say to yourself that if the result is not good, there is no one else to blame! In magazine photography I could very seldom control the outcome so completely as has been true in film.

Even if I am now working with film most of the time, I have not given up still photography. In fact, I have learned a great deal in my film work which will also be of use in future still photography assignments. It is quite interesting, for example, to examine the "decisive moments" in a slow motion documentary film sequence on an editing table to follow each step of the movement. And, techniques of combining image sequences with words in a documentary film are very precise. This knowledge also can be useful to the photojournalist.

I don't see any "media" borders; I don't wish to work solely with either the still photograph or film. Certain subjects can be presented with great effectiveness in a book, a magazine photo essay or an exhibition; others, certainly on film. Sometimes it is important to be able to choose the medium which offers the most effective distribution or communication possibilities.

I attended this year's Conference, in fact, to *film* some of the central discussions and

debates for a program series on *photography* for *television*. Whatever is the specialty of a visual communicator, it is no doubt useful for him to be familiar with the techniques and functions of other visual media.

PHOTOJOURNALISM AND
FILM-MAKING IN EUROPE

PANEL, 1965 (Excerpts)

A 1965 panel representing five European countries and the U.S. discusses the past and current status of photojournalism in its respective nations, paying attention not only to principal markets and significant contributors, but also to national interest in photography and educational opportunities — or lack of them. It was on the spontaneous note of the coming importance of film that the excitement, interest and involvement of the panel emerged.

Here presented is the editor's capsule digest of the opening statements by members of the panel followed by the transcribed discussion of European interest and activities in film. International panelists include L. Fritz Gruber, founder of Photokina in 1950, Cologne, Germany; Horst Bauman, photographer, Dusseldorf, Germany; Paul Huf, photographer, Amsterdam, Holland; Sven Gillsater, photographer, TIO, Stockholm, Sweden; Paolo Monti, architectural photographer, Milan, Italy; Romeo Martinez, editor, Paris, France; and Wilson Hicks, editor and teacher, Miami, Florida.

L. FRITZ GRUBER: Photokina was founded to show what the photographic industry is developing and what can be accomplished with photographic products. Germany has five weekly illustrated newspapers and other monthly publications with a combined circulation of 10 million copies in a country of 70 million population. The two largest newspapers each have a circulation of 1.5 million weekly and carry color. *Twen* is an important monthly magazine, created by young people for young people and carries very creative color photography. Its genius is Willy Fleckhaus. Circulation is low: 100,000.

HORST BAUMAN: No specific German "type" of photography is developing in the postwar years. In fact, in Europe there are not national boundaries in the style of or approach to photojournalism. The young generation of photographers is "European-minded" or "world-minded" in its thinking. Postwar photographers in Europe have mainly been influenced by American photojournalism. American photographers are better trained and have better agents. Germany has no formal education available in photojournalism as in the U.S., where photographers may study in colleges and universities.

PAUL HUF: Holland is a country with a population of about 10 million persons. It has an unusual language barrier with its magazines only being read by Dutchmen. Holland imports the photographic influence of Germany, France, England and the U.S. Dutch photojournalists cannot depend on very many assignments of a documentary nature from

Holland magazines; they must look to the magazines of other countries. No photographic education is available. Some excitement is being generated, though, in yearly Dutch exhibitions of photography.

SVEN GILLSATER: Interest in photography in Sweden is on a very high level. A photographic museum is being developed, and there is wide interest in photo clubs. Photographic education is available in the art and design schools of Sweden. Photojournalism is also taught at the Photo School in Stockholm. An energetic group of photojournalists in Sweden is TIO, a group of 10 independent photographers who have formed a cooperative. The group originally was involved in black and white magazine photography, though emphasis shifted to include color photography. Now, again, the emphasis is changing with more than half the membership actively involved in the production of documentary and feature films for television and education. Photographic books are popular in Sweden. Photographers here are influenced by German, French, Italian and U.S. magazines.

PAOLO MONTI: Photojournalism is in a sad situation in Italy. "Let's say it's one of the saddest situations in the world." Photography is yet to be discovered here. Italian photographers are not trained technically or professionally; they lack a cultural background. The country does not recognize a photojournalist as a journalist — a photojournalist cannot even carry a press card. The phenomenon of the *paparazzi* (sensation-seeking photographers who roam the streets searching for celebrated persons) has worsened the image of the photojournalist here. Italy has 13 illustrated weeklies, only one with a circulation above 250,000. Thus, there is tremendous competition among publications. Prices for photography are driven so low that sensitive Italian photographers have but one alternative: emigrate.

ROMEO MARTINEZ: The profession of photojournalism and conditions for photographers are good in France. There is a large colony of foreign photographers in Paris. France tries to avoid American influence in photography, since photographers here want to export culture, not import it. The function of the photographer in our society is seen as important by the people, even if not by the government. No museums exhibit photography in France, but photographers have personal projects and exhibitions. Schools of photography do not exist.

In England there is a resurgence of young talented photojournalists, especially in London. *Queen* and *Town* are important publishers of photojournalism along with the new Sunday magazines recently developed by the newspapers: specifically, the *Times, Observer* and *Telegraph*. The Sunday magazines which carry excellent editorial color, are edited and read by young people. These magazines have great impact in speeding up the development of photojournalism in England. Important English photojournalists include John Bulmer, Philip Jones Griffiths, Don McCullin, Terence Donovan and William Klein. Four of the top photographers in England are under 30.

WILSON HICKS: Europe — especially Germany — contributed mightily to photojournalism in the 1930's. In the postwar period the U.S. seems to be returning the influence.

The Panel Discusses Film

SVEN GILLSATER: Two years ago only two members in TIO were working on television documentary films. Today, more than half of our members are working solely in

television and film. It gives us an opportunity to travel, which we all like, and, besides, the market for documentary film for television is expanding all over Scandinavia — I daresay all over Europe. That is because we have very few commercial (non-government owned) stations in Europe, and documentary programs are very popular. I am selling all I can produce to Scandinavian and European television. That means we can plan our work and travel on an international basis. There is more money involved in television than in magazine or newspaper work.

I think more and more still photographers are moving to 16mm documentary film production. One of our best and most well-known photographers who worked mainly as a photojournalist has sold all of his still cameras and is now the owner of an Arriflex. He is working on documentaries, short 30-minute films and novel films. He is quite successful on the international market, just having won a top award in the Montreux festival last winter. That's the situation in Sweden at the moment.

MORRIS GORDON: Sven, how much influence did Ingmar Bergman have on the decision of so many of TIO's members to turn to motion pictures?

GILLSATER: I don't think he has had very much influence on the photographers who are now producing TV documentary programs. Bergman's wonderful way of handling people and light has been important to us, and I think he is a master of film. He does nothing in color, just black and white; that is his interest.

CONFEREE: I'd like to ask the panel if anyone can explain why in view of the contemporary and exciting film-making which is going on in Europe — in Italy you have Antonioni and Fellini working; in France you have the new wave — that still photography is lagging so sadly behind?

ROMEO MARTINEZ: The media are very different. First of all, cinema is entertainment, and I wouldn't say the same thing of photojournalism. Second, film is linked much more to the literary-minded; Antonioni above all is a man of mental images. The reason that the cinema has talented men is a reason proportional to the strong, cultural background of these men. In still photography we don't have the same kind and quality of men.

GORDON: That is an editor's reaction. As a photographer, Paul, what do you think?

PAUL HUF: In Holland the documentary film is the only possible way out, I think, because the photographer doesn't have to deal with print. The photographer can judge and control the quality of his film. As to the language barrier, film again provides a way out, because a documentary film is easier to be seen and understood in a foreign language than a written article with photographs in a magazine. We have some great documentaries made by Dutchmen, and I believe that this medium is the future for us. TV is still very young in Holland — we don't even have commercials! If in the future we do have commercials, those photographers who have gone into film will have an additional outlet to express themselves and have a greater audience to see what they have made.

HORST BAUMAN: This question of a still photographer for a magazine, a photojournalist, moving into the business of film-making is very interesting. There is not yet a similar movement in Germany, though I am aware of these developments in Holland and England. For example, Bill Klein is a highly regarded photographer. Now, except for handling some assignments for *Vogue* magazine, he does almost nothing in still photography. He is almost totally involved in producing television — even full-length and hour-long color movies. He isn't interested in doing stills any more.

FRITZ GRUBER: Another aspect is that a photographer who works in film can grow old and not be discarded. In still photography you grow old very soon. For two days at this Conference we have only had one theme: young photographers. How long do they live? What is in store after 30? After 35? The great Italian movie directors are over 50: Antonioni is over 50; Fellini is about 50. Some of the French film-makers are younger. But, there is such a waste in still photographers' talent. Magazines always want new, new, new; young, young, young. What happens to the older photographer? Had he better die?

GORDON: So the great talents go out of still photography and into motion pictures. It's a cannibalistic profession, isn't it? It eats up our young.

BAUMAN: One of the other reasons for going into movies was mentioned by Paul Huf: to have personal control over your production. When you are dealing with German editors, you go out of your mind after doing several stories for them. You discover that they regularly are wrong in their editing.

A sensitive photographer always wants to find or invent techniques for translating or visualizing a bit more of what he is thinking or what he believes about a story. It is in reaching that kind of goal that 16mm short or documentary movies excel as contrasted to making a portfolio of photographs for a magazine. Film is certainly a more interesting and exciting medium for somebody with ambition who strives to realize his personal ideas on certain subjects.

WILSON HICKS: May I call your attention to Mr. Richard Pollard, director of photography, *Life*.

RICHARD POLLARD: At *Life* we have six or seven photographers over 60 years old, just in case you're worried about youth taking over. Eisenstaedt is 67; Kessel, 64; they're doing fine. It is not a matter of age.

GRUBER: You handle them well.

GORDON: *Life* magazine doesn't eat its young!

GILLSATER: In Sweden when I am not on assignment working on another magazine story, I follow the story I have just completed to the printing press. My colleagues and I are allowed to work with the story from its very beginning to its publication. We are allowed to develop the film, print the pictures and work with the art director on the layout. That is also true of the books I am producing.

As a photographer I am annoyed and tired of being just a tool in the hands of editors and designers. I was in New York recently working on a story for a magazine with a circulation of about 8 million. The same day I came, the Churchill funeral story and its staff arrived. One of the editors told me that they were processing the film that day, but I knew this story would never be printed in the magazine. The editor interested in my story had asked me to come over to show it. He was not very interested in the photographs — I could see that he was playing cards with my pictures. I don't like that. Maybe that's why so many have turned to TV work, the documentary, because there we can watch and control our work. We are producers as well as photographers; we script the commentary. We watch all the details until the film is on the air. I'm an exception within TIO because I am creating films as a sole producer of the whole program. I enjoy this control very much even if the critics sometimes are pretty heavy on my head!

JOHN DURNIAK: In the United States we have a similar feeling to that in Europe: the

grass is greener on the other side of the fence. A movie course at the Museum of Modern Art just concluded, and if you stood on the stage, you could count the most famous photographers of New York — you name them — sitting there, trying to learn as much as possible about movie making. The still photographer wants to be the film director; the art director wants to become a still photographer. We are in a musical chairs business regardless of boundary.

POLLARD: I think this discussion is very interesting. The Miami Conference is supposed to deal with still photography, and we're all talking about how to get into the motion picture business. This is something that ought to be explored, economically as well as esthetically. Everybody suddenly wants to get into the motion picture business. Why is that?

GORDON: Right now Ernst Haas is working not as a photographer, but as a director for De Laurentiis doing "Genesis" in the movie *The Bible*. De Laurentiis selected Ernst to direct because of his great skill with abstraction.

HICKS: I think Paul Huf's point about the movie perhaps being the medium of the future in Holland is well taken, because, as he points out, it's a more readily comprehensible medium in view of the language barrier. That's a specific.

We know that for decades the motion picture in this country was tied to box office, but now it has been released. For many years, even while Hollywood was at its height in box office emphasis, Europe was turning out so-called art films and developing those forms to a high point of refinement.

What we're dealing with here are several means of transmission: television is simply a means of transmission. The common denominator of all these media which we've been discussing is the *image:* the *still image,* the *moving image* of film on the motion picture screen and the *electronic image* of television on the front end of the tube.

John Durniak said all photographers want to become movie directors. Still photographers in this country, for all their good work in the last number of years, have been greatly frustrated for one primary reason. Unlike a writer who can do a whole novel or the movie producer who can do the whole film, the photographer only does one element of it for a magazine or newspaper: the pictures. Somebody else does the writing; somebody else does the layout. One of the things which draws still photographers to the motion picture is that they can be the whole business instead of just one part of it.

We're going to have still photography with us for a long, long, time. It's going to be developed further; it's going to reach new heights, both in editorial and advertising. We're going to see in the next 10 to 25 years tremendous development in the motion picture. We are hopeful that television will become something more than what one speaker here referred to as "hogwash." I would guess that television will be the slowest to develop of these three means of transmission: ink-on-paper, motion picture on film and the electronic image on television. The principal competition will be between the ink-on-paper still picture technique and the motion picture film technique.

10

In Summary And
Into The Future

R. SMITH SCHUNEMAN, 1970

Adapted from 1970 Miami Conference Award Address

Dr. Schuneman is a professor of Journalism and Mass Communication at the University of Minnesota in Minneapolis in charge of the undergraduate and graduate majors in photographic communication. He holds the B.F.A. and M.F.A. degrees in photography from Ohio University and an M.A. and Ph.D. in communications research and television from the University of Minnesota. His professional experience includes newspaper and magazine reporting and photography and television news photography. He is co-author of *America's Front Page News, 1690-1970* (Doubleday, 1970) and has authored chapters on "Photographic Communication: An Evolving Historical Discipline" in *Mass Media and the National Experience* (Harper & Row, 1971) and "Photographic Communication" in *Introduction to Mass Communications* (Dodd, Mead & Co., 1970). He is immediate past president of the Minnesota Professional Chapter, Sigma Delta Chi and immediate past chairman of the Photojournalism Division, Association for Education in Journalism.

It was in 1967 that I first attended the Miami Conference, an experience which quickly proved to be the most refreshing and stimulating three days I had ever known! Since that time, I have witnessed each successive Conference in Coral Gables as well as all of the Conferences from 1957 through 1966 "on tape." But, I have not lived and studied those programs without a number of questions in mind.

What has been the essence of the Conference? What has it accomplished or tried to accomplish? Have there really been recurring themes permeating the years? What conclusions, if any, can be of value in guiding photographers and editors in the future?

While the Conference was to deal with the photograph as a medium of mass communication, quickly in its proceedings a great deal more was articulated: a very deep respect for the photographic image, a dignity of the photograph, if you will. High ethical values were called for by photographers and editors year after year. It was the value which they placed on the validity, integrity and dignity of the photograph which was unique. Their emphasis and goal toward an honesty of interpretation in photographic communication was a concern truly the mark of professionals at work with their colleagues.

And, as I have searched for changes in photographic communication over the years, I have come to one very strong conclusion which relates to remarks above and others which shall follow. The evidence from this Conference bears out that the values, the goals, the aspirations — the ideals — the sensitivities and sensibilities — of the professional photographic communicator have largely remained firm and unchanged since its founding. Possibly they have strengthened and matured. Wasn't that the very discovery and point of Ernst Haas when he was asked how his work had changed?

In some "dimensions" of our field, however, all has not remained unchanged. There have been profound developments. In the general interest and specialized consumer magazines, Sunday newspaper picture magazines, television and book publishing industries, changes have largely been brought about as a result of a rapidly developing technology of communications media as well as important economic adjustments which have impinged upon media consumers, advertisers and publishers. I shall return to some specific trend figures later.

Unchanging Ideals

However, first I want to develop the thesis that the photographer has not changed his ideals and standards of excellence in these past years. Photographers and editors as well have continued to urge their publishers to carry significant photographic stories of interpretation with a social conscience and have pressed for a raising of standards of reader, viewer and consumer.

Wilson Hicks wrote in his book *Words and Pictures* about the "mind-guided" camera. The goal of that "mind-guided" camera, the photograph of depth and interpretation, was emphasized in the birth year of this Conference by Ray Mackland, who was then picture editor of *Life,* in his keynote address. Mackland said:

> To be effectively meaningful stories must be interpreted for their significance. In this matter of perspective we have an obligation to crystallize what is important in stories which count. Press photography needs purposefulness: photographers' and editors' convictions. We should strive constantly to say something worth saying with intelligence and vision. We must use the camera in a sensitive, judicious way with understanding, feeling and honesty. In these times when a confused public so badly needs clarification of important issues, photojournalism is a force so potent it has a growing responsibility to the subjects it portrays, to the readers and to itself. What's really going on in the world? Why do things happen? What do they mean? The more we can contribute to answering these questions — if we can bring even a little more understanding to hopeful peoples eager to learn — the more we begin to justify the promise of our profession.

That *Life's* management was wavering in the goals set forth by Mackland was evident by 1963 when Roy Rowan, then assistant managing editor of *Life*, talked about interpretation in *words*, not words *and* pictures. He was promptly reminded in a question which followed about the value *Life* had placed on the significant photograph:

> Maybe we were over-responding to television, or maybe we were just responding to television, but we felt that people wanted more depth with stories than just the visual impact of the pictures. We also know that you're bombarded with pictures now much more than you were 10 or 15 years ago. I mean advertising pictures are much better, your television, your billboards. Everything has gotten very visual, and we just felt that we should add the dimension of more text. I think we're still a picture magazine.

One conferee responded:

> Very briefly, the formula 10 years ago gave *Life* a monopoly on the living picture. It was a permanent living picture and movies and news reels which existed then or television today could never detract from that. To me this is what *Look* and other magazines are doing, and *Life* seems to be attempting to discourage the living picture, the picture that tells something. You can pick out a 10-year-old copy of *Life* and almost relive the experience from that picture. Today's *Life* is getting involved in text. I think this is a problem, because I can pick up *Time* at the newsstand. In *Life* I'm looking for the living picture, or at least the rebirth of it.

Then, in 1969 William Albert Allard, a former student of mine at Minnesota, a staffer for three years at *National Geographic Magazine*, and currently a freelance, asked if something were wrong with the in-depth interpretive picture story approach of the late 1950's and rejuvenated the cry for interpretation by the photographer.

Thus, in this quick telescope from 1957 to 1969 one can see that photographers and editors were calling for in-depth interpretation in 1957; and in 1969, 13 conferences later, photographer Allard was re-affirming the same value.

About Photographers

I'd like now to shift your attention to the very specific. I want to share with you some of my discoveries of the profound, of the significant, and I might say, of the all-too-infrequent humorous highlights from the Conferences. One comedian *par excellence* has disguised himself for years as a photographer. I discovered that. His name, of course, is Mr. 100-*Life*-Covers, Philippe Halsman. Philippe had this answer for panel chairman Harriet Shepard in 1961 when she asked him why he became a photographer:

> Well, I drifted into photography like one drifts into prostitution. First, I did it to please myself; then I did it to please my friends; and, eventually, I did it for money!

That question about the early work of a photographer — the first assignment kind of thing — recurred almost yearly. In 1958 Margaret Bourke-White delivered the keynote address. Afterward in a radio interview, which was also preserved, she spoke of her first *Life* picture story:

So I'd begun with *Life* about 8 months before the first issue of the magazine came out, and there were just four of us then. Henry Luce sent me out to Montana to do the Fort Peck dam for the first cover of *Life*. Well, then I began to explore behind the concrete facade of the dam and to study a very primitive form of frontier night life. It must have been like the gold rush days. There were all sorts of things — bars that were a shambles, the little child of a bar maid, seated at the bar, and almost paper houses, as on a movie set. I took these shots just because I was so crazy about what I found. No one at *Life* had ever seen this, and the editors of *Life* made that into the magazine's first picture essay.

In that same interview she was asked about the future and what forthcoming assignments she anticipated. It was May, 1958, only seven months after the launching of Sputnick I. Miss Bourke-White said:

I'm quite serious about wanting to go to the moon. Several years ago when it looked as though it might be a possibility I asked *Life's* editors for the assignment. I just hope science moves along fast enough so that I can get there. Of course I know very well that for the first few years we photographers will be completely scooped by mechanical equipment. IBM will get there ahead of us, but the time will come, we hope, when they can pack away enough oxygen so that a photographer can go along. I just want it to happen fast!

The next year, 1959, Ed Thompson, then managing editor of *Life,* told conferees that Miss Bourke-White's fight against Parkinson's disease had just begun when she attended the conference in 1958. She had undergone surgery for the disease a few months after her appearance in Miami. Margaret Bourke-White died August 27, 1971. Lisa Larsen, well-known New York photographer, had spoken at the same Conference with Bourke-White, though she was to die of cancer before the 1959 session.

Photographers and Editors

The process of photographic communication — the taking and editing of photographs — has, of course, been a topic of principal concern through the years. Wilson Hicks described the steps of the photojournalistic process in his book, *Words and Pictures*. In every magazine picture story, he said, attention must be paid to the *idea;* to its *development, research,* and *scripting;* to *assignment of a photographer* and his *execution of the story* with the camera; and, finally, *writing, layout,* and *editing* at the editorial office.

This process has always been a point of controversy between photographers and editors. Often argued have been their respective roles and responsibilities. Hicks set forth his ideas clearly and succinctly in these remarks during a 1959 question-answer session:

The photographer, many photographers, are looking to the day when they will do the whole job from idea to publication. Perhaps that's an ideal. I'd be more inclined to characterize it as a dream. How you're going to circumvent the group operation or responsibilty I don't know.

Now there are two things involved here. *Rationale* and what I call — just to have a kind of similar word — *emotionale.* A photographer goes out on a story. He is essentially

operating as an emotional human being. Sure, he does it well, but he's *involved,* so *involved* — with the situations, the people, the ideas, the points of view, the stances, the selectivities and everything that goes into the making of pictures and picture stories — that he becomes a bad judge. Perforce he becomes a bad judge of his own pictures, because he's too involved with them emotionally.

Back home in the editorial office you have fishy-eyed editors to whom your images are all new in the light of the idea, you see. Their approach is new; they're hard boiled; they're cool and calculating; they're dispassionate. They don't care if the photographer had to climb a 150 foot ladder or if he hung by his heels over Niagara Falls. They only are concerned with what those pictures should *say* — that's their responsibility — and how well the pictures say it.

So there's a dichotomy there. I think it's wonderful. I've always thought so, ever since I've consciously been a picture editor. I have thought it was wonderful if the photographer *couldn't* participate in the layout and selection. I would be more inclined to say to the photographer take your emotionale and to hell with you! We're going to be completely rational. We're going to make the best possible use. We have a great sense of responsibility. We're not going to do you dirt. Pictures are our livelihood. We're not going to let the photographer down. So, we proceed to put together the best possible story. And, I think that photographers should be very happy about that situation.

I greatly question this business — what I call a dream; what photographers call an ambition — to do the whole job, because I don't think you could do it nearly so well without having this important partner, the editor. There!

Frank Zachary, who was then art director of *Holiday* magazine, further defined the singular importance of the magazine editor this way:

> Great magazines exist only because there are good editors. Talent is essential, sure; but only in the way it shows. If you study the history of magazines from the time they began, you'll discover in back of every great book there has been a great editor associated with it for very long periods of time. You can't do it by committee. The editor has to be a dynamic, quirky, cranky, ubiquitous ignoramus who wants to be informed, who wants to be amused, who wants to be entertained and who wants to be instructed. Somehow this editor pulls together the talent available and produces something in his own image. It bears his signature and none other. The *New Yorker* or any other great magazine is simply the product of one man's ambition. The talent, I must say, is almost secondary in the respect that he's using it; he's processing it. Sure it's essential, but it's essential only in the way the editor is using it.

Gjon Mili, well-known *Life* photographer, emphasized in 1966 the very special responsibilities and professional approach necessary for a photographer who works as part of an editorial team:

> I was talking to Wilson at lunch and we were discussing the difference between being a *photographer* and a *professional photographer,* which is a much narrower profession. In being a professional photographer, first of all, being a genius is taboo! You're supposed to be like the true professional, like the true actor, like a trooper. Sometimes you shoot with seven other guys around you; sometimes you shoot alone. Sometimes you shoot a subject that you are not necessarily interested in, but you realize that there is a need for it, and you happen to be on the spot, and you must do it. Sometimes you risk your neck — you don't even think that's a wise thing to do — but you do it.

That some editors do not understand the esthetic of the photographic image, and hence, often weaken the impact of a photographer's vision are criticisms often advanced by photojournalists when arguing against the editor's final authority and exercise of that authority. Wilson Hicks and W. Eugene Smith were engaged in a very spirited discussion of the matter once again at this Conference in 1959. Gene Smith commented:

> Finally, I would like to say that as far as I'm concerned I think there is no separation between the esthetics and journalism or photographic reportage. But, there is almost invariably a separation in our publications; this is one of the main errors.

Wilson Hicks replied:

> One of the vital and practical problems of photojournalism is how to combine esthetics and, if you like, the document. If you leave photographers on their own they'll produce documents. Well, there's nothing wrong with documents. They serve a purpose, but they lack the esthetic. And, what we're constantly trying to do as editors is to replenish the document with the esthetic.

Eugene Smith:

You are?

Wilson Hicks:

Well, we don't always succeed very well, but we're trying, of course.

Eugene Smith:

> This has been absolutely my whole fault with trying to exist in photojournalism . . . that there has been an effort to destroy the esthetic quality by forcing a superficiality upon us.

While the issue of argument seems clear at this point, Hicks' position was surprising, especially so when one considers his belief in objectivity. Clearly it caught Smith by surprise, as well.

Technique: Means to an End

A theme, though, on which there has been general agreement through all the years of the Conference is that the technicals of photography are but a means to an end: the end being the communicative photograph. That a professional photographic communicator must consider the camera only as a tool of expression was articulated in a rare moment of the 1961 Conference. Photographer Art Kane addressed himself to photographic mechanics:

> The only tool the photographer has to paint with is light. We do not have pigment. We have only this damnable machine which, frankly, I hate; I do not like cameras or ma-

chinery. I don't even like the way the world is going. I'm an extreme romantic. I prefer green grass and human flesh and human anything. I don't particularly like science, so I really resent this camera which I am forced to use in expressing myself I wish there were a thing that I could put in my eye, just blink, twist my ear and pull it out of my mouth!

Professional Responsibilities

We in photographic communication — as professional journalists — do indeed bear a social responsibility to our many audiences. In 1960 co-chairman Morris Gordon, then president of the American Society of Magazine Photographers, set forth the criteria which indeed distinguish the amateur from the professional photographer.

One conferee, Harold Feinstein had spoken during a 1959 question-answer session with emotion, with conviction and with intensity on the photographer's professional responsibilities:

> It's the man; it's the man and what the man has to say. And this is what I believe the magazines forget about.
>
> We're all waiting for the big revolution, and when the revolution happens, we'll all join in. But those kind of revolutions never happen. It's an individual revolution. It has to happen right now to you.
>
> What's the future of photojournalism? How will we find something new? How will we advance? These are the questions which must be brought up. What are you waiting for? What do you expect to see? Fireworks happening? Do you expect to see a march on Washington? It's happening, it's happening with certain people.
>
> A lot of reference has been made to "Country Doctor," to Gene Smith, almost by every speaker at one time or another. Well, here he is. Here's his work. Here is the beginning of part of a revolution.
>
> New ideas are not easy, are not smooth. New ways of working are not obvious, and you can't expect the revolution to happen if you want it to happen in the same formula, in the same way, that you've been seeing everything happening before. You are here now. You are seeing revolutions happening. You are seeing the new work That's all!

And *Life's* publisher in 1961, the late Henry Robinson Luce, focused on the photographer's professional and social responsibility when he said:

> The challenge then to the photojournalist is to know that he is a human being in the highest sense, that he is endowed with reason and with the awesome knowledge of good and evil. He must carry the sense of reason and judgment in every picture he takes, in every story he prints. Every picture must say something; in fact, every picture will say something. It is the responsibility of every photojournalist to know what his picture says and whether it speaks for good or for evil.

In some of the most sincere and eloquent moments of Conference history, Aron Mathieu, founder of *Writer's Yearbook* and *Modern Photography*, gave this intensely personal anecdote to affirm the import of striving for excellence and professional responsibility in "What Photographers Need are Standards" (beginning on p. 284):

So, although I became editor-in-chief that day, I still was the office boy, because this man had a short memory. I would run and get beer; I would get cigarettes, but the fellow who hired me loved me He gave to me his entire life. But he did one thing that was hurtful, and although I remember the thousand acts of love, I want to tell you how he hurt me. Because that is the only thing I have to say that will help you And this is one of the reasons that I'm here, because I'd like not to happen to you what happened to me.

My friend, my employer, my otherwise teacher put me in a cage. It took me a long time to get out of it. He used to make a sign — it was the symbol that almost cut me down. A dozen times a day he would flash it to me. And it meant, "It doesn't matter that much." And what he meant was, let's put three colors on the cover instead of four, make three-color plates. Let's use 50 pound paper instead of 60. Let's run 80 pages instead of 88. Let's do it for less. Take the money you save and print more copies And you could really make a lot of money and not be very smart. And I made a lot of money, and I wasn't very smart. But, I was boxed in by this man who told me, "It doesn't make that much difference." And let me tell you, *each detail matters!*

Certainly if the ideals of a Feinstein and a Luce and a Mathieu were to permeate the field of photographic communication, there would be no argument that our specialization would have reached the criteria Morris Gordon set forth for professionalism.

Education

This Conference has periodically focused its attention on the education of photographic communicators. Of course the subject holds great interest for me, since my own deep involvement with the photograph can only be matched by a continuing desire to see others become involved with this most viable and significant visual medium. So my ear was tuned as I listened to those miles of tape for any clues I could find on the education of photographers. The very sensitive, yet the pragmatic, Gjon Mili gave in 1966 some of the most important advice a teacher, if lucky, could ever impart to a student:

In the last analysis there was one thing which I wanted to tell you. This is addressed to the students. For all the knowledge you may acquire — and I am a man who has spent time acquiring knowledge in photography — there is no getting away from the fact that if you want to be a photographer, you must be so entranced, so attached to your subject that there is physical communication. It's the one thing that makes a photographer — the ability to attach yourself to the subject to the point of eliminating any other preoccupation. As I say, it's almost physical contact, and it's the only lesson I can teach you after 40 years of it. You must get connected! You can be clever; you can be able; you can be successful; you can do many things and be very useful. But, if you would want to call yourself a photographer, it is not possible unless you find subjects that you can attach yourself to wholesomely.

As we enter the 1970's students are vocally and physically rebelling against traditional educational systems, as well as traditions in business and government. It is an important time for examination and re-evaluation. Students want freedom — total freedom — to do what they deem important. They rebel against self or external discipline, wanting to create images of personal merit; few students of the last few years find the group journalistic process appealing.

But, a man whom history will most certainly judge as a creative genius in photog-

raphy at mid-twentieth-century, a non-traditionalist, commented at this conference in 1967 on the import of *discipline* to any creative being. Of course I'm speaking of the photographer and philosopher, Ernst Haas (see pages 215-216).

Philippe Halsman observed in 1961 that photographic techniques were becoming so simple that ever increasing numbers of people were entering the field of photographic communication with nothing approaching the skill of a carpenter, but he quickly added that technical skill alone was only prerequisite . . . that there was much more to being a fine photographer.

It seems to me that photography is one of the professions that is the easiest to learn. It is probably the only profession in which you can learn enough to begin to produce, let us say, within a month. In a month you can take a very decent picture. Can you, however, make a decent table in a month? Or a watch? Or become a dentist? It isn't possible. So the mechanics of our profession are incredibly easy, and therefore our profession attracts a tremendous number of people. However, I have found that the successful photographers usually are not successful only because they are technically good.

International Dimensions

Contributors from Europe, the Pacific and Latin America have brought to this Conference a context, a benchmark, to aid in forming attitudes, judgments, and later, perhaps, conclusions. From the very flip Stephane Groueff, who told of the antics at *Paris Match* in the early 1950's, to the serious Romeo Martinez, editor-in-chief of Switzerland's *Camera* magazine, the international flavor of this Conference has added to its uniqueness. Martinez charged in 1959 that while American photographers were rule breakers — and hence, creatively desirable — editors were conformists.

America and especially American photography has a great influence on new, young photographers of Europe — really, a very great, great influence. On the other hand, America's photography is a bad influence. This negative influence is mostly the contribution of the American magazine — the American standards to make a magazine. And here I'm afraid we're coming to trouble very soon!

Wilson Hicks was next in on this one:

But who's influencing whom?

Martinez replied:

I will be more precise. On the one hand you have photographers who break all of the rules. On the other hand you have editors who are absolute conformist people, and this conformity is the negative American standard I am mentioning.

Then Hicks concluded:

We complain over here too, that our photography is conformist. Roy Stryker said last year, "I protest!" "Conformity! Conformity! Conformity!" I hear editors asking, "Why don't they take new kinds of pictures; where are the rule breakers? Everything has begun

to look alike. Are there any new styles?" The first year of this conference, Ray Mackland said, "The great need is for individualism in photography."

One of the most dominant centers of conferee attention — and also an area most filled with change — during the life of this Conference can be found in economic and business developments of the mass media. Each year speakers and conferees alike have concerned themselves with what has been happening to the "market." The American Society of Magazine Photographers met in October, 1969, to discuss the future of magazines. A report of that meeting was carried in both the November and December issues of *Infinity,* though, in my opinion, the report barely touched the many interrelated complexities involved in the present economic and business situation.

The Future

In concluding, I want to attempt to define where the photographic communicator in the printed media now stands and where he may expect to move during this decade of the 1970's.

First, permit me to draw from the Conferences. One of the first speakers to accurately assess the situation of the 1960's and certainly the early '70's was Franz Furst in 1959. At that time Furst was associated with the agency *Pix* in New York. He urged photographers to continually search for new markets. He indicated that the '60's would be a time of expanding markets — new markets — an observation which couldn't have been more accurate. Howard Chapnick of Black Star said in 1958 that our field is "dynamic, not dying." Franz Furst gave as the reason for the death of *Collier's* not reader disinterest in the word-picture story as content, but financial considerations not directly linked with magazine content.

Wilson Hicks was deeply concerned with the same subject in 1962 when he gave the keynote address. His topic was appropriately titled, "What's the Matter with Photojournalism?" One of the ills he described is helpful in our consideration of the economic and business picture:

Certainly it is no secret that for the consumer magazine this is a time of trouble. By trouble just what do I mean? Permit me to give you a list of particulars.

The magazine has one problem in common with the newspaper, and that's the competition of television. Television has had and is having a profound effect on ink-on-paper journalism

Television has made radical encroachment on the magazine reader's time To put it quite bluntly, television is cutting down the magazine's advertising revenue. This hits the magazine where it lives

How does a magazine get advertising? It's through circulation, of course. And how should it get circulation? The answer is only too obvious — through the quality of its editorial content. An old principle in general interest magazine publishing was that the more circulation a magazine had, the more its advertising volume. But, with rising costs, circulation can reach a point where to produce and deliver magazines is so expensive that the economic law of diminishing returns takes over, and the advertiser no longer sees the purchase of space in the magazine as desirable.

Hicks saw clearly the influence of television in 1962, an electronic mode of communication which has become a very significant factor in the economic mix of mass communications during the life of this Conference. At the end of World War II there were only six television stations beaming news and entertainment to 10,000 receivers in the U.S. When the first Miami Conference convened in 1957 there were approximately 250 stations reaching 50 million receivers. Television had become in its first decade an established and viable medium.

What has happened to television as a medium during these years of the Miami Conference? Today 98% of American homes are equipped with one or more television receivers; 40% of these homes now receive color. More than 625 stations today blanket the country with a moving image in full color that talks. A formidable competitor you print-media-types say? How has television affected both the circulation and the advertising — those two inter-related variables Wilson was considering — of American magazines? Is printed communication dead?

Certainly if readers were today showing disinterest in magazines one would expect to find a drop-off in circulation. Such, as you know, is not the case. Circulation of *all* printed media is increasing today. In the last 20 years during the phenomenal rise of television *consumer* magazine circulation has grown 68%, while newspaper circulation has grown 20%. Magazines are growing *faster* than the U.S. population aged 15 or older.

In 1948 there were 130 magazines for every 100 people — not titles, but copies of magazines. In 1968 there were 168 magazines being circulated per 100 population.

But, you say, the number of markets is tightening; there are magazines dying all the time — for example, *Collier's, Post* and *Look*. Let's again examine the figures. In the 10-year period 1958-1968 there have been 676 new consumer magazine titles copyrighted while 162 magazines ceased publication. That is a net gain in 10 years of 514 consumer magazine titles. In 1968 alone there was a net gain of 80 titles.

The consumer magazine for a specialized audience has shown the most significant development in recent years — particularly magazines in the sports and hobby fields, which now make up one-third of all consumer magazine titles.

While *Life* and *Look* together were down about 20% in the total number of pages since the beginning of this conference — 13% since 1964 — men's magazines such as *Playboy, Esquire, Argosy* and *True* are up 88% in the number of pages since 1949. Business magazines are up 76%. And, since 1949, sports magazines including *Sports Illustrated, Sports Afield,* and *Field and Stream* are up 247 percent in total number of pages.

Now, what about circulation, another part of the mix? As one example, the leisure magazines — *Sports Illustrated, Holiday,* and *National Geographic Magazine* — have grown 57.4% in circulation in just the past five years. Certainly no sane analyst could conclude from this x-ray view of magazine publishing that the magazine is dead.

What, then, are the problems? What may we see occur in the 1970's? The two basic problems facing the magazine publisher are (1) rising costs of production and distribution, and (2) in some of the general interest, mass-appeal magazines problems of securing sufficient advertising support.

The solutions are not so easily defined, but perhaps some possibilities are emerging.

Consumer magazines must cultivate a select audience — an audience which represents to the potential advertiser a significant fraction of his potential market. His cost per thousand then can drop significantly below that of network television. Selective advertising sections — zoning — also make the magazine a more appealing sales medium.

But, what about the problems of production and distribution? We know that as the density of population increases, communication media become more and more necessary. People simply are not able to accomplish information exchange through interpersonal communication. But, larger populations and larger circulations of wide appeal publications drive up those printing and circulation costs, thus, again, casting the magazine in an unfavorable light to the advertiser.

The question, then, finally is how to print and deliver the magazine in the cheapest possible way, yet, at the same time — and this is what Aron Mathieu would demand that be said — preserve a fidelity and a quality of the image not possible with television. Certainly the recent combinations of such companies as G.E. and Time; Reader's Digest and Sylvania; Random House and RCA; and Science-Research Associates with IBM have not been by chance.

Dissemination of printed media in the future, I believe, will be electronic over a cable through a home information center, giving the subscriber a kind of "custom communication." I've heard people at this Conference say we should be talking about *involvement* in communication, and that we shouldn't encourage *mass* communication. I don't believe the communication of the future will be *mass*. I believe it will be *custom,* where the reader, the receiver, can call forth his own media mix of news, entertainment and specialized communication services. It will be possible for him to receive a printout of incoming electronic signals in full color by a Xerox-like process. Remember, there is no indication that people do not want the printed word and image. They are continuing to buy ink-on-paper communication in greater quantity than they are expanding in population. As a consumer of media you will also be able to do your banking, get your medical diagnoses, check a book at the library and receive your mail — all from this little black box which we'll come to know as the home information center. Transmission will not be over the ether — there isn't the spectrum space — but it will be by coaxial cable — the community antenna television cable (CATV).

And, as greater numbers of homes connect to CATV systems — one research study projects that 30 million homes will be connected to CATV in this country by 1975 — these systems will transmit their own programming as well as that of the networks. Already by regulation of the FCC any CATV distributor with 3500 receivers or more must originate his own programs. Thus, the very large audience formerly shared by three TV networks will be fractionated — that large, one-purchase audience which has always been so attractive to the advertiser. There will be many program sources available on a cable system which can handle 50 or more channels. Thus, again, the general interest, wide-appeal magazine will emerge as a viable advertising vehicle. But it will be delivered not by the mailman, but by a community antenna television system to a home information center.

To be on the ground floor of this electronic revolution of printed communication I would urge that those interested in the future of photographic communication pay particular attention to economic and electronic developments of mass communication in the '70's.

The visual communicator — the photographic communicator — is just being discovered by the American audience. Young people have great interest in and respect for the photographic image. As communicators we must understand their interests. We must look at their images. Let us try to understand more about the photographic communication which they desire and will accept. If we can better comprehend the electronic and business aspects of our field as well as further understand the content of future media, we will be much better prepared to face the 1970's and after. What we now need is a spirited interaction among publishers and creative people to begin to prepare for the day when the new media come into focus.

Speaking of that day, Ernst Haas best concluded my thoughts when he said in 1967:

Times have changed, and with them the magazines have changed. Photography has changed. But what has not changed is a human being who wants to be a photographer. As long as there are young people who are willing and trying to do interesting things, in spite of it all, and not always because of it, things will go on

Talking about the future and talking to young photographers, I can only give this advice. Be as flexible as possible; learn everything; go into television; learn the camera; learn movie making. But, don't forget the hand over the finger — draw, paint, let yourself go. Become a universal visual man. And read, and listen, and live, and don't be afraid. Even if a period is over, that means it's an end. But every end is always a new beginning, and this new beginning is really in your very hands.

INDEX

Numerals in Italics refer to photographs, newspaper layouts or magazine spreads.